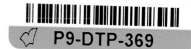

NATIONAL GEOGRAPHIC

THE
PHOTOGRAPHS

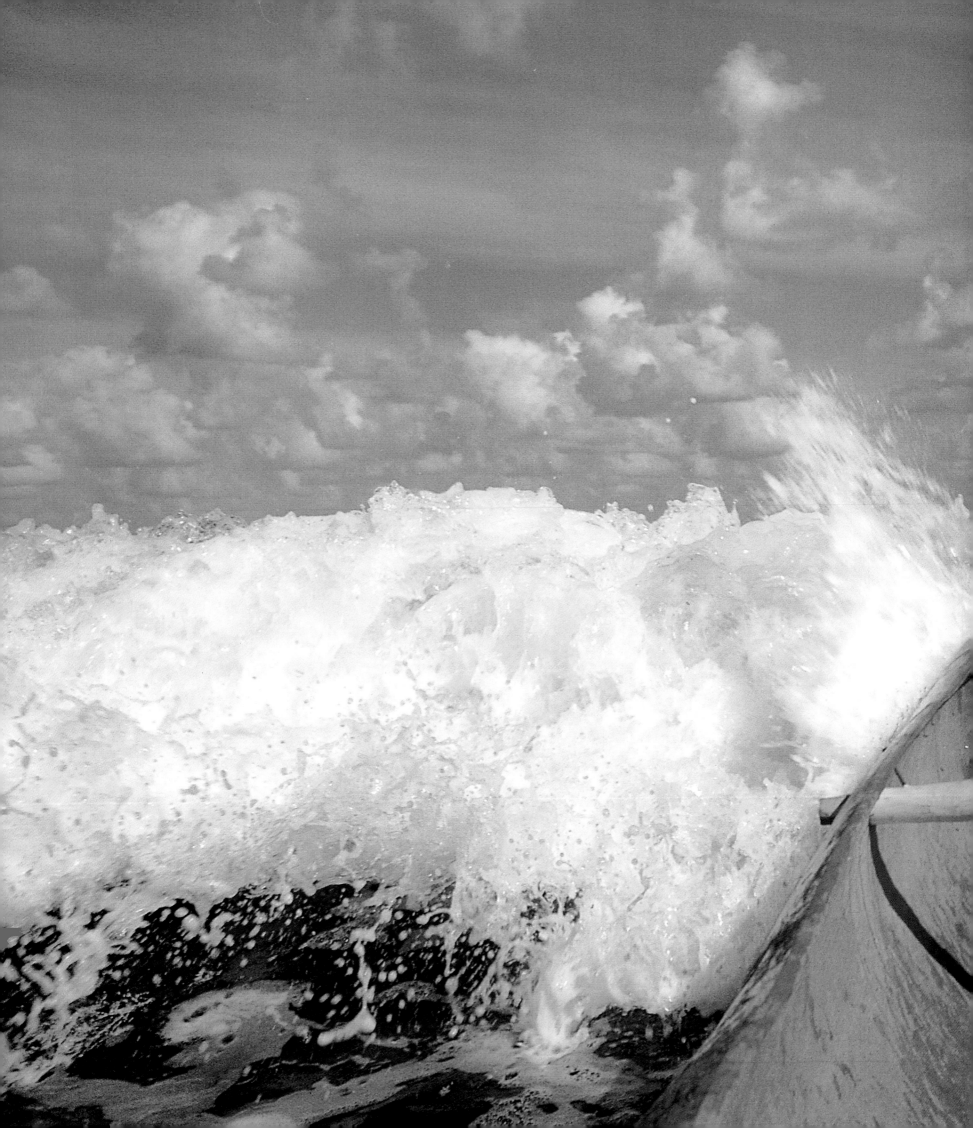

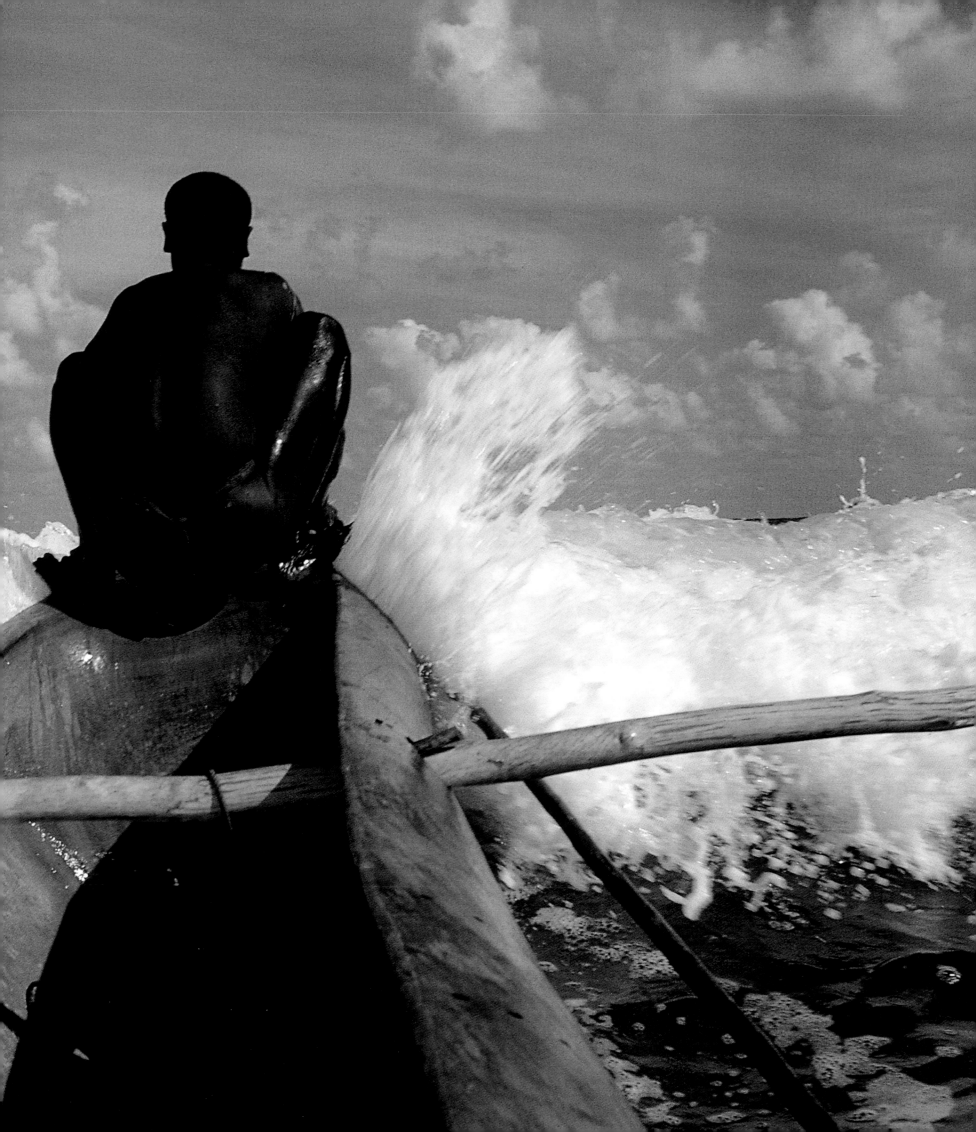

Kuwait 1991
STEVE McCURRY

*Desperate for untainted
water and browse, camels
wander across still-burning
oil fields, after the Gulf War.
Photos "cannot convey...
the deafening roar" in this
"black, hellish landscape,"
McCurry says.*

preceding pages:

Andaman Islands 1974
RAGHUBIR SINGH

*With the prow of his
outrigger an Onge fisherman
breaks through waves off
Little Andaman. Singh
braved leeches and an
occasional hostile arrow to
document life in these remote
islands in the Indian Ocean.*

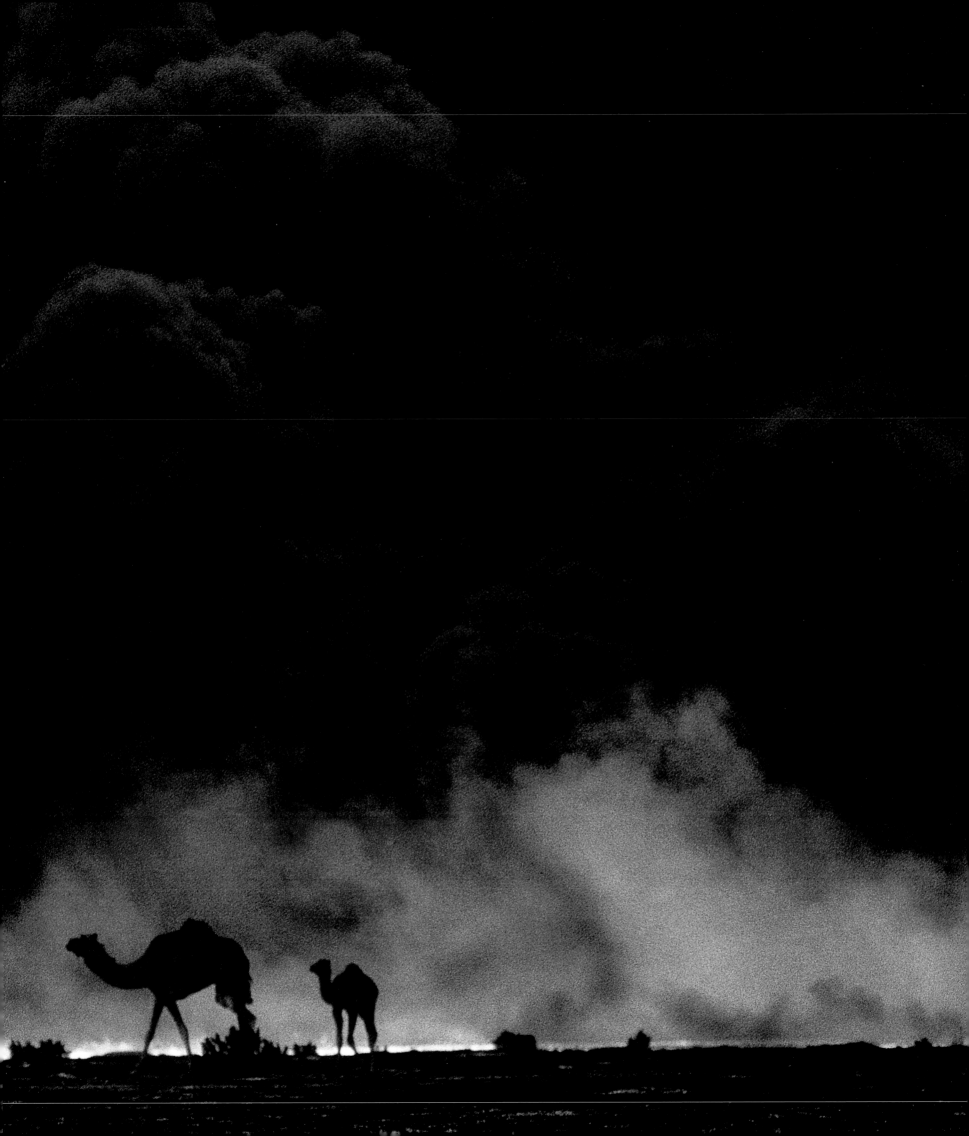

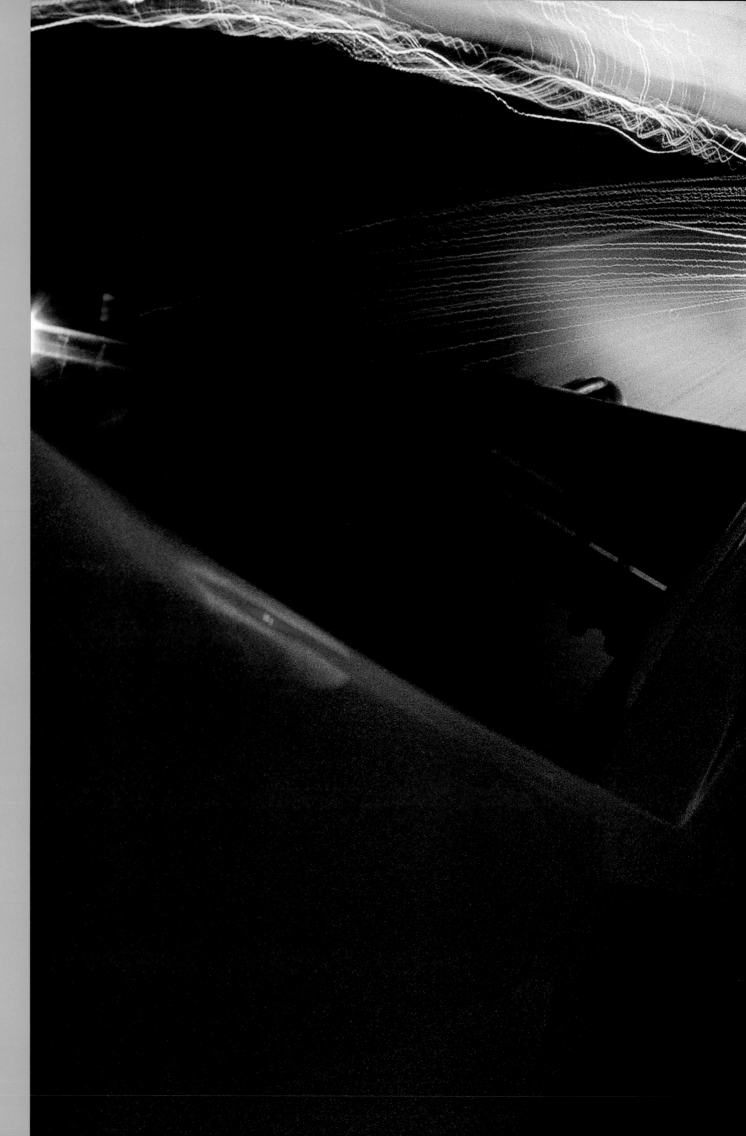

Palmdale,
California 1977
BRUCE DALE

*Streams of light trace a
Lockheed TriStar landing
on automatic pilot. From the
cockpit Dale activated two
cameras mounted on the
aircraft's vertical stabilizer.*

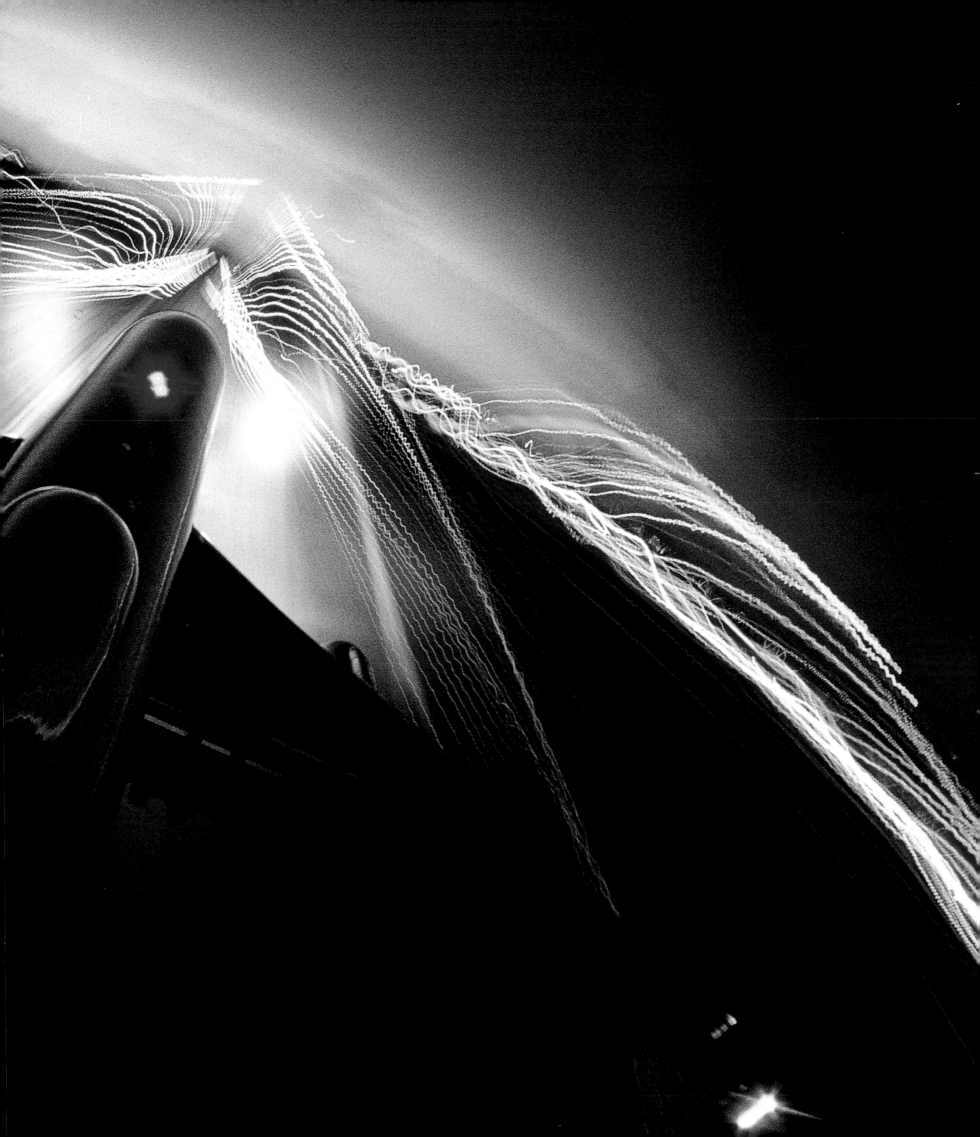

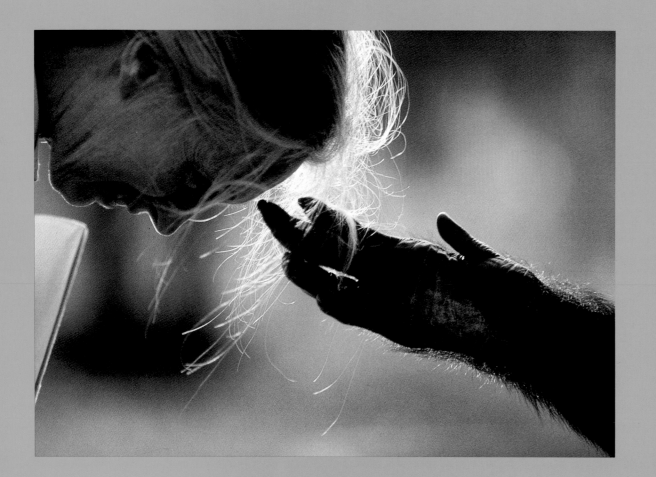

Brazzaville, Congo 1990
MICHAEL NICHOLS

Long held in a zoo, an aging male chimpanzee responds to Jane Goodall's greeting gesture with a tender touch. Nichols has covered research on primates in captivity as well as in the wild.

Virunga Mountains, Rwanda 1991
MICHAEL NICHOLS

An infant gorilla nestles in its mother's embrace. Deriving tremendous satisfaction from his experiences with the mountain gorillas, Nichols observed that "they had let me into their world."

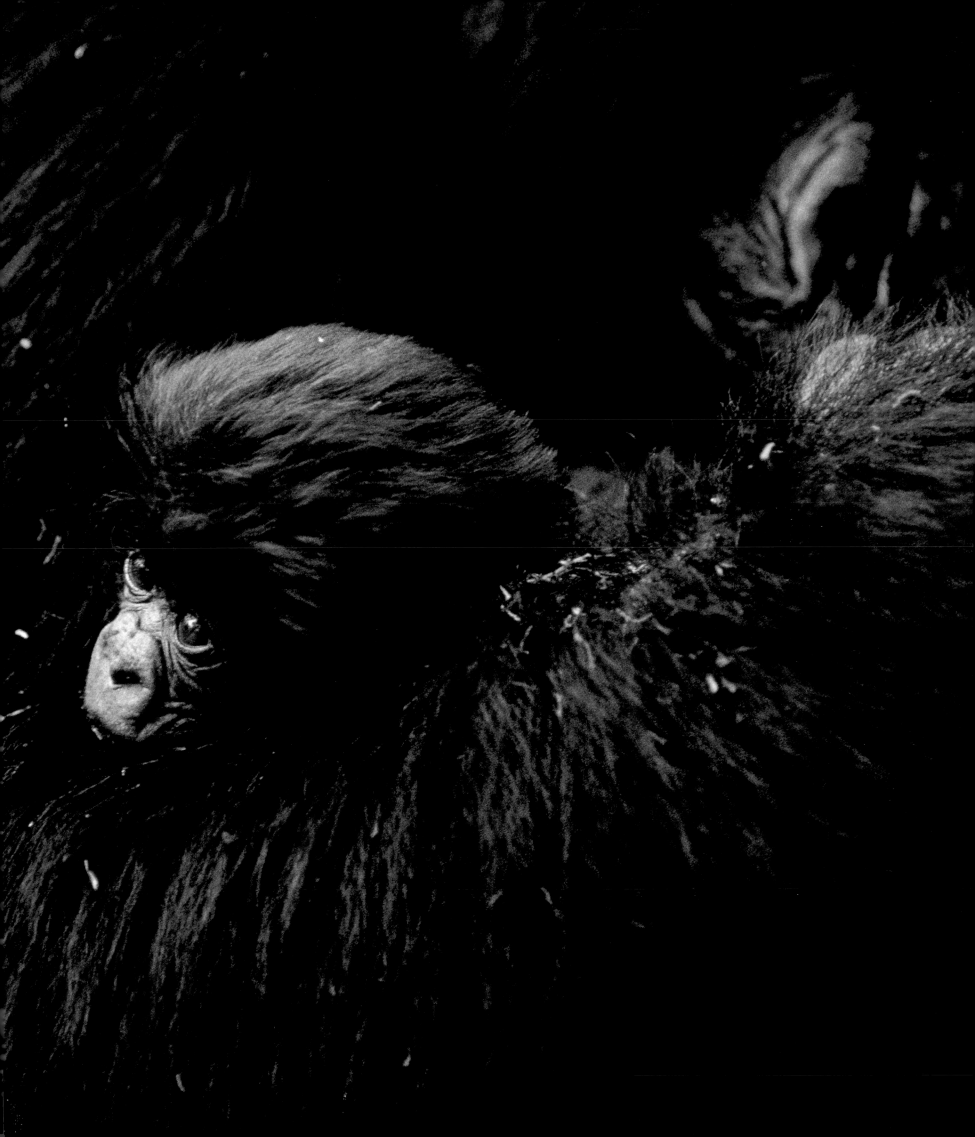

Arizona 1970
WILLIAM ALBERT ALLARD

Holdout with a 48-star flag, rancher Henry Gray muses over a half century of running cattle in Arizona's Sonoran Desert. For a story on the U.S.-Mexico border, Allard traveled 8,000 miles by motorcycle.

following pages:

Ellesmere Island, Canada 1986
JIM BRANDENBURG

Leaping between ice floes, an Arctic wolf scavenges, perhaps for fish. Brandenburg once had to posture submissively to avoid a confrontation after touching food left by this alpha male.

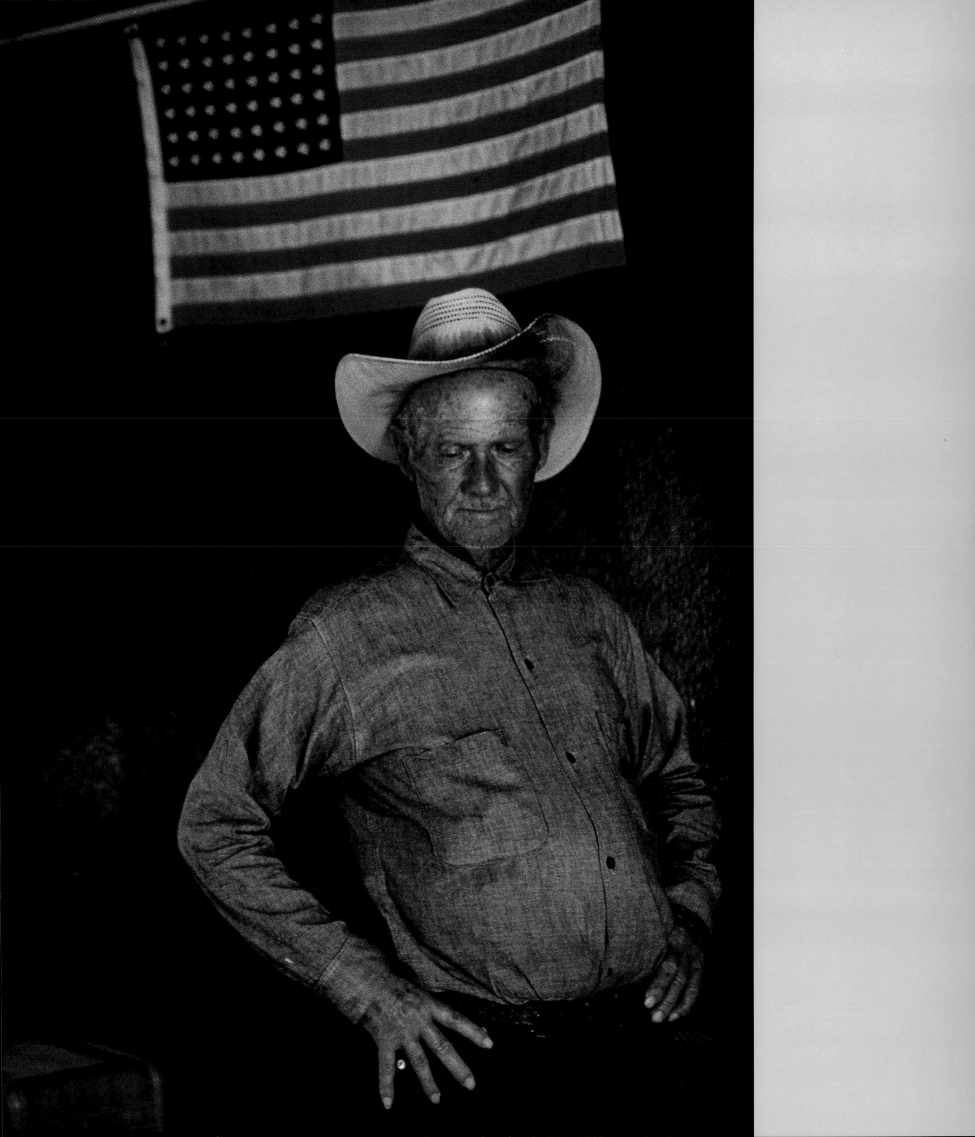

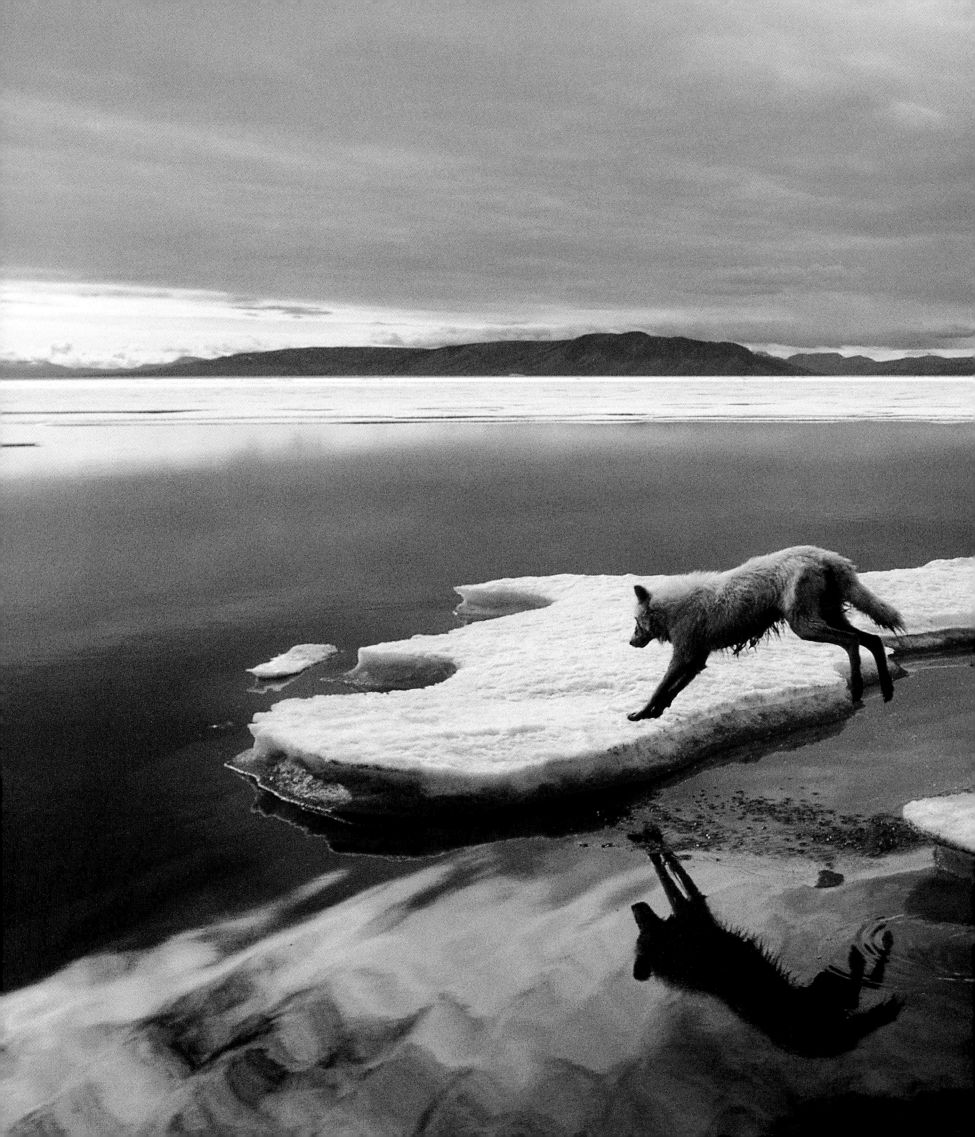

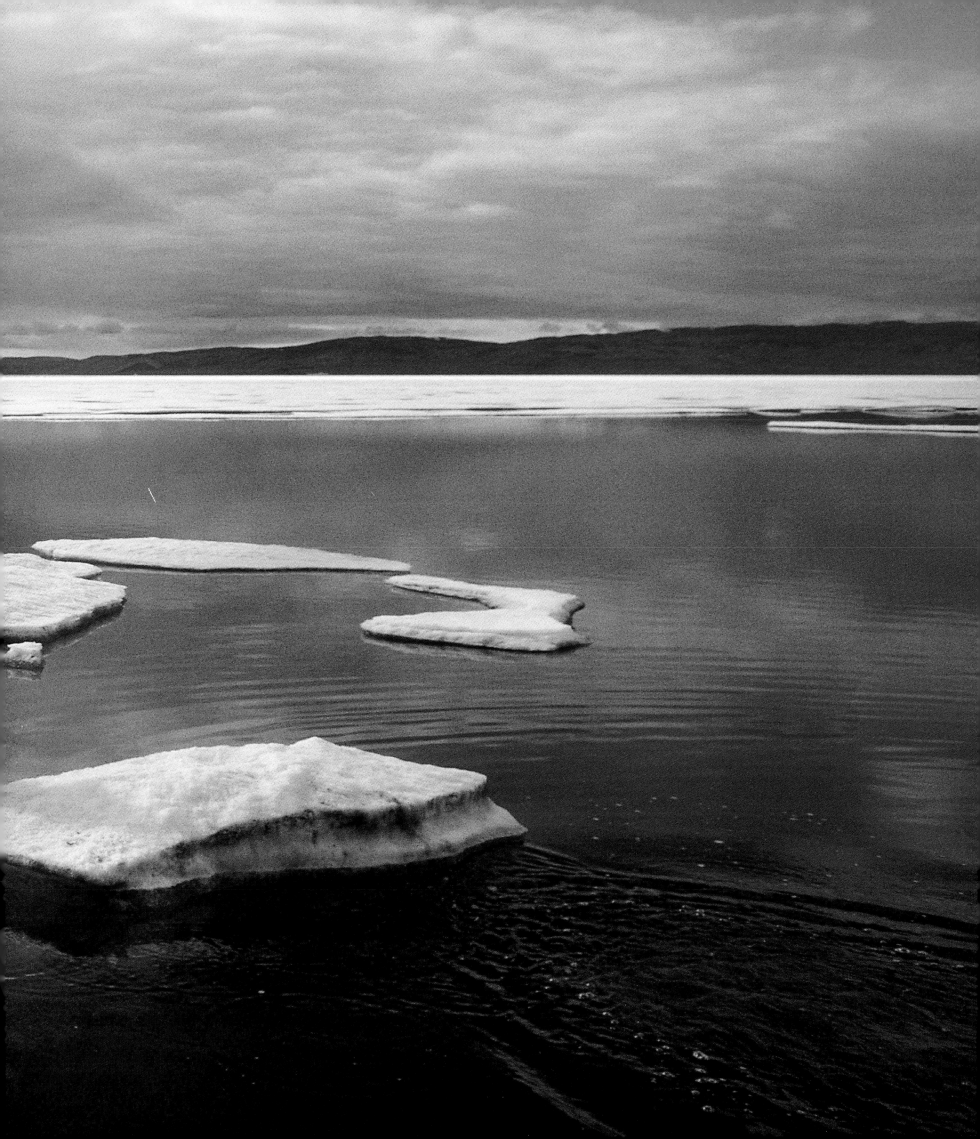

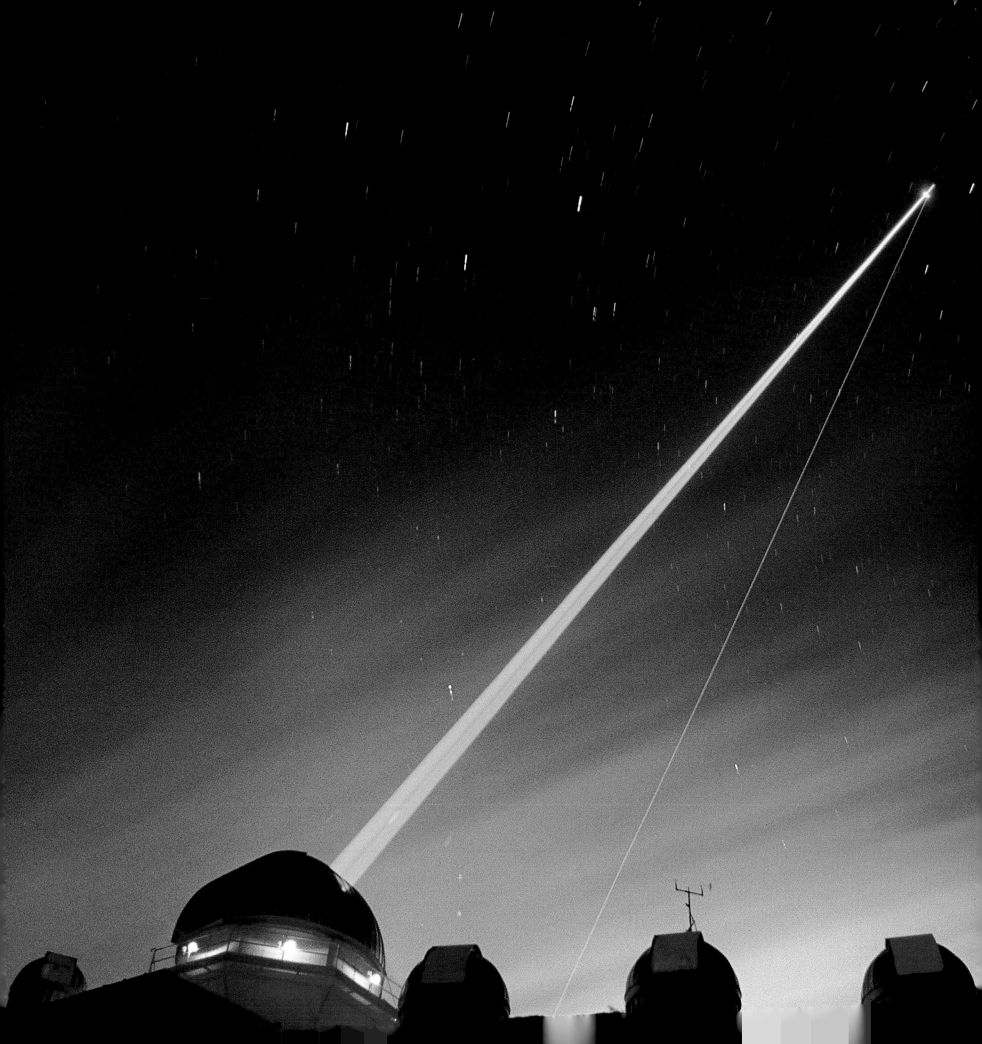

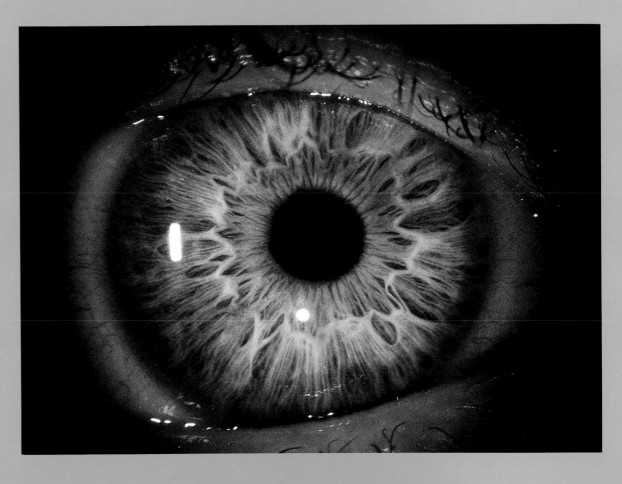

Los Angeles, California 1992
JOE McNALLY

In a clinic, a camera's lens probes the sensitive landscape of a human eye. McNally used a special ophthalmic camera to reveal the view a doctor would have during an eye exam.

Starfire Optical Range, New Mexico 1992
ROGER H. RESSMEYER

Lasers from an observatory beam skyward to measure the atmospheric distortion of starlight. For such technical shots, Ressmeyer may set up a dozen cameras.

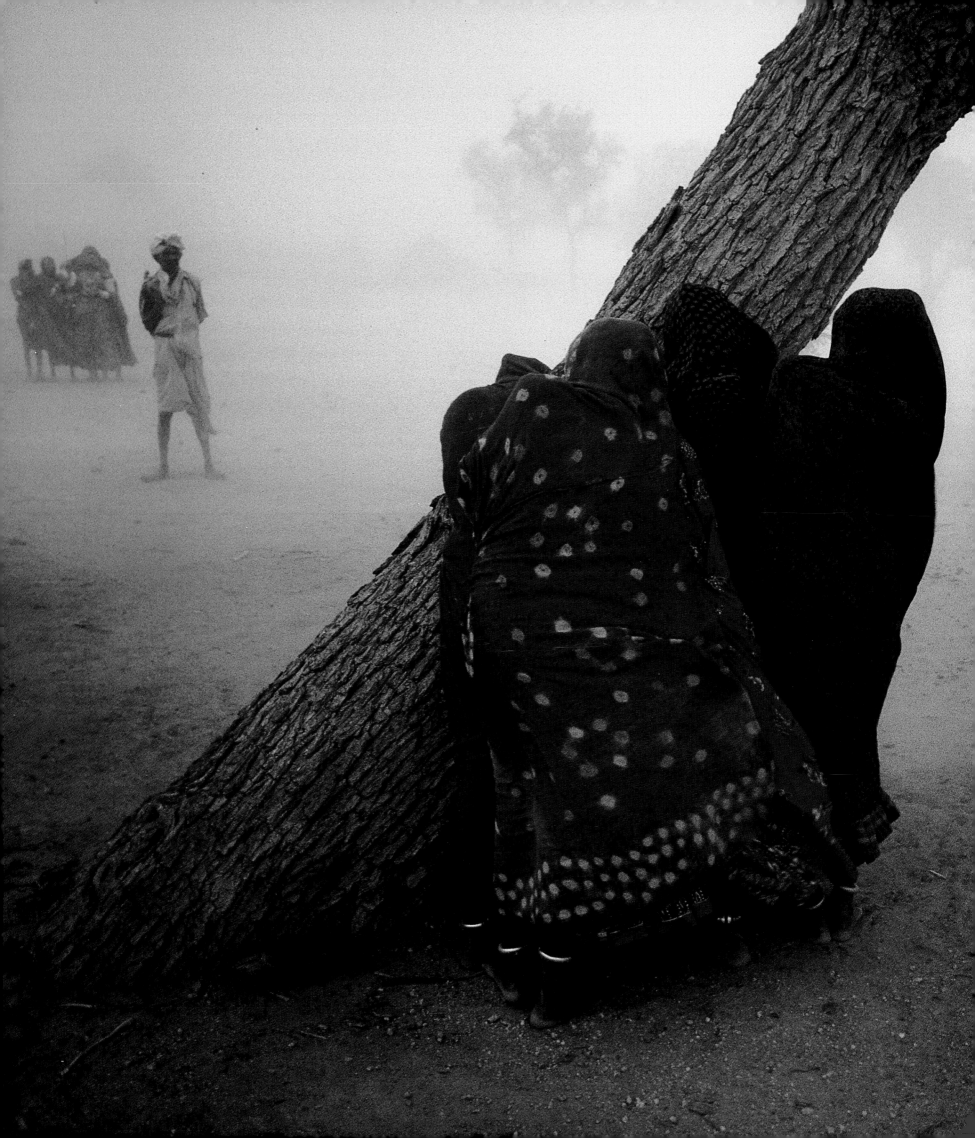

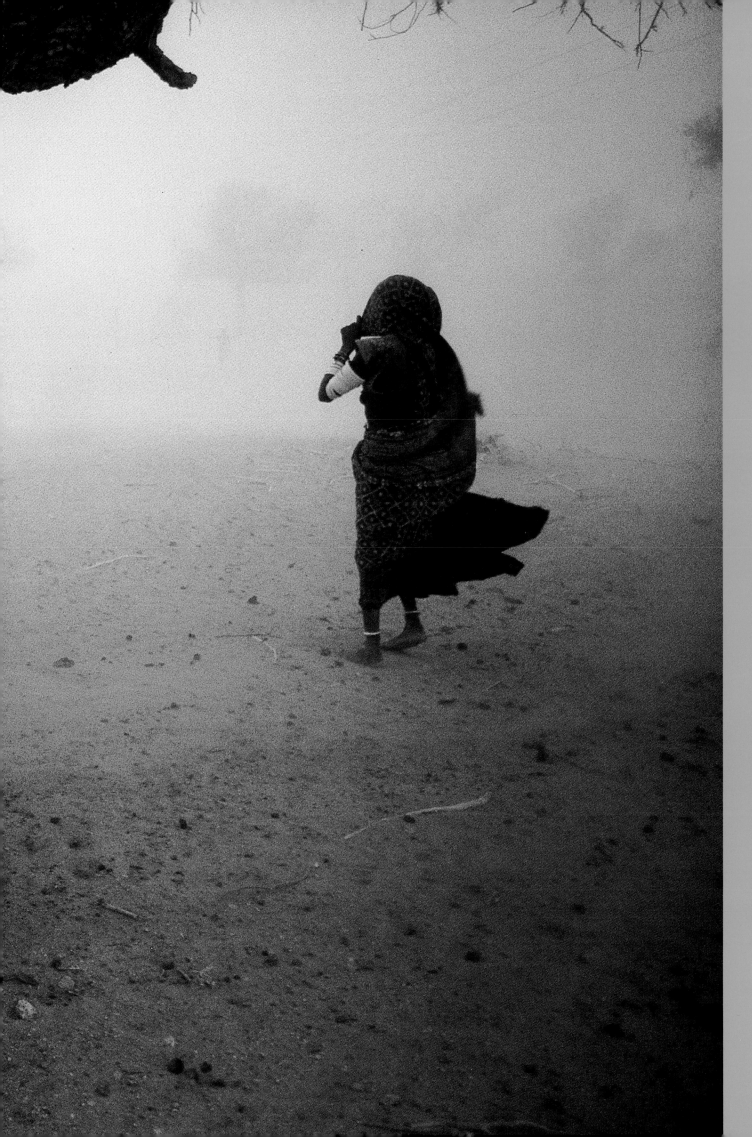

Rajasthan, India 1983
STEVE McCURRY

Huddled behind a tree, women retreat from dust-laden winds that blast across the plains of Rajasthan before the monsoon's onset. Fascination with the subcontinent has drawn McCurry to the region many times.

following pages:

Western Australia 1990
DAVID DOUBILET

Diver trails a 35-foot-long whale shark—largest fish in the world—cruising the Indian Ocean. "The whale shark is so big, it is more of a place than a thing in the ocean," says Doubilet, who has spent more than three decades photographing beneath the world's seas.

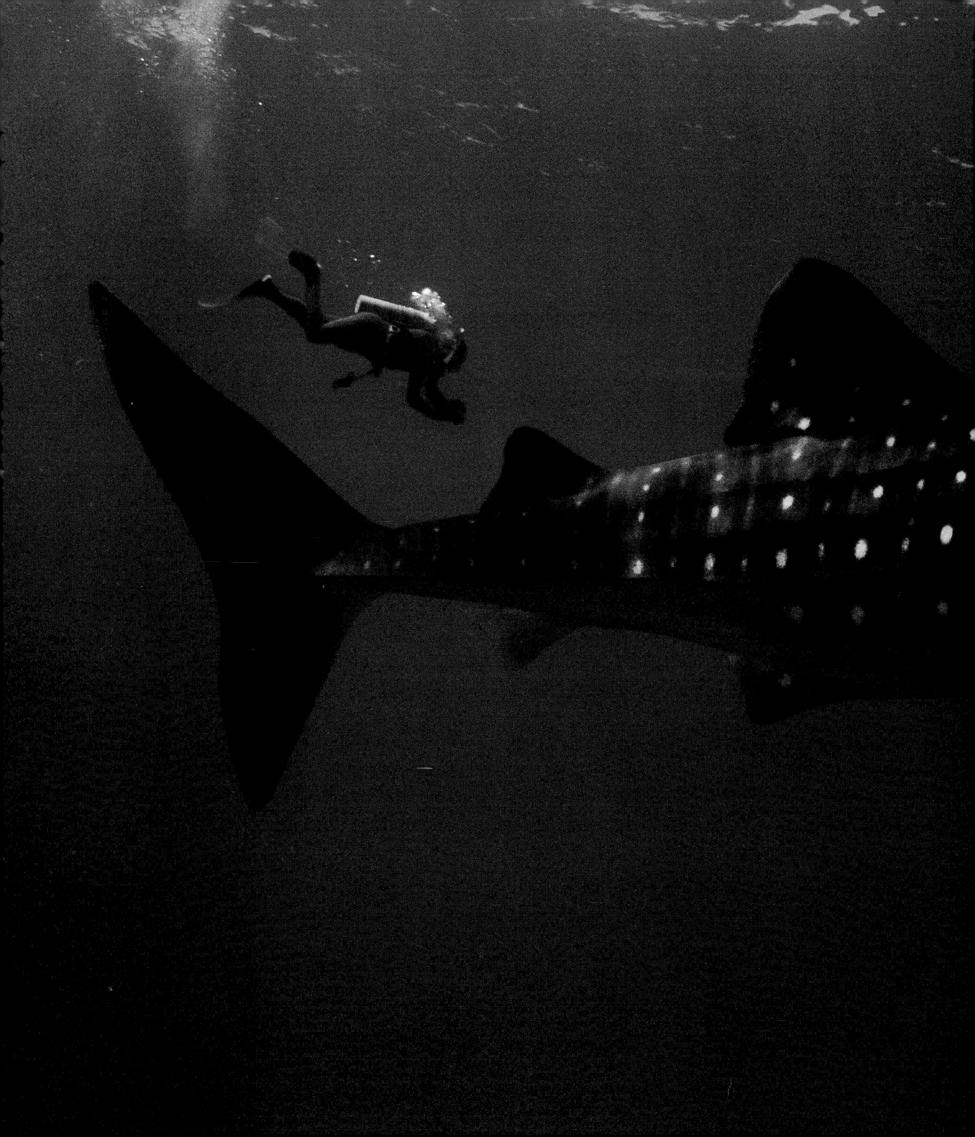

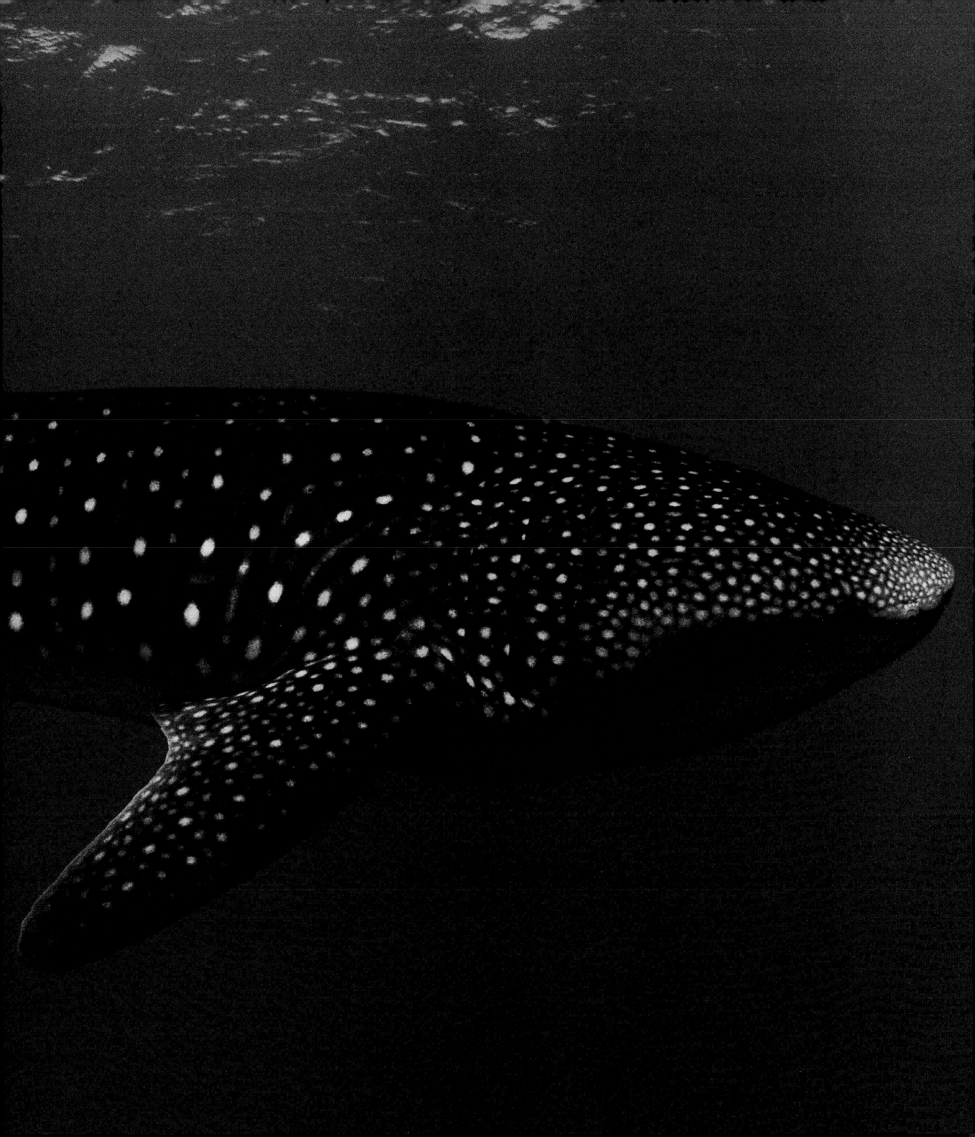

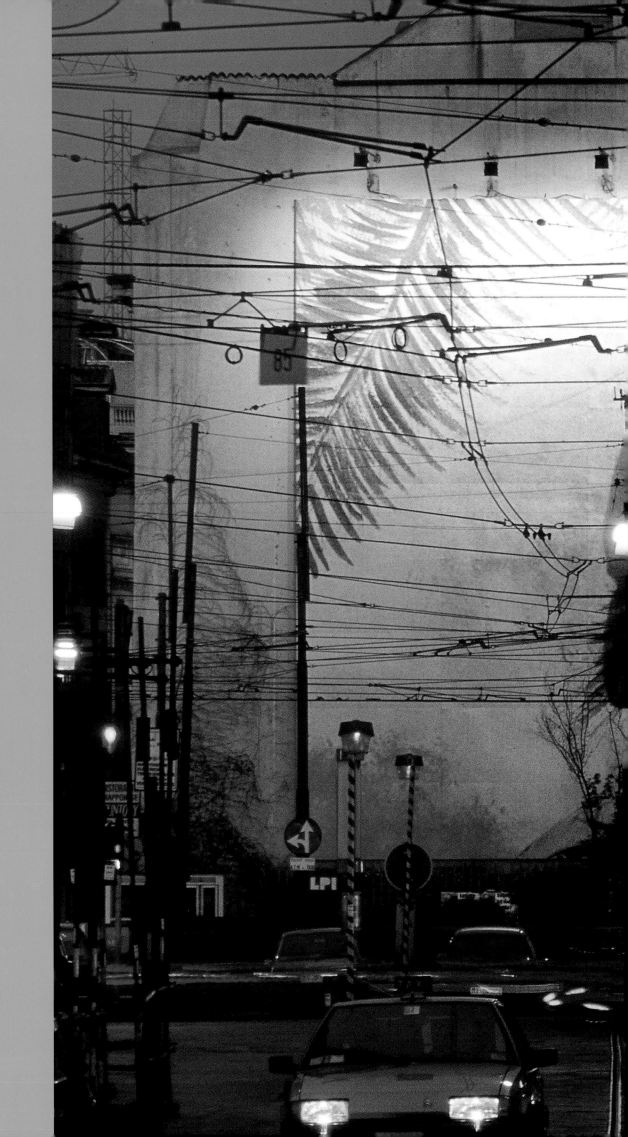

Milan, Italy 1992

GEORGE STEINMETZ

Gleaming from a billboard, an Armani advertisement oversees Milan's bustling Brera district. In his telephoto-compressed composition Steinmetz attempted to convey the "myths and realities" of the northern Italian industrial metropolis.

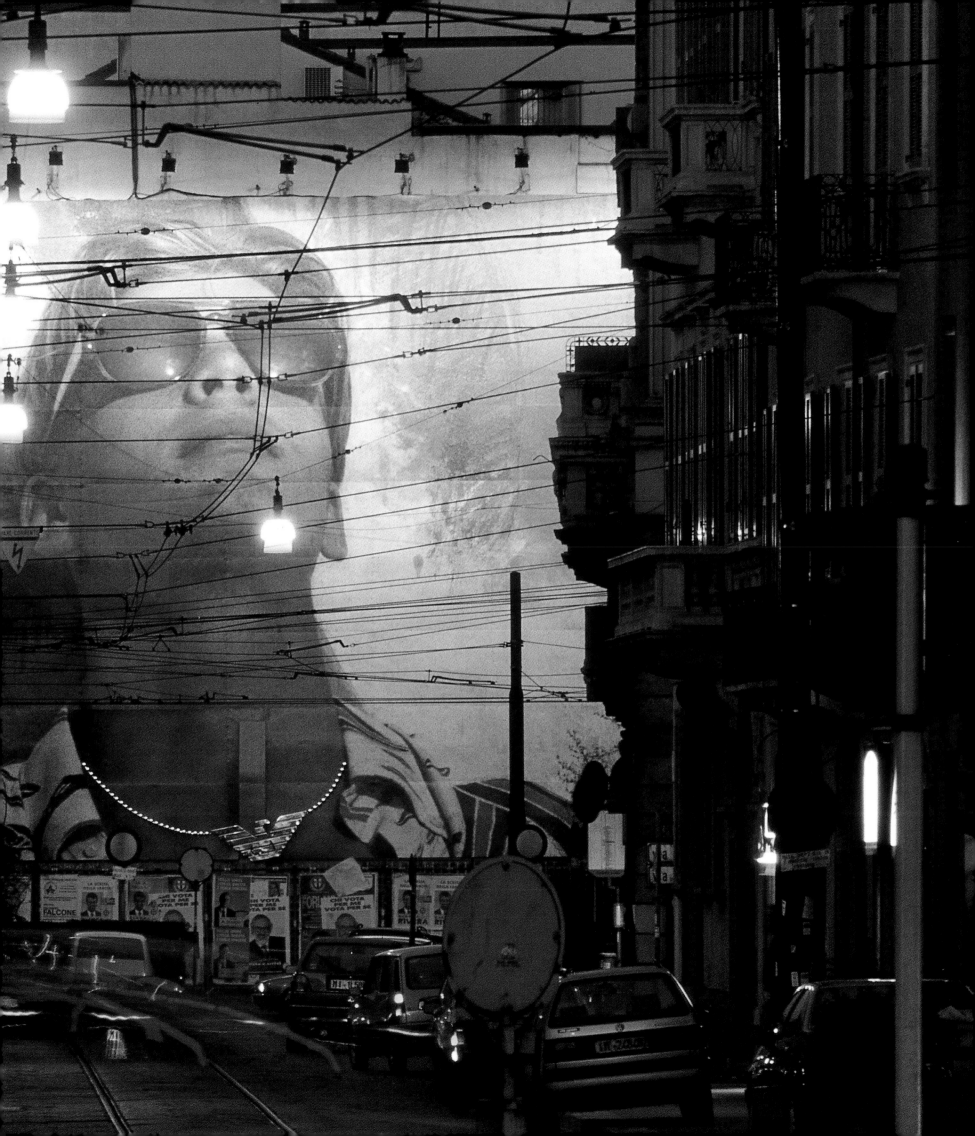

Dusky Sound,
New Zealand 1970
GORDON W. GAHAN

*Touched by a shaft of
afternoon sunlight, Dusky
Sound seems as remote as
when Captain Cook first
sailed in, 200 years ago.
Gahan thought the South
Island bay "the only place in
New Zealand completely
unchanged by time since
Cook's landing."*

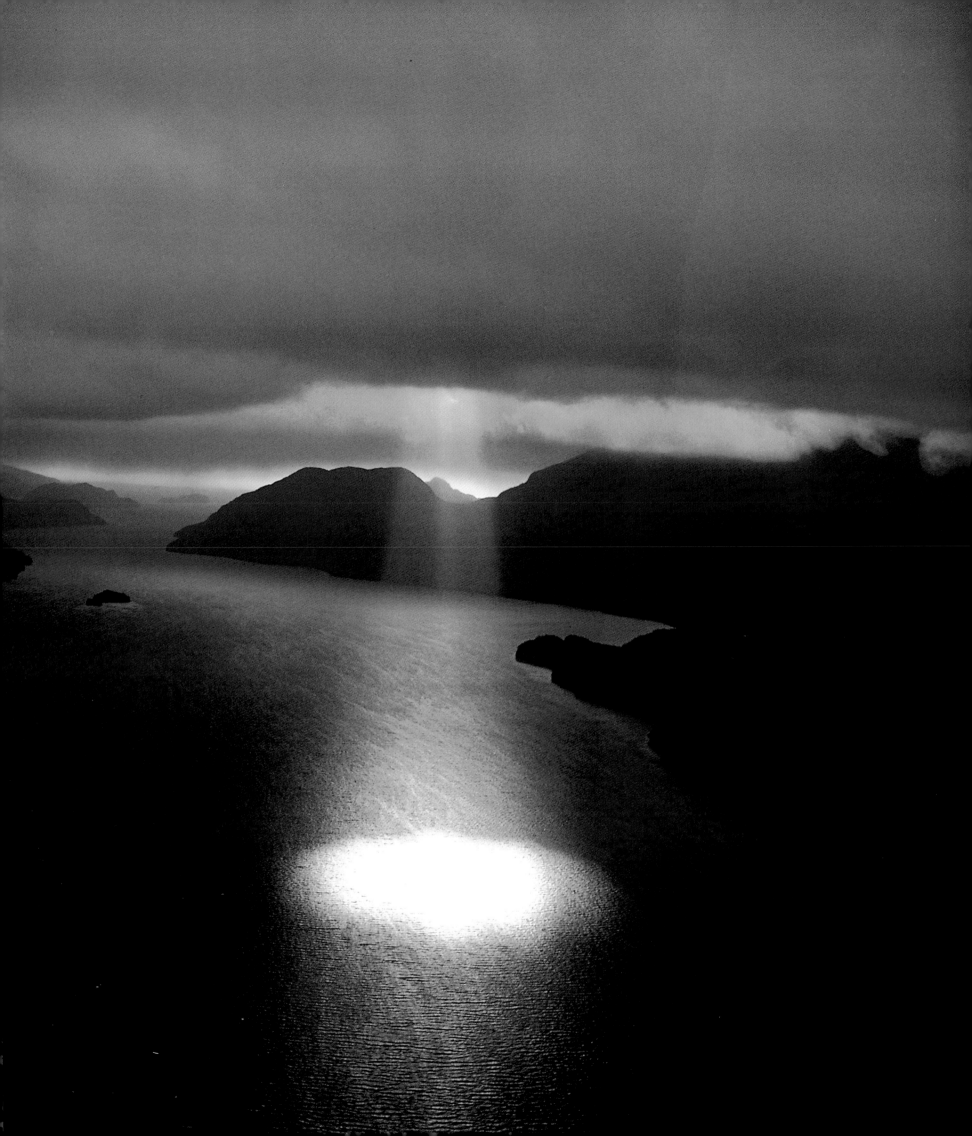

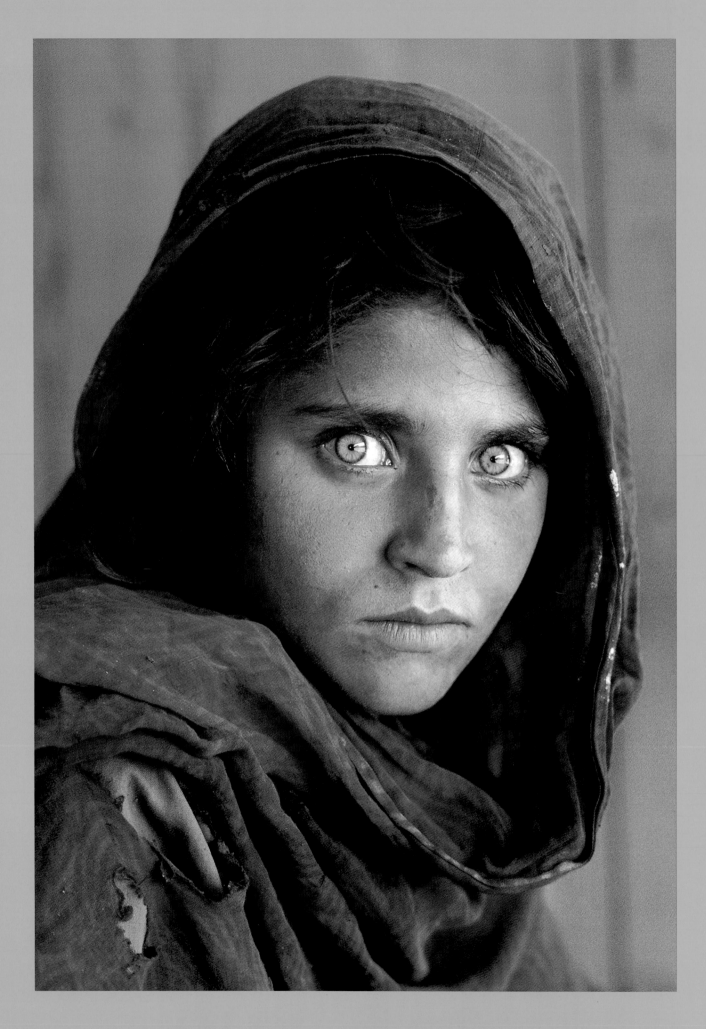

Afghan Border,
Pakistan 1984
STEVE McCURRY

Tattered clothing and fear-filled eyes of an Afghan refugee reveal war-zone trauma. During one Afghanistan foray, McCurry faced Soviet helicopters flying "low like a swarm of hornets… rocketing and strafing everything that moved."

NATIONAL GEOGRAPHIC

THE PHOTOGRAPHS

BY LEAH BENDAVID-VAL

**NATIONAL
GEOGRAPHIC
SOCIETY**

NATIONAL GEOGRAPHIC: THE PHOTOGRAPHS

BY Leah Bendavid-Val
PHOTOGRAPHIC CONSULTANT Sam Abell
EDITORIAL CONSULTANT Thomas B. Allen
DESIGN CONSULTANT Constance H. Phelps

THE NATIONAL GEOGRAPHIC SOCIETY
PRESIDENT AND CHAIRMAN OF THE BOARD Gilbert M. Grosvenor
EDITOR, NATIONAL GEOGRAPHIC William Graves
SENIOR VICE PRESIDENT Michela A. English

PREPARED BY THE BOOK DIVISION
with contributions by
the Layout and Design staff of NATIONAL GEOGRAPHIC
VICE PRESIDENT AND DIRECTOR William R. Gray
ASSISTANT DIRECTORS Margery G. Dunn
Charles Kogod

STAFF FOR THIS BOOK
EDITOR Ron Fisher
ILLUSTRATIONS EDITOR Leah Bendavid-Val
ART DIRECTORS David Griffin
William H. Marr
Constance H. Phelps
SENIOR RESEARCHER Victoria Cooper
RESEARCHERS Bonnie S. Lawrence
Dean A. Nadalin
LEGEND WRITERS Thomas Y. Canby
Victoria Cooper
Mary B. Dickinson
Noel Grove
K. M. Kostyal
Margaret Sedeen
Jennifer C. Urquhart
ILLUSTRATIONS ASSISTANT Karen Dufort Sligh
EDITORIAL ASSISTANT Sandra F. Lotterman
INDEXER Jennifer A. Teefy
PRODUCTION PROJECT MANAGER Richard S. Wain
PRODUCTION Lewis R. Bassford
Keely L. Barber
Elizabeth A. Doherty
Timothy H. Ewing
A. Elliot Smyth
Susan A. Stenquist
STAFF ASSISTANTS Karen F. Edwards
Elizabeth G. Jevons
Peggy J. Oxford

MANUFACTURING AND QUALITY MANAGEMENT
DIRECTOR George V. White
ASSOCIATE DIRECTOR John T. Dunn
MANAGER Vincent P. Ryan
EXECUTIVE ASSISTANT R. Gary Colbert

Library of Congress CIP Data
Bendavid-Val, Leah.
 National geographic, the photographs / by Leah Bendavid-Val.
 p. cm.
 Includes index.
 ISBN 0-87044-986-9. -- ISBN 0-87044-987-7 (deluxe)
 1. Travel photography. 2. Documentary photography. 3. National geographic.
I. National geographic. II. Title.
TR790.B46 1994
778.9'907049--dc20 94-29971
 CIP

NATIONAL GEOGRAPHIC

THE
PHOTOGRAPHS

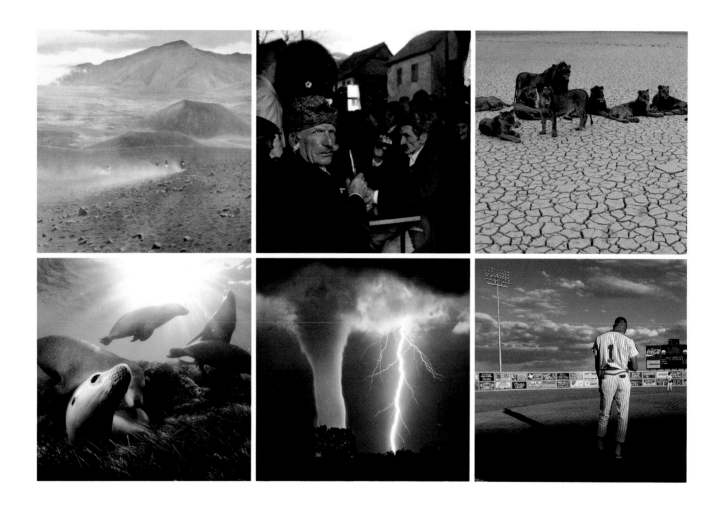

FOREWORD

From the beginning, a journey of invention and discovery

Like a medieval artisan, my father believed in teaching the family craft to youngsters at an early age. He gave me my first camera—and some intimidating instruction to go with it—when I was 12 years old. When I was 16, he arranged for me to follow a famous *National Geographic* photographer around for a few days on his assignment in England.

"Stick right with him," my father told me. "If he puts a 50-millimeter lens on his camera, you do the same. Shoot exactly the way he does from dawn till dark."

At this point my mother chimed in. "But when it gets dark, you quit copying what he does!"

Even in those days, *Geographic* photographers had a reputation for more than photographs. As one of them recently remarked, "I would love to have lived the life people think I have." If the dashing image of the *Geographic* photographer seems exaggerated in novel, folklore, and cinema, well, his is still not a humdrum life. Our photographic teams have survived attacking sharks, invading armies, crashing planes, and erupting volcanoes.

When people ask how our photographers make the world's greatest pictures, they may shrug and say, "f/8 and be there." But being there means a lot.

I recall my own difficulties on assignment in Bali. For day after day, I had tried to take a sunset picture of dancers in front of an elaborate gateway in Pliatan. Twice we were rained out, and for another two nights the light at sunset seemed flat. Then—without warning—a tropical storm blew in at just the right time. The sky turned apricot in color, and the dancers' bodies were burnished by the strange light. I got the picture we needed (page 96)—just before the clouds opened and a torrent of rain shorted out my lights. Luck? Of course. But being there did it.

In the early days of photography, with slow film and primitive cameras, light was valued for quantity rather than quality. Even so, *National*

Geographic magazine was publishing photographs by 1895, and gradually developed the picture story, as social historians later named our reports.

My grandfather used to tell me about the way he and other pioneer photographers worked at the turn of the century. They carried a cargo of bulky—and fragile—equipment into remote parts of the world: breakable glass plates, chemicals for developing pictures in improvised darkrooms, tripods for the long exposures, and cameras that could hardly be called portable. On an entire assignment, a photographer might take no more than a hundred pictures.

Today, our people take many times that number in a single day. They still work with light, the variable that everyone has but no one commands. With faster films and sophisticated new cameras, they can use light to compose pictures that the pioneers could only dream about. By staying in the forefront of new technology in photography and printing, the *Geographic* has maintained both continuity and change during an amazing century—the world's longest time exposure.

In these pages readers can follow the evolution of the photograph. Techniques aside, some of the earliest photos compare favorably with those today. Why? Because, like the chicken and the egg, imagination and image must go together. It is the photographer, not just his camera, that catches the moment.

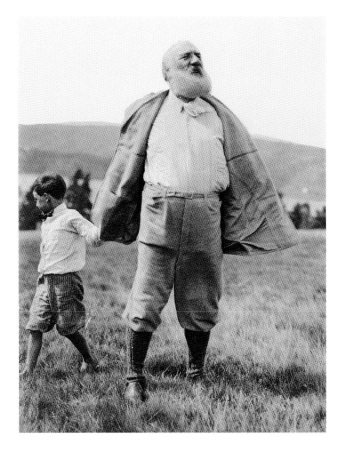

Alexander Graham Bell and his grandson Melville Bell Grosvenor, father of today's Geographic *president and board chairman, explore Baddeck, Nova Scotia, site of the Bell estate.*

GILBERT M. GROSVENOR
President and Chairman
National Geographic Society

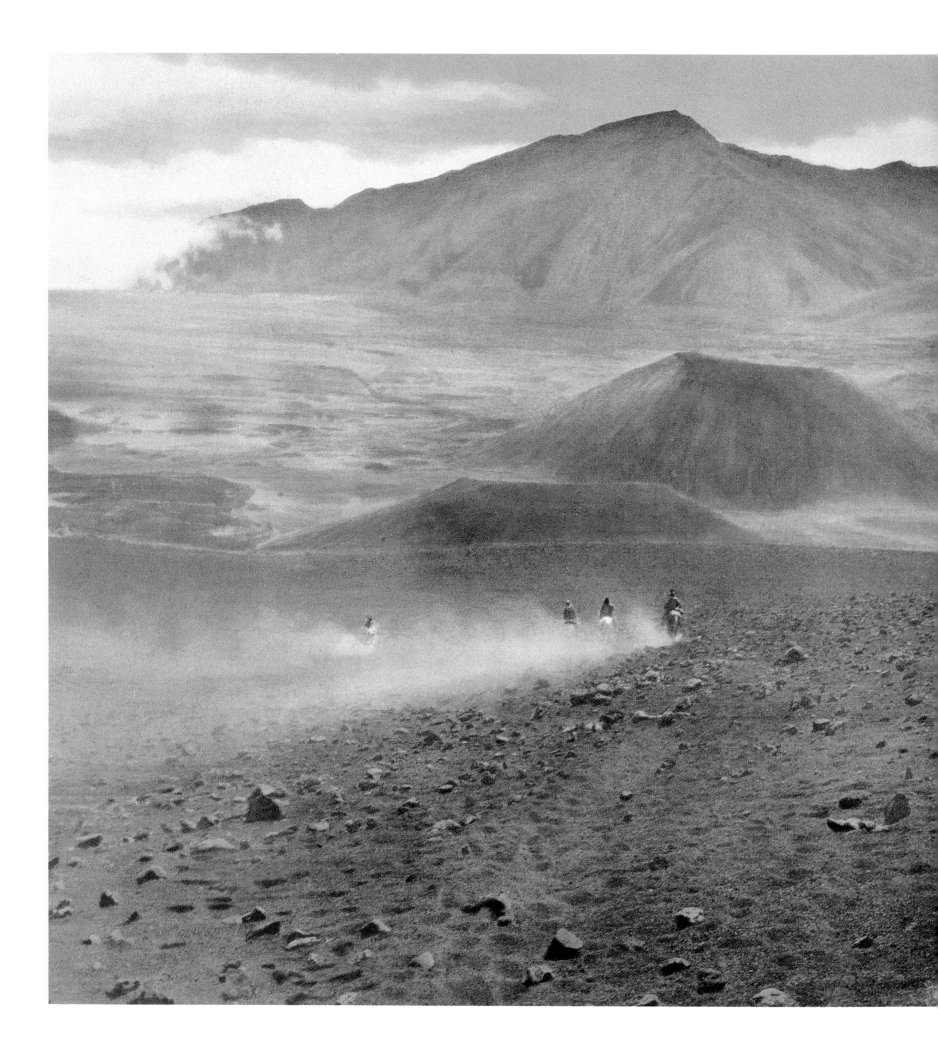

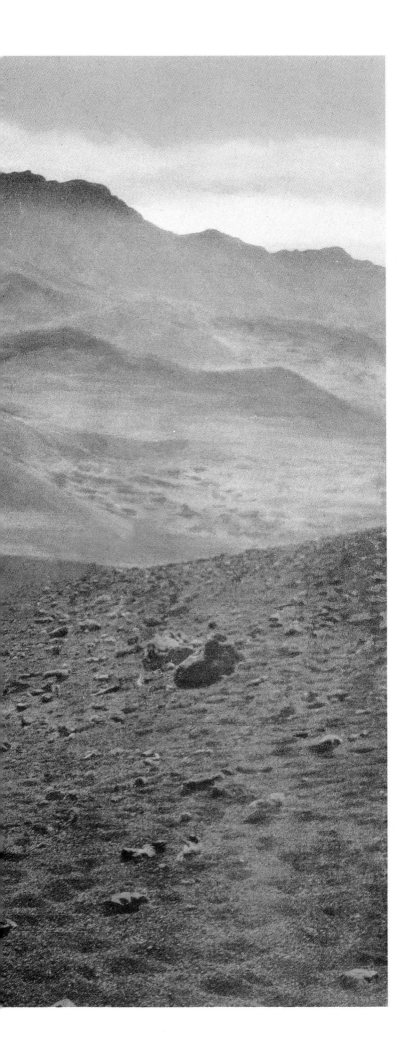

NEW IMAGES OF AN OLD WORLD

Maui, Hawaii 1920

GILBERT H. GROSVENOR

Editor Grosvenor pioneered the use of color photography at the Geographic. *His photograph of riders entering 19-square-mile Haleakala Crater was hand-tinted.*

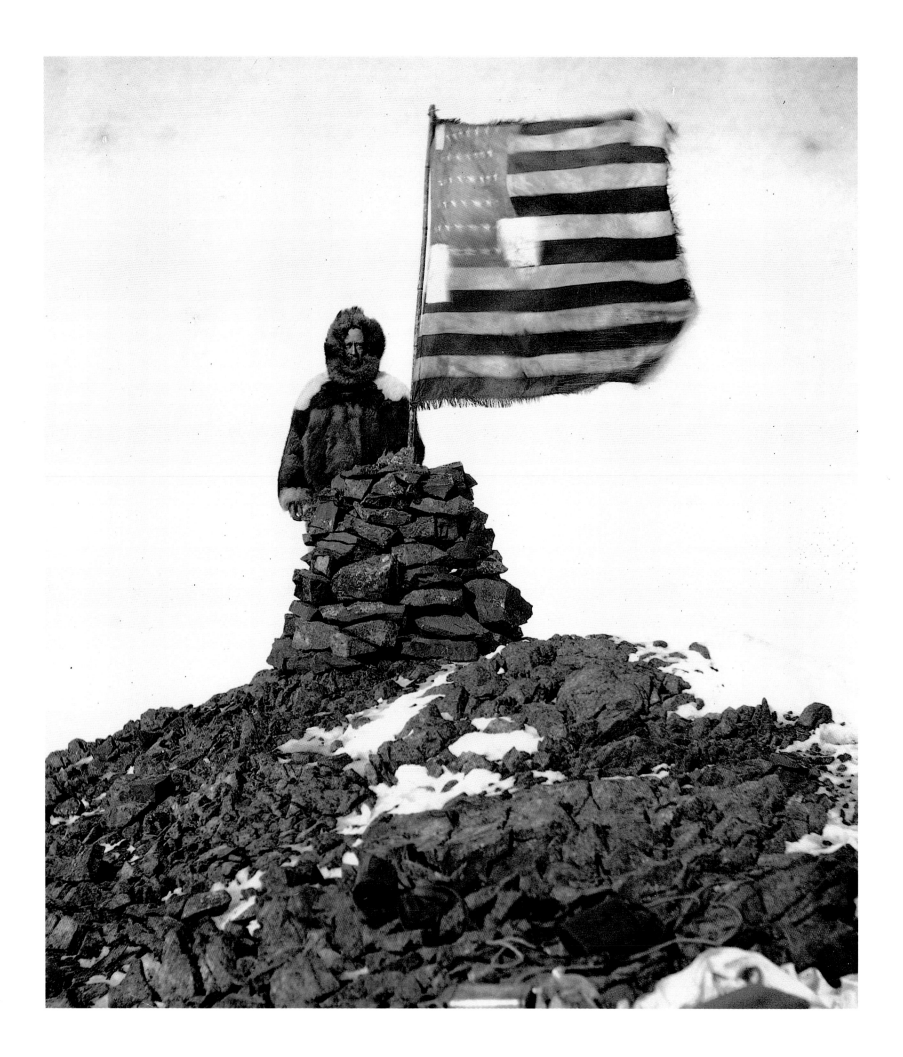

Cape Thomas Hubbard,
Canadian Arctic 1906
**PHOTOGRAPHER
UNKNOWN**

*A historic portrait records
Robert E. Peary with his
tattered polar expedition flag
at the farthest western point
then sledged across Arctic ice.
Clippings from the flag were
cached at each goal. The
patched banner now rests in
the Society's Explorers Hall.*

A dozen photographers crowded into a room on the eighth floor of the National Geographic Society's building complex in Washington, D.C. Most employees had gone home, leaving the building to security guards, a few people working against deadlines, and the group of photographers with their trays of slides. They gathered in a windowless projection room. There were slide projectors at one end of the room, a screen at the other, and a few chairs in between. The photographers, taking advantage of scheduling that happened to give them rare time together, settled in for an entertainment peculiar to them. This was a "tray party." You bring your tray of 35-mm slides and, if you want, a bottle of wine.

Some kicked off their shoes and settled on the carpeted floor. Others sat on chairs. Someone turned on a projector and switched off the overhead lights. By the dim glow of the projector bulb, they began a ritual that unites them. They were showing what they had shot. This wasn't for the *Geographic's* readers. This wasn't for the editors. This was for one another.

Depending on the assignment, photographers can come back with 600 to 800 rolls of film—about 20,000 to 30,000 frames. But the pictures are not of 20,000 different subjects. Photographers think ahead to the editing process, which reduces the number of pictures to a single slide tray—80 slots. Many photographers say they shoot for the tray. They want to create a tray so perfect that a picture editor will find it nearly impossible to go from 80 to the 30 selected for publication.

Michael Nichols, just back from Congo's Ndoki region, projected pictures of elephants and chimpanzees seeing humans for the first time. As the slides flashed by, Nichols told a tale about landing in a plane with wobbly wheels. He answered questions about his sophisticated but troublesome remote cameras.

George Steinmetz ran through slides showing members of a tribe in Indonesian New Guinea and casually explained the anthropological content of some of the images. The men, he said, wore carved shell nose ornaments pointed up or down to reflect their state of mind. The women had only stumps of fingers, chopped off in childhood when relatives died.

David Alan Harvey projected pictures of the people of Oaxaca, Mexico. Through most of his career he has traveled the Spanish world. His idea of a good photo is one that shows someone in Oaxaca doing something that an American can look at and recognize as more familiar than foreign. Jodi Cobb showed images of ghostly, white-faced Japanese geisha—intimate pictures full of grace and heart.

Maria Stenzel, in the midst of a *Geographic* assignment on Walt Whitman,

brought a single transparency instead of a tray. Her slide showed a young man sitting on a beach and gazing into the summer sky at an image of a bare-chested man on a poster being towed by a plane as an aerial advertisement. Stenzel had captured this unstaged, unexpected moment near Montauk, Long Island, to conjure up Walt Whitman, who often went to Montauk. "Youth," Whitman wrote, "large, lusty, loving—youth full of grace, force, fascination,…" In a single image Stenzel had found a radiant place, a line of poetry, and an evocation of the poet she was illumining.

The photographers who gathered for that tray party were sharing an appreciation of photography that was both personal and institutional. Each had a personal view of perfection, and all were following a tradition bridging generations.

A CENTURY AGO, the National Geographic Society began using photography to educate members and to support scientific research. Born in an age of invention, the National Geographic Society fostered photographic invention, particularly the use of color. *National Geographic* magazine's brand of photography blossomed when photography became the key to reporting world events. Later, when television lifted the news burden from the still image, *National Geographic* magazine's approach to photographing persisted. Ideas about what made a good picture ran deep, linking one generation to the next.

The *Geographic,* as the Society's publication came to be called, had already printed many halftone photographs when Gilbert H. Grosvenor became the magazine's first full-time employee in 1899. But the 23-year-old editor, an early champion of photography, encountered a board that considered nature photography frivolous. When Grosvenor published some sharply lit nighttime pictures of deer, raccoons, porcupines, and other animals in the wild (page 61), two board members resigned in protest, accusing Grosvenor of "turning the magazine into a picture book." Grosvenor held his ground, certain that photography, as the ultimate eyewitness, would help to fulfill the Society's mission.

Grosvenor spent a month's salary on a 4A Folding Kodak camera and a Wynne meter and began to shoot pictures himself. An ardent amateur photographer, he was apparently inspired by U.S. Geological Survey photographs, which supplied geographical data on the American West. The photographs, meant to be only documents, were direct, simple, and eloquent.

To have photographs on hand, he combed museums and agencies, purchasing thousands of pictures and watching for photographers of unusual talent. In the July 1907 issue he published 14 striking photos of Indians by Edward S. Curtis, who spent more than 30 years picturing the "vanishing race in all its glory."

In the early decades of Grosvenor's editorship, the magazine published pictures by the scientists and explorers who wrote its articles—Hiram Bingham on Peru's newly excavated Machu Picchu, Joseph F. Rock on China and Tibet, and Grosvenor himself on the geography of Russia, the North Pole, and Hawaii (pages 30-31).

Joseph Rock, the quintessential early explorer-scientist-photojournalist, would

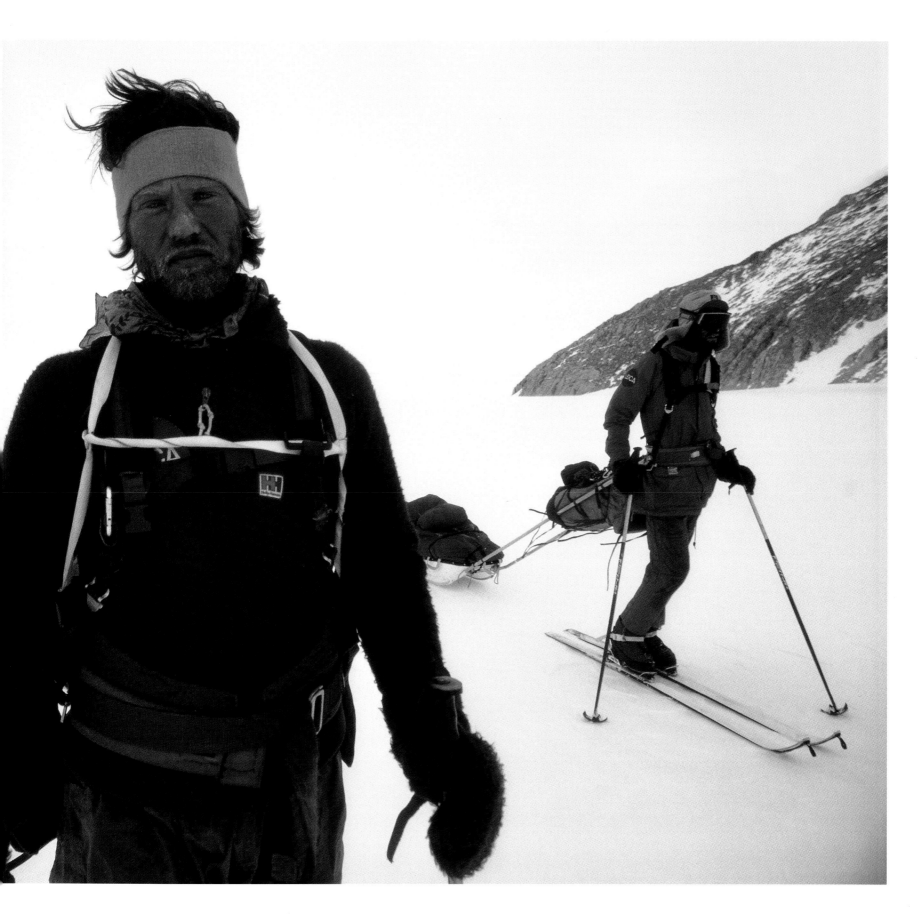

Beardmore Glacier, Antarctica 1985
ROGER MEAR

*Britisher Mear snaps his teammates, Robert Swan (foreground) and Gareth Wood, on their trek along
explorer Robert F. Scott's route to the South Pole. "Each mile has to be fought for and won," wrote Swan.*

sometimes disappear for years on assignment. Often he was given up for lost while exploring, photographing, and mapping the mountainous borderlands between China and Tibet (page 62). He collected thousands of specimens of plants and animals, and his adventures filled a series of *Geographic* articles.

Readers thrilled to accounts of Rock holed up by bandits in a temple full of coffins or escaping across a river on inflated goatskins.

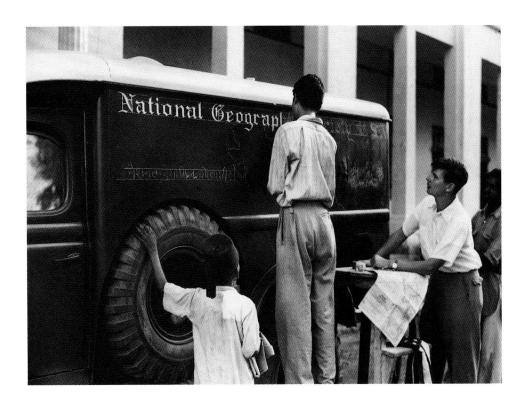

Delhi, India 1946
VOLKMAR WENTZEL

An ambulance found in a military salvage yard served Wentzel as a vehicle—and its roof as a lofty vantage point—on his 40,000-mile photo survey of India.

An eccentric loner, Rock traveled in style (right), carrying with him a phonograph and opera records, fine china and table linens, a folding bathtub from Abercrombie & Fitch, and a formal shirt, jacket, and tie for meetings with village or tribal leaders. Austrian by heritage, he insisted on Austrian cuisine, cooked over a charcoal brazier. The photographs he sent back from his expeditions offered unique insights into the geography and culture of this unknown and magnificently photogenic region.

Photography became such an important aspect of the magazine that Grosvenor installed a black-and-white photo laboratory, soon followed by a color lab, the first in American publishing. He realized that color portrayed foreign scenes more accurately and graphically than black-and-white—and also brought the magazine new members. In July 1914, he published Eliza R. Scidmore's black-and-white photos of Japanese people. The photographs were hand-tinted in delicate colors, as had been done in the past. In this same issue appeared the magazine's first natural color photograph, "A Ghent Flower Garden." The photograph was made on an Autochrome glass plate, a process invented by two French brothers, Auguste and Louis Lumière. It was the first successful commercial method of taking photographs in natural color. But the Autochrome required a long exposure, one second or more in sunlight, and full-color photoengravings were expensive. Nevertheless, the *Geographic* published Autochromes for several years, except for a three-year, war-caused hiatus, and later used the Agfacolor, Finlay, and Dufay processes as they became available.

AFTER WORLD WAR I, color photography took hold in American magazine publishing. Beginning in 1928, Grosvenor published some color in each issue. He sent technicians to Europe and to Eastman Kodak in Rochester, New York, to study color-process techniques, always with an eye toward ideas that would be potentially useful to the Society. Franklin L. Fisher, chief of the illustrations department of the magazine, organized a network of freelancers in the United States and Europe to supply color pictures. Most of Fisher's photographers were painters or wealthy amateurs.

Staff photographers apprenticed in the lab before they were allowed to work in

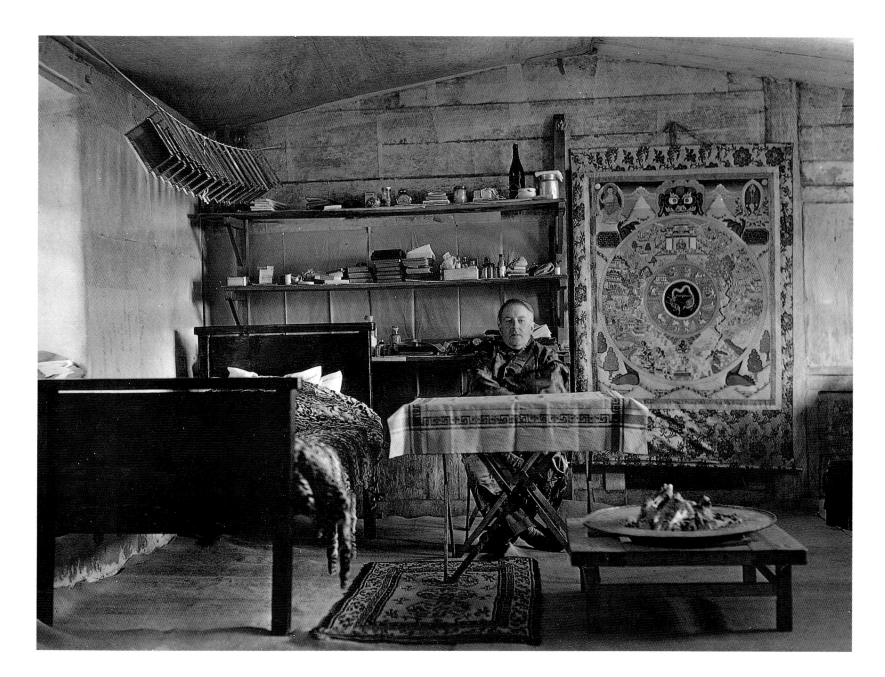

Yunnan Province, China 1927

JOSEPH F. ROCK

Explorer-scientist Rock, veteran of two lengthy expeditions to bandit-infested southwestern China,
poses in cramped but elegant quarters on his 1927-1930 trip. Negatives hang above the bed to dry.

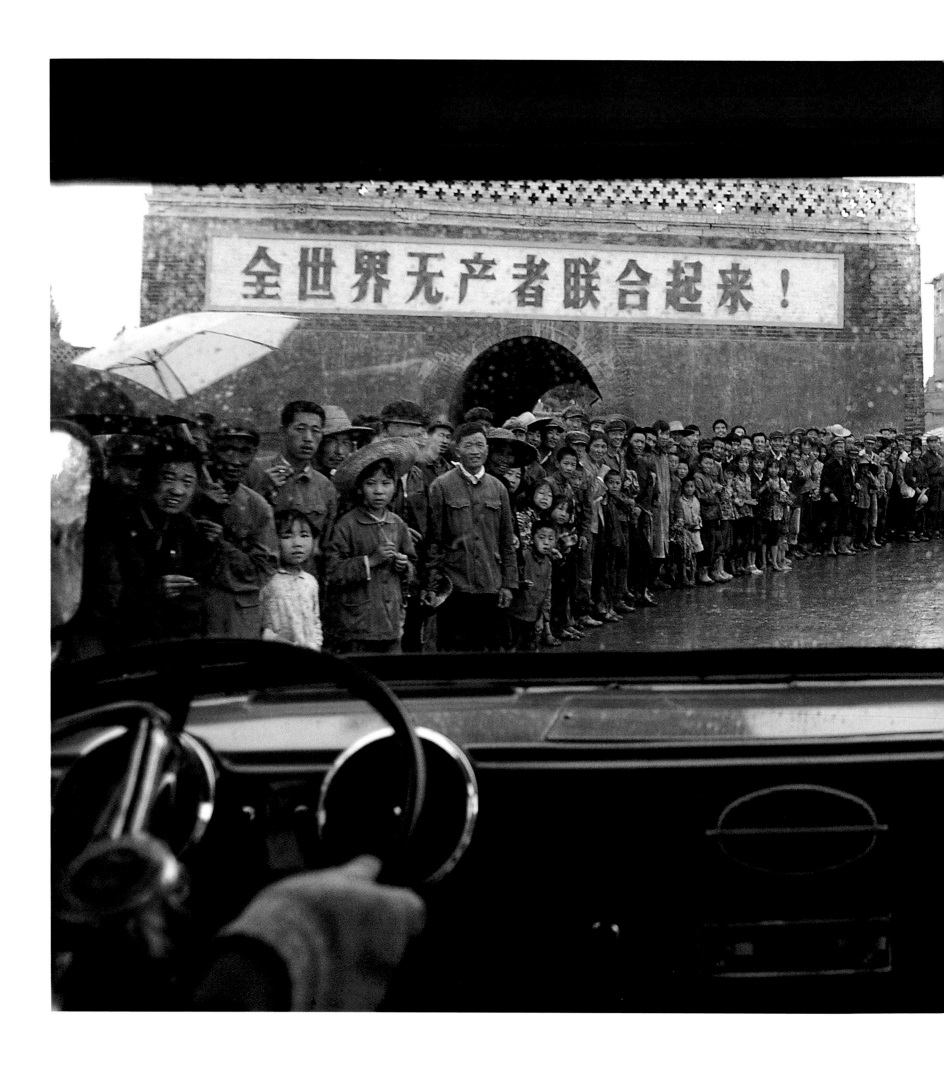

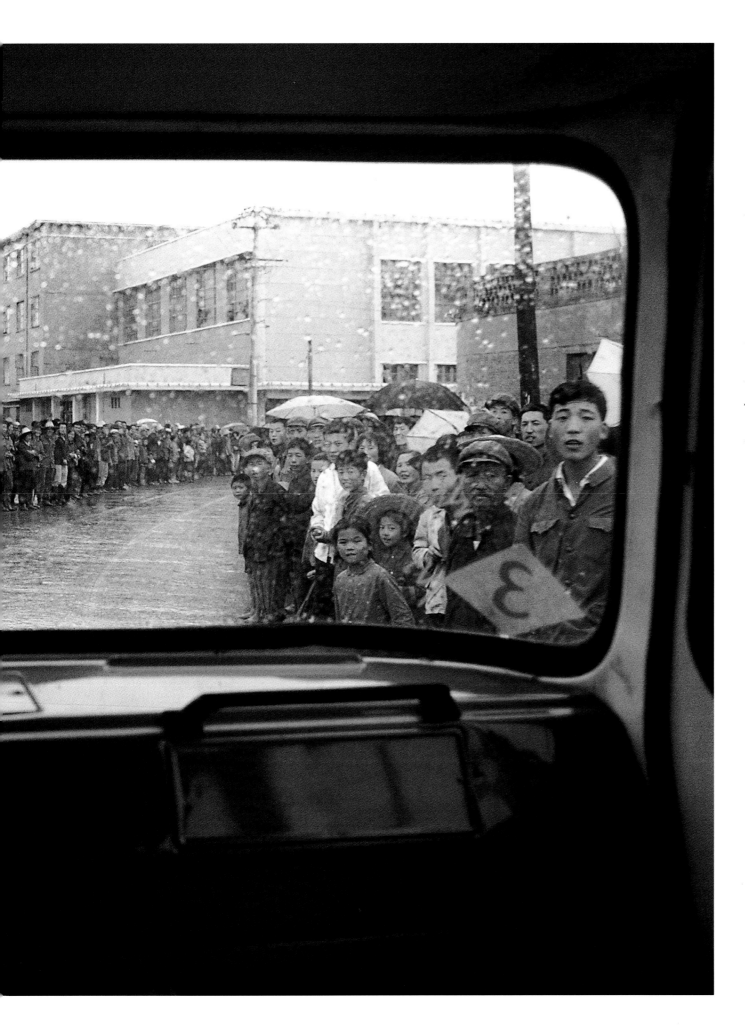

Zhongwei, China 1979
BRUCE DALE

Thousands of Chinese turn out in the rain to welcome a desert-study delegation accompanied by Dale and writer Rick Gore. "We were overwhelmed," said Gore, as the people greeted their first American visitors in some 30 years. The sign proclaims: "Proletarians of the world unite!"

the field, a practice that continued into the 1950s. Photographers traveled with specially made cases full of chemicals and up to 150 pounds of color plates. Grosvenor lightened the load by providing automobiles, a generous gesture at the time. "A man who has the brains and ability and enthusiasm to take our class of color pictures cannot be expected to pack his equipment on his own back," he wrote to his illustrations chief in October 1928. Grosvenor had special reason to pamper photographers working in Autochrome: They were hard to find.

Between 1921 and 1930, the magazine published more than 1,500 Autochromes. The *Geographic* became the preeminent publisher of reproductions of color photography. One pioneer was Edwin L. (Bud) Wisherd. He went off in 1923 on his first assignment, the southwestern United States, riding a horse and towing a mule loaded down with 50 or 60 pounds of equipment. On the trip, Wisherd became the first *Geographic* photographer to expose natural color plates in the field. Wisherd later became chief of the photo lab, following Charles Martin.

In 1926 the magazine achieved a photographic first that many thought impossible: color photographs of fish swimming beneath the surface of the sea (page 58). The Autochrome required a long exposure and so could not make snapshots of moving subjects even in full sunlight, let alone underwater, but Charles Martin discovered a way. He bathed the glass plates in a hypersensitizing solution. Working in the subtropical heat of the Florida Keys, he had to complete the operation before dawn to keep daytime heat and dampness from melting the emulsion on the glass. The treated plates reduced exposures from one second to a twentieth of a second. But this was not enough. A mere 15 feet down, sunlight was so attenuated that even the hypersensitized plates were inadequate.

Martin then built a three-pontoon float to carry *one pound* of magnesium flash powder connected to a trigger that could be tripped underwater when a fish swam by. After each flash, the powder had to be replaced and the electrical connections reset. Normally, on land, a pinch of magnesium flash powder sufficed. The explosion of a whole pound was powerful enough to kill or blind. A premature explosion of only an ounce of powder severely burned the diver-photographer and ichthyologist W. H. Longley of Goucher College. But the device worked. A subtitle in the January 1927 issue proclaimed the feat: "Marine Life in Its Natural Habitat Along the Florida Keys Is Successfully Photographed in Colors."

THE NEXT CHAPTER in the color saga opened when 21-year-old Luis Marden walked in the door in 1934. He had just written a book, "Color Photography with the Miniature Camera." He was hired. His ability to shoot and develop in color impressed his new boss, Franklin Fisher. But Fisher dismissed Marden's 35-mm Leica camera as a toy. The Leica's black-and-white film showed its grain when the negatives were enlarged.

Only a few years later, the problems of graininess and dot patterns in color photography were solved. Two musicians named Mannes and Godowsky, working on their own in New York, had coated film with three layers of emulsion, each sensitive

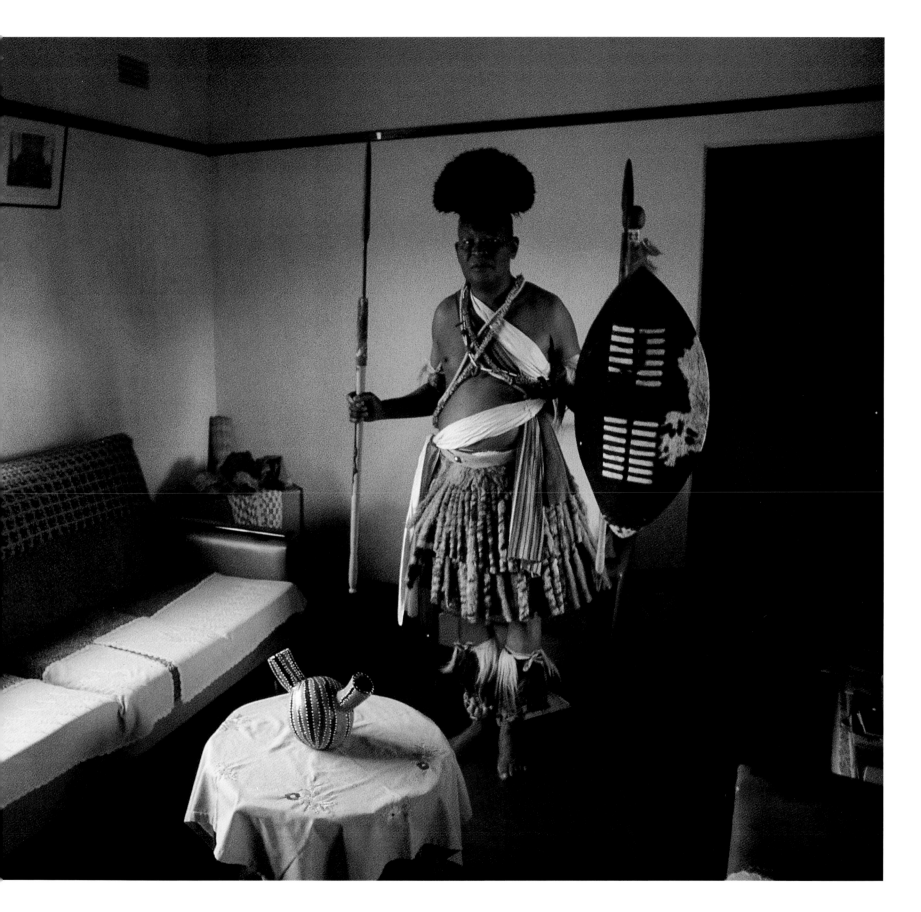

Rhodesia 1974

THOMAS NEBBIA

Chief Mtonzima Gwebu's modern house was a gift from Ian Smith's white minority government,
which also paid the Ndebele leader a salary before Zimbabwe became a republic in 1980.

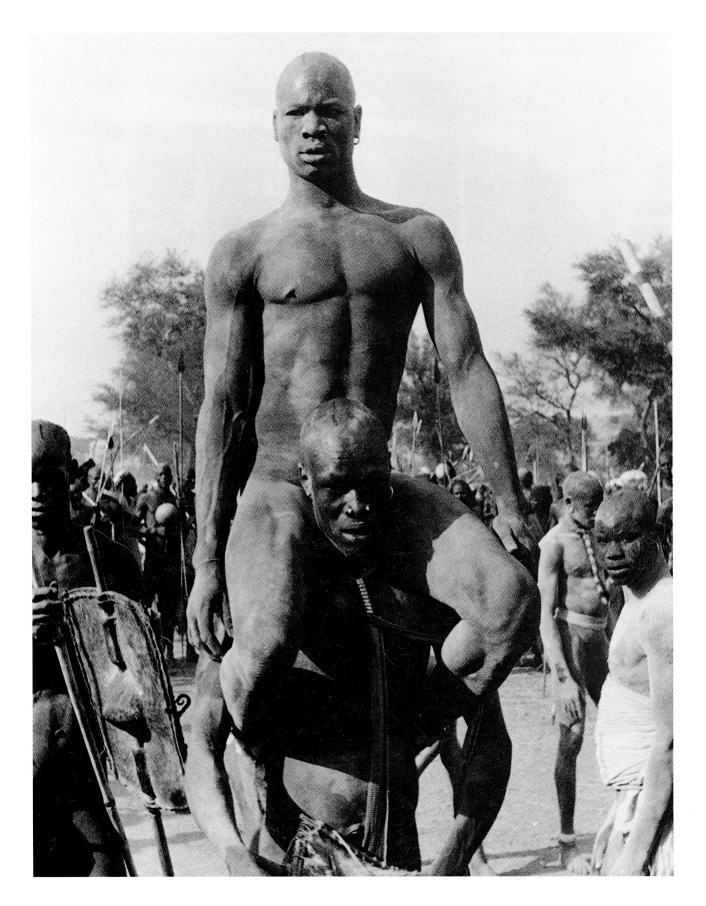

Kordofan, Anglo-Egyptian Sudan 1949

GEORGE RODGER

A victorious Nuba wrestler is carried shoulder-high from the scene of his triumph by a teammate.
Wrestling remains a major sport among the Nuba in this region, which is now part of Sudan.

to one of three colors: red, blue, and green. Eastman Kodak gave them laboratory space and by 1936 they and Kodak had produced a commercial film, Kodachrome, that would revolutionize photography. In the processing of Kodachrome, the silver grains were bleached and replaced by transparent dyes, thus rendering the new film practically grainless, enabling nearly limitless enlargement.

One day, Marden and another *Geographic* photographer, Volkmar Wentzel, on a lunchtime stroll in downtown Washington, entered a camera shop displaying the new Kodachrome 16-mm motion picture film. Wentzel remembers Marden's thrill at discovering Kodachrome's lack of color flecks, most vividly apparent in the whiteness of a shirt. "It was a changeover time," Wentzel recalls. "The generation change, from large format to 35 millimeter, came with Luis Marden's vision." Eastman Kodak sent Marden two rolls of 35-mm still-picture Kodachrome when it appeared some time later, and he exposed them in his Leica one weekend. Marden projected these first National Geographic Society Kodachromes for the illustrations chief shortly after, but aroused little enthusiasm.

Although the Leica would serve as a supplement to large-format cameras for several years, liberation from heavy cameras and tripods had begun.

NOTHING BETTER SUMMED UP the legend of the daring, free-spirited, widely traveled *Geographic* photographer than the two-word assignment that Fisher gave Wentzel in 1946: "Do India." Wentzel left Baltimore harbor on a freighter. A month later, he docked in Bombay. In need of a vehicle, he found his way to a military salvage yard outside Calcutta, where he bought a used ambulance for $400. He painted "National Geographic Society U.S.A." on it in English, Hindi, and Urdu, added American and Society flags and an outline of India, and began a 40,000-mile trip (page 36).

On his way through Kashmir, crossing 9,000-foot Banihal Pass, his fan belt shredded. He coasted 50 miles to Srinagar, discovered it would take a month to get a new fan belt, and decided to use the time to go, by pony and foot, to Leh in Ladakh. "My trip was about 550 miles, so I did it in stages, like Marco Polo," says Wentzel.

One of his goals was to photograph the Ajanta caves, whose ancient frescoes portrayed the life of Buddha. "The best ones were near the top, so I had to build scaffolding," he recalls. "It was dark, and I just had peanut bulbs. No strobes, of course. I did a series on Ektachrome, which I processed in the caves. I had to send for big blocks of ice from 60 miles away to cool down the solutions."

Another enterprising photographer, Thomas J. Abercrombie, arrived at the *Geographic* in 1956. By this time Gilbert H. Grosvenor's son, Melville Bell Grosvenor, was editor. Abercrombie was hired on the basis of a prize-winning bird photograph that he had taken for his newspaper, the *Milwaukee Journal.* Grosvenor, in search of young blood, found that the brand of photography he wanted was being practiced at the *Journal, Life,* and the University of Missouri School of Journalism. "The Missouri attitude was to see the world as it was, to capture reality," says Abercrombie. "This you could do with a small, fast, flexible camera, which up until this time the

Geographic only used as an auxiliary tool—to run some Kodachrome into a black-and-white story."

Abercrombie's first foreign assignment was Lebanon. Melville's son, Gilbert M. Grosvenor, was Abercrombie's picture editor. Abercrombie and Gil Grosvenor were in their mid-twenties. Instead of sending the traditional dozen rolls of film back from the field, Abercrombie shipped 150 rolls. "At first Gil was confused by the deluge," he says, "and I think he was worried because, in a couple of cases, the main subject was in focus, but the background was purposely out of focus." In fact, Gil Grosvenor liked what he saw.

After the Lebanon assignment, Abercrombie began specializing in the Middle East (so much so that a half dozen of his photographs appeared on the currency of Yemen). He learned Arabic and converted to Islam. He was able to make the first color photographs of Mecca, a holy site forbidden to non-Muslims (page 83).

Like other *Geographic* photographers with special interests, Abercrombie sometimes strayed from his specialty. To get around the vastness of Alaska in 1966, he bought a Cessna 185 for $26,000. He flew it a couple of hundred hours and then sold it for about what he paid for it. While he had the plane, he put his life in the hands of a local pilot. In one Alaskan fishing village, the main street was the runway. "You've got dogs chasing you down the street when you're taking off, and pickup trucks parked in the wrong place," he remembers. "Once, when we took off, a dip in the main street was full of water. He gunned the baby right toward the puddle. When he got to Third and Main, he just turned the corner and went up."

To make certain that *Geographic* photography did not depend too much upon the style of one photographer, Melville Grosvenor—partly at Abercrombie's suggestion—in 1958 offered the *Milwaukee Journal*'s picture editor, Bob Gilka, a job. Gilka turned it down.

"There were too many layers," he says. "They had two sets of picture editors—one for color and one for black-and-white. They had a chief for each and a chief of the whole thing. And they had a guy who was supposed to be a combination hatchet man and financial overseer, making sure the stories didn't cost too much." The black-and-white editor and the color editor might not be speaking to each other, but they somehow had to lay out stories together.

Gilka, assured that the *Geographic* was changing, finally took a job as picture editor. He was later made director of photography, put in charge of all still photography, and told he could hire anyone he wanted. "I want you to go out and get

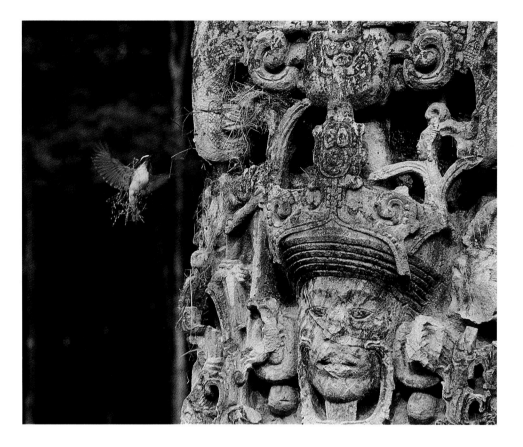

Copan, Honduras
1988

KENNETH GARRETT

A brightly colored great kiskadee flutters near its nest in an eighth-century stone stela portraying Maya ruler 18 Rabbit—an instance of the Geographic*'s abundant coverage of archaeology.*

Antigua, Guatemala 1936

LUIS MARDEN

"Belfries of sixty-odd ruined churches speak in cracked, thin voices or deep, booming tones," wrote Marden. An 18th-century earthquake had destroyed this Guatemalan city for the third time.

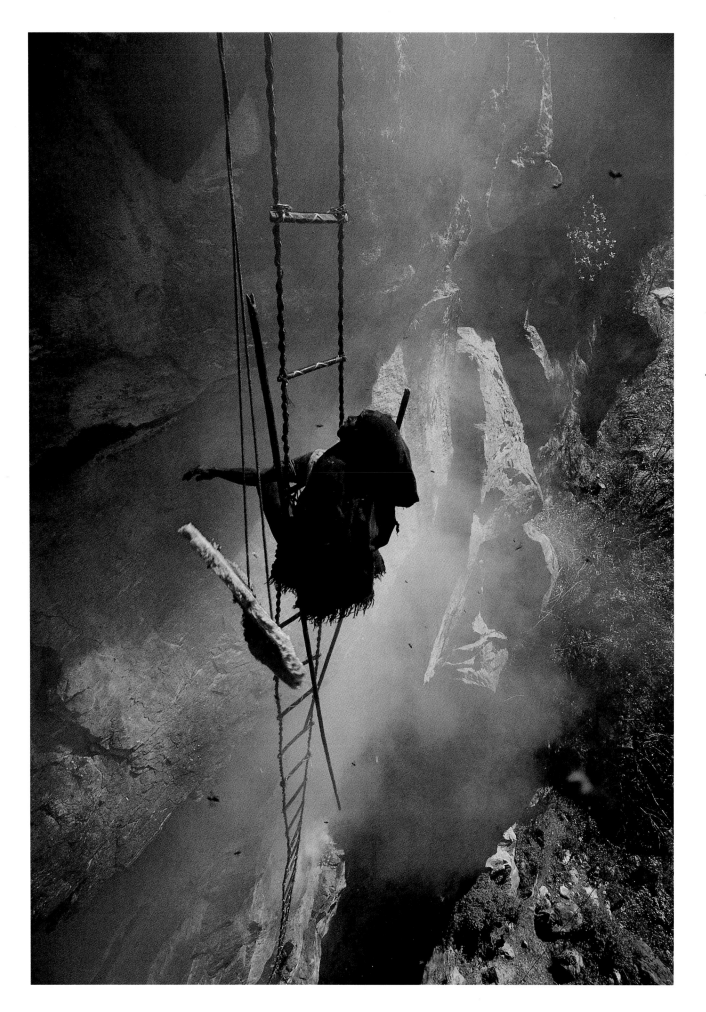

Western Nepal 1987
ERIC VALLI

Dangling from a 400-foot cliff on a rope ladder, Nepalese honey hunter Mani Lal directs a helper in lowering a brood comb from a giant honeybee nest to the ground. Valli rappelled down the precipice alongside the hunter to capture close-ups and to record a vanishing tradition of the Himalayan foothills.

young photographers in here," Melville Grosvenor told him. "I want our magazine to show what photography is today, not what it was 20 years ago."

Even before Gilka arrived, the changes had started. Young photographers and picture editors had preceded him. Among them were Dean Conger, Winfield Parks, Al Moldvay, Jim Blair, and Bill Garrett, who one day would become editor of the *Geographic*. Grosvenor scrapped the dual picture editor system and decreed that the magazine would be all in color.

Gilka stepped up the hiring of young professionals, such as *Toledo Blade* photographer Bruce Dale, and was signing up three summer interns a year. Many of the interns became staffers, among them Bill Allard, Sam Abell, Bob Madden, and Emory Kristof.

Gilka knew James L. Stanfield's father and uncles, all photographers, and when Stanfield sent Gilka his portfolio, Gilka responded with advice. "Strive to be an individual," he wrote Stanfield. "Once you're satisfied with photographing the subject in the same style or manner, you're defeated."

Three years after being named Missouri's Newspaper Photographer of the Year, Stanfield joined the staff in 1967. "Gilka was frightening," says Stanfield. "I didn't know where he was coming from. I felt insignificant and inferior. But I wouldn't want him any other way, and there's not a photographer here who would want him any other way. He's got a heart of gold, he'll do anything for you, and when he speaks, you listen."

His words usually were few. "If you got one grunt, you did pretty well," Stanfield says. "If you got two grunts, the story must have been a blockbuster."

To see what a young photographer named David Alan Harvey could do, Gilka sent him on a trial assignment to Cooperstown, New York. Harvey shot for about three weeks and sent back his film. Gilka edited the slides and then wrote Harvey to tell him what he thought of his work. As Harvey remembers, Gilka began: "Dave, I'm glad you're young and strong because what I have to tell you is going to make you feel sick and old." Harvey still winces at the memory.

"He went on and said in such and such a roll I hadn't done this, and in such and such a roll I hadn't done that. Well, the fact is I hadn't really liked what I had done either. I had sort of done this postcard kind of photography."

A few years later, assigned to cover Tangier Island in Chesapeake Bay, Harvey remembered the lesson: "I just went right in there and did it exactly as I thought it should be done, and it was well accepted."

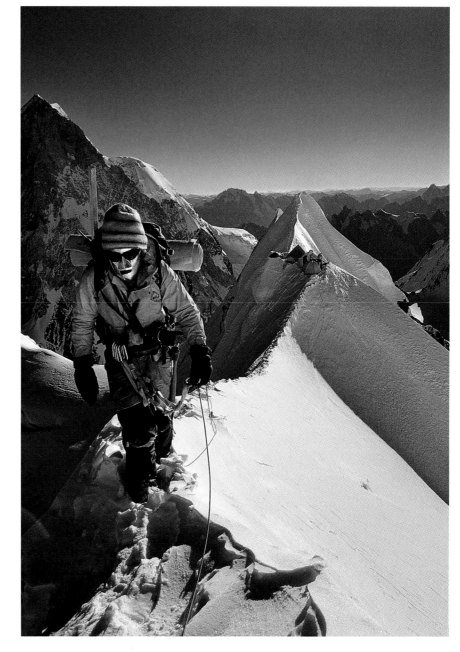

China-Pakistan 1978
JOHN ROSKELLEY

A member of an American team that climbed K2 (Godwin-Austen) negotiates a sharp ridge.

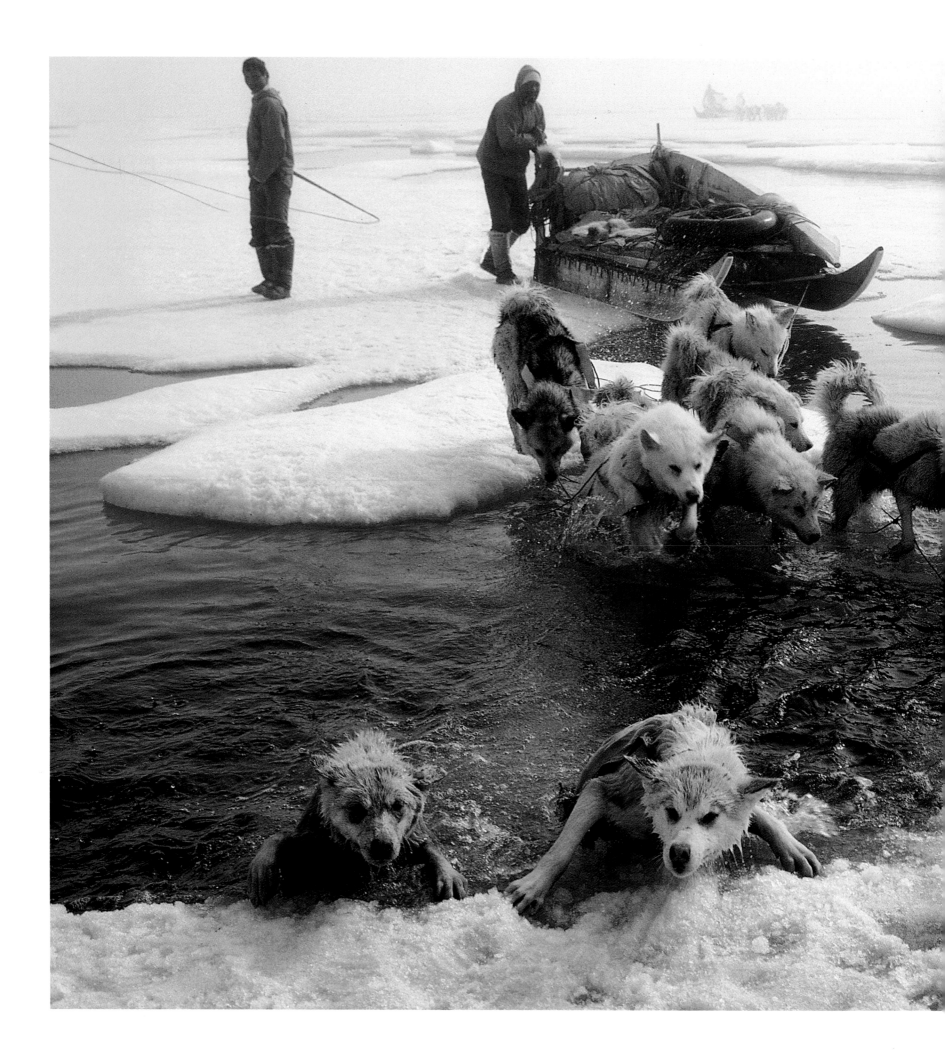

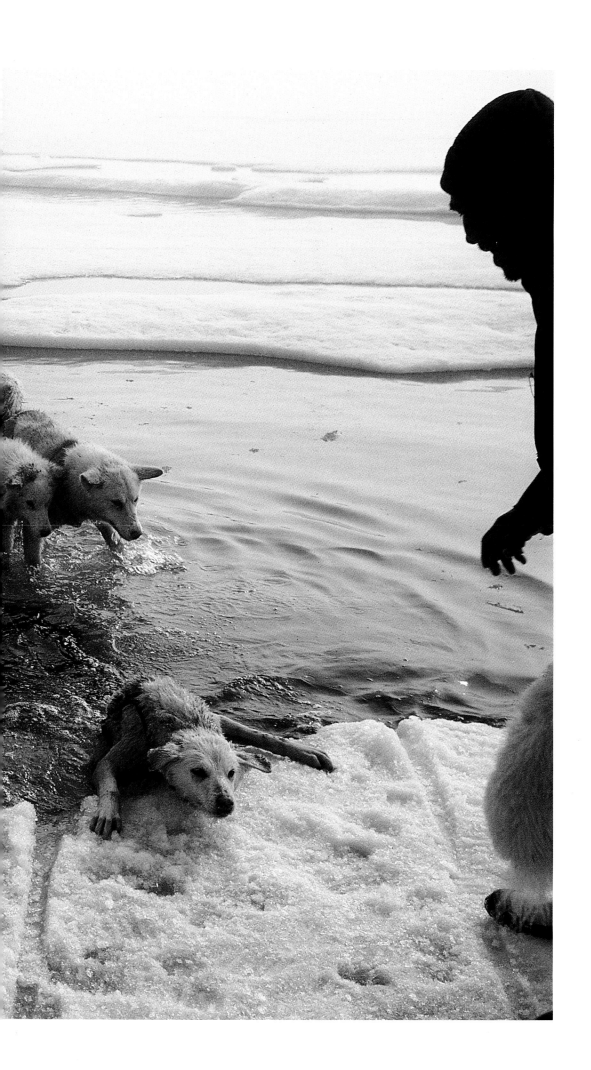

Inglefield Fjord,
Greenland 1981
IVARS SILIS

*A sled team towing kayaks
in July to hunt narwhals—
small, tusked whales—fights
for its life in the swift current
of a lead in the melting ice.
Greenland photojournalist
Silis hunted narwhals with
the Polar Eskimos.*

Gilka wanted versatility. But he shrewdly nourished photographers' passions. Jim Brandenburg could devote himself to wildlife and Emory Kristof to the deep ocean. Dean Conger could return to the Soviet Union again and again, and George Mobley could tramp through the cold of the far north.

A few older photographers had a rough time in the new era. B. Anthony Stewart had always traveled with a notebook in which at night he listed successful pictures he had made that day. When his list numbered 30, he felt he had the assignment covered. In the twilight of his career, struggling with a story on nuclear energy, Stewart went to Gil Grosvenor and asked to see images that the young picture editor liked. "So I hauled out Abercrombie's latest take, and they were fantastic, and he didn't say a word," says Grosvenor. "I didn't see him again for three weeks. The next shipment came in, I laid them on the table, and it looked like Abercrombie had shot them."

GIL GROSVENOR, who became editor in 1970, opened the magazine to controversial subjects—Cuba under Castro, life in Harlem, separatism in Quebec. Members of the Society's Board of Trustees reacted by threatening to create what Grosvenor called an "oversight committee to throttle the editor." When the *Geographic* published "South Africa's Lonely Ordeal" in June 1977, the penetrating images, by staff photographer James P. Blair, symbolized the new *Geographic* realism that Grosvenor had been encouraging (page 77). The South African photos and text led to another Trustee censorship threat, which Grosvenor again successfully fought off.

He had spent ten years working at what he called "the best job in the world" when, in 1980, he became president of the Society. Bill Garrett, who had joined the staff as a picture editor in 1954, was associate editor in charge of illustrations. He succeeded Grosvenor as editor.

"After working on some 30 magazine articles as either writer or photographer, or both, Garrett was well prepared to be editor, and it is fair to say he had a vision," Bob Gilka says in assessment of Garrett's editorship. "That vision was to keep the magazine moving in the present, but faster, and to lead it into the future."

Garrett rarely yielded to challenges over what he wanted to publish. He experimented with layouts and ran politically provocative pictures on such subjects as the killing fields of Cambodia, AIDS, and the smuggling of endangered species. He published a Spanish Harlem story that featured vivid coverage of the drug trade, including a photo of a junkie shooting up.

After a while, Garrett and Grosvenor began clashing over personnel and budgetary matters. Finally, in April 1990, they acknowledged that their differences had become irreconcilable. Garrett resigned. He was replaced by William Graves, senior assistant editor for expeditions. Graves had written 22 articles for the magazine as well as *Hawaii,* a book published by the Society. He had also worked with such *Geographic* writers as Jacques-Yves Cousteau, Thor Heyerdahl, Bob Ballard, and polar explorers Naomi Uemura and Will Steger.

Graves had the advantage of being a word man and a field man. "It helps to

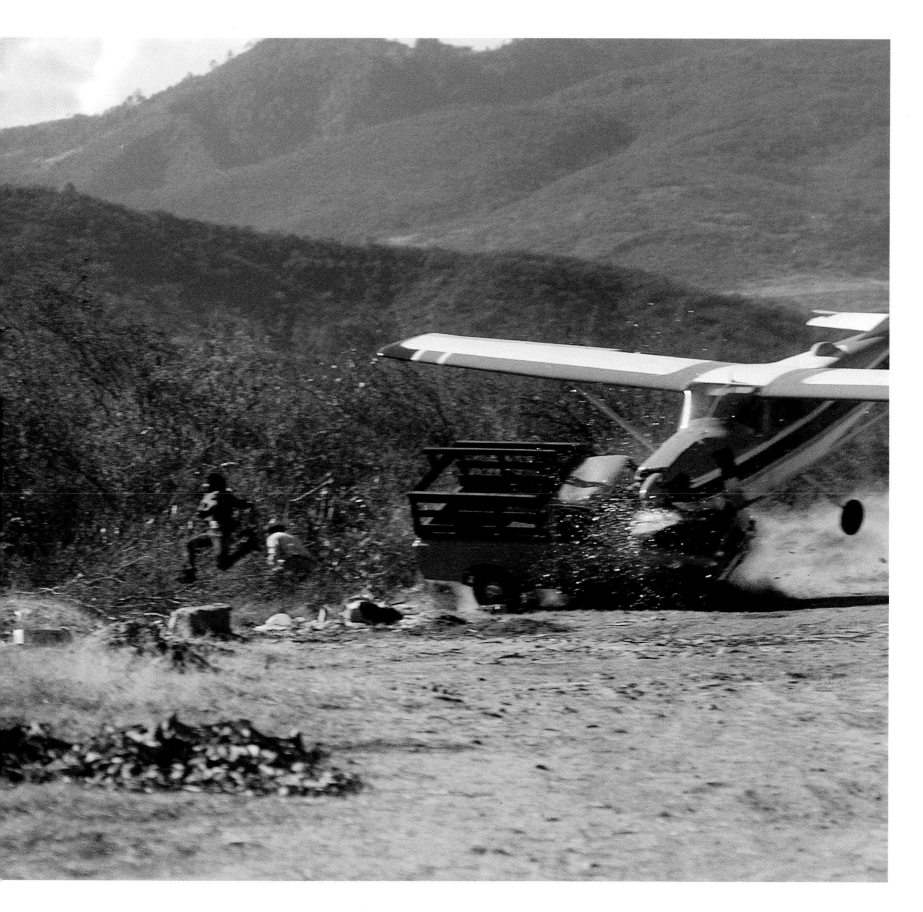

Sanarate, Guatemala 1976

ROBERT W. MADDEN

On a rescue mission after an earthquake, a plane caught by a crosswind crashes. Moments earlier,
Madden had landed on this same road; he took the photo through the window of his plane.

know, firsthand, the frustrations and rewards in the field in order to guide people from headquarters," he says. "I have to trust the photographers, and I do. My tendency has always been to give them as much latitude, as much control over their own work as the magazine allows."

In the 1980s the photographic staff also was changing. Bob Gilka brought in as his assistant Rich Clarkson, a picture editor on the *Denver Post.* When Gilka retired in 1985, Clarkson took over, hiring Tom Kennedy away from the *Philadelphia Inquirer.* Kennedy became director of photography in 1987. "My orientation coming into the job was that I wanted to encourage individual photographers to find their own vision and express it," Kennedy says. As the *Geographic's* photographic staff shrank, he looked more and more to freelance and contract photographers. He wanted them to show the world in unexpected, thought-provoking ways. "But sometimes an image is intensely personal and so complicated it would be indecipherable to the *Geographic's* public," he says. "Our pictures have to be strong, but mainstream enough to be understood by our members."

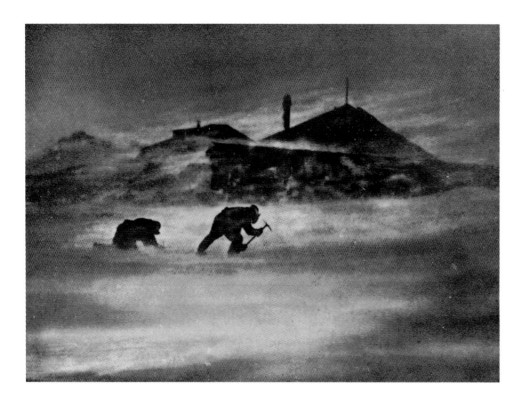

Antarctica 1912

FRANK HURLEY

At Commonwealth Bay, members of Australian Douglas Mawson's 1912 polar expedition "plunge into the writhing storm-whirl" of a blizzard to collect ice for water.

At times, a photographer's point of view conflicts with the *Geographic's.* The conflict can become so intense that the coverage is rejected, and another photographer may be sent out to reshoot or supplement another's assignment. But exceptional viewpoints or styles do get published. "It's too late in the evolution of photography for people to photograph just what's there," says Michael Nichols. "You've got to put your own stamp on it."

Sophisticated equipment has affected much more than the way photographs look. Technology has created a world where little remains undiscovered. But imagination and the quest for adventure endure.

To get pictures of Nepalese honey hunters, French photographer Eric Valli and his wife Diane Summers spent two years tracking rumors and searching a thousand Himalayan cliffs (page 46). When he finally found a hunter, Valli rappelled down the 400-foot cliff alongside his bamboo-and-rope ladder to a hive thick with bees. Hanging from the cliff, with bees buzzing in his ears, Valli photographed the hunter harvesting honey and wax by tearing at the hive with long bamboo poles.

Valli walked into Kennedy's office with the photos, and Kennedy quickly began shepherding the story of the honey hunters through the system to publication, even though the photos had already been published in Europe. Kennedy saw the story as one in the grand tradition. What Valli did, Kennedy says, is what the great photographers have always done on assignment for the *Geographic:* "Find a story that is almost impossible to cover, and then cover it."

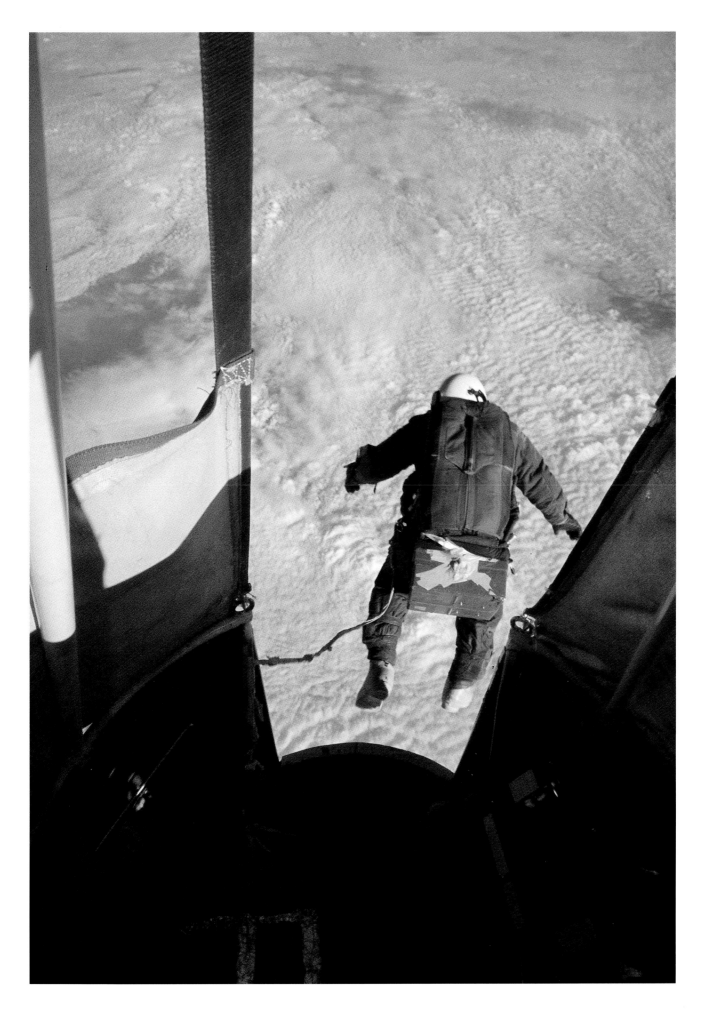

New Mexico 1960
VOLKMAR WENTZEL

A motor-driven camera mounted above this balloon gondola photographed the world's highest jump—from 102,800 feet—which tested new parachute equipment.

following pages:

Mount McKinley,
Alaska 1978
NED GILLETTE

An "awesome, unforgiving, and beautiful" terrain challenged the photographer and three companions on their circuit of North America's highest peak.

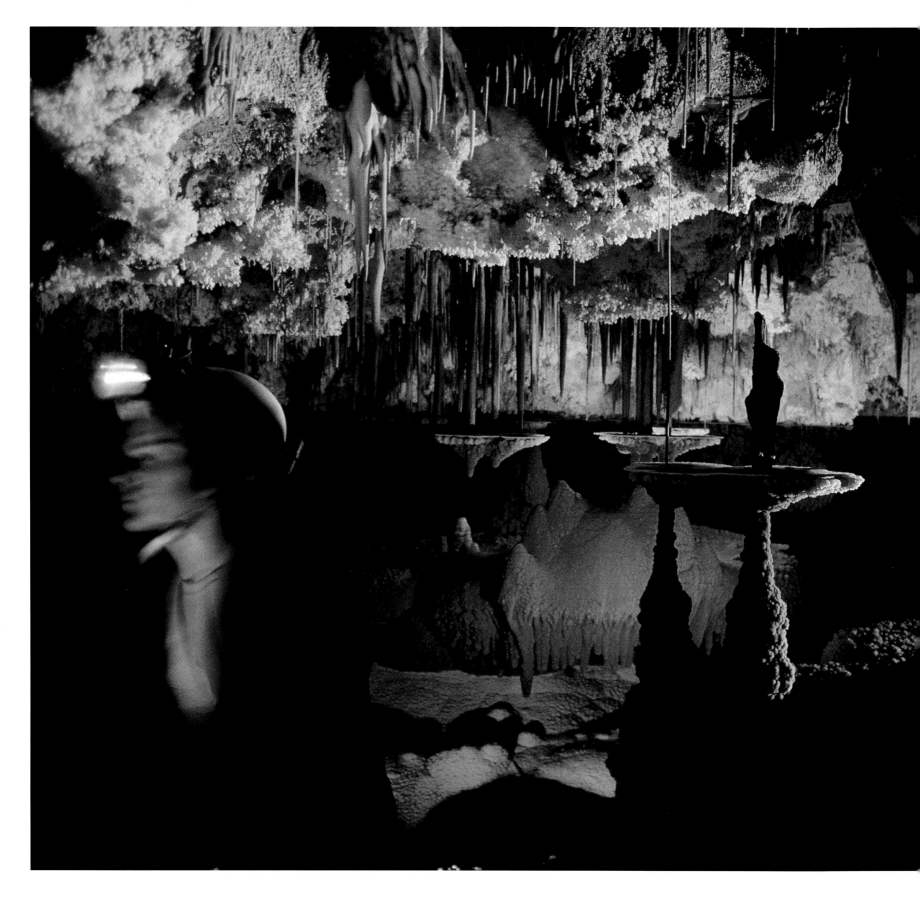

Lechuguilla Cave, New Mexico 1990

MICHAEL NICHOLS

Atlantis—a rock garden with strange "birdbath" formations—lies in the High Hopes section of this recently discovered cave. More than 75 miles of the sculptured wonderland have so far been explored.

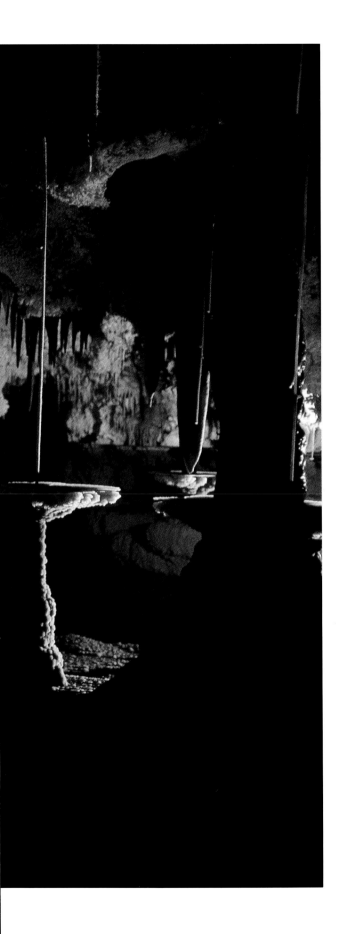

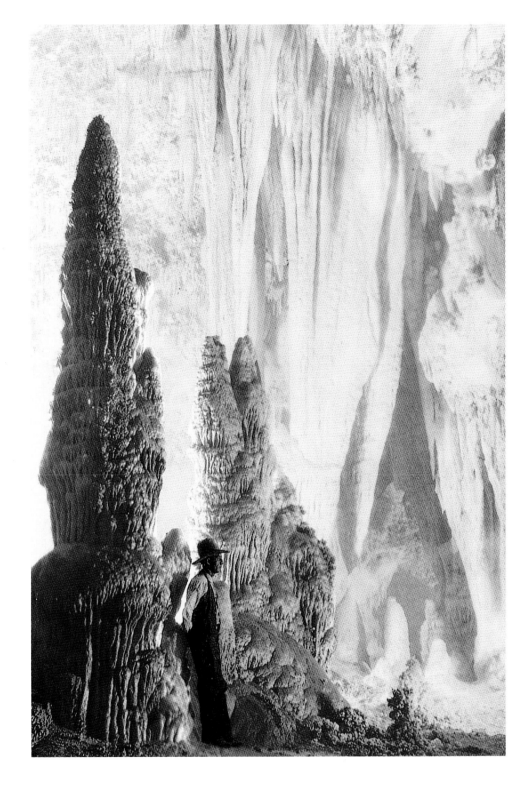

Carlsbad Caverns, New Mexico circa 1923
RAY V. DAVIS

*Carlsbad was still being explored when this picture was taken, and visitors were lowered in
a bucket used to haul out bat guano. Geographic publicity helped create a national park here.*

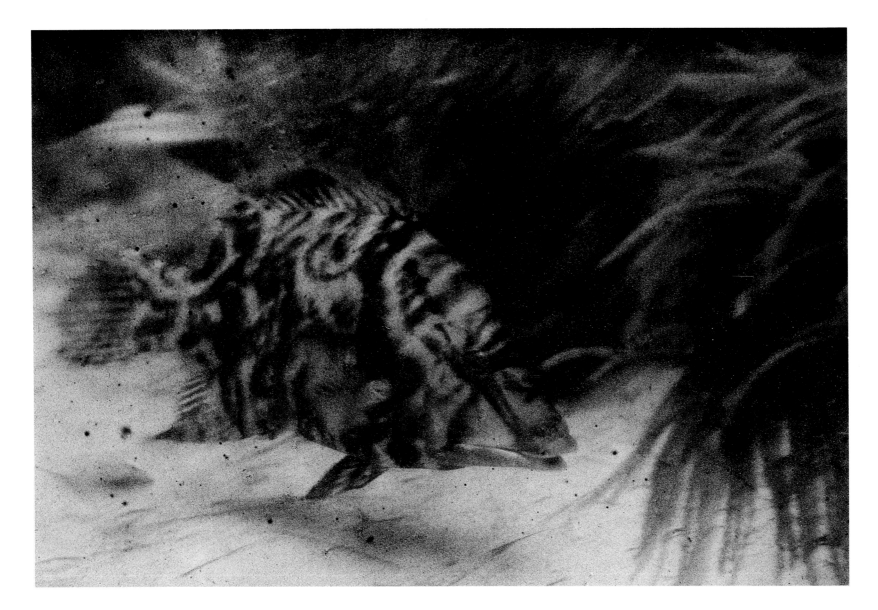

Dry Tortugas, Florida Keys 1926

W. H. LONGLEY AND CHARLES MARTIN

The first successful underwater color shots, taken 15 feet down, included this hogfish. The photographers used Autochrome plates and a dangerously volatile charge of magnesium flash powder.

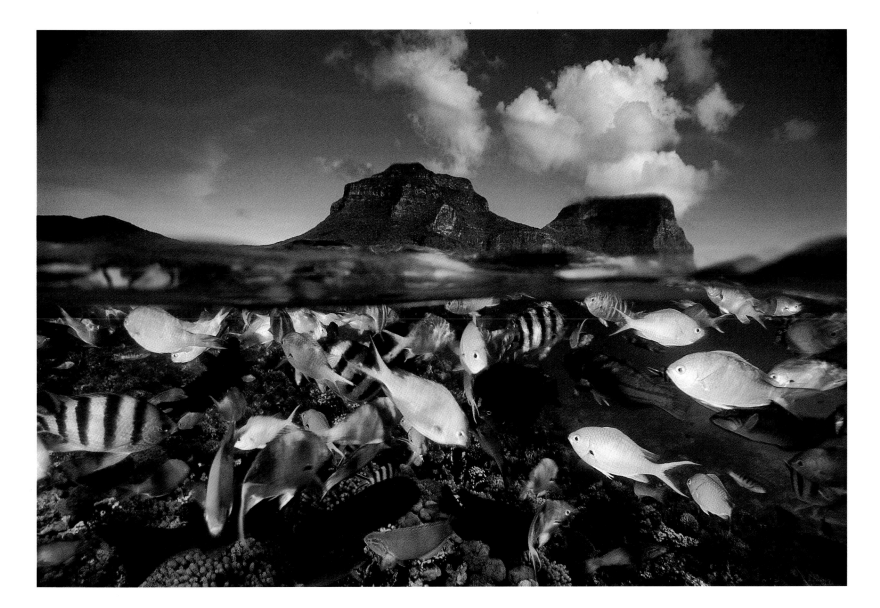

Lord Howe Island, Australia 1990

DAVID DOUBILET

Doubilet, who specializes in underwater photography, juxtaposes a sharp image of wrasses and damselfish in the world's southernmost coral reef with a perspective of Lord Howe Island's twin peaks.

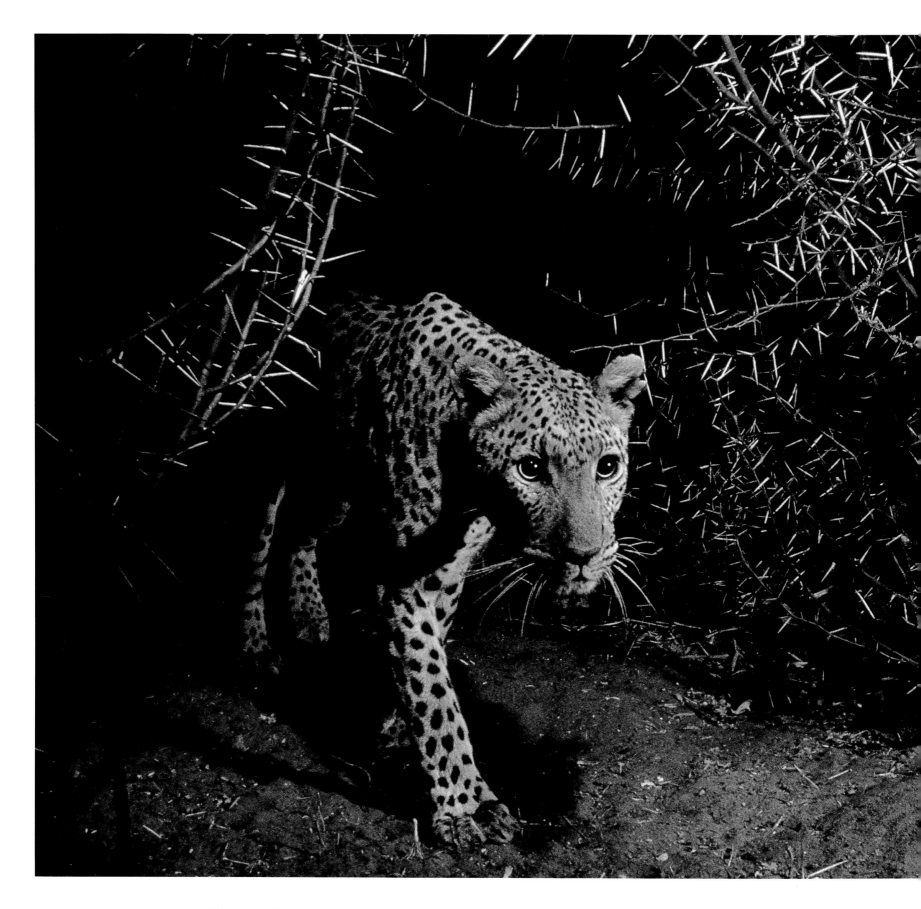

Okavango, Botswana 1989

FRANS LANTING

"A robot camera triggered by an infrared beam captured the stealth of a leopard I never saw myself,"
said Lanting of this rare shot—the only leopard picture he obtained in a year at Okavango.

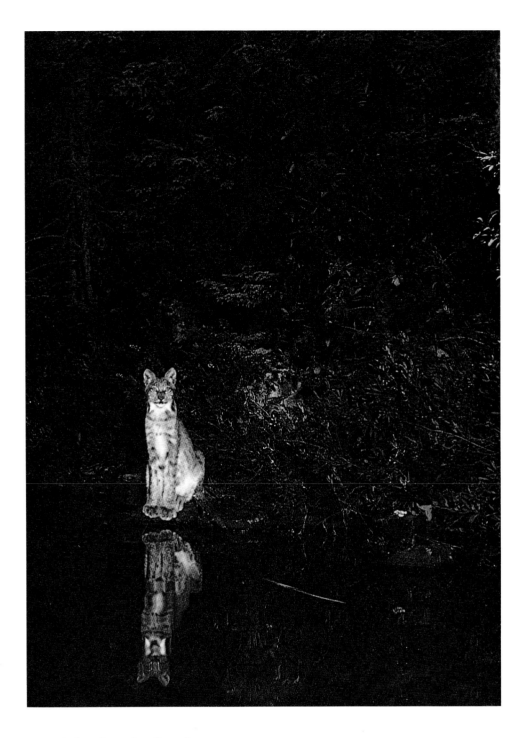

Loon Lake, Ontario, Canada 1902

GEORGE SHIRAS III

Unfazed by Shiras' lantern, which detected the glow of its eyes, a lynx was alarmed by his flash photography. Shiras pioneered nighttime close-ups of wildlife and the use of remote-control devices.

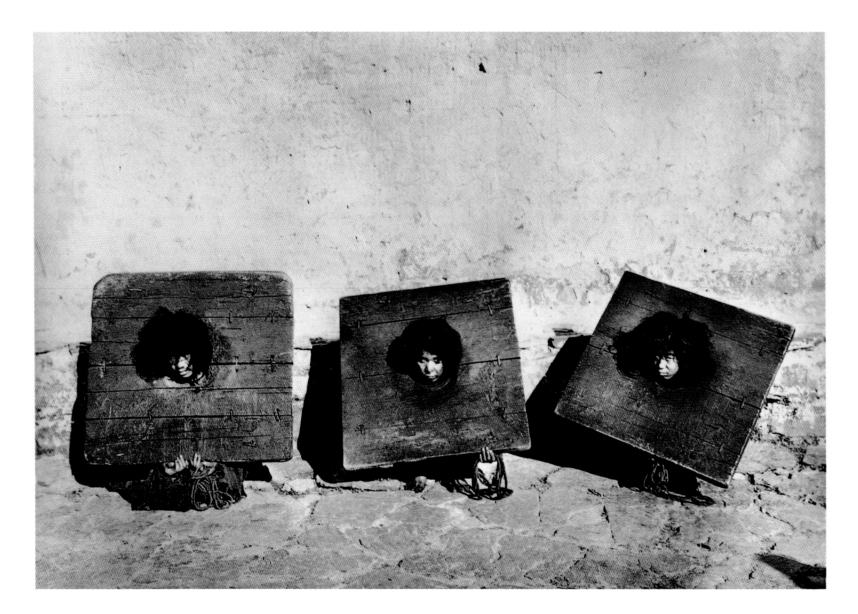

China-Tibet 1928

JOSEPH F. ROCK

These pilloried Chinese murderers spent months in a dungeon before being led outdoors for Rock to photograph. Rock's stories about unknown customs of old China kept Geographic *readers enthralled.*

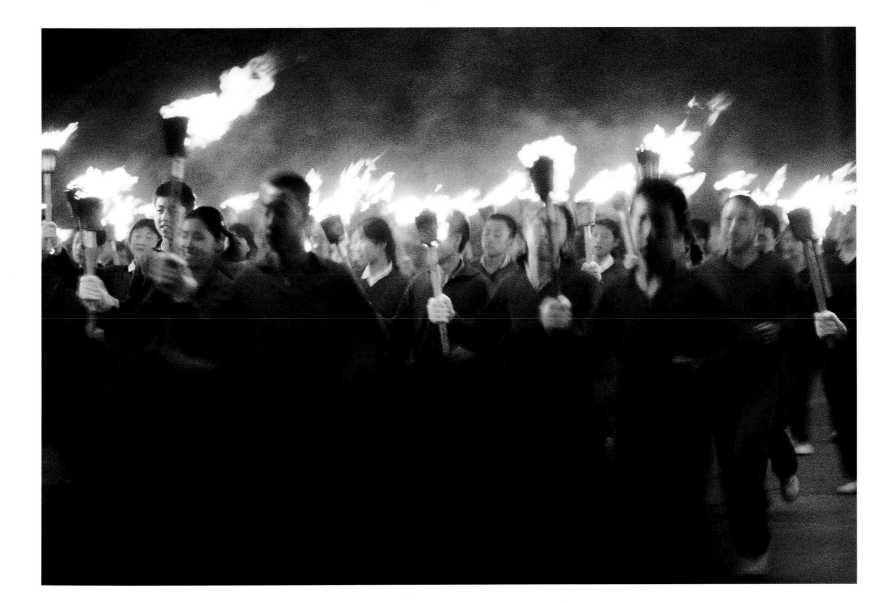

Gansu Province, China 1979
BRUCE DALE

*Honoring the 30th anniversary of the modern People's Republic of China, a torchlight procession
of relay runners traces the arduous path of the Long March, the Communist retreat of 1934-35.*

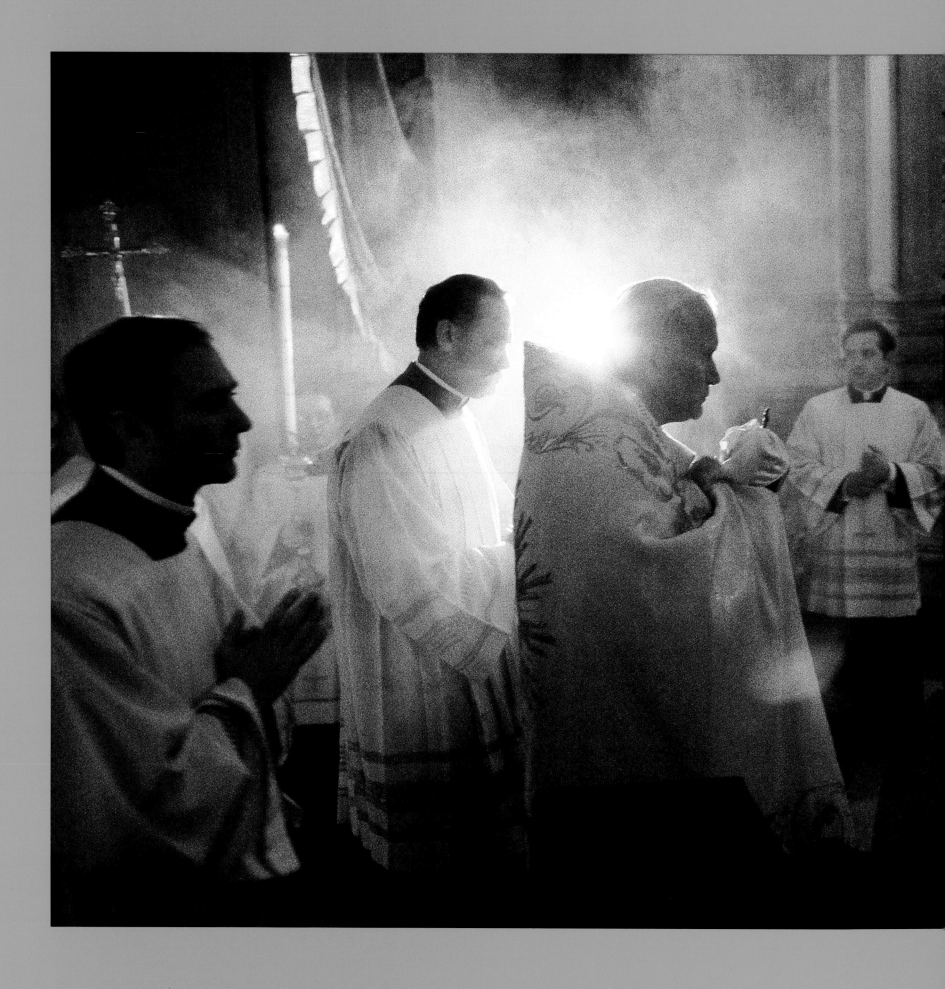

The Vatican

Outside the Vatican, Pope John Paul II leads a Holy Thursday service in the Basilica of St. John Lateran, his seat as Bishop of Rome. Photographer Stanfield recorded the Pope's activities at every ceremonial occasion open to him during nine months of magazine and book coverage.

Jim Stanfield had been working six months on a Vatican story for the *Geographic*, his deadline was approaching, and he was upset. "I wasn't getting pictures of the Pope's private moments," he recalls. "That intimate portrait of the Holy Father was always hovering, and I wasn't getting it. I was going to have to break some rules."

He befriended a sergeant major in the Swiss Guard and prepared a letter and a couple of dozen photographs showing the quality and variety of his work. The officer delivered the package to Pope John Paul II's private secretary. Within 36 hours Stanfield was in a helicopter going on vacation with the Pontiff.

They landed at Castel Gandolfo in the Alban Hills near Rome and drove in two cars toward the residence. When the cars pulled over, the Pope emerged and walked up a wooden stairway. His personal photographer, Arturo Mari, pushed Stanfield forward, alerting him to what was about to happen.

"I followed the Holy Father up the stairs, through an archway, and into the Garden of Our Lady," Stanfield remembers. "He went to the shrine of the Virgin Mary and knelt. When he got up, he came toward me. I just backpedaled for the next hundred yards or so. He was concentrating so intensely, he didn't even know I was there." A photograph Stanfield

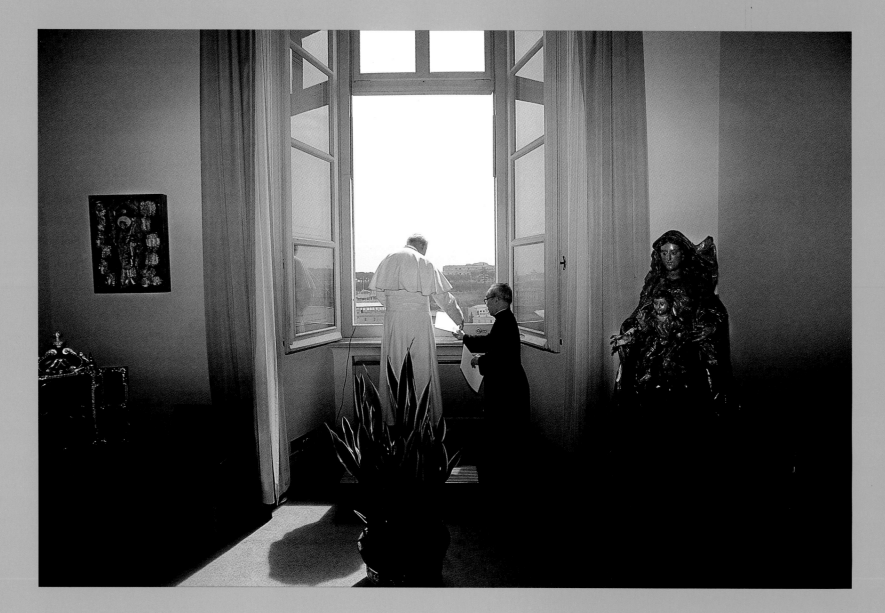

"I wanted to capture the human and intimate side of this age-old institution," said Stanfield. Above, the Pope prepares to bless the crowd in St. Peter's Square, an intimate scene that contrasts with an ordination Mass for candidates for the priesthood inside St. Peter's.

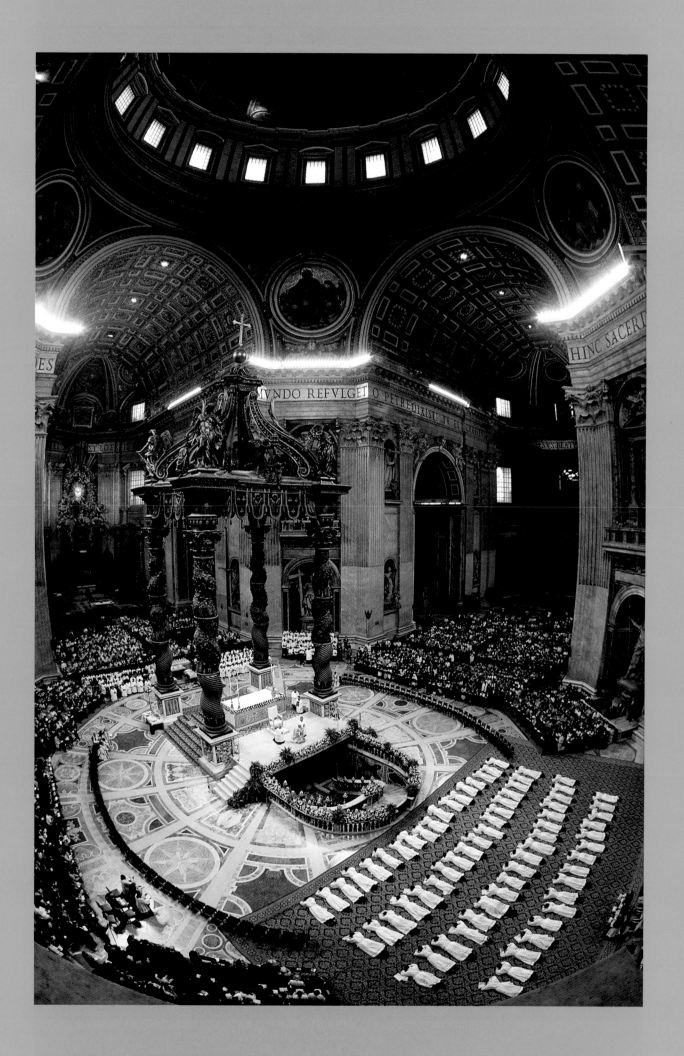

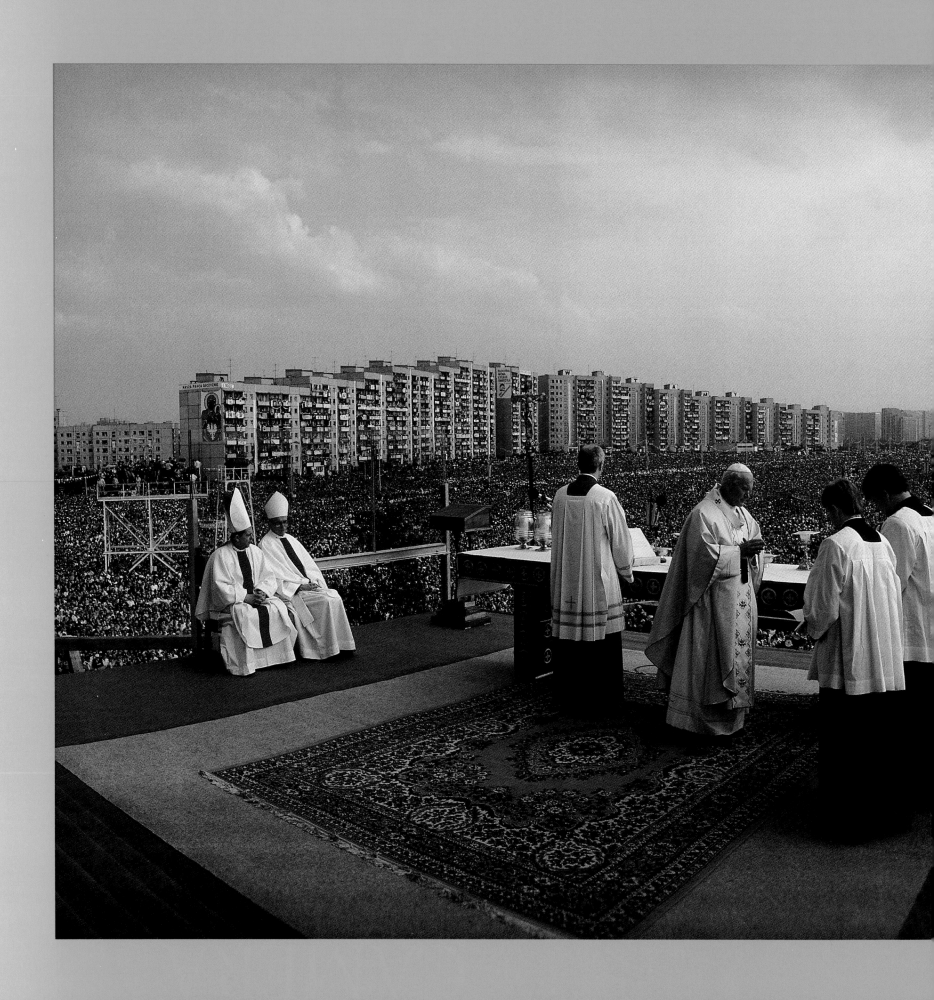

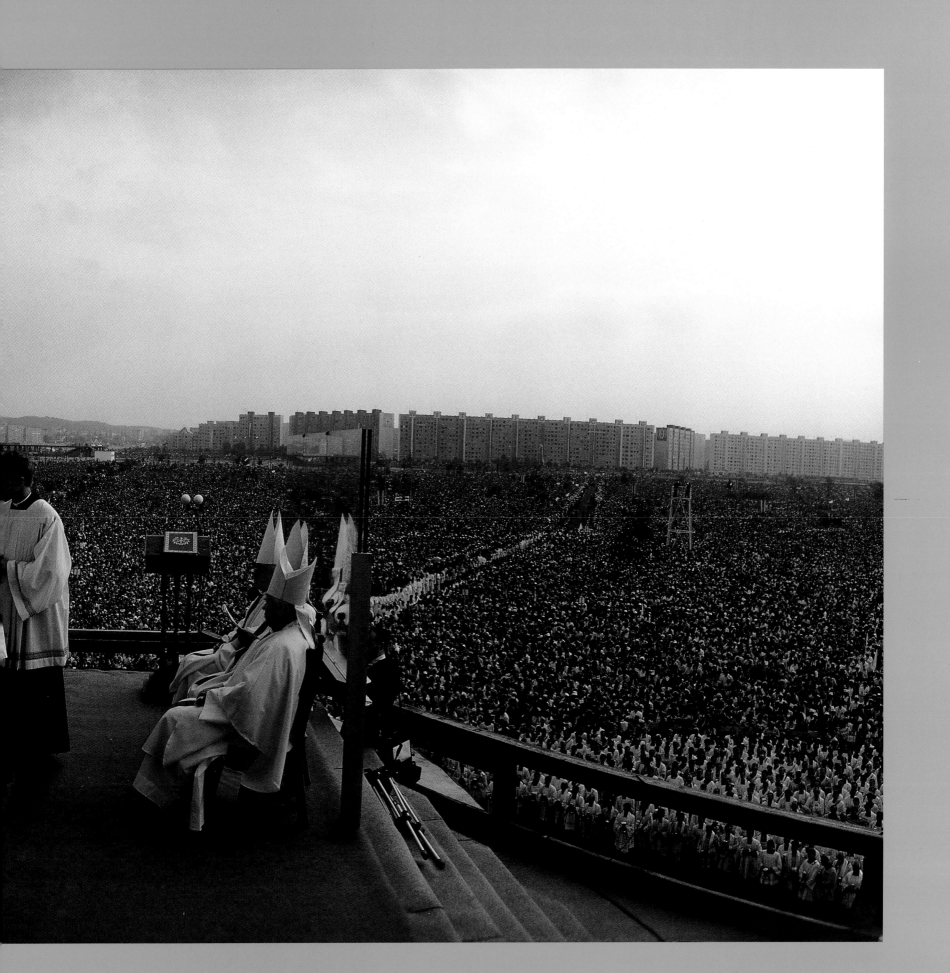

In June 1987, on a tour of his native Poland, the Pope celebrated Mass in Gdańsk before a sea of more than 750,000 worshipers. Stanfield, on assignment for a Poland story, caught the moment.

made about 35 feet from the shrine (right) is one of the finest of his entire Vatican coverage.

Before this crucial day Stanfield had become friends with Mari, who had taken the American under his wing. "I studied this guy," Stanfield says. "watching how he worked and how he stood, making the smallest silhouette possible, with his arms at his side and his feet tight together. He would pop out and make a photograph and pop in, and you didn't even see him."

Much of Stanfield's coverage involved being in the right place and reacting quickly. "But," he says, "I missed a lot of photographs in practicing patience and not being aggressive. I would go back to the hotel and kick myself remembering scenes where someone stepped in my way when the Holy Father held a baby up and kissed it."

Stanfield also established a rapport with the Vatican security officers. "The security staff has a lot of power," he says. "If they trust you, you're in. If they don't trust you, you're with other photographers on a stand 200 yards away."

Stanfield's sumptuous photographs of spectacles provided the setting and contrast for his hard-earned close-ups and informal pictures. Once, four stories above St. Peter's Square, he stood behind the Holy Father in a quiet room. Both faced a window that looked down upon the multitude of people who filled the square below.

Stanfield photographed an exchange between the Pontiff and his secretary before the Sunday blessing (page 66). Then, in the caption book that all *Geographic* photographers fill out as they work, he modestly wrote, "I was finally invited to photograph the Angelus from the Pope's study! Should be a couple good things here!!!"

The Pope strolls pensively in the gardens of his summer retreat at Castel Gandolfo near Rome. Stanfield felt he had captured the Pontiff in a new light—not as a public figure but as "a private, serene, and prayerful man. That is why this photograph means something special to me among thousands I made in the Vatican."

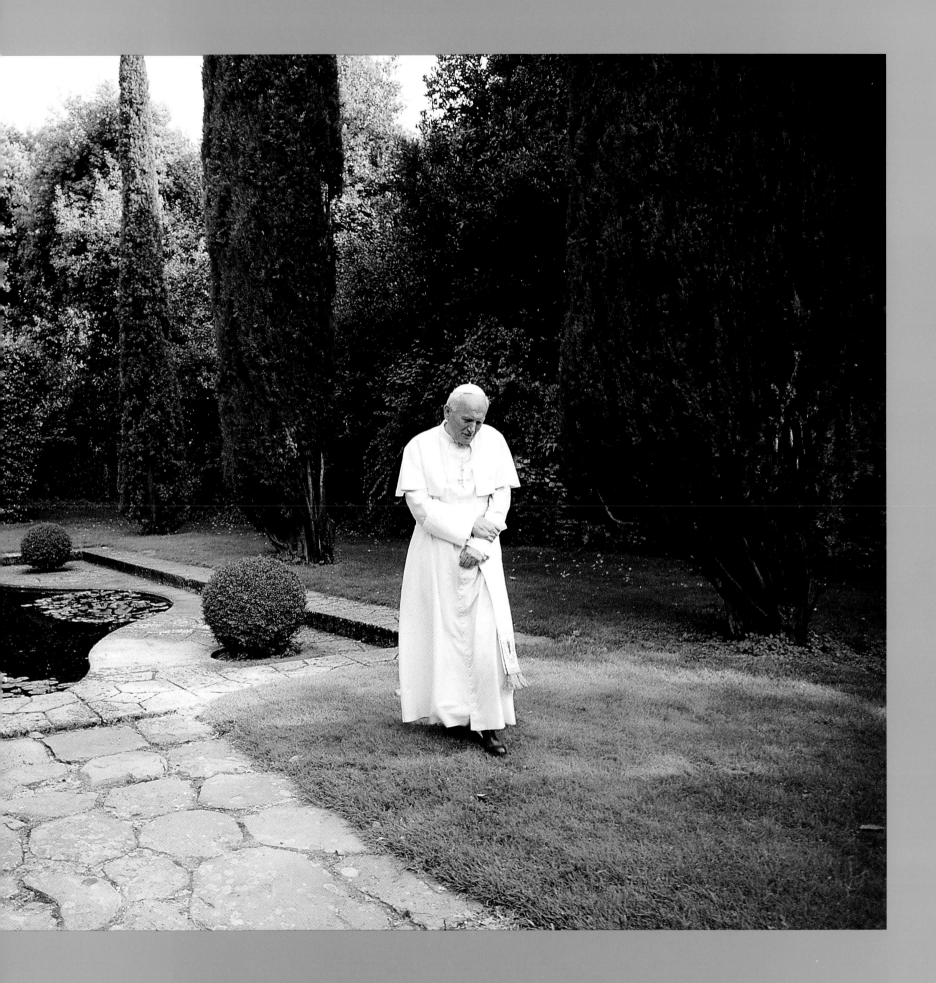

THE CAMERA AS A WINDOW

Gusinje, Yugoslavia 1969

JAMES P. BLAIR

Recording both sides of a picture, Blair photographs Muslim men having soft drinks in a café, while the window's reflection includes him and some young, grinning bystanders.

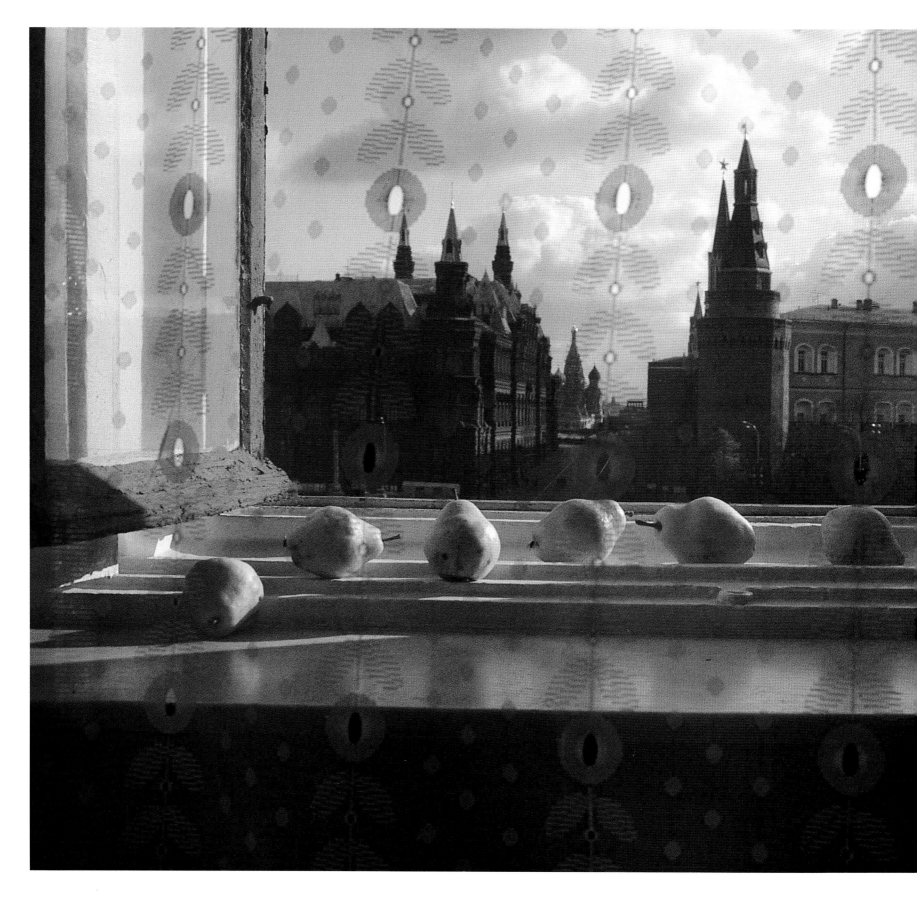

Moscow 1983

SAM ABELL

Simple beauty softens a bastion of cold war tensions, when sun-lit pears, the Kremlin, at right, and other buildings around Red Square are viewed through the lace curtain of a Moscow hotel room.

For *Geographic* photographers, the world beyond the United States is, professionally, just another assignment. But working conditions abroad can be very different from those at home. There's the language problem. Discomfort is common. ("Stomach disorders and politics," sums up one photographer.) Trouble is frequent. Danger is expected. And strewn across every path are bureaucratic and cultural hurdles. Getting over or around them is usually the toughest part of the job.

So it was with Jodi Cobb, who set out to photograph the women of Saudi Arabia. Cobb started with one connection to her subject. The writer assigned to the story, Marianne Alireza, had been married to a member of a prominent Saudi family. Despite the connections, Cobb still ran into the Saudi custom that forbids women from having their pictures taken. The women Cobb approached, no matter how mature or professionally independent, had to seek permission to be photographed from husbands or fathers. The men usually said no.

"I was emotionally beaten down by the experience," says Cobb. "To be turned down by 99 percent of the people you want to photograph, day in and day out, makes it hard to get pumped up every morning."

As a woman, she needed a letter from her sponsor, the Ministry of Information, whenever she wanted to go anywhere. "I wasn't allowed to drive, fly anywhere without permission, or even check into a hotel. I wasn't allowed to ride in a taxi alone with a man, even the driver," says Cobb. "It was like photographing from a cage. But I knew that at any moment I could be deported. So I had to play by the rules." Subjects fled from her camera and passersby interfered when she was trying to shoot. She got arrested for photographing in a marketplace and was taken to jail but not locked up.

"There wasn't room for experimentation because I was so nervous about just getting a story," says Cobb. "I was more conservative photographically than I like to be." When she did maneuver her way into a situation, she worried that the circumstances were too mundane to make interesting photographs. But the balance she struck between pressing her cause and accepting constraints paid off in a landmark story published in 1987. Her photographs of veiled women at work, on the street, and at home portrayed a lifestyle that few Westerners had ever seen.

Anxiety accompanies Jim Stanfield on every assignment, so he photographs everything he can think of. "I blanket a subject. I maul a story until it's lying on its back like a turtle," he says. "I meet myself coming around the corner and then I'm happy." Covering the Vatican, he stayed so long and turned up in so many places that a Vatican official expected the Pope to "look around and ask, 'Where's Stanfield?'"

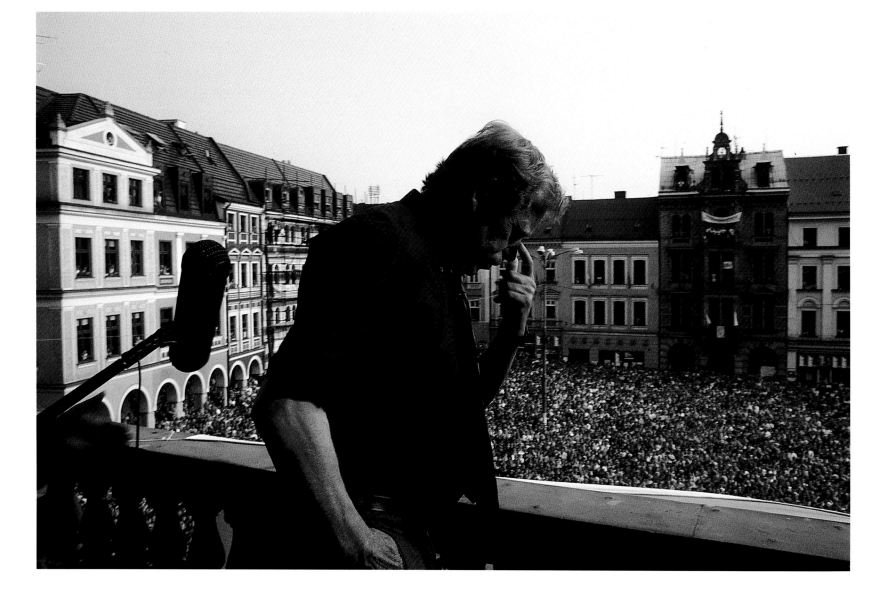

Liberec, Czechoslovakia 1990

TOMASZ TOMASZEWSKI

Freedom's responsibilities weigh heavily on playwright-turned-president Václav Havel
as he addresses his countrymen—still buoyant after shedding decades of communist control.

For a piece on Poland, he felt he needed a technology picture. He discovered a self-taught heart surgeon who had read scientific papers about transplants and then went on to perform several dozen. Stanfield photographed the doctor performing two consecutive (and successful) heart transplants in a marathon that began with preparations at 8 a.m. one morning and ended at 7 a.m. the next day. "I kept studying the doctor and watching his eyes," says Stanfield. "I could tell, even though he had a mask on, that things were going wrong. He was so focused, he didn't even know I was there." About 20 hours into the ordeal, Stanfield made a picture of the surgeon that shows the drama and exhaustion (page 85). "It was a good thing I did not turn and leave with just another surgery photograph," he says.

Karen Kasmauski's persistence is coupled to her intuition. In Kyoto, preparing to photograph a Japanese wedding, she insisted on visiting the bride's house before the ceremony. "The translator refused to send me because, he said, they were just getting dressed," says Kasmauski. "It was pouring, it was an hour-and-a-half drive on poor roads." But Kasmauski persisted and photographed a now rare pre-wedding custom: The ornately dressed bride sits in a windowed room so neighbors can catch one last glimpse of her before she leaves for her wedding. That photograph opened Kasmauski's story on Japanese women.

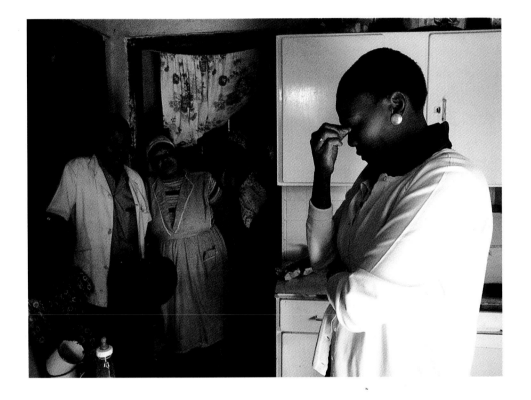

Soweto, South Africa
1976
JAMES P. BLAIR

The burden of apartheid overwhelms a social worker as she visits a family of 21 living in a three-room house. Coverage of South Africa's racial situation caused concern among some members of the Society's Board of Trustees.

Some hurdles are also logistical. Vic Boswell's work—evoking history by photographing works of art—took him to such places as the Egyptian Museum in Cairo, the Sistine Chapel in Rome, and the Louvre in Paris. He inevitably carried lights and cables and sometimes complex rigging. On his first trip to the Sistine Chapel he used 20,000 watts of illumination to photograph the entire ceiling in one great mosaic. In 1989, twenty years later, he needed only one-tenth of the light to photograph the cleaned and restored ceiling. To give the sense of a visitor looking up to the ceiling some 60 feet above, Boswell included curves of the ceiling as it merges with the walls. He relied on knowledge gained through long experience to make adjustments for distortion.

IN THE 1970s, when certain types of stories were covered in well-defined ways, one old standby, the "city story," was especially unpopular with younger photographers. Bob Gilka, the director of photography, put up a note asking if anyone was interested in a city story on Madrid. Dave Harvey, whose first two assignments were in Virginia, was getting tired of working only in the United States. He volunteered. "Several guys around the office said, 'You don't want to do Madrid. It's just like any other city,'" he recalls. "But all I could think of was bullfights and a chance to go to Europe."

Soon after Harvey got the assignment, the editors expanded it to include all of Spain. The city story became a country story, which offered more photographic possibilities. To keep up with the assigned writer, Peter White, Harvey began reading everything about Spain he could put his hands on. He also started learning Spanish. "I had a Volkswagen van and Peter White and a bottle of wine and a loaf of bread," he says, "and we drove all over and had a great time."

During the assignment, one skill especially grew: an ability to infuse his intensity for life into his photographs, particularly of people. But he did not go native. He knew he had to be himself. He did not treat Spaniards as strangers. "I don't blend with other cultures by pretending I'm one of them," he says.

"I've always thought that, as a photographer, you should start in your own backyard. I think you have to sort of take your backyard with you."

Harvey's interest in the Spanish world deepened and expanded beyond Spain's borders. Between other assignments, he photographed portions of Spain's former empire in the New World: Guatemala, Chile, Oaxaca, and the Maya world. In terms of subject matter, he became both generalist and specialist. This balance is sought by many other *Geographic* photographers who work beyond U.S. borders.

"One of the enjoyments of this job is the ability to choose how you want to spend the next six months or year of your life," says Bruce Dale, who might go from covering the Philippines to photographing a story on airline safety. "I guess what I like most of all is a challenge," he says, "the challenge of trying to show something in a provocative way, with feeling, something that will make people pay attention."

His long connection with China began in 1979 when he got permission from the Chinese government to travel across the country's northern deserts and villages as part of a scientific exchange program. During the next nine years he made nine more trips. "Traveling to China was a little bit like surviving a plane crash," says Dale. "Absolutely horrible to go through, but great to talk about later." He came home from every Chinese trip with a viral infection.

On his first visit, people lined the streets to get a glimpse of him (pages 38-39). It had been 30 years since Chinese people living outside big cities had seen Westerners. "At one point I ducked into a store to get away," he remembers. "About 200 people followed me in—went in one end, charged by the counters, and out the other."

Chinese escorts monitored his every movement. He could not leave a hotel without registering at the desk and saying where he was going, and when he did leave, he was often followed. To find a little time alone, he told his escort that it was against his religion to work on Sunday. The escort left, and Dale crept out with his camera. At night he was locked onto his hotel floor. Officials listened to his telephone conversations and opened his mail. "Once," says Dale, "I arrived in a town and a local said, 'Mr. Dale, Mr. Dale, you got some mail. It's a birthday card from your wife.'"

Realizing that officials felt obliged to bestow a favor after about five refusals, he would pile up impossible requests. But he most often got what he wanted by staging a scene with the writer accompanying him. "At night, I would say something like,

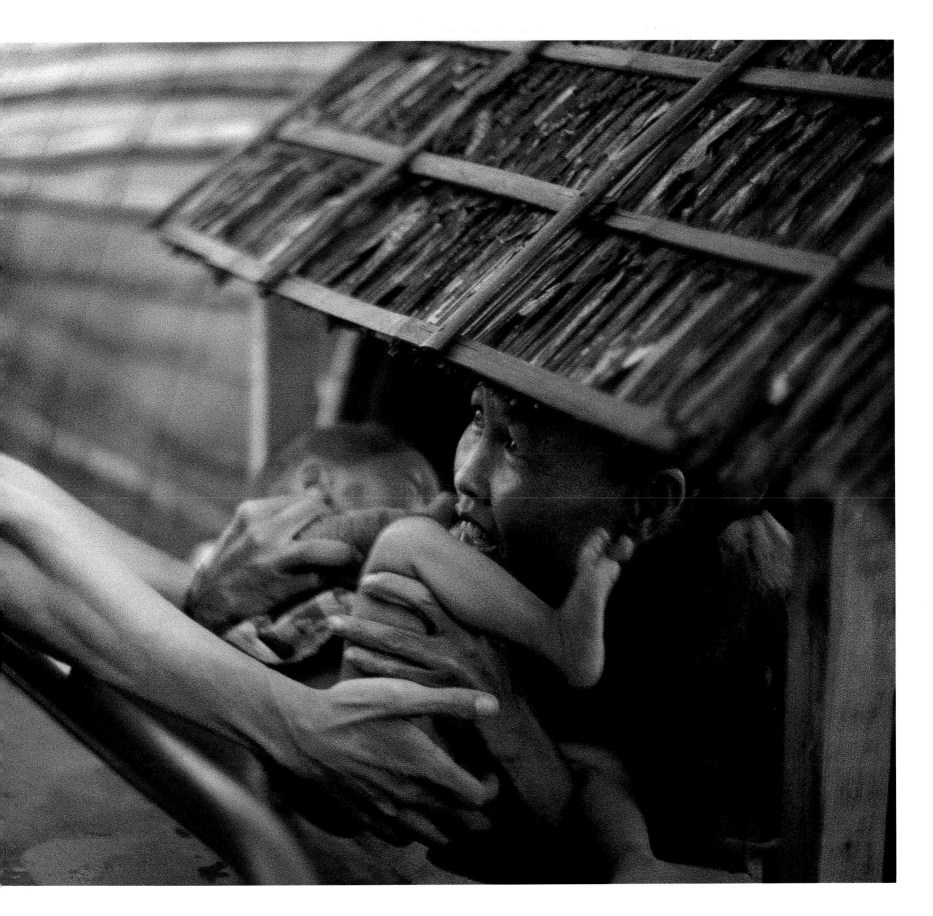

Mekong Delta, South Vietnam 1968

W. E. GARRETT

Desperate for medical help, a mother handed a sick child to a Vietnamese interpreter
when a U.S. Navy patrol boat stopped her sampan in search of Viet Cong or contraband.

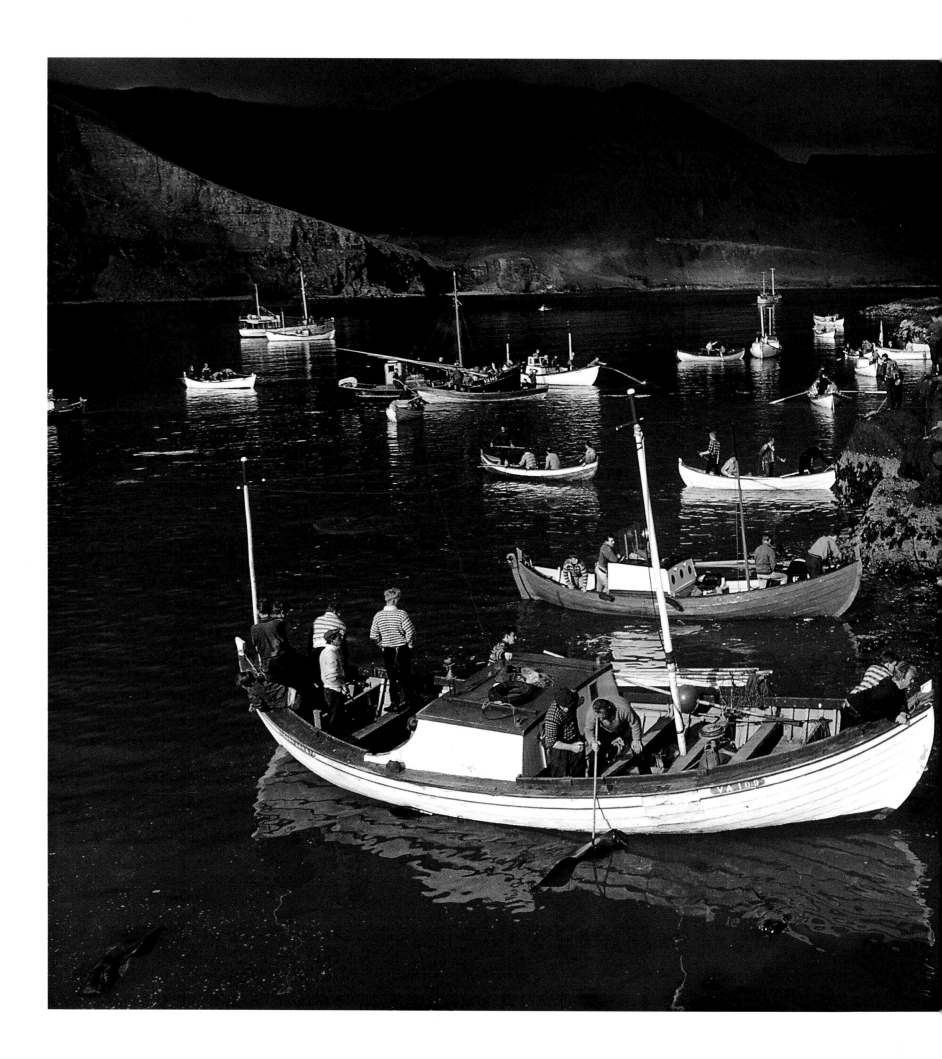

Tindhólmur,
Faeroe Islands 1968
ADAM WOOLFITT

*A bay runs red with the
blood of pilot whales after
a traditional hunt by
North Atlantic islanders.*

'Goddamn it, I'm going back tomorrow. I don't need to put up with this anymore. If they don't want me to photograph their country, the hell with it,'" Dale recalls. "The next morning they invariably said, 'Mr. Dale, we have reconsidered. We have decided that it is OK for you to photograph that shoe factory.'"

The Soviet Union during the Brezhnev era was also hard to work in. But Dean Conger, who visited the Soviet Union more than 30 times in 25 years, managed to photograph more of the country than most of its citizens ever saw. Like Dale, Conger learned to make the system work for him. He discovered that when he telexed angry messages to his editor, he usually won some of the access he sought.

Conger stayed away from politics and ideology, focusing on people. "In a way," he says, "I have thought of my work as a 'people to people' project and my lens as one small peephole through which others may gaze into a world not often seen." One of his most famous photos shows a little girl from Murmansk shyly smiling and holding up four fingers in response to Conger's question, "How old are you?"

When Conger retired, he passed the torch to Steve Raymer, who was in the Soviet Union when it fell apart. During glasnost, access for Westerners widened. Physical hardship, though, did not diminish. Raymer has monitored himself for radiation exposure in Chernobyl and worked against shutter-freezing cold in Siberia.

By the time Gerd Ludwig began photographing the former Soviet Union for the *Geographic* in 1992, he faced different official restraints. Before, officials at the top had issued permits; now, permissions had to be sought at the local level, often from officials who were very difficult. Ludwig traveled through Russia, Kazakhstan, and Ukraine, reporting on "A Broken Empire" for the March 1993 *Geographic*. His edgy images showed people who had once lived by puritan Soviet values experimenting with dance styles, bodybuilding, and capitalism. He also photographed the effects of Soviet pollution (page 126). The contrast between Ludwig's pictures and Conger's photos of theater performers, school children, traditional crafts, and ordinary people show the changing realities in Russia. And, to some extent, Ludwig's pictures showed the *Geographic*'s changing photographic and editing styles (page 123).

The styles reflected a changing world. Televised world events, overseas tourism, and home video cameras altered Americans' perceptions of other lands. The *Geographic* reflected these new perceptions. Earlier, the magazine showed the exotic side of other cultures. And if the *Geographic* portrayed a primitive society, it still appeared noble or picturesque. In recent years, the *Geographic*'s photos of foreign lands have begun to appear less exotic, more familiar, and to depict problem areas.

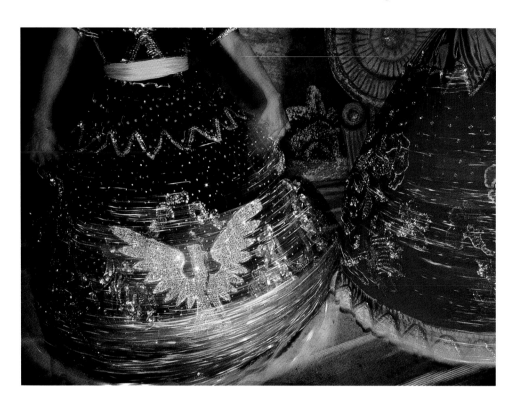

Acapulco, Mexico
1989
SISSE BRIMBERG

Dancers whirling in sequined dresses inspired by the Orient reflect Spanish trade with the Philippines during earlier centuries.

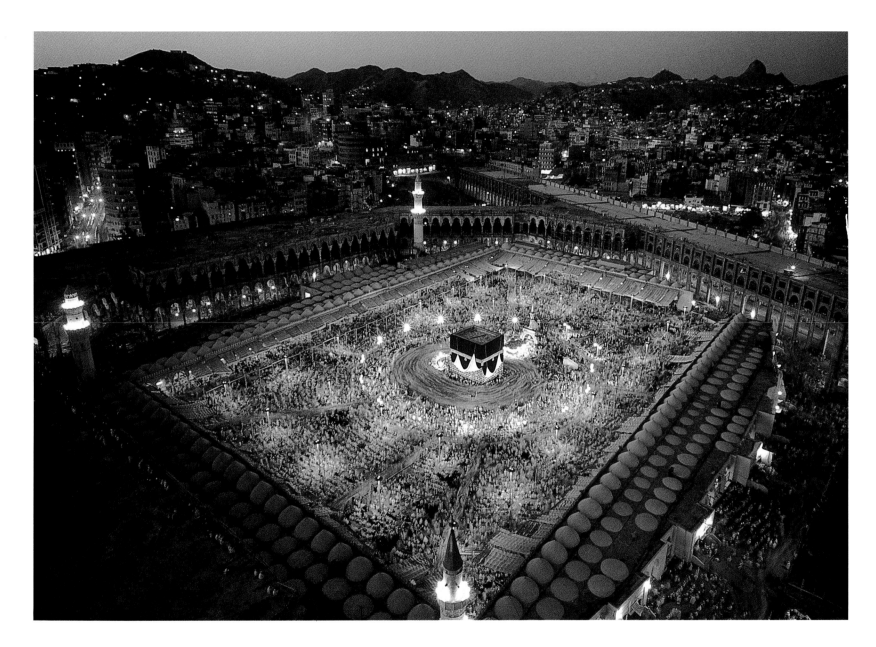

Mecca, Saudi Arabia 1965
THOMAS J. ABERCROMBIE

A quarter of a million Muslims press toward the sacred Kaaba, then circle it to praise Allah. The time exposure blurred the people in the center, creating "an image of cosmic motion," said Abercrombie.

One technique that never changed combined adventure and education. A story might join history and geography by following in the footsteps of a famous person. As early as the 1920s and 30s, Maynard Owen Williams, a former missionary who became the *Geographic*'s first writer-photographer and chief of its foreign editorial department, followed in the footsteps of such men as Moses and Marco Polo and told their stories in words and pictures. In more recent times, one photographer, Gordon Gahan, recreated the exploits of Sir Francis Drake, Captain Cook, and Napoleon. He used weather—severe or gentle—to create the moods he was after, and searched for angles that would keep modern objects and architecture out of the image.

Trying to photograph Botany Bay, Captain Cook's first anchorage in Australia, Gahan found an airport and an oil refinery in the way. No camera angle would eliminate them. So he accompanied students examining some of the botanical species that Cook had collected. By photographing them he got his evocation of Botany Bay.

In Moscow to retrace Napoleon's military campaigns, Gahan had a hotel room whose window faced Red Square. One dawn, from the window, he photographed St. Basil's Cathedral fringed with steam from a power plant. He, and later the editors who published the image, felt that it suggested the burning of Moscow when Napoleon took the city in 1812.

Gahan, who wanted to return to Russia, proposed a story on Tolstoy. By the 1980s, the concept of recreating lives had expanded to include literary and artistic figures. But in 1982, before the editors assigned the Tolstoy story, Gahan left the staff to launch his own photographic agency. Sam Abell got the Tolstoy story. Finding himself in Gahan's Moscow hotel room and his thoughts on the photographer he had replaced, Abell took a photograph through the same window. He mailed Gahan a Polaroid showing the buildings around Red Square through a lace curtain. On the windowsill, a line of pears echo and contrast with the architecture, bringing the viewer into the scene (pages 74-75). In 1984, two years after he left the *Geographic,* Gahan was killed in a helicopter crash in the Virgin Islands while shooting for an advertising agency.

PHOTOGRAPHERS WHO WANT TO DOCUMENT the world in the pages of the *Geographic* must produce what the magazine demands and yet have individual visual styles. The meshing of demand and style can create tensions that produce powerful stories. But too much editorial control can produce dullness.

An example of the creative process going haywire came when William Albert Allard's emotions about his Peru pictures clashed with the *Geographic*'s editorial philosophy. Allard had spent five months in Peru. He had shot 1,300 rolls of film. He photographed slaughterhouses, toreadors, market scenes, religious rituals, and rural life (pages 86-87). His refined, subtly colored compositions of people embodied, to his eye, the essence of Peru. In layout sessions at the *Geographic*, Allard was angered by the way his pictures were being selected and presented. Later, during a seminar that included his peers and bosses, he complained publicly and vociferously, offending the

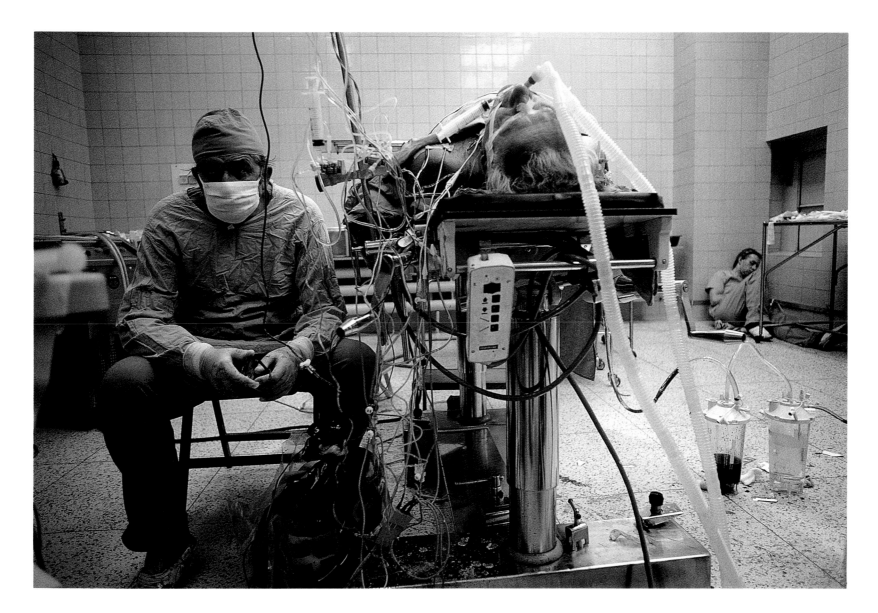

Zabrze, Poland 1987

JAMES L. STANFIELD

*After all-night surgery, a physician who learned to do heart transplants by reading scientific papers
eyes a monitor tracking the vital signs of a patient as an exhausted colleague dozes in a corner.*

very people he needed to work with. At that time a freelance, Allard was given no assignments for three and a half years.

Some *Geographic* photographers choose to specialize, to plunge so deeply into a single subject that they come to know it better than almost anyone else. One of them is George Mobley, who joined the staff in 1961, traveled widely, then settled on the Arctic regions as the focus for his life's work.

On an Eskimo hunting trip in the Thule District of Greenland, he spent two weeks marooned in a tent whipped by an Arctic storm. On another assignment, as he was heading for an isolated Lapp—or Sami—village in northern Finland, his boat foundered in the white-water rapids of a river flooded with melting snow. Mobley, his interpreter, and two Sami were thrown into the cold water. Weighed down by parkas and boots, they struggled to shore. One of the Sami had clung to a nearly empty fuel can. "There was a little gasoline left in it," Mobley remembers. "There were stunted birches in the area so we were able to find wood. But nobody had any waterproof matches." He rummaged through his pockets and found an extra pair of gloves in which he had wrapped a book of matches—damp but not soaked. "I kept trying and kept trying. Well, on the third from the last match I got a little spark and the gasoline ignited with a bang. You never saw four people so happy."

World travel may sound romantic and adventurous. But for photographers like Mobley and Bruce Dale, travel also means a strain on their families. Dale was on the *Toledo Blade* when he first inquired about a *Geographic* staff job. On a trip to Washington, Dale recalls, "I looked up all the photographers in the telephone directory and drove by their houses to see the quality of life they had. I also found out that ten or so photographers had been divorced, and I thought, 'This is not for me.'"

When he did later join the *Geographic* staff, Dale got some advice from an older staff photographer, Tony Stewart. "At his retirement party," Dale says, "Tony pulled me aside and said, 'Bruce, I've been here 42 years and it's been an absolutely marvelous 42 years. But I want to tell you something. If I had it to do over again, I wouldn't do it. I had a son that I not only did not know; I never even met him.'"

Dale took the comment to heart and made sure that his wife and three sons could join him on as many assignments as possible. He went off alone to Africa on one assignment, however. When he was finished shooting, he came home with his last film instead of following standard procedure: Ship the film and wait for a telegram from Gilka on how the film looked. Photographers stay and ship because if something has gone wrong with a take, they can immediately re-shoot, saving the *Geographic* the expense of sending them back into the field. When Gilka asked Dale why he had violated the normal procedure, Dale explained that his wife was about to have a baby and he had to get home. "Let's get one thing straight," Gilka said. "What comes first, your job or your family?"

"I decided that a long time ago," Dale said. "My family."

"All right," Gilka said. "I just wanted to know."

Dale remained a staff photographer for 30 years.

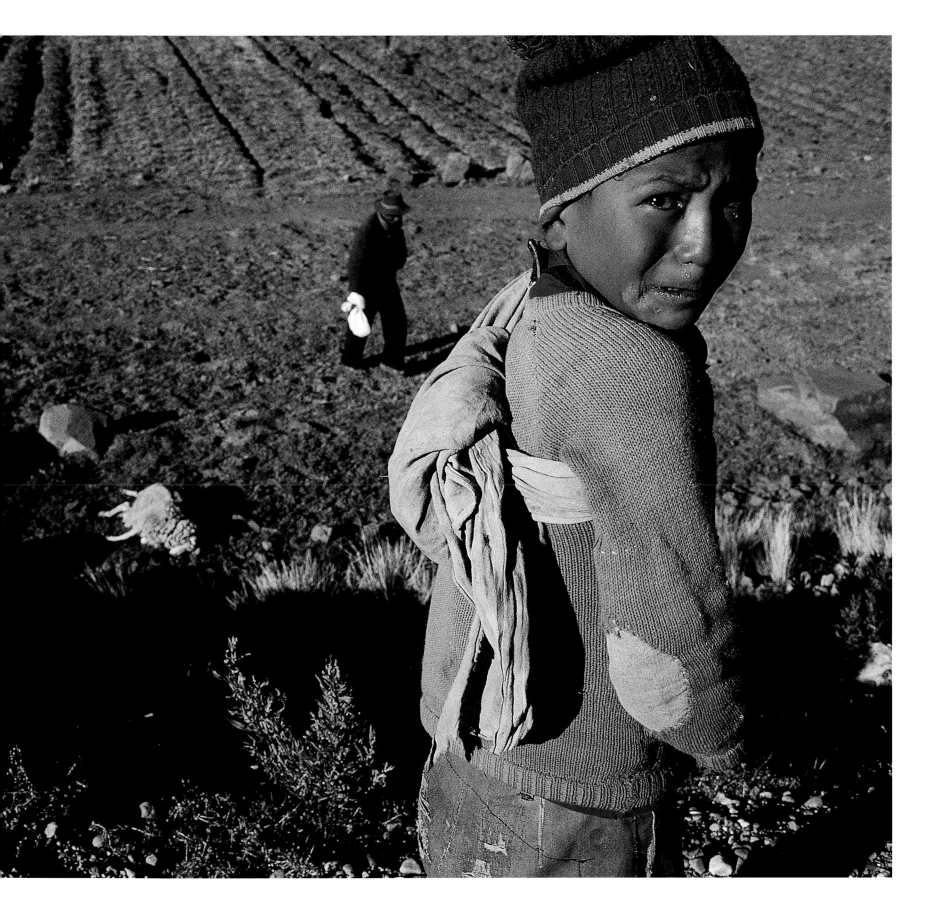

Puno, Peru 1981

WILLIAM ALBERT ALLARD

A boy weeps over six sheep killed by a hit-and-run taxi, a sharp blow to the economy of subsistence farmers. Donations of $7,000 by sympathetic readers offset the loss and deeply gratified Allard.

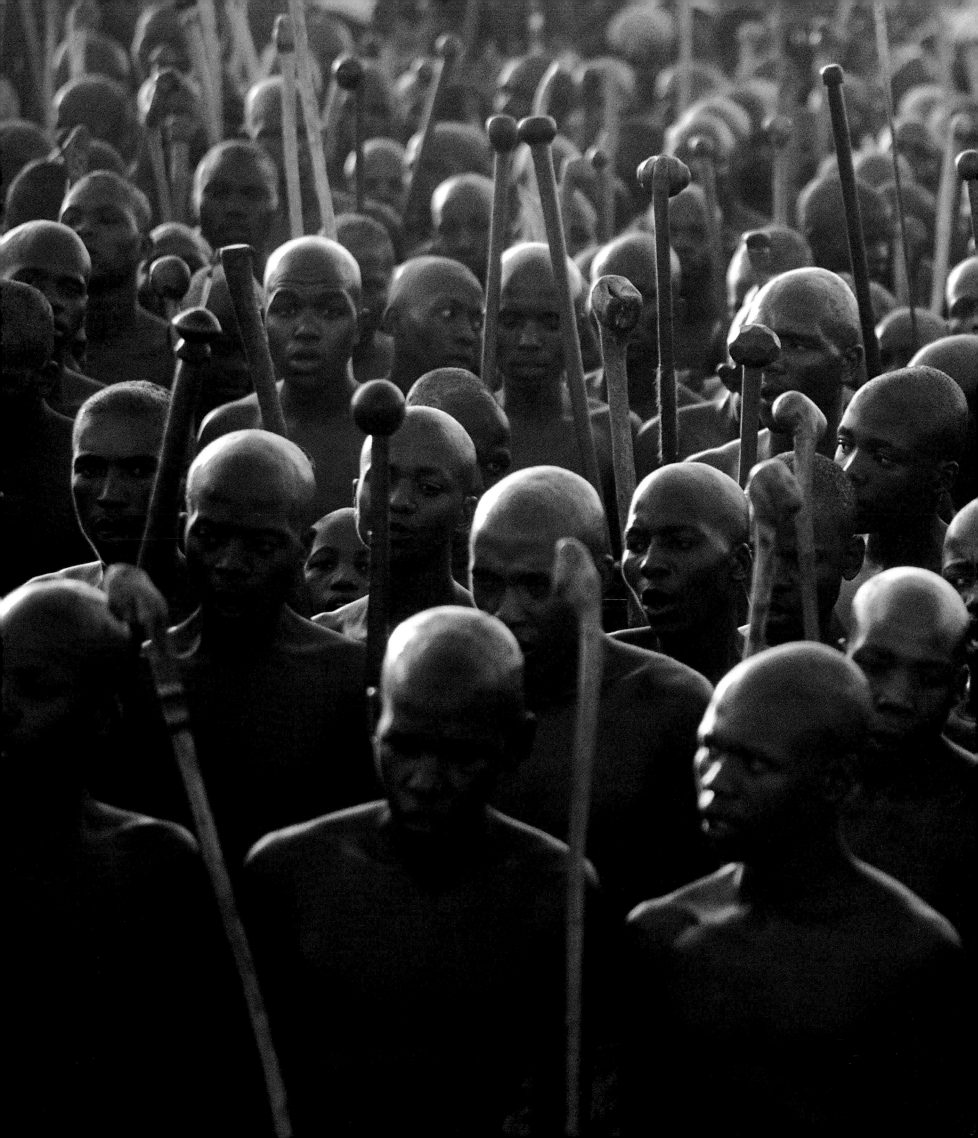

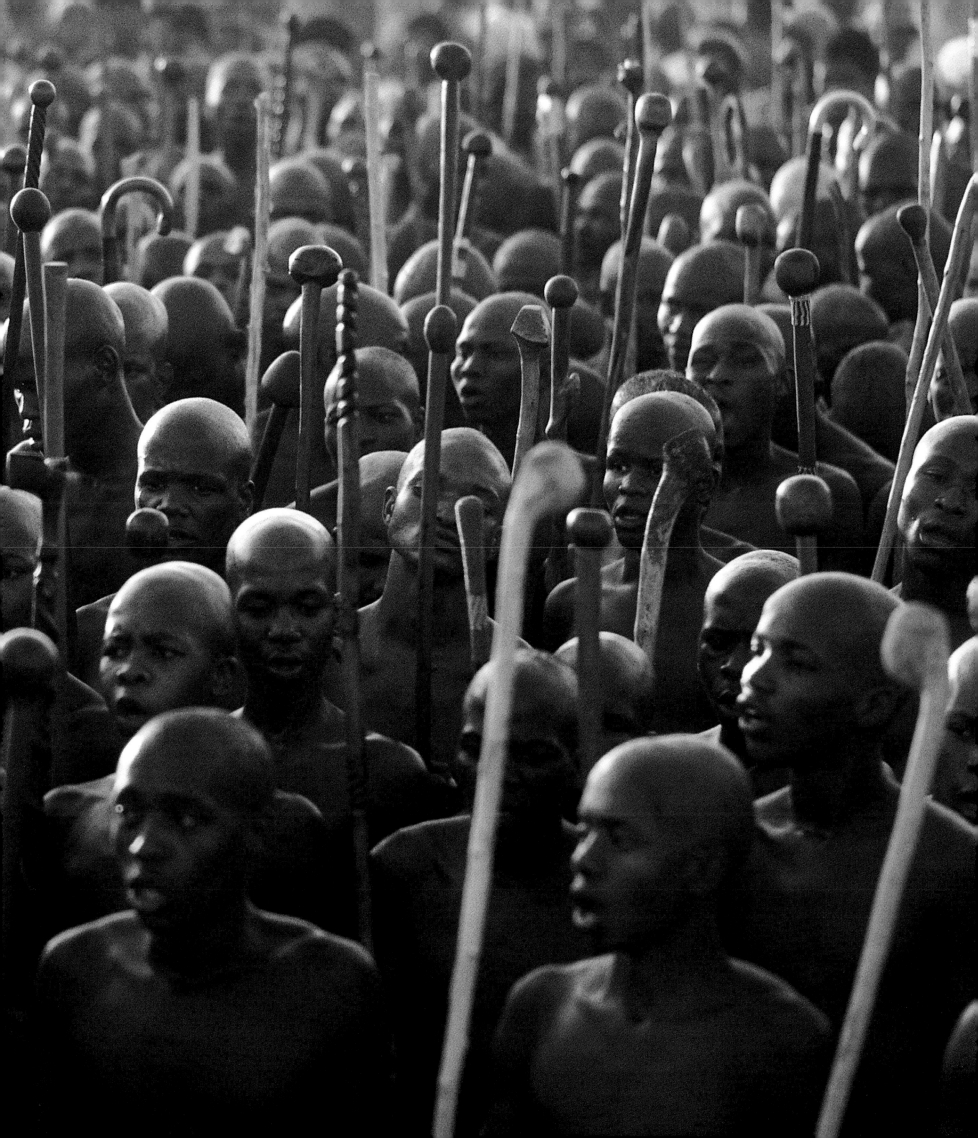

preceding pages: KwaNdebele, South Africa 1985

PETER MAGUBANE

Men at last, Ndebele youths who have spent two months in the bush as part of initiation into
manhood gather with their dancing sticks—also used as clubs—before the paramount chief.

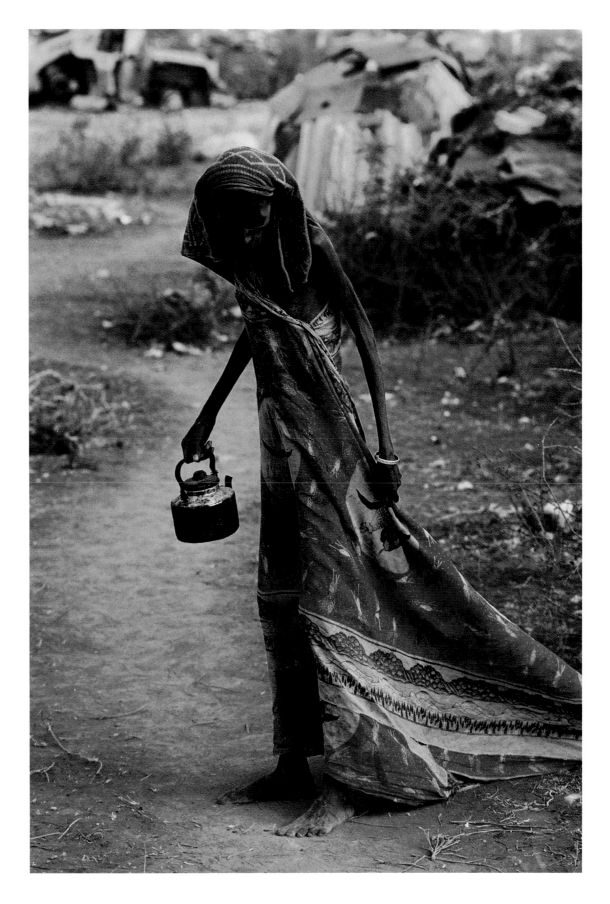

Baidoa, Somalia 1992

ROBERT CAPUTO

Thinly veiled despair marks victims of famine in the Horn of Africa. Skeletal beneath her light garment, above, a woman struggles toward supplies at a relief center. Another shields her infected eyes from insects with a scrap of netting. "I have no more tears left," one woman told Caputo.

Transkei, South Africa
1992
JAMES NACHTWEY

Xhosa youths smeared with clay rest from hunting on the veld during a rite of passage into manhood.

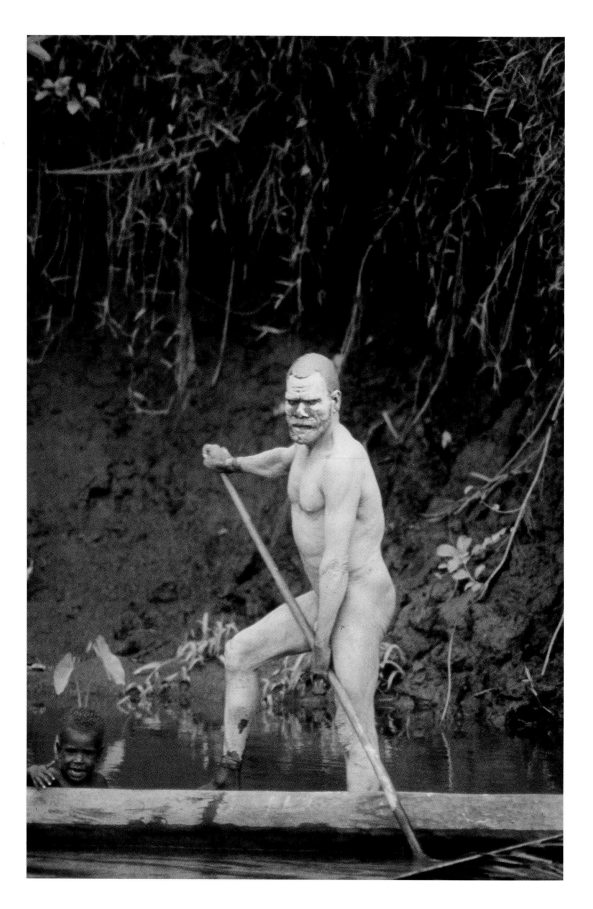

Papua New Guinea 1973

WILSON WHEATCROFT

Naked and clay-smeared in mourning for his wife, a New Guinea tribesman paddles a dugout homeward on the Upper May River, a tributary of the Sepik; the small passenger is his son.

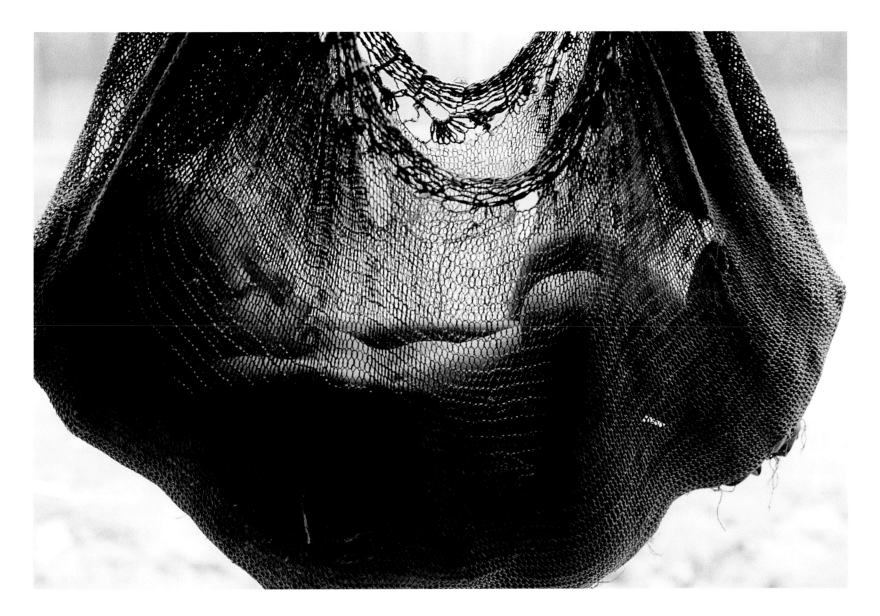

Sepik River, Papua New Guinea 1972
MALCOLM S. KIRK

Cradled in innocence, a child of the Sepik naps in a traditional net bag. Change moved upriver in this century, ending such customs as headhunting; Papua New Guinea won nationhood in 1975.

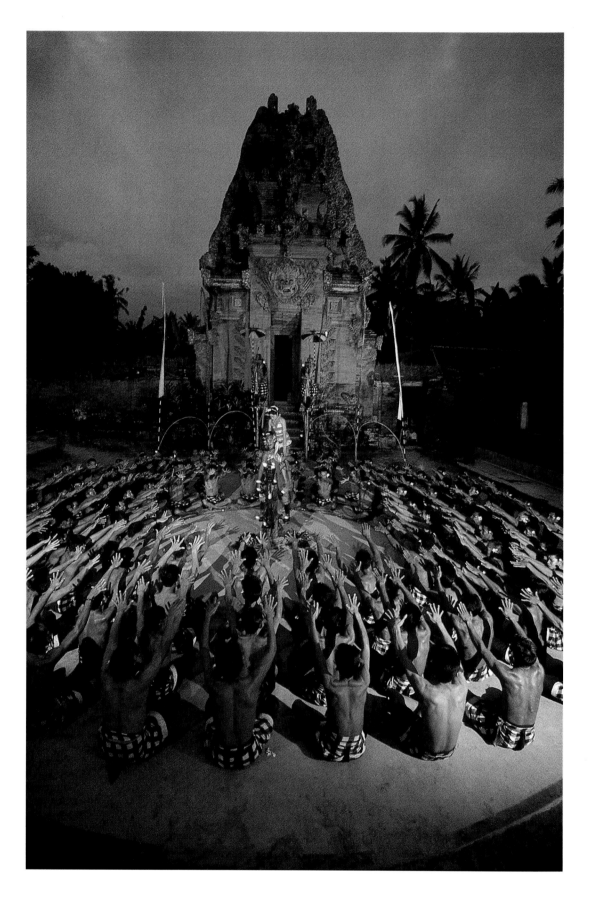

Pliatan, Bali 1968

GILBERT M. GROSVENOR

Re-creating a legend, villagers wave their arms to symbolize a monkey army attacking an evil king.
The storm that provided dramatic lighting soon sent a torrent of rain to short out Grosvenor's lights.

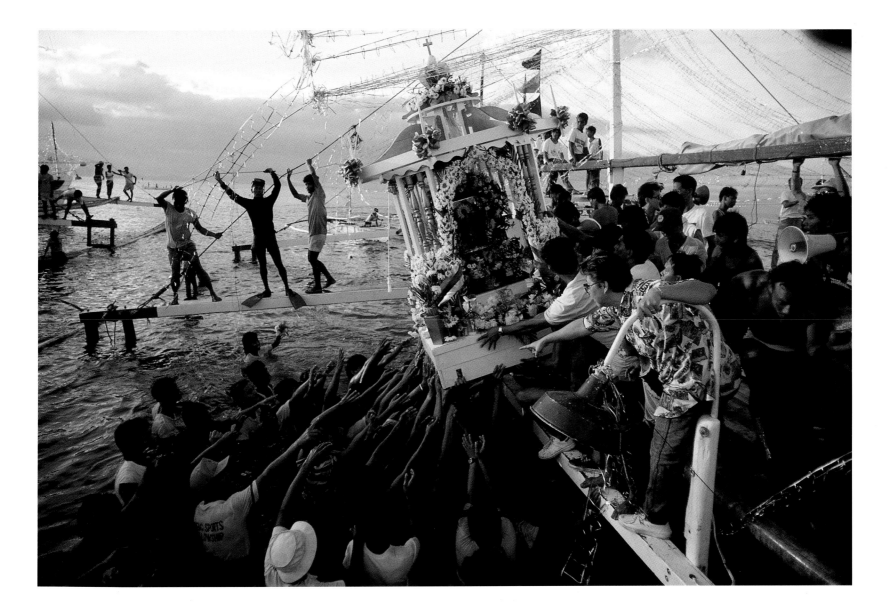

Cavite, Philippines 1989

SISSE BRIMBERG

Every November the faithful bear an image of Our Lady of Porta Vaga across Manila Bay.
She is patron of the galleons that traded between Acapulco and the Philippines for 250 years.

Watson, South Australia
1985

WILLIAM ALBERT ALLARD

Santa rides the rails.
Locomotive inspector Alf Harris
greets aborigines from the Tea
and Sugar Train, lifeline to
remote regions of the country.

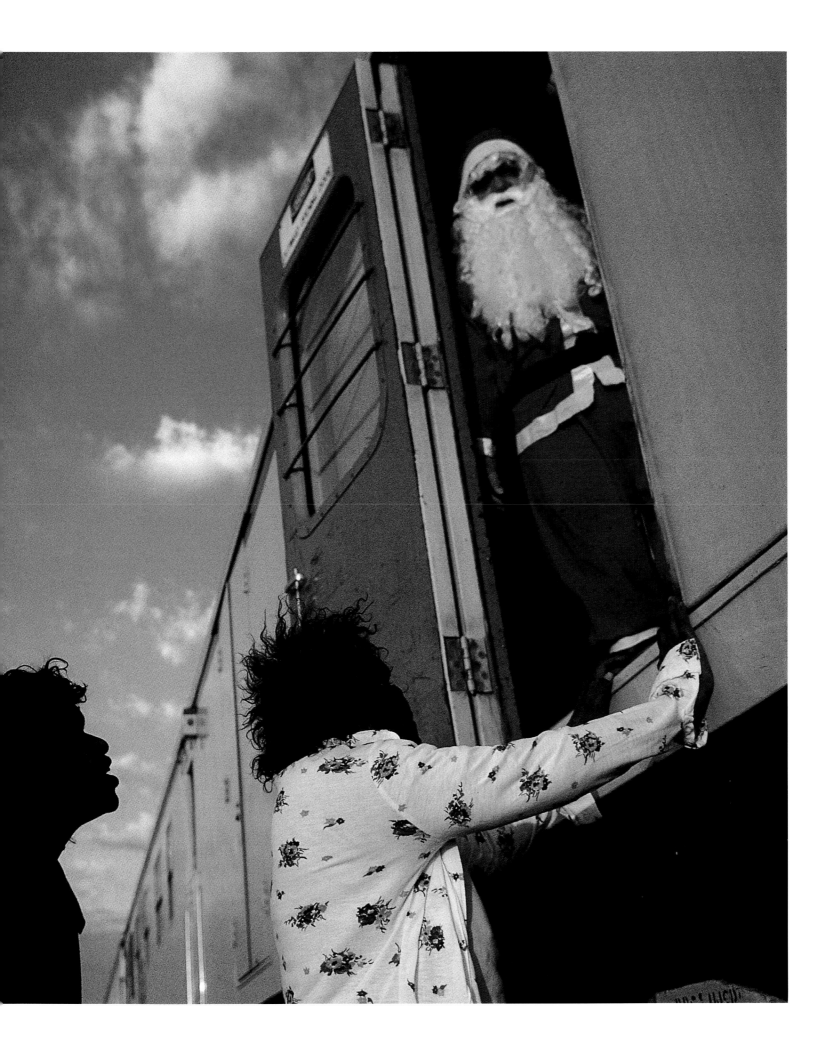

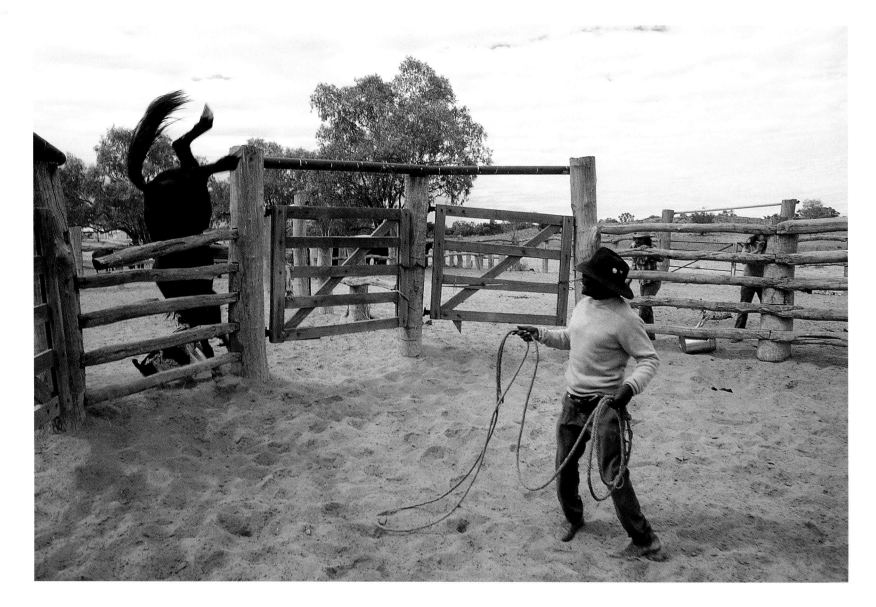

Innamincka Station, South Australia 1977

JOSEPH J. SCHERSCHEL

Desperate to elude a lasso, a wild horse captured in a roundup clears the top bar of a corral fence but nose dives into the dirt. Scherschel retraced the route of explorers Burke and Wills for a story.

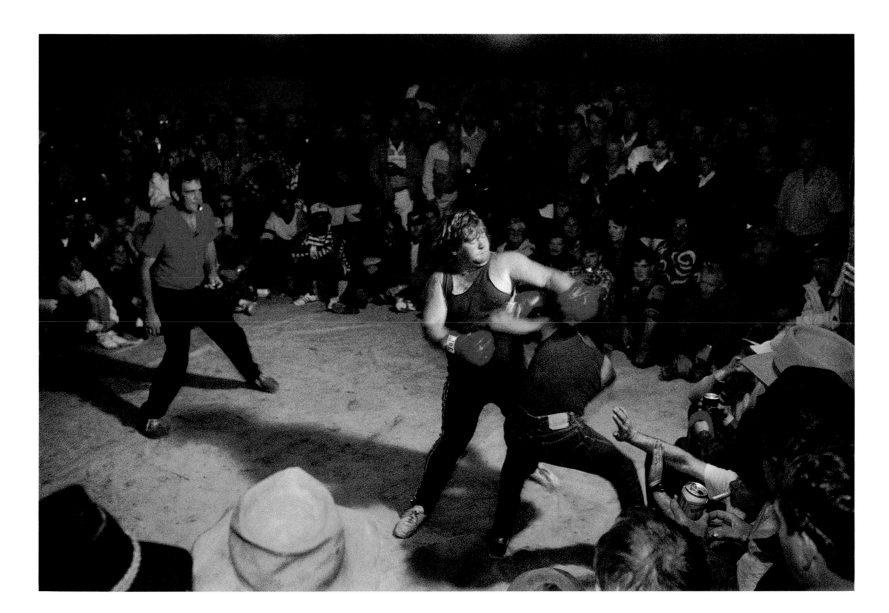

Queensland, Australia 1990

MEDFORD TAYLOR

Night life during the annual Birdsville horse races: A hefty local challenger, on the left,
takes on a member of a traveling boxing troupe and punches his way to a $30 prize.

following pages: Dacca, Bangladesh 1974

STEVE RAYMER

"Another tired train cranks to a stop," wrote Raymer. An overloaded cargo of the undernourished
from the countryside rolls into the city in search of food during a Bangladesh famine.

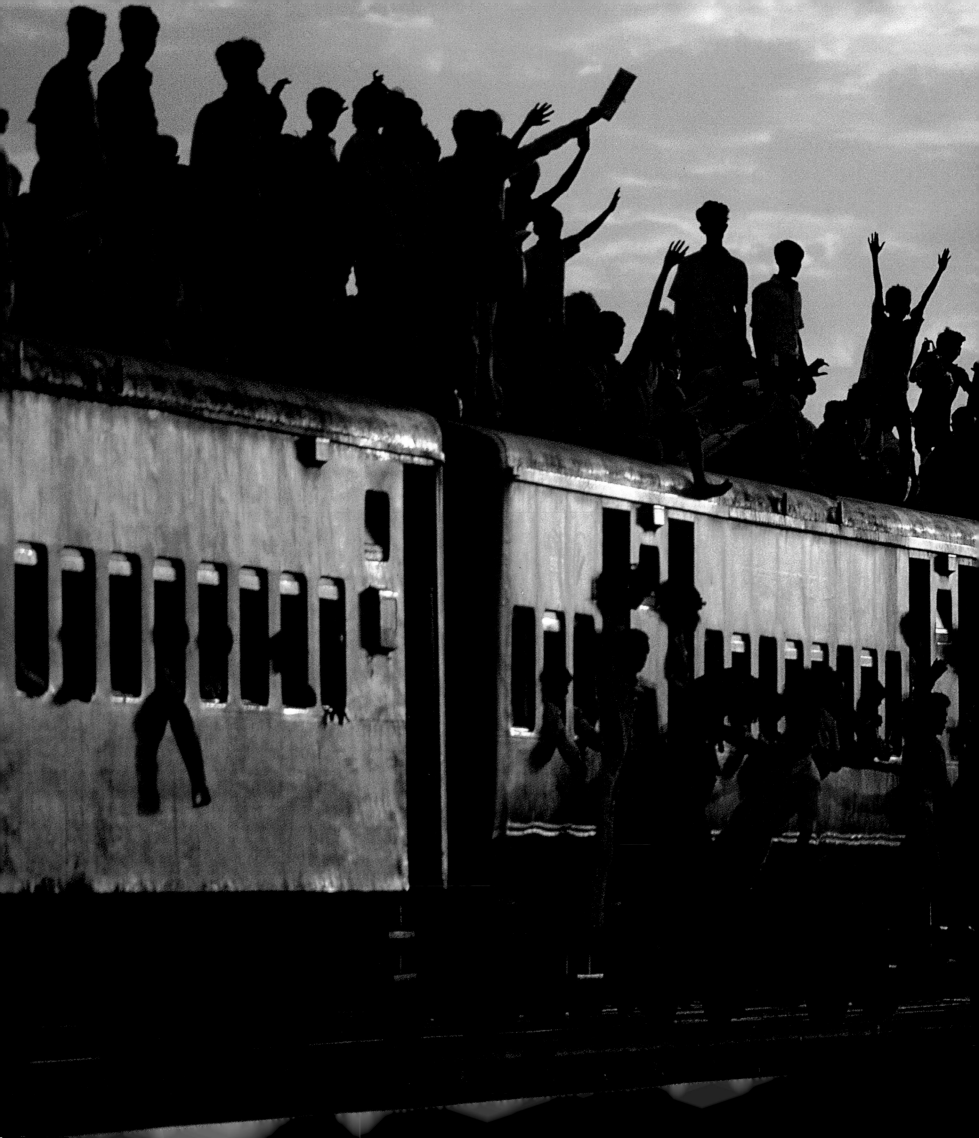

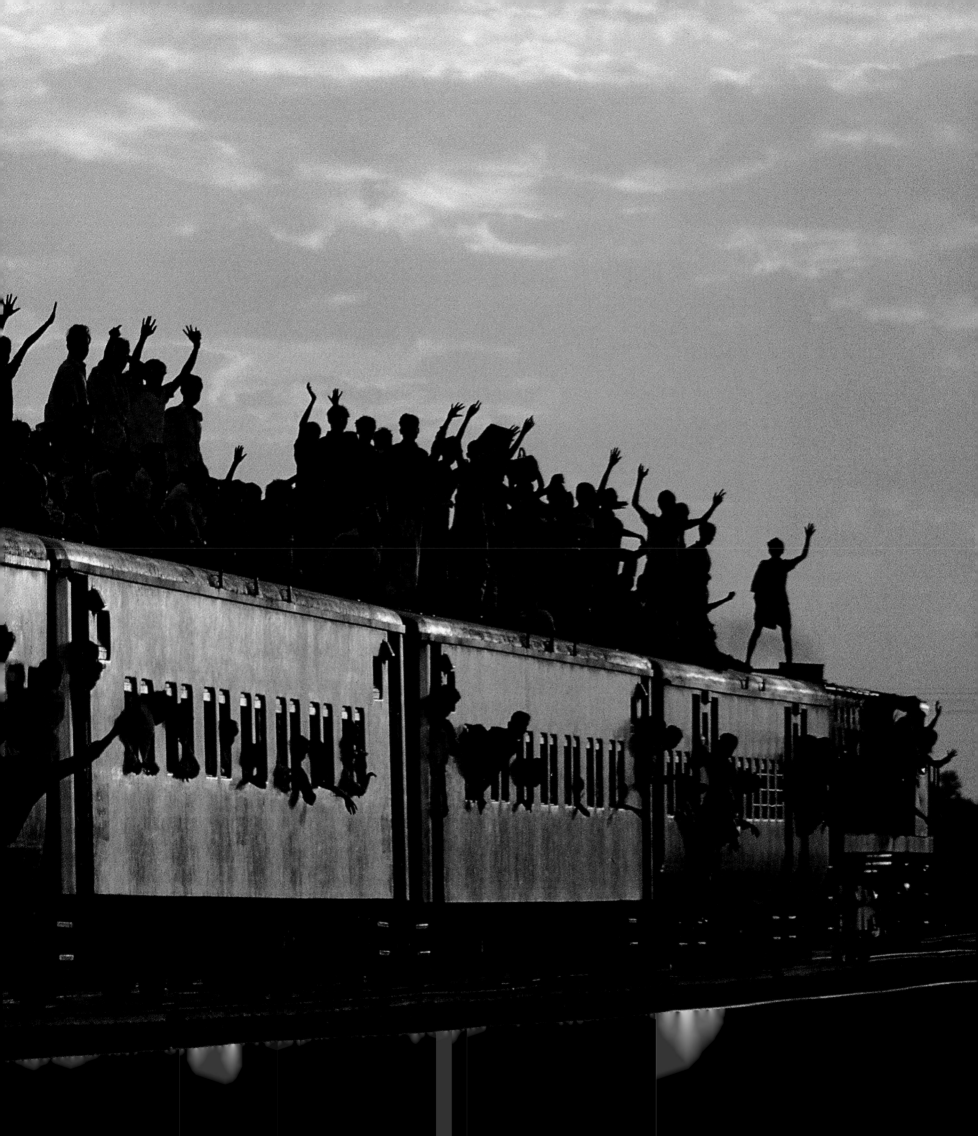

Mekong River, Cambodia 1991
MICHAEL S. YAMASHITA

Two sisters bathe in warm, waste-polluted waters at Phnom Penh. Yamashita and author
Thomas O'Neill were the first Western journalists to reach the headwaters of the Mekong in China.

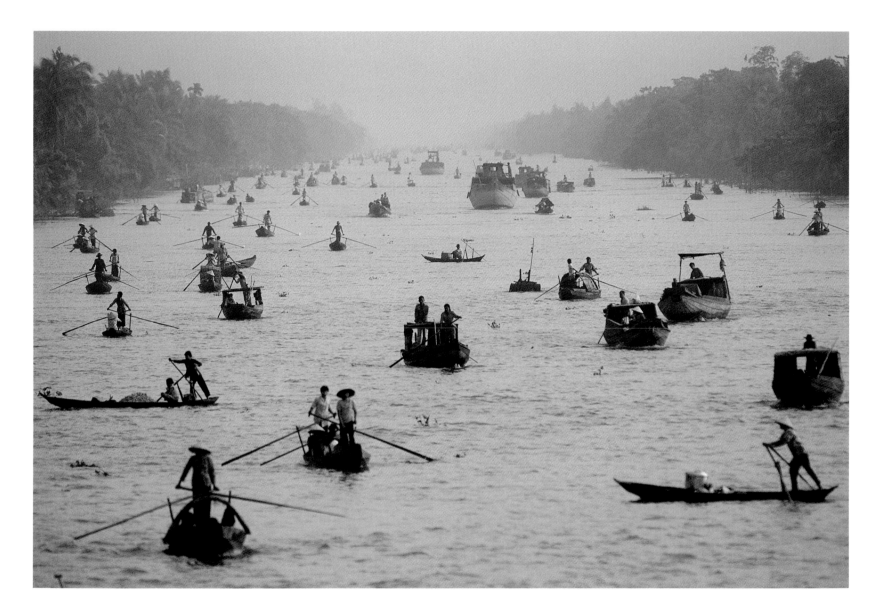

Mekong River, Vietnam 1991

MICHAEL S. YAMASHITA

*Market-day traffic clogs a canal in the river's delta. Yamashita and O'Neill traveled on or along
much of its 2,600-mile length; police finally stopped them a quarter of a mile from the mouth.*

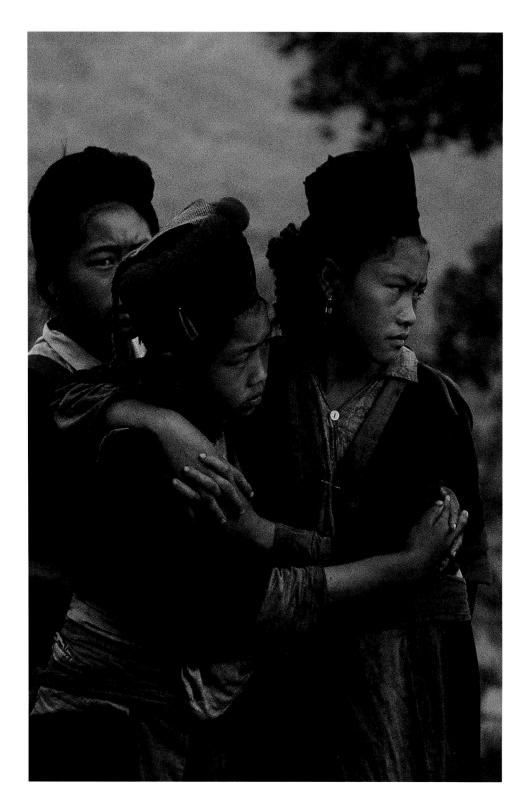

Laos 1973

W. E. GARRETT

*Sisters in uncertainty, Hmong girls cling together in the face of war. "If you came to a village
in peace…they extended unaffected hospitality and a great deal of curiosity," wrote Garrett.*

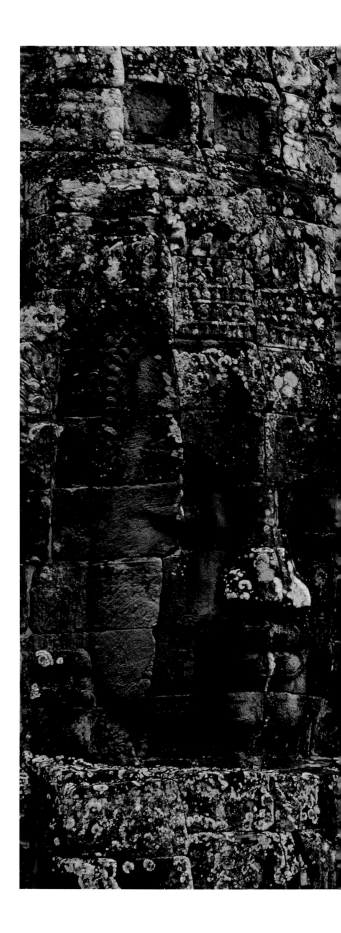

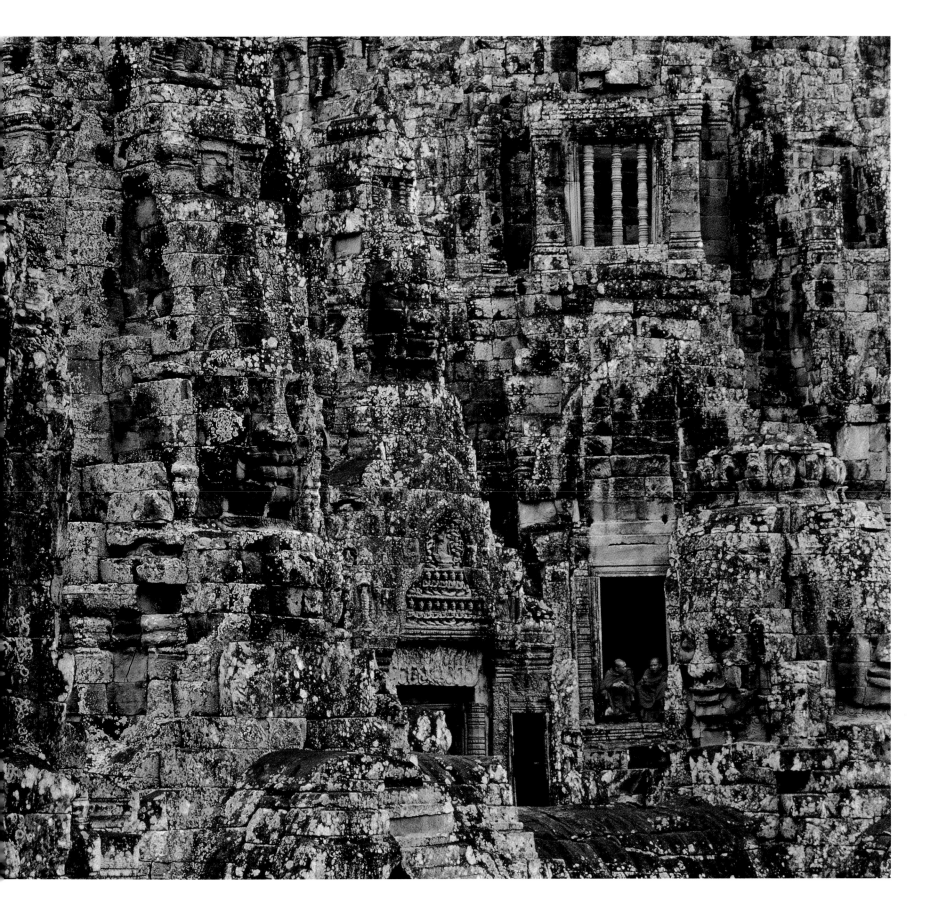

Cambodia 1968

W. E. GARRETT

Two saffron-robed Buddhist monks are framed by a window at the central temple of Angkor Thom,
built by the ancient Khmer people. Over the years, Garrett made 20 journalistic forays into Asia.

Kowloon, Hong Kong 1989

JODI COBB

In his flour-dusted cubicle, a noodle maker plies his trade in the Walled City within Hong Kong, the British-controlled colony that is scheduled for transfer to China in 1997.

Tokyo 1990

KAREN KASMAUSKI

Kasmauski got this crowd scene at a busy train station. The photograph was "a spontaneous moment that I didn't even know I had until I saw it on film later," says Kasmauski.

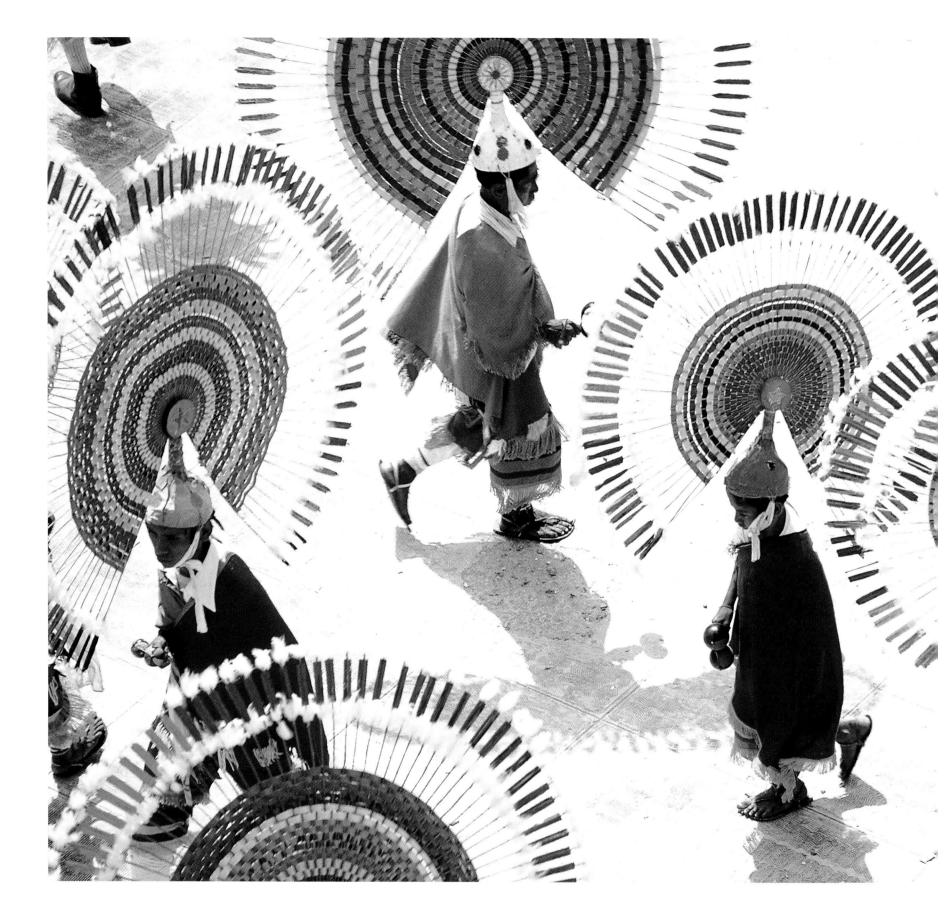

Cuetzalan, Mexico 1979

DAVID HISER

*Evoking the world of the Aztec, Mexican dancers wear crowns representing
the brilliantly plumed quetzal of Central America.*

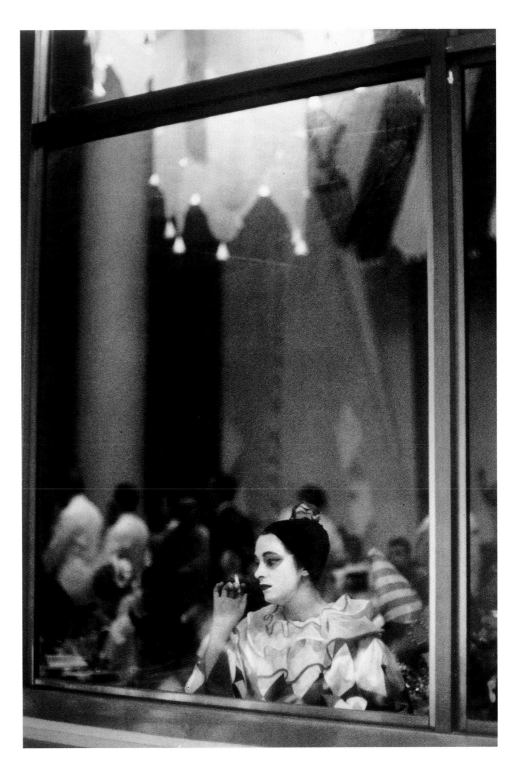

Rio de Janeiro, Brazil 1962
WINFIELD PARKS

*Carnival's revelry seems to sober a costumed clown watching from a window
as merrymakers dance in the streets outside.*

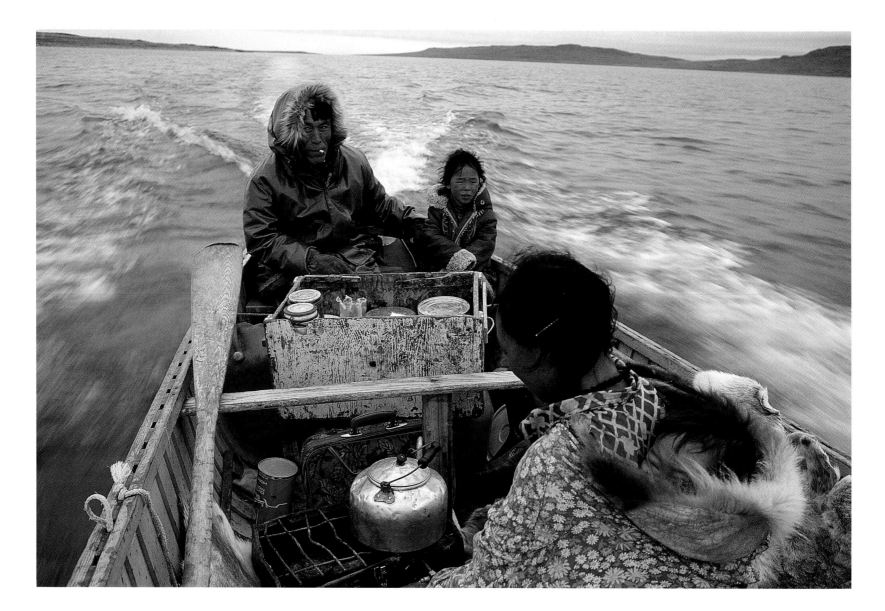

Umingmaktok, Canada 1976

YVA MOMATIUK AND JOHN EASTCOTT

On a summer spree above the Arctic Circle, an Inuit family heads across Melville Sound
in the Northwest Territories for a spontaneous visit to friends some 60 miles away.

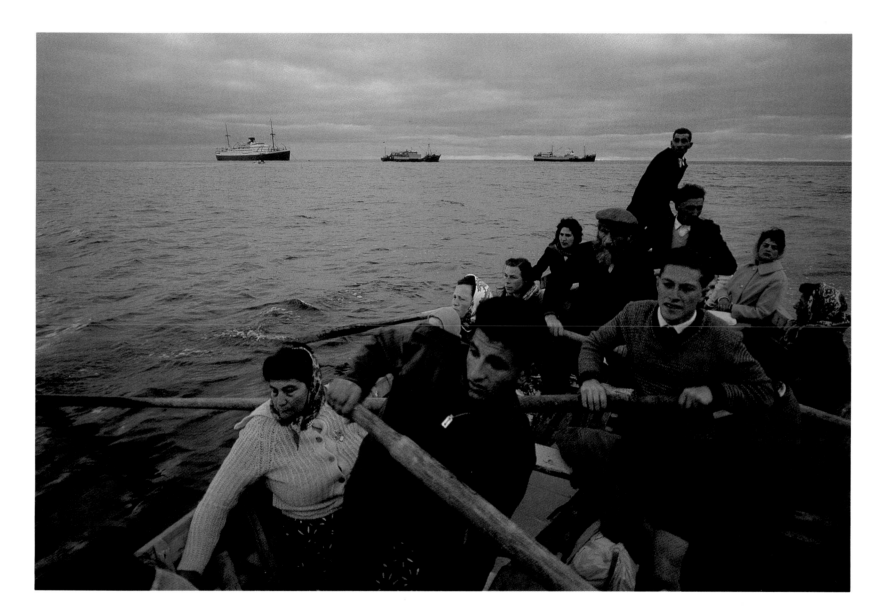

Tristan de Cunha 1963

JAMES P. BLAIR

Pulling for home after having fled an erupting volcano 18 months earlier, residents of the remote
South Atlantic island row the final yards to shore from a liner that brought them from exile.

following pages: Oymyakon, Siberia 1974

DEAN CONGER

Reindeer pass through a frosted valley, a frozen cloud of their own breath hanging above them. It was
minus 50° F, remembers Conger, who made more than 30 visits to the Soviet Union over 25 years.

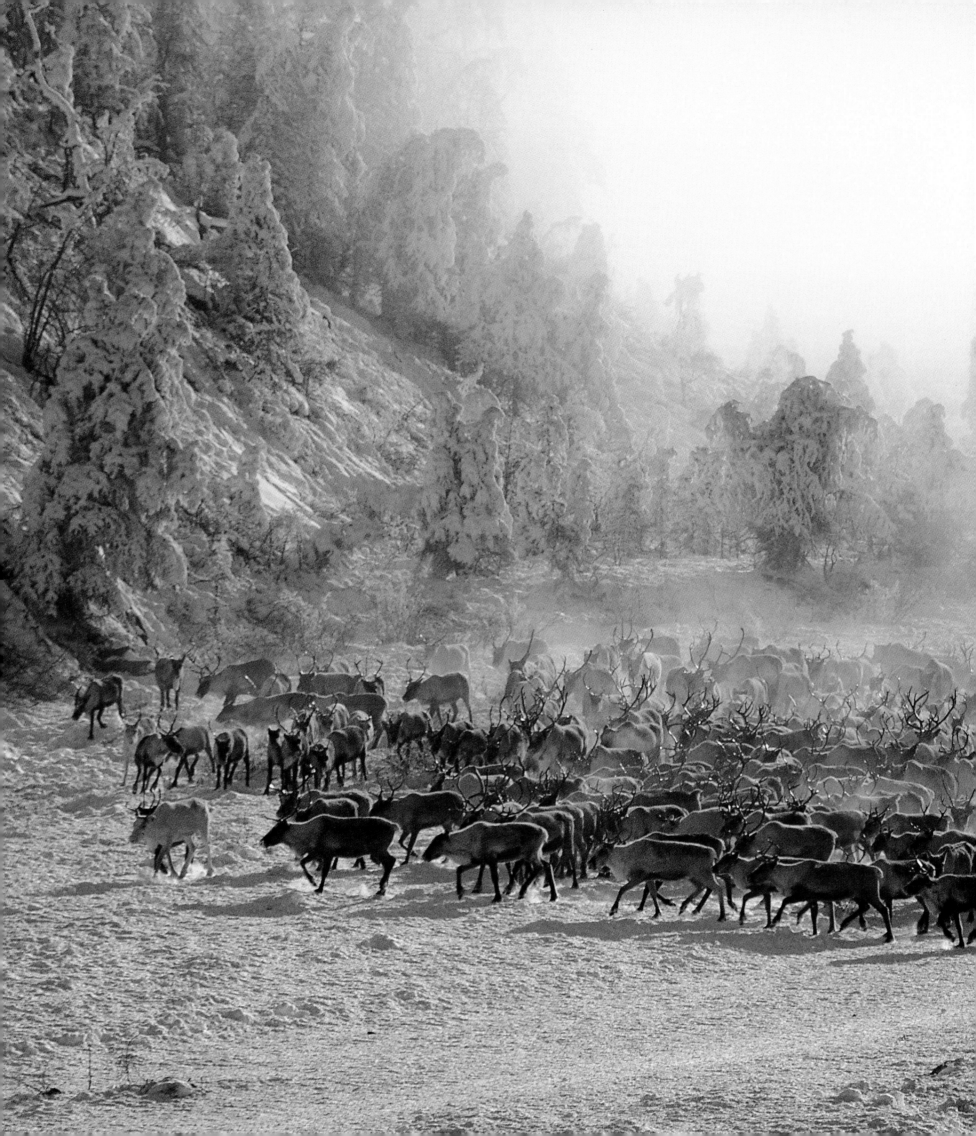

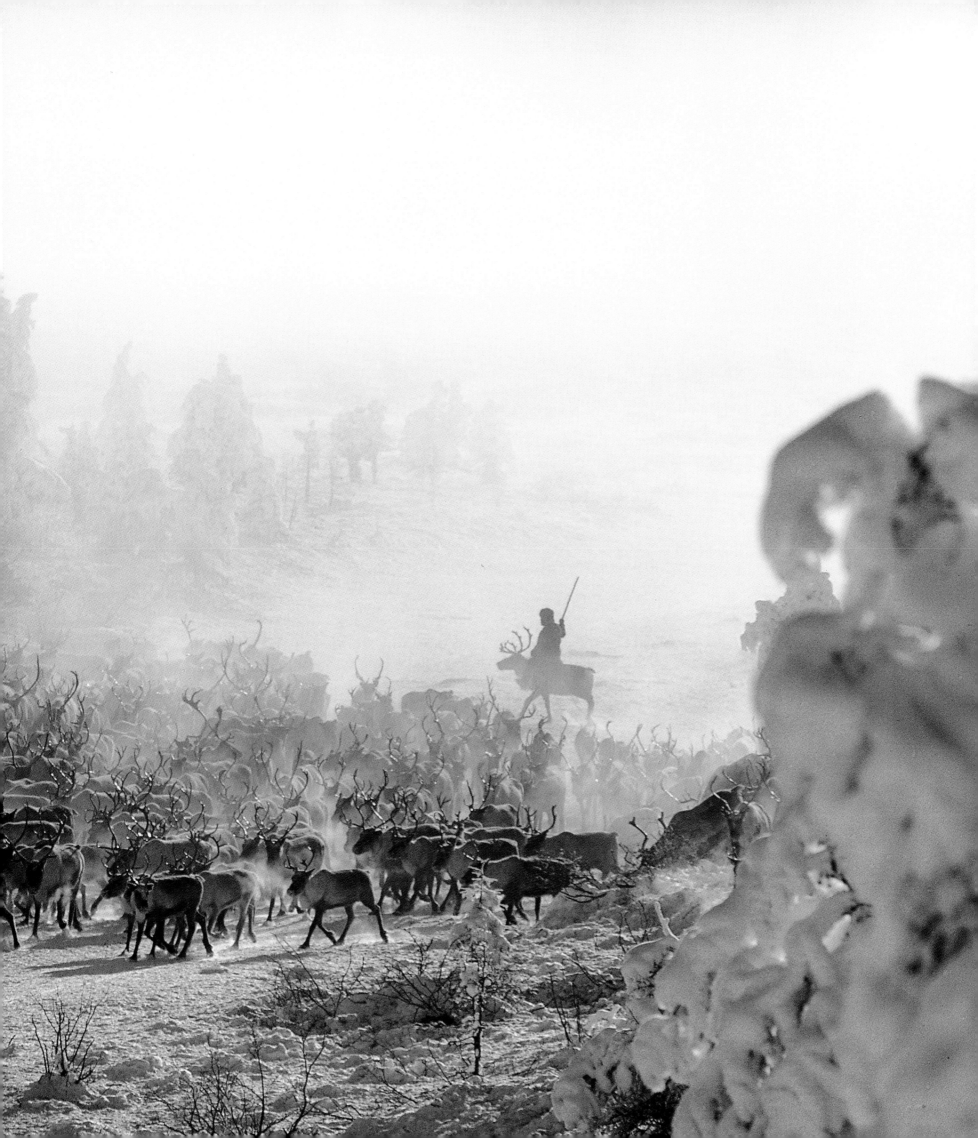

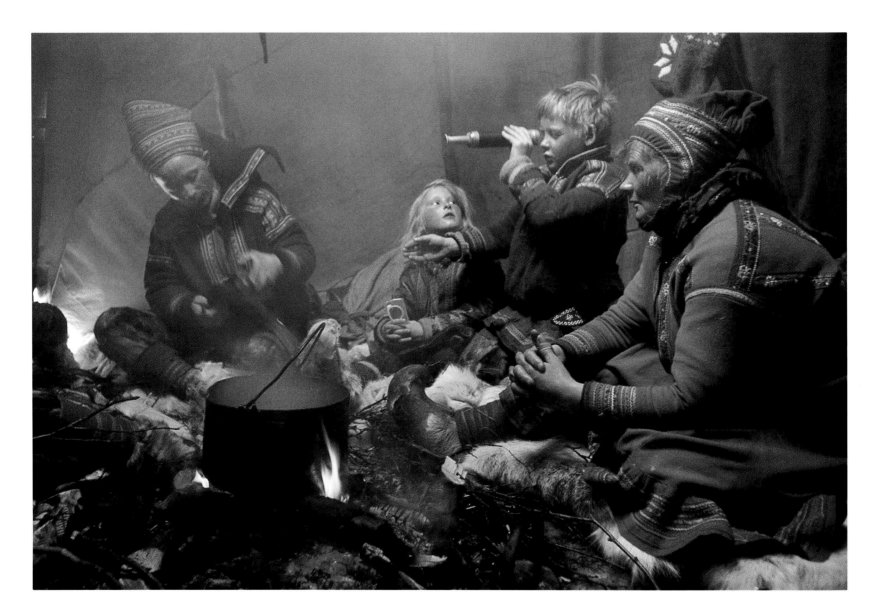

Finnmarksvida, Norway 1968

GEORGE F. MOBLEY

*In close family quarters, nomadic Sami—earlier called Lapps—gather in their tent to escape
from the cold. The boy peers wrong-end-to through a telescope used for spotting stray reindeer.*

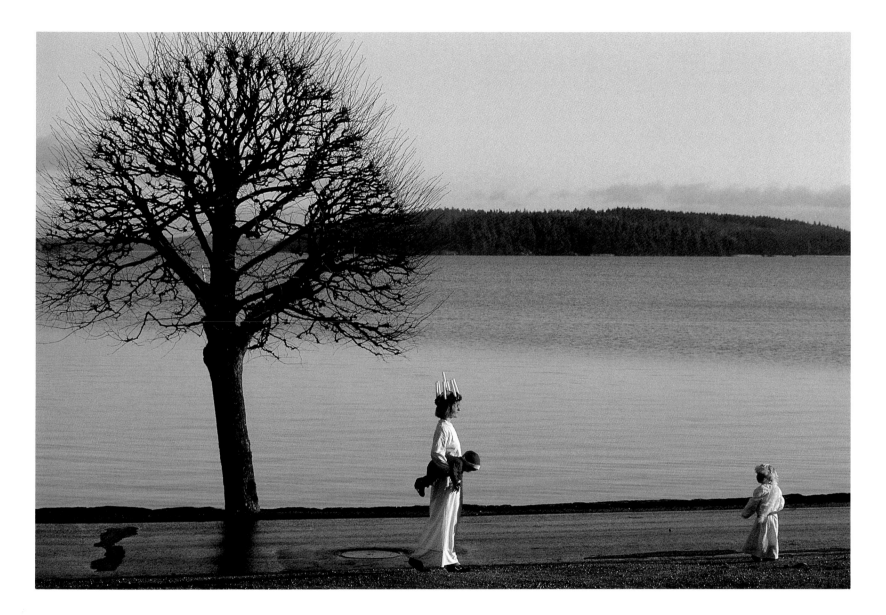

Mariefred, Sweden 1992

TOMASZ TOMASZEWSKI

Crown of candles marks the arrival of St. Lucia, believed to light homes every December 13.
Tomaszewski's country story focused on the Swedes' recent doubts about their welfare state.

Paris 1988

DAVID ALAN HARVEY

*Good friends celebrating
summer with a cruise on
the Seine, French students
display Gallic disregard
for career choices and
university entrance exams.*

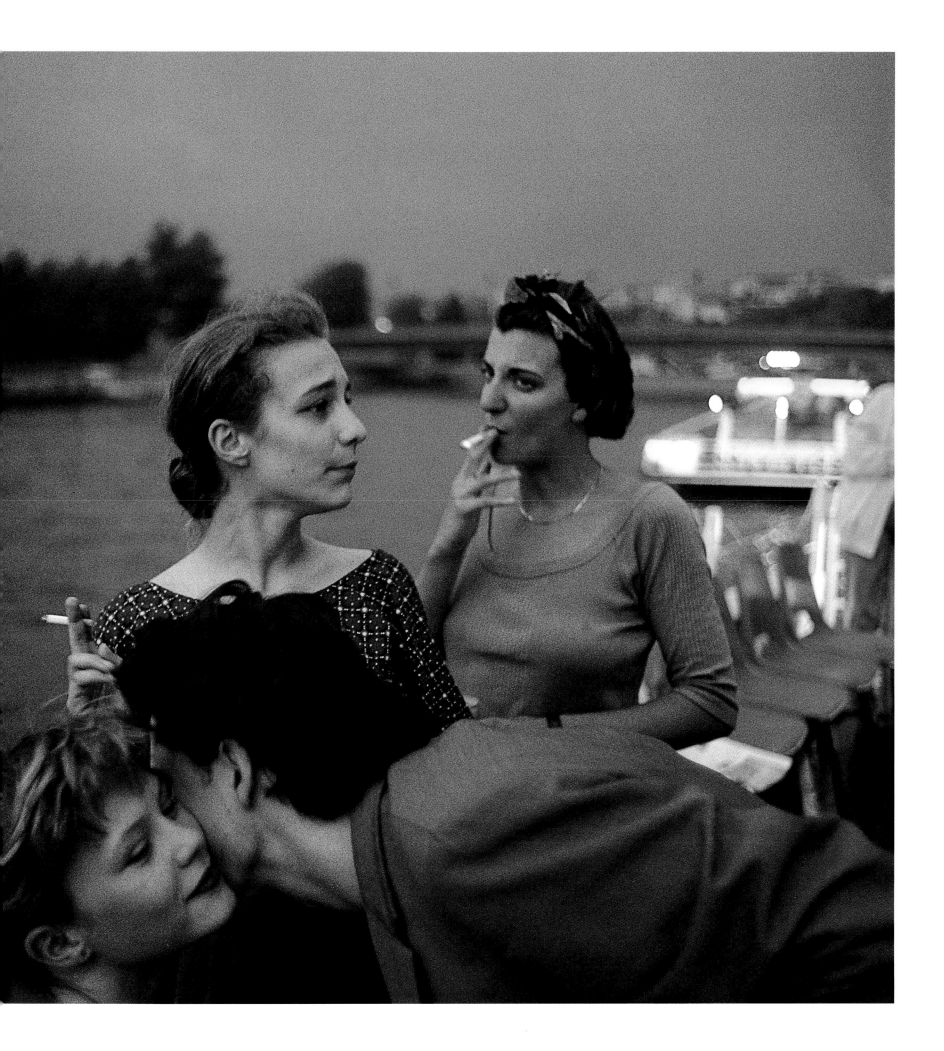

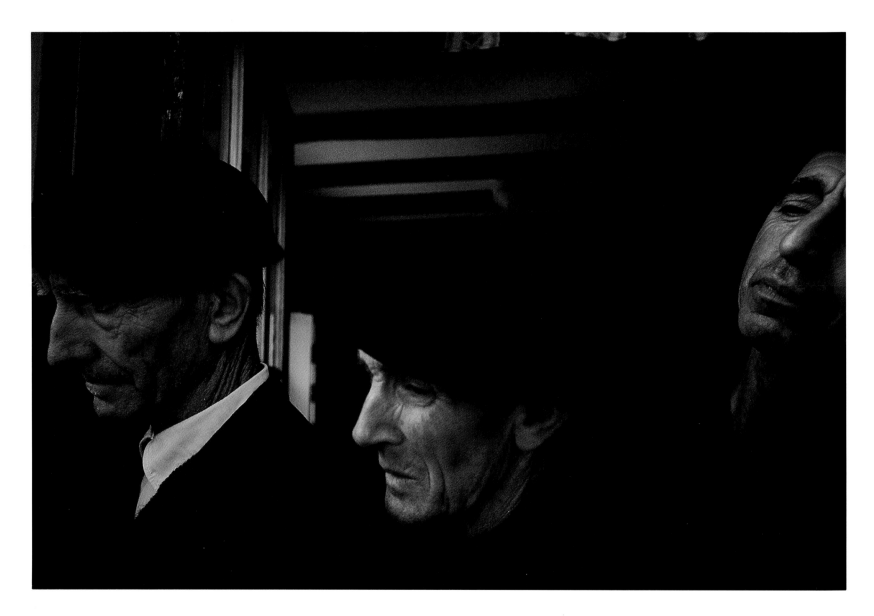

Sare, France 1967

WILLIAM ALBERT ALLARD

"Definitely Basque faces," wrote Allard of these men. "The Basques are famous for their poets, really troubadours, because their poems are sung.... These men are listening to the poets."

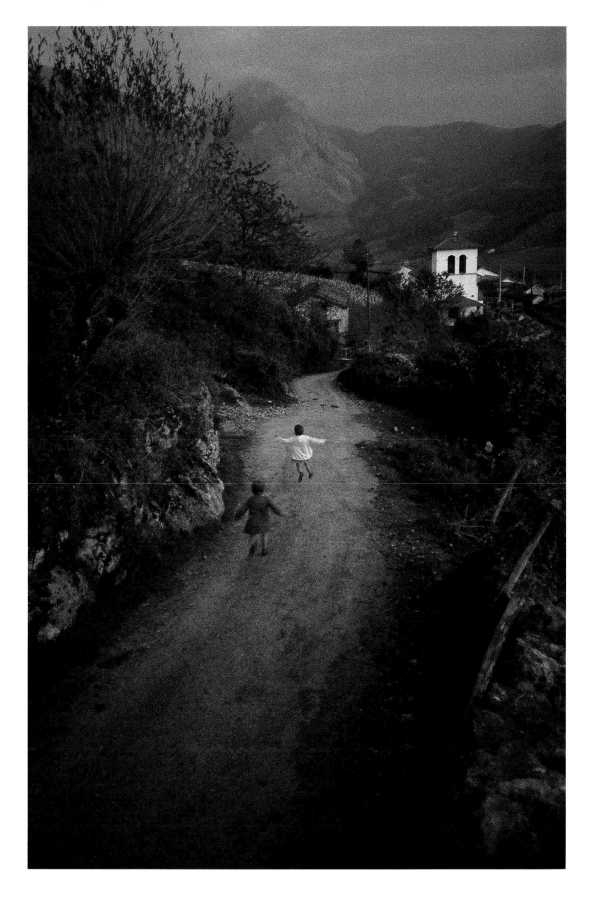

Béhorléguy, France 1967
WILLIAM ALBERT ALLARD

The end of a rain lightens the feet of children running home to supper. The "light reflecting off the clouds falls like a soft spotlight, catching the first of the girls in midair, almost floating," says Allard.

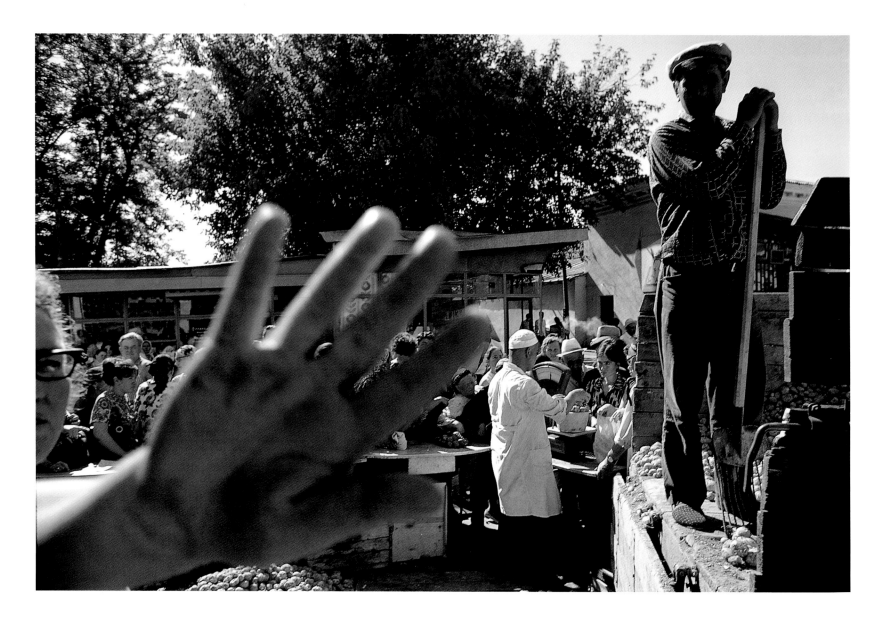

Tashkent, Soviet Union 1972

DEAN CONGER

Civic pride prompts a woman's censoring hand. "She may have thought I was depicting her city as substandard," said Conger, who focused on people, not politics, when working in the Soviet Union.

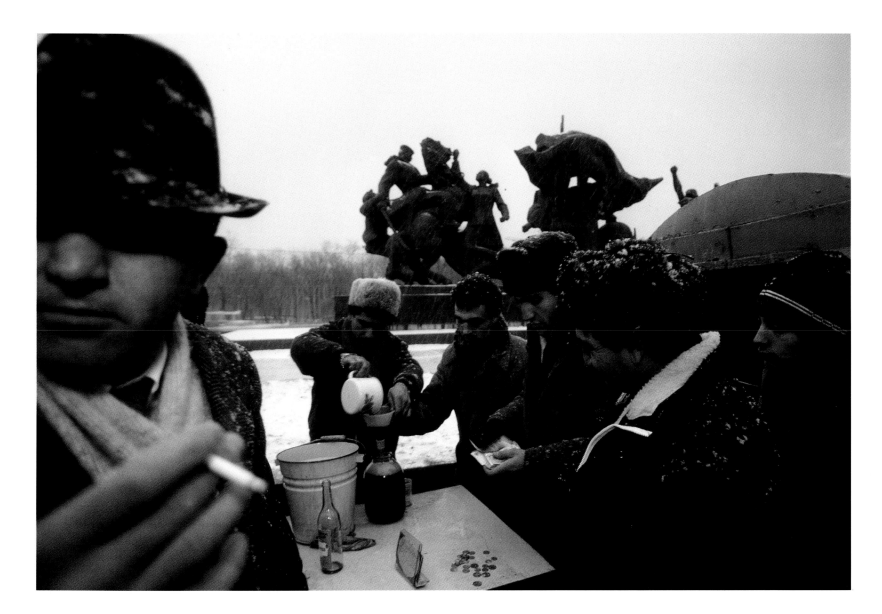

Moscow 1992
GERD LUDWIG

Free enterprise keeps a watchful eye as moonshiners sell homemade wine. "People line up with all kinds of empty bottles and containers and sometimes take a glass of it right away," says Ludwig.

following pages: Petropavlovsk, Russia 1992
SARAH LEEN

An uncertain future clouds a city threatened by earthquakes and two active volcanoes in Kamchatka, located near a tectonic plate boundary that forms part of the Pacific Ring of Fire.

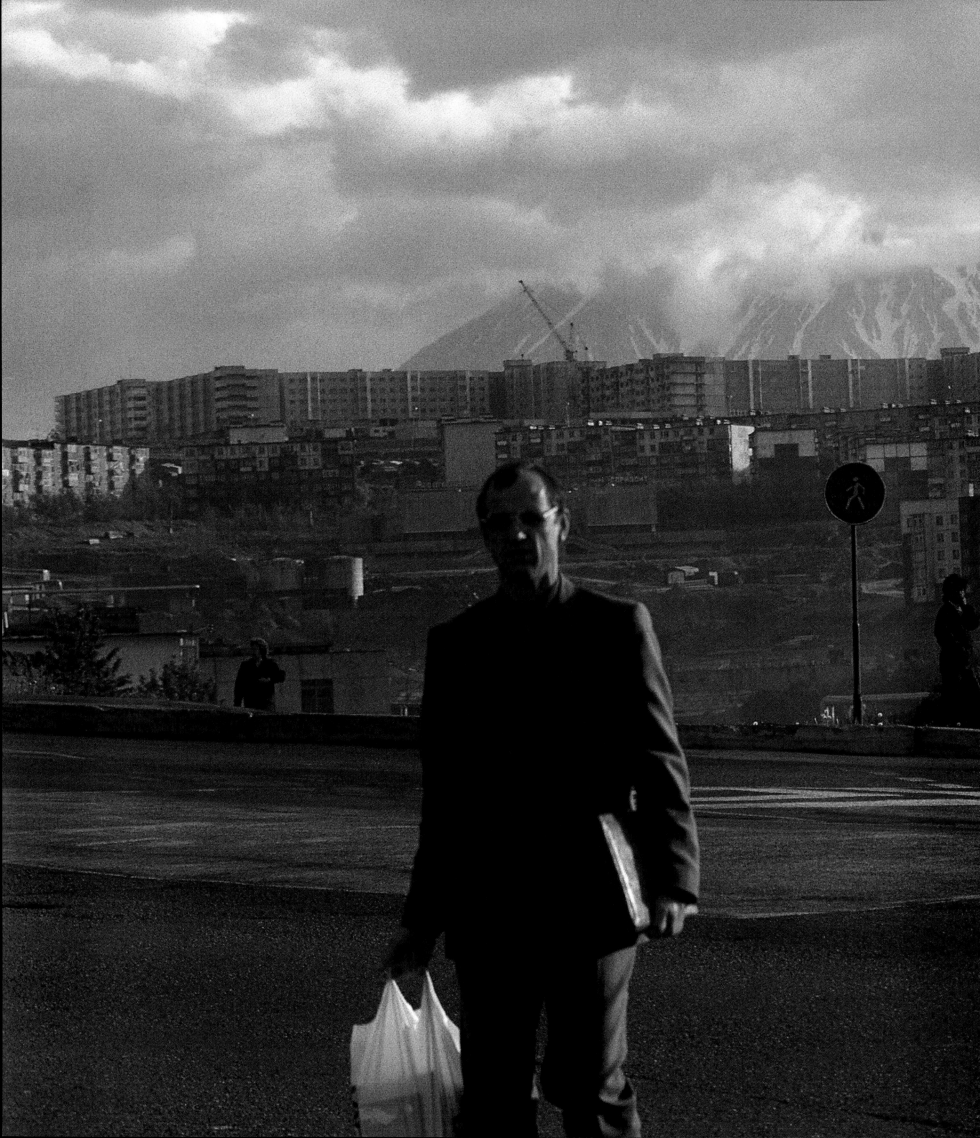

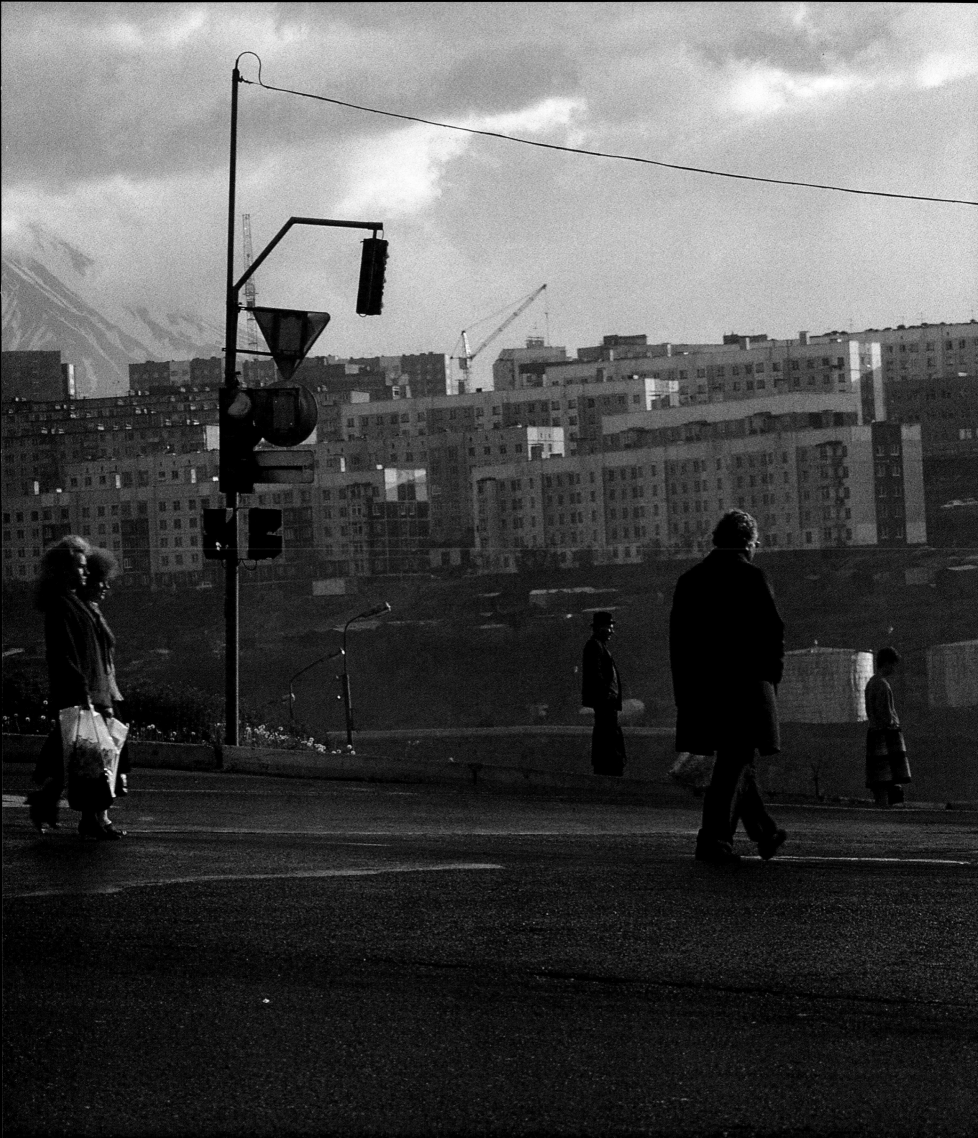

Moscow 1993

GERD LUDWIG

Arms without hands may point to pollution's gruesome price. Eight children were among 90 born since 1973 with missing terminal limbs in homes clustered near an industrial section of the city.

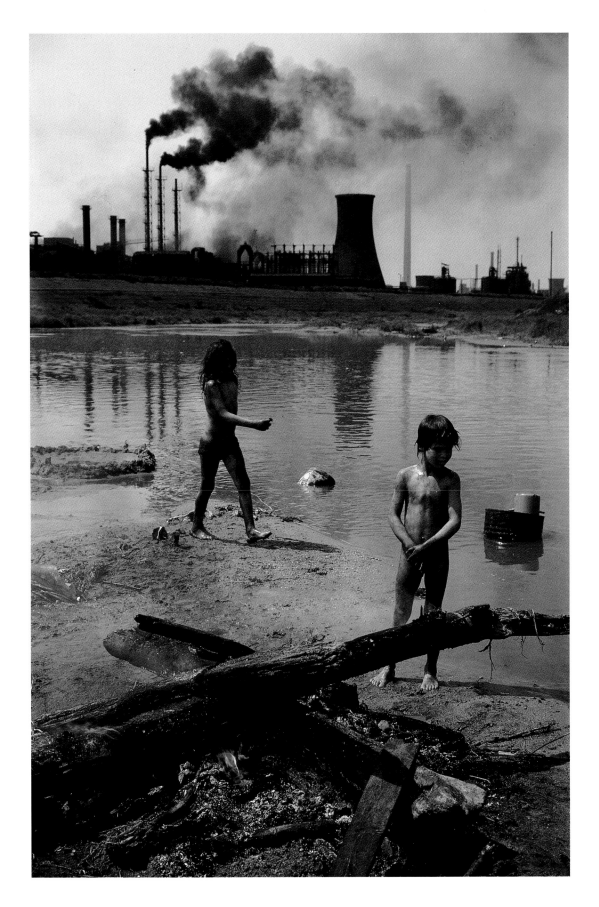

Copşa Mică, Romania 1990

JAMES NACHTWEY

Grime owns the air around this Eastern European carbon-black factory, darkening everything, including playing Gypsy youngsters. "Just sitting still leaves you covered in black," says Nachtwey.

Cizre, Turkey 1993

REZA

Tracer bullets pierce the night outside the photographer's hotel window as Turkish police exchange fire with Kurdish nationalists who seek creation of their own state.

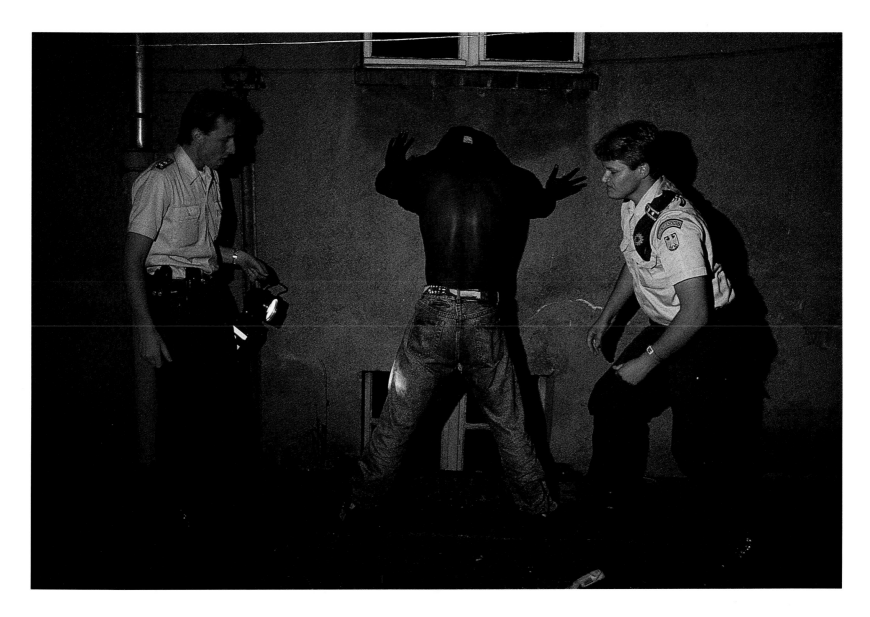

Guben, Germany 1992

JOANNA B. PINNEO

Night chase ends for a Nigerian who entered Germany illegally, one of hundreds of thousands
of immigrants flooding Western Europe in search of opportunities for employment.

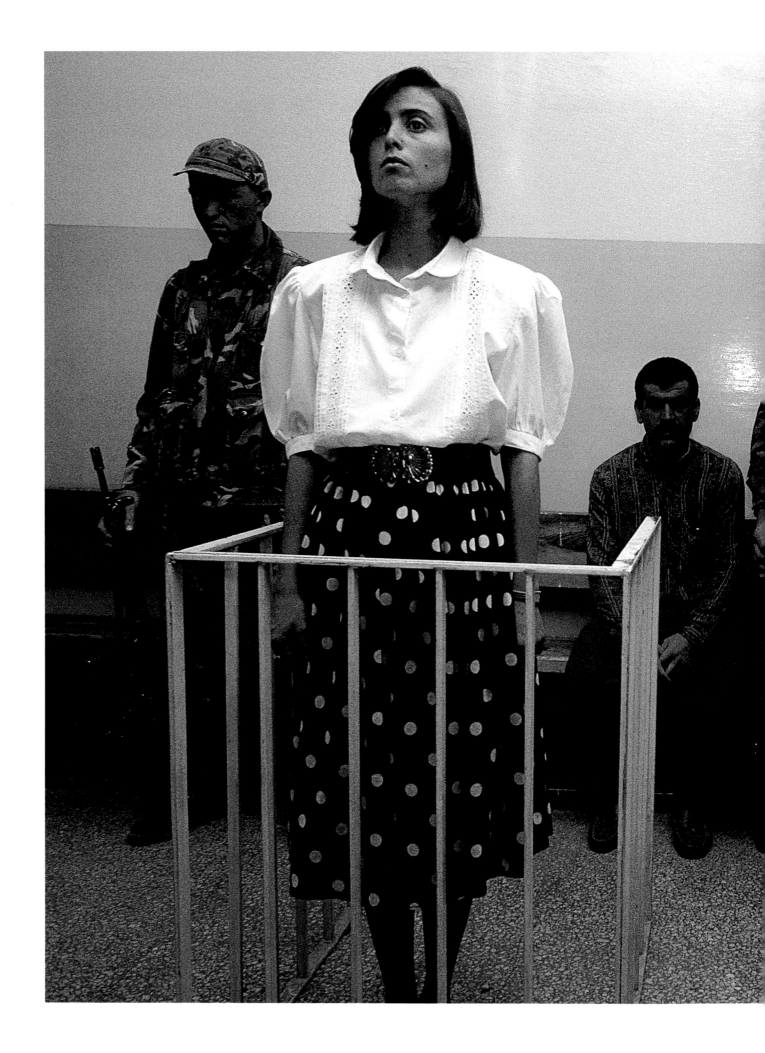

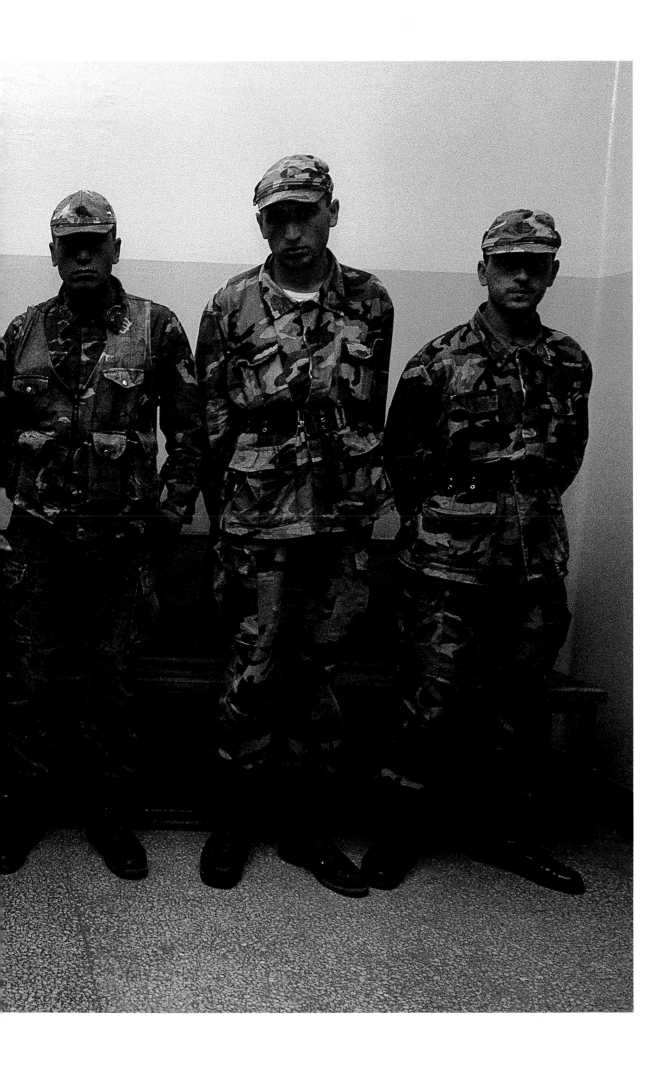

Diyarbakir, Turkey
1991
ED KASHI

*Accused of terrorism, a
Kurdish woman was later
convicted of belonging to a
group fighting for an
independent Kurdish state
and sentenced to twelve and
a half years in prison. After
Kashi snapped this single
frame of the defendant, the
judge made him sit down
and put his camera away.*

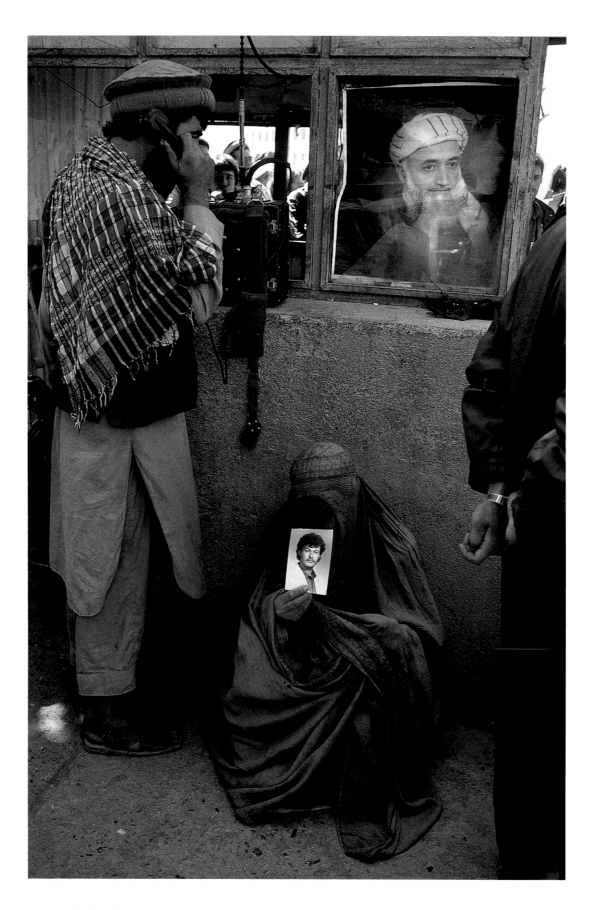

Kabul, Afghanistan 1992

STEVE McCURRY

*Searching for a son missing since the war with the Soviet military, an Afghan woman waits outside
the presidential palace while a sympathetic guard attempts to set up a meeting with officials.*

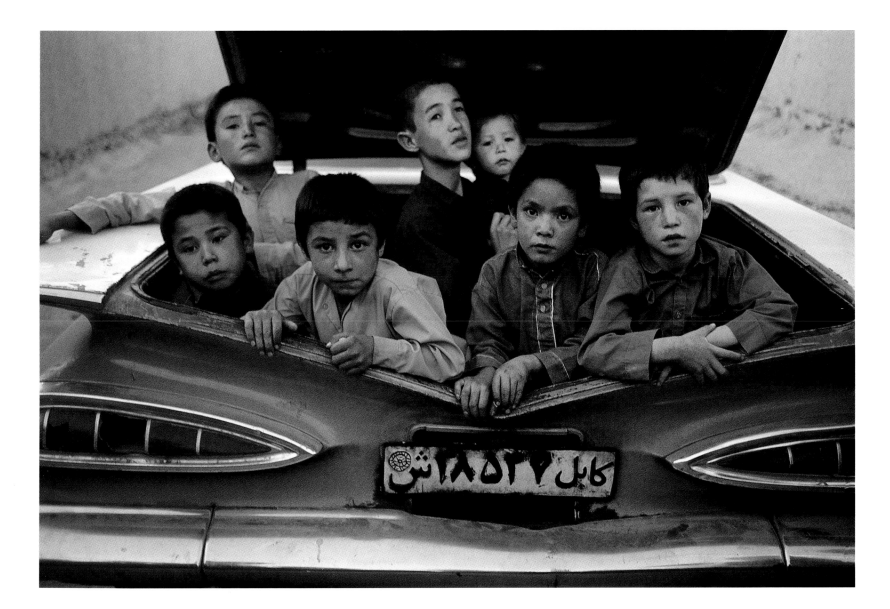

Kabul, Afghanistan 1992

STEVE McCURRY

Youngsters riding in the trunk of a taxi, while adults occupy the front, adapt to crowded transport.
Their faces reflect the ethnic mix in the capital, where different groups tend to intermarry.

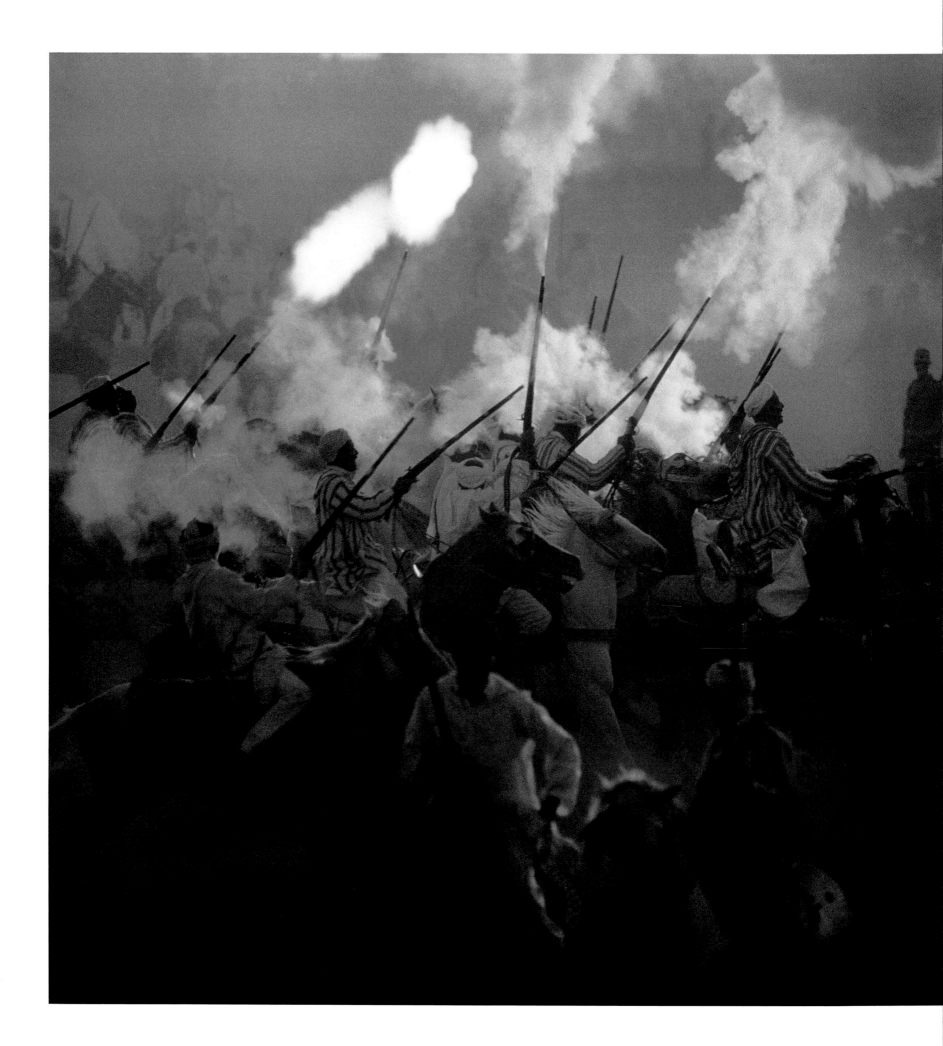

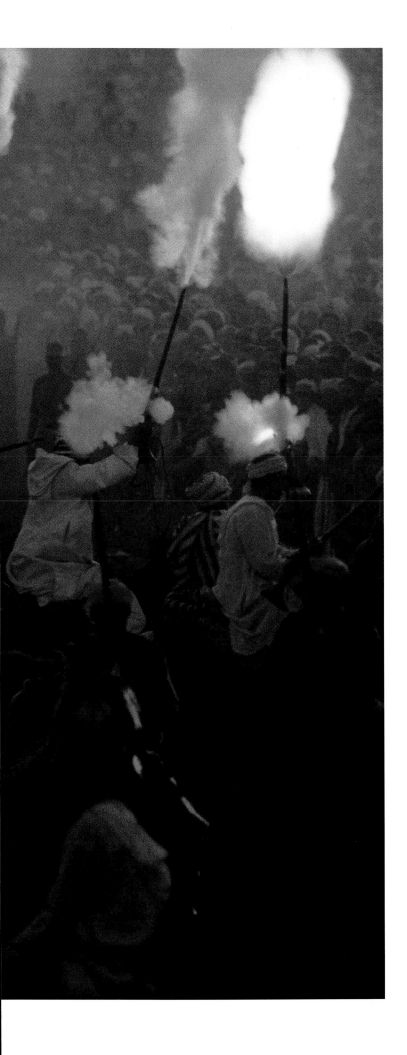

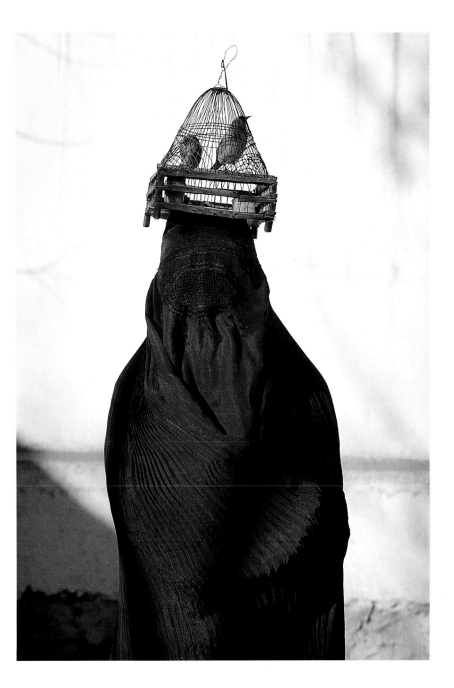

Kabul, Afghanistan 1967

THOMAS J. ABERCROMBIE

As enclosed as her pets, an Afghan woman secludes herself behind the traditional chadri *as she balances caged goldfinches bought at market.*

Fez, Morocco 1984

BRUNO BARBEY

Friendly charge of musket-firing Berber horsemen ends at a crowd gathered outside the ancient city. The melee celebrated the marriage of the daughter of the King of Morocco.

ON ASSIGNMENT
DAVID ALAN HARVEY

Spain

When David Alan Harvey went to Spain for the first time, he wrote his thoughts about the culture on the backs of envelopes and napkins—"Spain is: Passion." "Spain is: Politics." "Spain is: Machismo."

Searching for a way to show the Spanish spirit, he spotted a small item in a Madrid newspaper about a wild horse roundup in the northwestern province of Galicia. The event seemed to promise a fine display of just what he was looking for: men run after the horses, drive them into a corral, wrestle them bare-handed to the ground, and cut their manes to be used for fine paintbrushes.

"I went out with the men early in the morning and we went running after the horses," says Harvey. "They brought them in and put them in a makeshift corral up in the hills, and that's when I took my picture of the rearing horses" (page 142). Afterwards, the Galician men drove the horses down into town, where spectators gathered to watch the cutting of the manes (pages 142-43).

Nearly 15 years elapsed between Harvey's first and second assignments in Spain. By the time he returned, he spoke the language and had refined his craft.

An invitation to lunch took him to a small, private bullring (page 139), where students were practicing. "It may have been practice for the wanna-be bullfighter,

Their faith undimmed by dust and difficulty, pilgrims travel hundreds of miles in a Pentacostal trek to a shrine in El Rocío. More than half a million Catholics still make the annual journey, even though modern Spain grows increasingly secular.

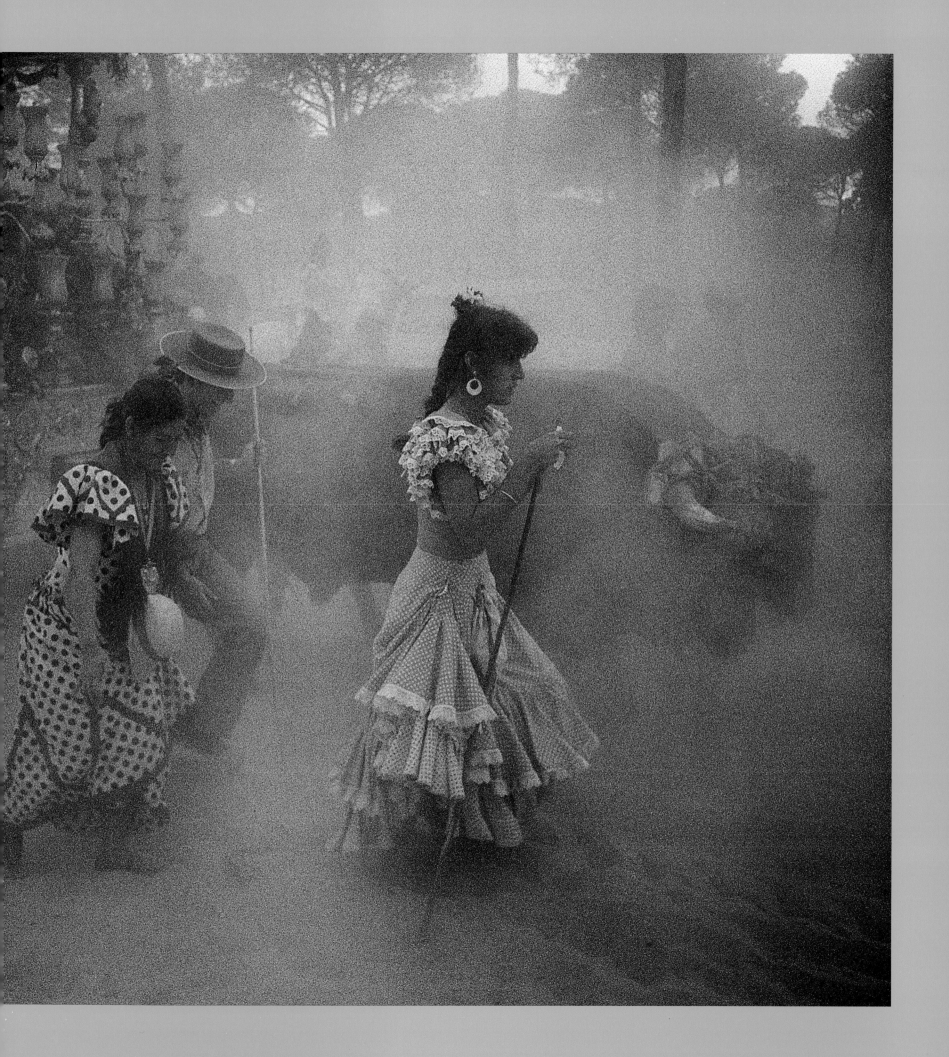

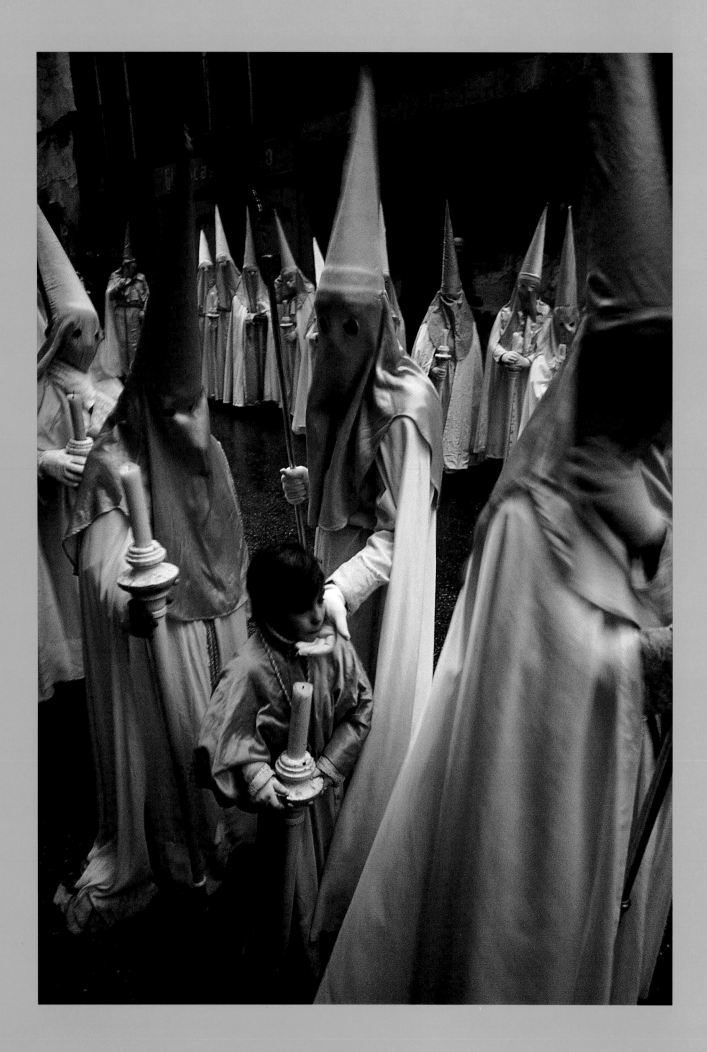

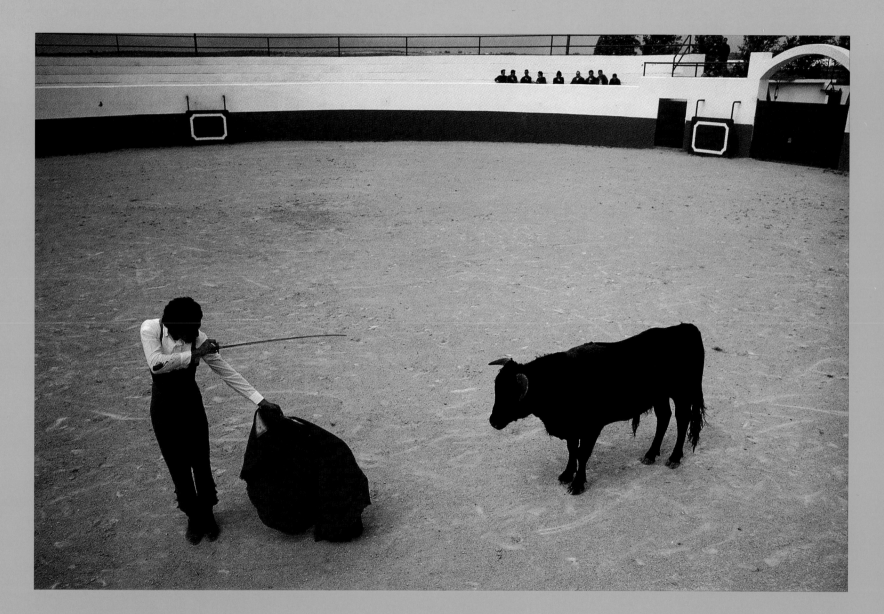

An invitation to death is extended to a bull as apprentice torero Leocadio Domínguez practices on a farm in southern Spain. The national passion for bullfighting still draws millions of Spaniards annually. With gentler emotion, a parent in Valladolid to the north encourages his son just before the youngster's initial procession with a religious brotherhood during Holy Week. Men all over Spain share these rituals. Their costumes, of medieval origin, may differ in color from group to group—but always mark them as penitents.

but it was the real thing for the bull," Harvey says.

On both assignments he included religious life in his coverage. A Holy Week procession of penitents preparing to march in Valladolid included a father tenderly encouraging his small son, who was participating for the first time (page 138).

In Seville, while young people watched the Holy Week procession, floats commemorating the life of Christ moved past medieval architecture. "The Spaniards are very religious," Harvey says, "but they don't mind mixing church rituals and partying." He saw a pilgrimage to El Rocío (pages 136-37) as a religious event and fiesta rolled into one. More than half a million people travel for days on foot or by horseback or cart to offer homage to a wooden Madonna—the Virgin of El Rocío. "The cohesiveness and willingness to help each other are the qualities that I remember from this trip," says Harvey, "and the effort people made to walk for five or six days."

Every *Geographic* photographer must bring back pictures that give a sense of place. For Harvey it was a rural mountain village nine miles from Spain's southern coast.

"Whitewashed walls and terra-cotta roofs suggest its 800-year Moorish past. I kept going back until the light was exactly right," says Harvey. "There's only going to be a few seconds when the light will actually hit the church like that" (right).

Old Spain can still be found in farm villages like Casares, where a low sun spotlights a church and a Moorish fortress. Farmers here live in villages, not on their lands. Donkey hoofs still click on the cobbled streets, just miles from congested tourist beaches of Costa del Sol.

Hoofs fly in the wild pony roundup at Galicia. Testing their machismo, wranglers throw and pin the animals bare-handed to cut their manes for hair to make fine paintbrushes. "All the local guys are out there," says Harvey of the free-for-all. "I think they've had a couple glasses of beer by this time." Before the trim, two stallions battle for supremacy (below).

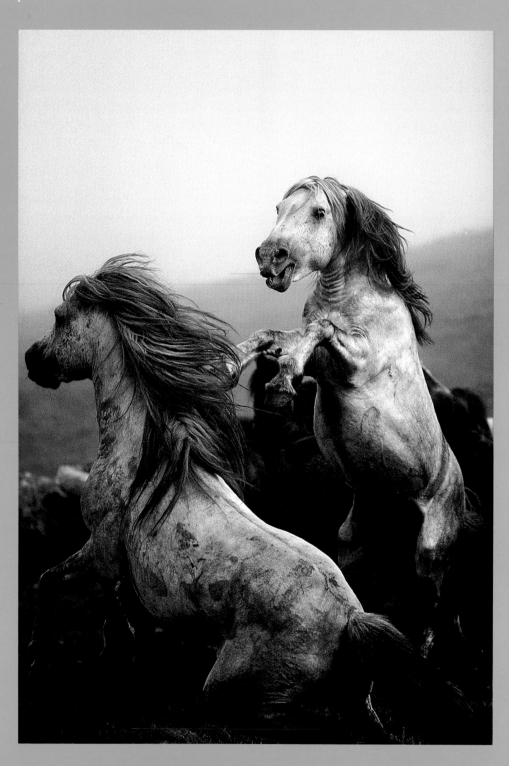

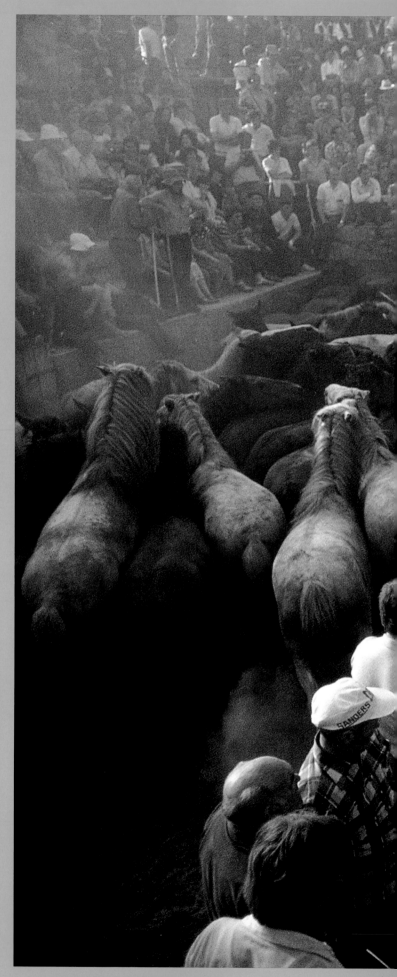

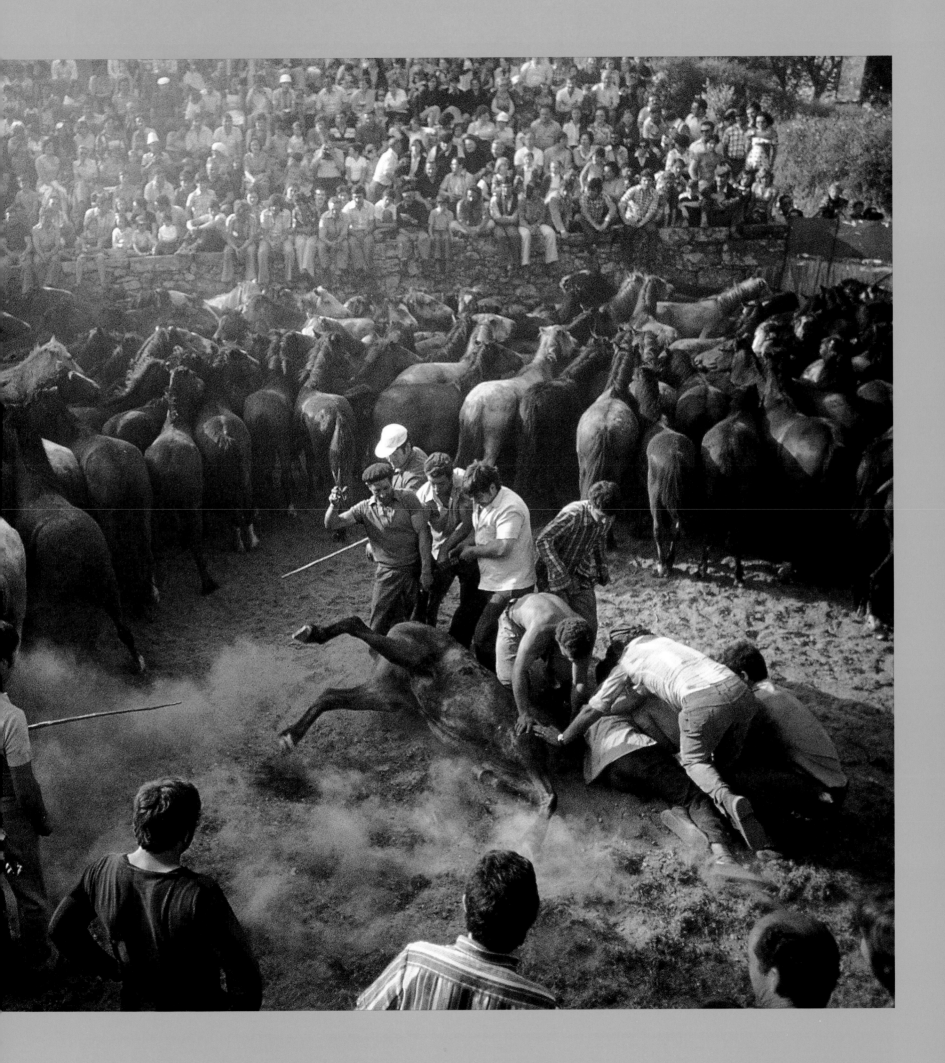

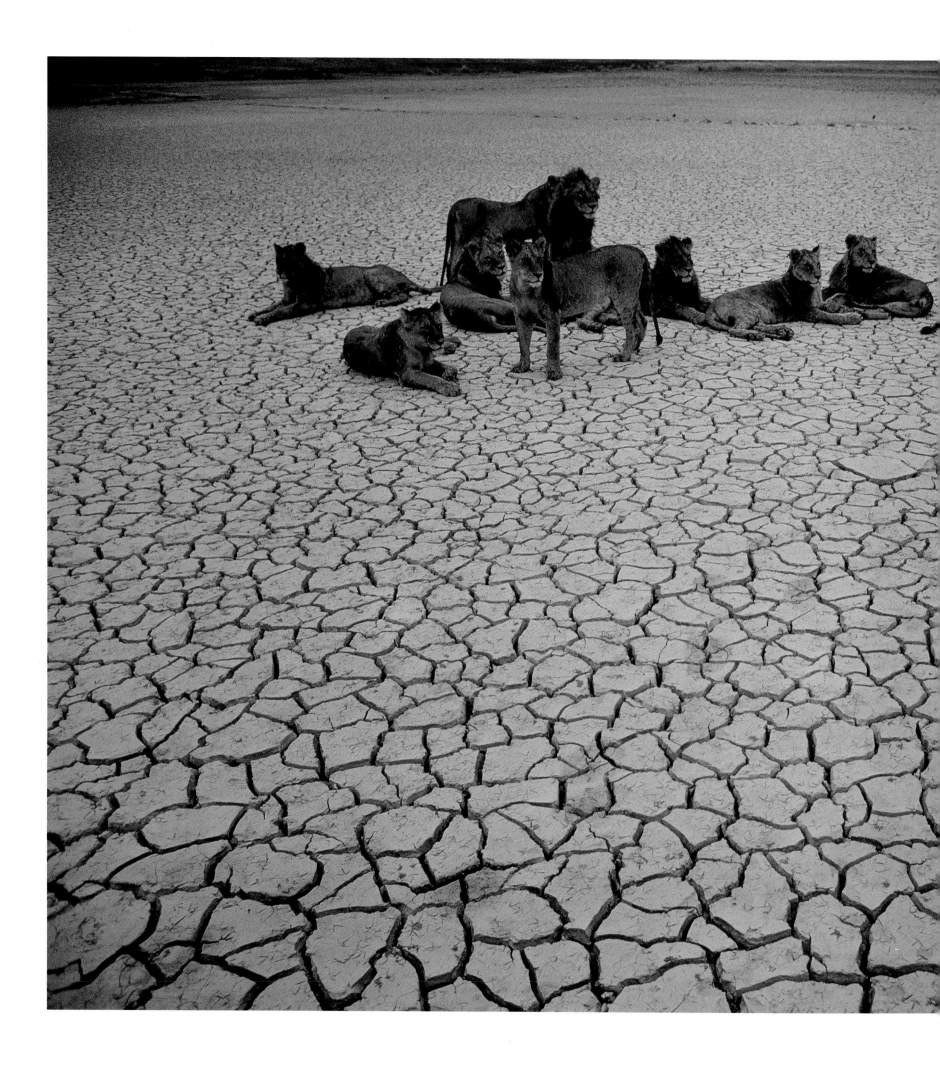

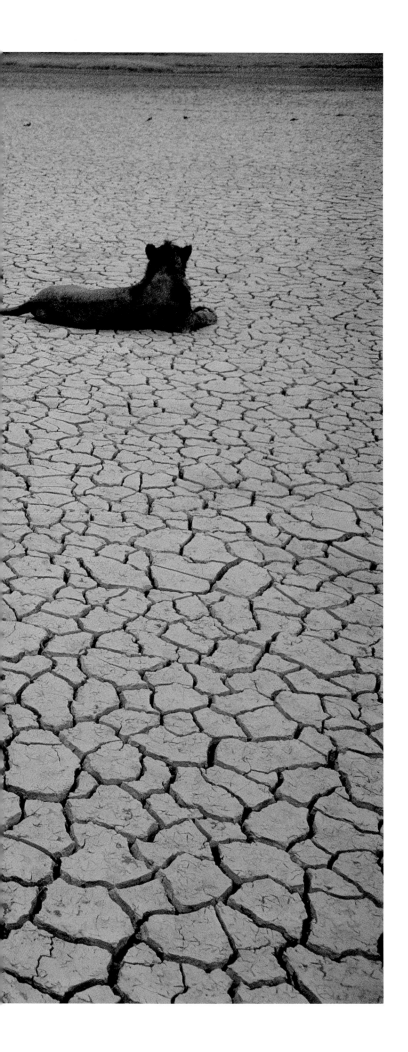

THE KINGDOM OF THE ANIMALS

Ngorongoro Crater, Tanzania 1984
MITSUAKI IWAGO

Young lions loll on a dry lake bed in an ancient volcanic caldera near Serengeti National Park. Iwago lived 18 months among the animals of the Serengeti.

Sam Abell and James Balog both have covered traditional *Geographic* subjects in recent years: the land and the wildlife that the land sustains. Abell's quiet photographs were a departure from the magazine's action-packed, adventurous style. His subtle images, many of them landscapes, were aesthetically complex. Yet they worked as photojournalism. Abell followed the rules, recording the real world and never manipulating it. Balog rigged lights and set up white screens in zoos and wildlife ranches, staging portraits of endangered animals. By photographing the animals in artificial environments, he treated them like precious objects and dramatized their imperiled status (page 149).

Just as Abell took his own path from *Geographic* conventions, Balog veered from the one usually taken by wildlife photographers, who go where the animals are, photographing in places that are hard to work in and sometimes hazardous. Jim Brandenburg followed arctic wolves, Michael Nichols pursued gorillas, Frans Lanting stalked elephants. They, along with many other photographers, followed a tradition as old as the National Geographic Society.

Every early wildlife photographer was part explorer, part scientist, part journalist, part artist. Just getting the photos was an accomplishment. But as technology evolved, photographers could bring back images that would have been impossible to capture in the early years. As the number of remote places on the planet dwindled, and as nature became more vulnerable to human intrusion, the emphasis shifted from the splendors of nature to concerns about the environment. And photographers were expected to provide insights as well as images.

Emotion and intellect play new roles in natural history photography, which now demands more than sentimental beauty. At the same time, pictures have to satisfy *Geographic* editors on two levels: providing information for a magazine story and serving the photographer's own vision.

In the summer of 1935 Frank and John Craighead, 18-year-old twins, walked into Society headquarters with some photographic prints. Four years before, inspired by an article on falconry by Louis Agassiz Fuertes in the December 1920 magazine, they had taken up the sport. The Craigheads photographed the training of hawks and owls, as well as themselves in action photographing birds in the wild. The brothers' use of the camera fit the *Geographic*'s human-interest format perfectly. The story of the Craigheads and their birds, published in July 1937, began a long association between the magazine and the brothers.

The Craigheads soon began using lightweight Leicas and the new Kodachrome

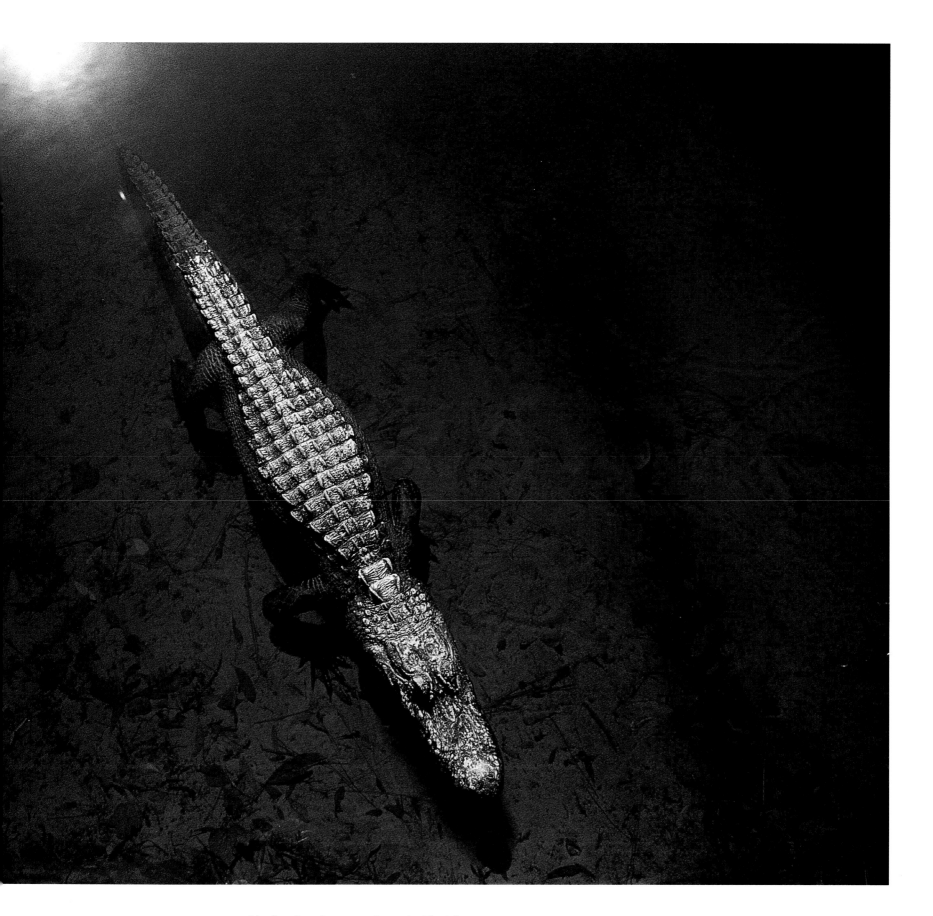

Okefenokee Swamp, Georgia-Florida 1991
MELISSA FARLOW

An alligator basks in shallow water. Farlow assumed she would get her best photos at dusk, when the swamp comes alive. This image was made at high noon, when she wasn't even anticipating one.

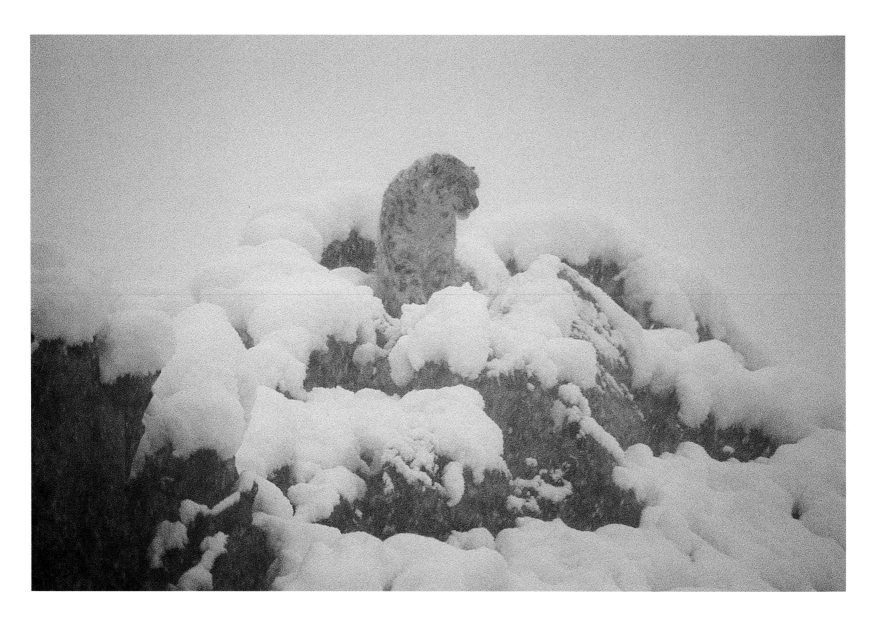

West Pakistan 1970

GEORGE B. SCHALLER

"A creature used to immense solitudes and snowy wastes," wrote Schaller of the elusive snow leopard.
His photographs in the November 1971 issue were the first published of a snow leopard in the wild.

film to stop animals in action and in natural color. During the 1940s and 1950s they recorded falconry in India, golden eagles in Wyoming, explored the Tetons, and showed how to survive on a Pacific atoll.

Beginning in 1959 and continuing through the 1970s, the brothers' photography intertwined with research supported by Society grants. The Craigheads immobilized grizzly bears with drug-filled darts, then tagged, weighed, and measured the bears, finally putting radio collars on them to track them in Yellowstone National Park. Craighead photographs, documentary records of their work, also portrayed the beauty of eagles and grizzlies and their wilderness habitats.

Frederick Kent Truslow left an executive job in the late 1950s to slog through swamps and climb trees to photograph whooping cranes, wood ibis, limpkins, and eagles. In the Everglades he sat in a hot canvas blind atop a 12-foot tower to record the comings and goings of a pair of pileated woodpeckers nesting in a dead slash pine tree. Suddenly, "a splintering of wood, rending of bark, and shuddering crash of a heavy trunk shattered the silence of the piny woods. Peering out, I saw that the whole top of the tree had broken off at the nesting hole."

As Truslow snapped a remarkable series of images, the female, home alone, descended tail-first into the cavity of the tree and emerged with an egg in her bill. She flew off with it and within two minutes was back for another. In 16 minutes from the time the tree broke, she safely moved all three eggs. When the male returned, "he seemed highly agitated, not to say incredulous, at what had happened."

Not all *Geographic* wildlife images are produced by professional photographers. George B. Schaller is a famed field biologist who uses a camera. He found and photographed pandas in the bamboo thickets of China and snow leopards in West Pakistan (left). He learns an animal's behavior and tracks it, sometimes feeling he is even thinking like it. Zoologist Merlin D. Tuttle flunked the fifth grade because, as he recalls, "I was spending too much time studying bats and other small mammals." He became a good student and stuck with bats for the subject of his doctoral dissertation. Tutored by *Geographic* photographer Bates Littlehales, Tuttle became a skilled photographer (page 243).

Mark W. Moffett is a zoologist who also became a photographer-scientist trying to portray "a real understanding of the rich lives of living things." He traveled to the tropics to photograph jumping spiders, but was unable to capture one image in nature: a high-speed sequence of one spider leaping. For this he worked in a lab assisted by Nelson Brown, a Society equipment specialist. They set up a special flash, propped two twigs in water, and put a spider on one of the twigs. The spider, trying to

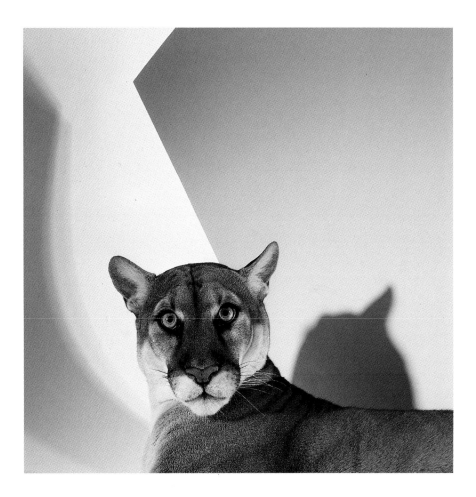

Tampa, Florida 1989
JAMES BALOG

The camera captures the haunted gaze of a mixed-breed descendant of wild Florida panthers. Balog believes that the "age of truly wild animals is nearly over."

following pages:

Namib Desert 1981
JIM BRANDENBURG

A gemsbok roams forbidding desert sands along Africa's southwestern coast.

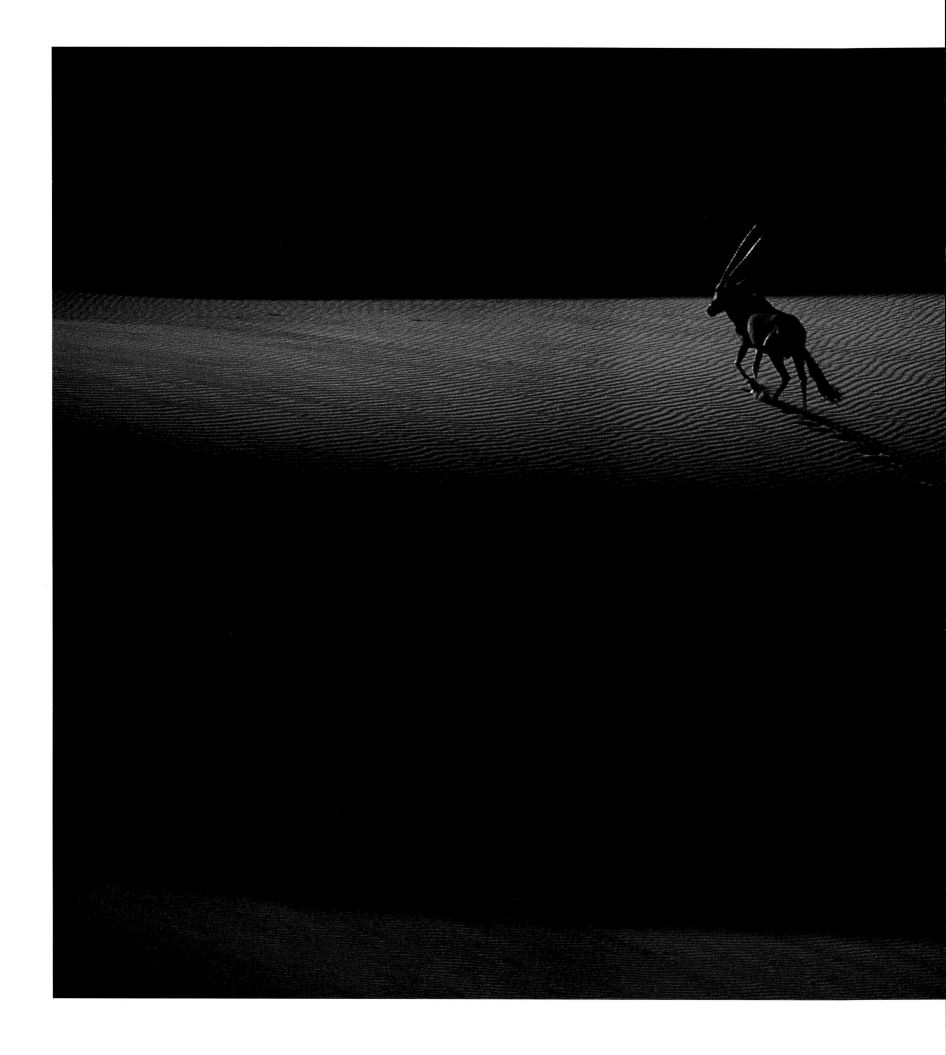

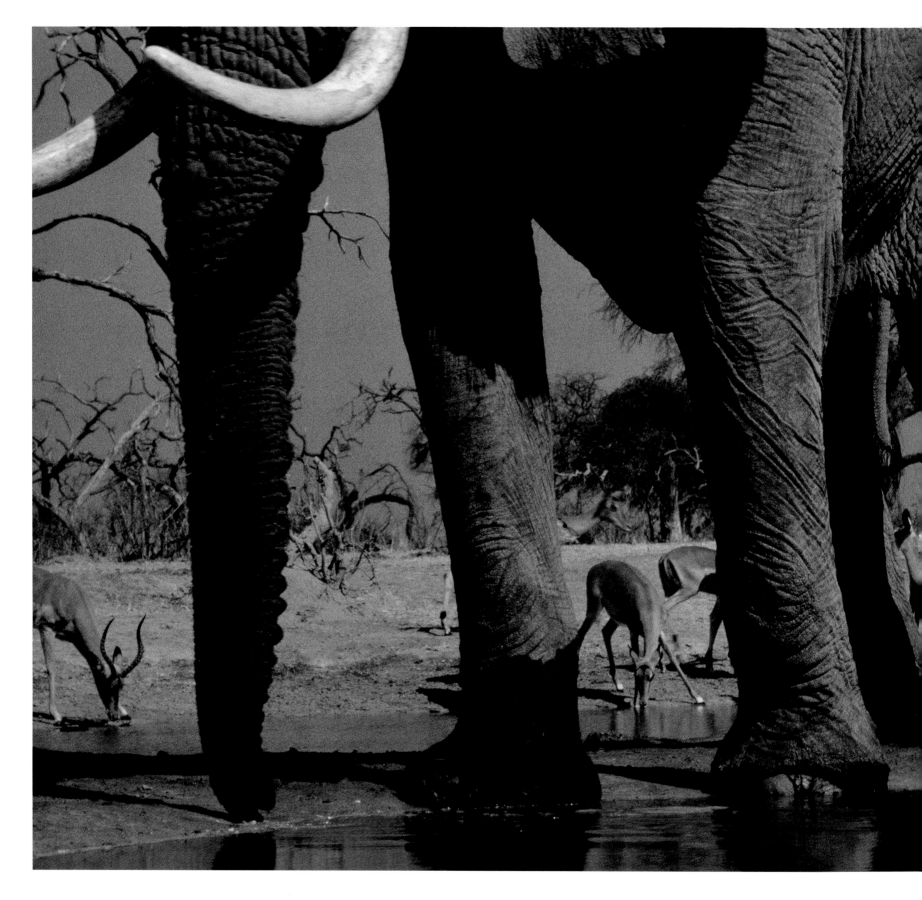

Okavango, Botswana 1989
FRANS LANTING

Impalas drink near a bull elephant at a water hole. "I was often belly-down in sand, mud, or water,
going about my daily work as the animals went about their daily survival," wrote Lanting.

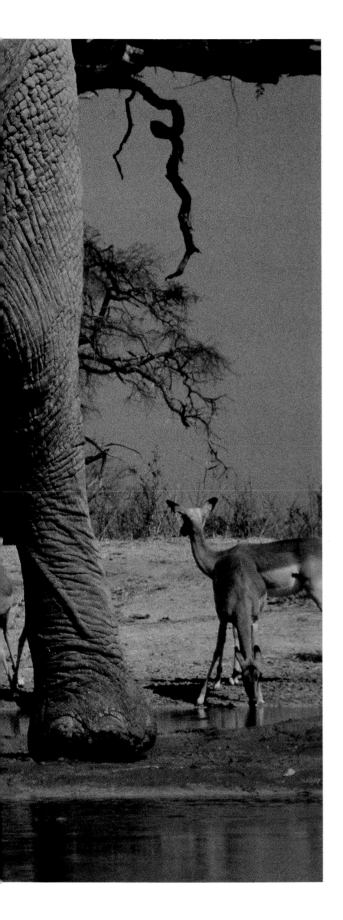

escape, retreated down the twig, only to discover the water, which it wanted to avoid. Moffett, familiar with jumping spider behavior, expected the jump and started the camera. The strobe captured four images of the spider in midair (page 243).

For Loren McIntyre, the subject is South America. "So strange and wonderful," he wrote about the continent soon after he began exploring it as an 18-year-old. "This enchanted land is casting a spell over me from which I shall never escape." He was right. He has spent half a century walking, canoeing, and flying through South America, climbing the Andes, sailing the Orinoco, living with tribes wherever he found them. And he has put his mark on his realm: The site of the ultimate source of the Amazon River, which he helped pinpoint, is named Laguna McIntyre.

More than 500 McIntyre photographs have appeared in the *Geographic.* One, so unusual that veteran photographers thought it was staged, shows a young jaguar sinking its teeth into the neck of a juvenile caiman (page 155). McIntyre found the pair while with a friend who was rescuing sloths and snakes from Amazon floodwaters.

Geographic photographers working in the wild are charged with bringing back authentic images of their subjects. Frans Lanting approaches the job with the belief that wildlife photographers have too long portrayed their subjects as innocent and pure. His photographs convey the struggle, the power, and sometimes the brutality he sees in the lives of wild animals.

Lanting, born and raised in the Netherlands, took his first pictures at age 21, with his mother's camera, while hiking in U.S. national parks. He does not mind manipulating wildlife when situations he seeks in nature do not readily present themselves for the camera. "I could sit in a forest in Borneo until the end of my life and never happen on a situation that would allow me to depict, without exerting any influence, a flying frog in midair," he says. So he captures frogs and positions them where he can put his camera, creating conditions that increase his chances for a picture but still allow for spontaneity. "The animal is given choices and I react."

OVER THE YEARS, certain photographs have raised questions about manipulation. On January 6, 1967 *Life* magazine splashed across two pages a photograph taken by John Dominis of a leopard attacking a terrified, shrieking baboon. Unknown to the reader, a handler had just released the leopard from a cage. Defending the image 20 years later, former *Life* photographer and picture editor John Loengard wrote that it showed the animals behaving naturally under the circumstances, that it was not faked from the standpoint of either the leopard or the baboon.

Staff photographer Walter Meayers (Toppy) Edwards duplicated Dominis's approach, using a mountain lion and a badger, for a photograph published in the Society's 1972 book, *Great American Deserts.* The caption for the picture said that "a handler freed the captive animals for a time" and "they reacted instinctively"—the badger crouched to attack and the cat ran.

The heart of the issue is how photographers mix the worlds outside the camera with the worlds inside their heads. Judgments on what degree of manipulation is

acceptable shift continually, depending on the photographer's purpose, a publication's agenda, and the state of technology. In the early 1980s the *Geographic* published a slight computer-aided change in a photograph. The editors were not pleased with the results. From the experience came a strict policy that says a photograph cannot be altered by electronic or conventional photoengraving techniques.

Motion picture film has largely taken over the job of bringing back images of events and behavior, and this has freed the still wildlife photographer to some extent to pursue a more individual vision.

Nowadays *Geographic* wildlife photographs are rarely simple documentary portraits of animals. Frans Lanting took such trouble to record a frog flying because his vision of a Borneo rain forest centered on its elusive, flying creatures. For similar reasons, in Madagascar, he kept branches in his hotel room to capture the changing colors of a dozen chameleons perched on them.

JIM BALOG, POSING ENDANGERED ANIMALS in zoos and wildlife ranches, maintained his own ethical standards. He knew he was working with institutions denounced by many people for exploitation of animals. But he shot in these places to show the relationship between people and nature.

When Michael Nichols began photographing endangered species, he focused mostly on humans and their relationships with animals. Later he concentrated on animals in the wild (page 165), gaining the intuition to sense a creature's next move.

Frans Lanting believes all nature photographs are the products of the photographer's own ideas about nature. When he went to the Okavango Delta in northern Botswana, he saw wildlife bursting out of park boundaries in an ecosystem where desert and swamp dwellers meet. At the heart of his story was water, which determines the ebb and flow of Okavango life. He spread his coverage over two years, spending a total of 12 months in the field.

One of the most striking images he brought back shows an elephant standing at a water hole east of the delta. Between the elephant's legs, impalas can be seen at the water's edge (pages 152-53). Lanting made the low-angle photo while lying on the ground. "Elephants appear in the African landscape almost like monuments," he says, "so I approached them as works of architecture." This one stands on great pillars, bursting out of the frame. The impalas look fragile by comparison.

Like all wildlife photographers, Lanting faces dangerous situations and takes calculated risks. Crawling among elephants or standing up to his neck in a swamp where crocodiles live, he makes judgments and hopes for the best. He measures his success by the fact that, so far, he has all his limbs. "There have been close calls," he says, "but I don't like to dwell on them; that would create the impression of an Indiana Jones style, and I'm not a very physical guy. I'm not a hero. Whenever there's been a close call, it's been because of my own ignorance or carelessness. And the animals were trying to tell me something."

Lanting likes roaming the African savannas. "It's wonderful to synchronize your

own rhythms with those of a pride of lions," he says. "By contrast, working in a rain forest is all blood, sweat, and leeches." He compares photographing in the thick vegetation, with no sunrises or sunsets, to taking pictures underwater. "You have the feeling, when you're working in Borneo's rain forest, that you're in someone's basement, rummaging around in semidarkness while the inhabitants are one or two levels up. Animals appear in rain forests, but most of the time they're just glimpses."

Photographing in the South Atlantic, he used the albatross as a symbol of the subantarctic ecosystem. On Albatross Island, he spent a week with the birds, concentrating on their courtship dance. At one point in the complex sequence of gestures and sounds, the male spread its enormous wings and pointed his bill skyward. It was a thrilling moment, one that Lanting remembers as a high point in his career.

And the photo is one of the best he ever made (pages 158-59). A super wide-angle lens maximizes the birds' size and the sense of intimacy at the same time. The landscape behind the birds—tussock grass, heavy clouds, shimmering water, and mountains beyond— contributes to the theatrical mood.

Lanting uses fill flash as a supplement to daylight. "Many of my rain forest photos have benefited from some kind of reflected light," he says. "Without that, you just have murky photographs." Fill flash gave him just enough artificial light to work in the rain forest and to extend his working day. He tries to avoid provoking his animal subjects and has experimented with robot cameras that allow them to trip the shutter themselves, producing photographs that have a different look (pages 60-61). "They tend to become very naked, unglorified pictures," he says. "The animals are stripped of romanticism and drama in the same way that passport pictures can be."

Jim Brandenburg tries to influence his wild subjects as little as possible. As a beginner he was preoccupied with technical matters. "Sitting out in a field, I'd literally have tears rolling down my cheeks, because I couldn't figure out which extension tubes, f-stops, or shutter speeds to use," he remembers.

As a child growing up in Minnesota, Brandenburg loved to go where he thought no one had been before. Solitary and melancholy, he daydreamed in school but came alert when alone, exploring the prairie around his home. Snowstorms invigorated him by obliterating evidence of humanity, and he persuaded his mother to take him out during blizzards, drop him off in the prairie, and let him walk home. He felt like an Arctic explorer.

When he grew up, he worked for the *Worthington Daily Globe*, a small paper in southwestern Minnesota. "I was lucky. It was a great little paper," he remembers. "I did the layouts, wrote the stories, took the pictures, ran the printing press, and

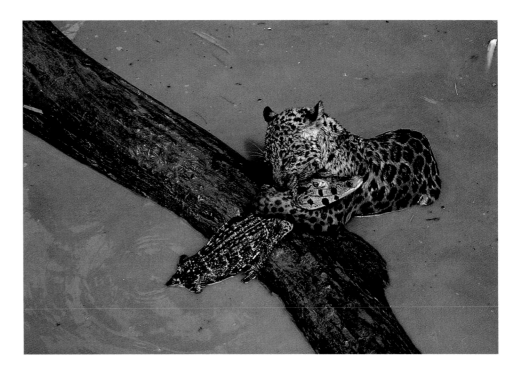

Amazonia 1972
LOREN McINTYRE

A juvenile caiman becomes a meal for a young jaguar in an unusual high-water encounter. McIntyre sometimes searches floodwaters for isolated animals to photograph, "but seldom with such good luck as this."

delivered the papers." Brandenburg has a reputation for turning every assignment into a nature story. He went to Africa to photograph Namibian independence but came back with wildlife coverage as well (pages 150-51). "I'll never forget that projection session, how they teased me about it," he says.

One of his main interests in the 1970s and 1980s was photographing wolves. To gain the trust of gray wolves, he felt he had to live in wolf country, so he built a cabin in their northern Minnesota habitat. His most spectacularly successful article on the wolf, however, took him far from his cabin. On assignment to photograph a dogsled expedition to the North Pole, Brandenburg was tracking musk oxen in sub-zero temperatures when six arctic wolves emerged, like ghosts, from a blue dusk.

"I knew immediately that this was to be my mission, to come back and tell their story" (pages 12-13; 180-87). Financial and technical problems stood in the way, but Brandenburg's planning eventually resulted in a *Geographic* article, a book, and a television documentary.

Back home, Brandenburg kept photographing the prairie (page 174). "I don't know of two subjects in North America that have been abused more than wolves and prairies," he says. About 25 years ago, he began documenting this familiar ecosystem as it used to be. "It's nearly gone now," he says. "There are patches of a few hundred acres here and there. I'll wait for the right sky, for the animals, for the mood, and I'll try to bring everything together."

Empty of people and almost devoid of wildlife, Brandenburg's landscapes make unusual fare for the *Geographic,* whose articles and photographs usually do not simply describe terrain. Landscapes almost always have something going on in them that gives them interest and shows people or animals using the land. But Brandenburg's vision of his land produced a *Geographic* article on the prairie and another on what the country might have looked like before Columbus.

THE NORTH'S OPEN, FEATURELESS SPACES resonate in the photographs of Sam Abell, who finds a link between his boyhood in the farm country of Ohio and his attraction to the subdued geography of the far north.

At the age of 12 he began learning photography from his father, who had just taken it up himself. Together they photographed their neighborhood and searched for design among snow-covered pipes of the Toledo Concrete Pipe Company. They built a basement darkroom and spent evenings developing their pictures. When Abell could not stay up late enough to see the finished prints, he would find them by his bed in the morning.

His father appointed him the official photographer on a family vacation trip to Canada in 1959. Light touching patches of water along the St. Lawrence River at low tide inspired him to make his first landscape pictures. By then he was photographing incessantly. He entered contests, found mentors, and honed his craft by working on publications in high school, then college.

When he was a student at the University of Kentucky, he shipped his portfolio

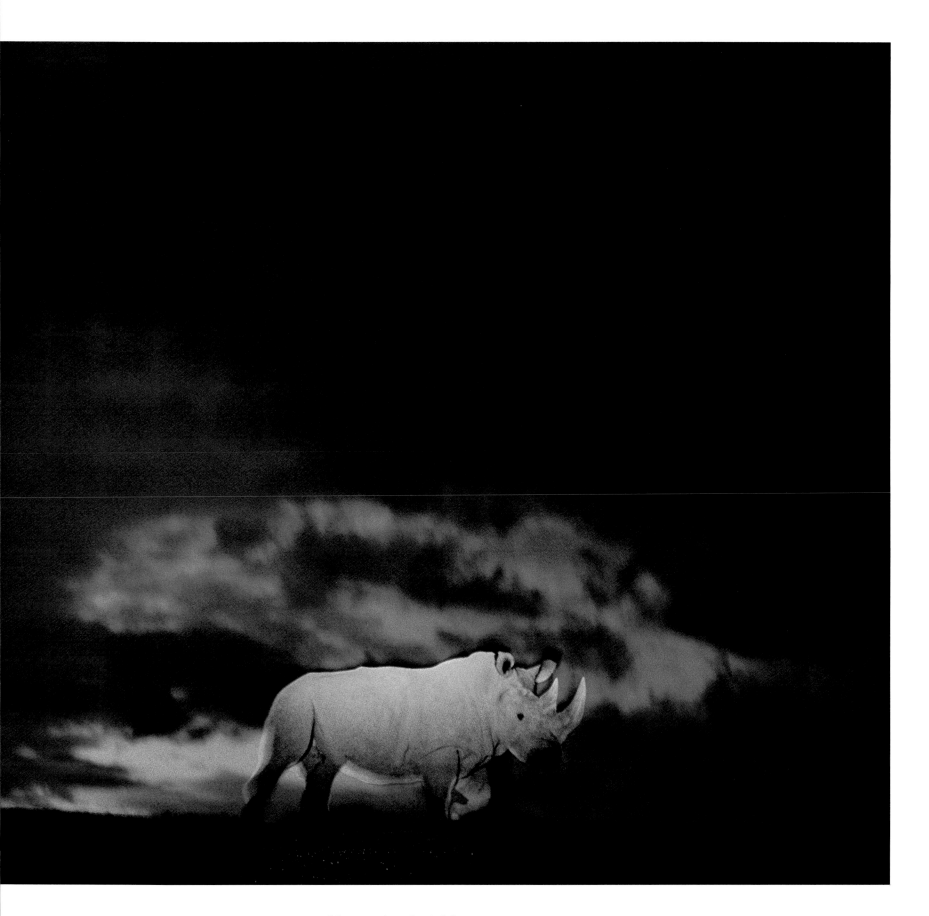

San Diego Wild Animal Park, California 1992

MICHAEL NICHOLS

Lonely sentinel under a foreboding sky, a northern white rhinoceros is one of perhaps only 40 left
alive. Nichols chose this symbolic photograph to end his article, "New Zoos: Taking Down the Bars."

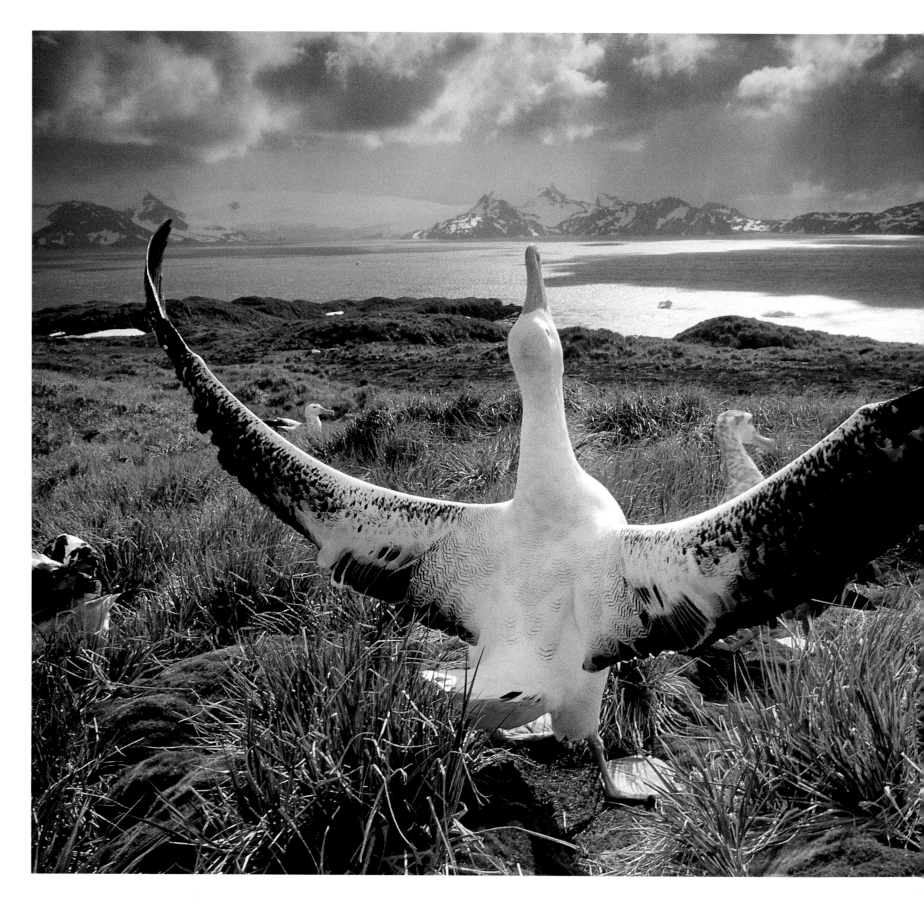

Albatross Island, South Georgia 1987

FRANS LANTING

A wandering albatross—the world's largest flying seabird—postures for a prospective mate. Lanting
lived for a week in a small tent on this storm-lashed island photographing the courting birds.

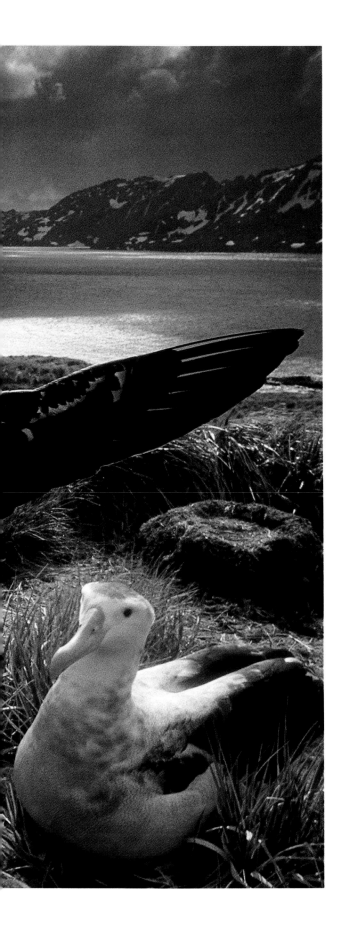

to the *Geographic* in two packages, one containing black-and-white photos and the other color. The color package got lost in the mail, and the black-and-whites were so tightly packed in a shipping box that when Bob Gilka, director of photography, opened it, tiny foam chips exploded all over his office. Gilka offered Abell a summer internship anyway.

Working for the *Geographic*, Abell fulfilled his dreams of traveling, and his style matured. His pictures of landscapes and people grew more refined and contemplative. He was told that his work was too quiet, and his future at the *Geographic* was uncertain. But he did not waver from his vision, and gradually his style came to be accepted and then respected.

Of all the places he has traveled, Alaska and Canada affected him the most. "In the far north, beauty begins right at your feet and goes to the horizon," he says.

Photographing a story about Western artist Charles M. Russell, Abell was struck by the importance of the bison skull as an icon in Russell's work. To get the bison skull photograph he wanted, Abell searched six months, following one lead after another. He finally found a few intact skulls flung out after a butchering on a remote ranch in Alberta, Canada. "I photographed them diligently, with the moon and a special stormy kind of light in September," he recalls. "I thought the picture couldn't be improved upon."

But when he returned to Washington and saw the film, he realized the picture would be better with snow. His picture editor let him return to Alberta to improve that image. When he got back to the skulls, he climbed onto a snow-covered knoll and stood prepared with his camera. His fingers began to freeze, and a storm closed in. The light was good for about a minute. At the end of that minute, Abell got lucky: A bison strode into the background of his picture (page 176).

Abell is patient and considers luck his partner. Patience finds a stand of giant termite mounds in Australia, but luck makes a herd of cows wander among them in the day's last light.

He looks for what endures and also contains a fleeting element (page 170). "I photograph backward," he says. "By that I mean I compose the setting of a photograph, then wait for the moment." A white, diaphanous mosquito net temporarily floats from a solid, ancient boab tree (page 171).

Abell tries to take the viewer with him into the geography of a place. "I try to choose lenses, perspectives, and points of view that give a you-are-there feeling," he says. A small, ephemeral clump of snow will soon disappear from the enduring valley of the Firth River in Canada's Yukon Territory. The deep background beckons. "From this intimate vantage," Abell says, "the viewer looks toward infinity."

When Abell goes on assignment, he tries not to overprepare, for he does not want to destroy the surprise of a new place. A map on his refrigerator or office wall launches his imagination. He decides how to photograph when he arrives at his destination. "Every landscape has a character," he says. "The thing to do is put yourself under its spell. Spend time with it. Discern what it is, and then nail it."

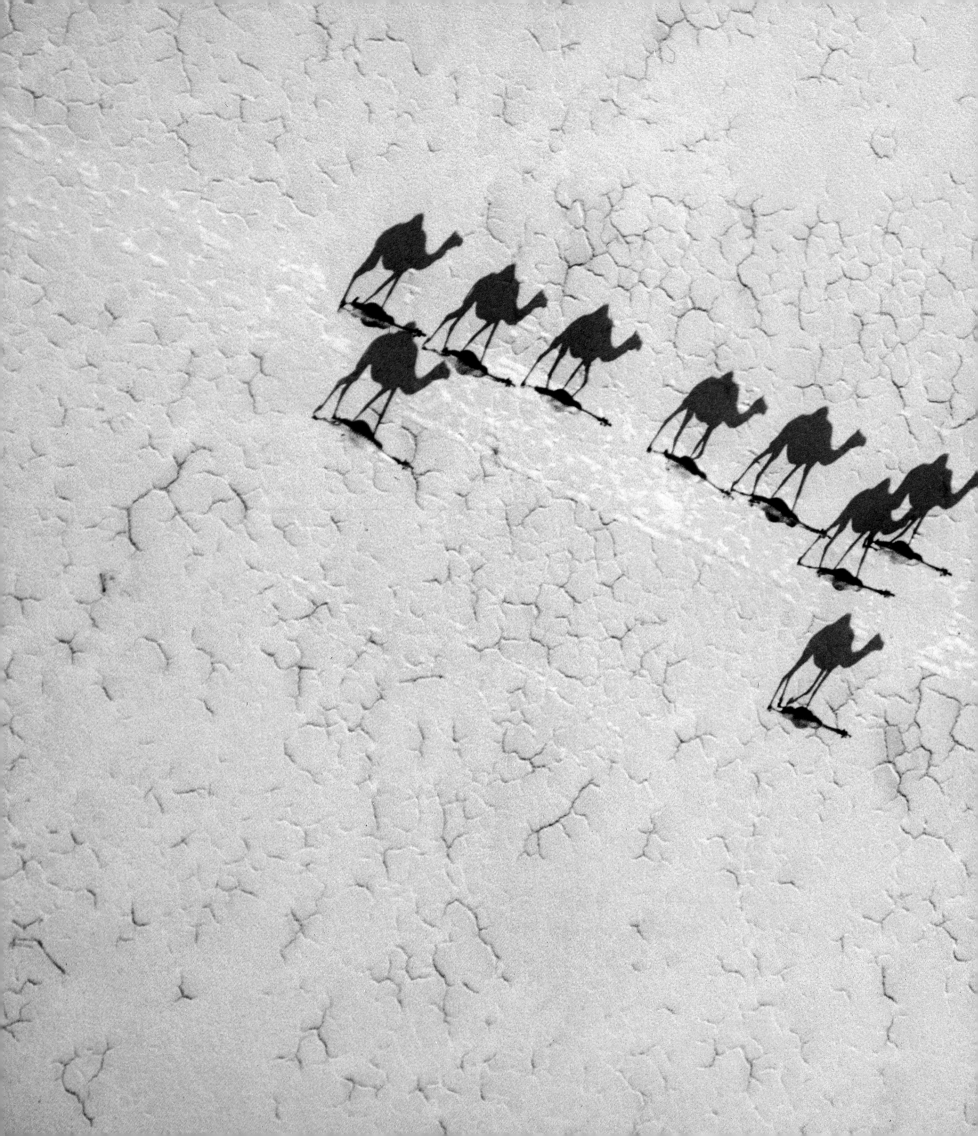

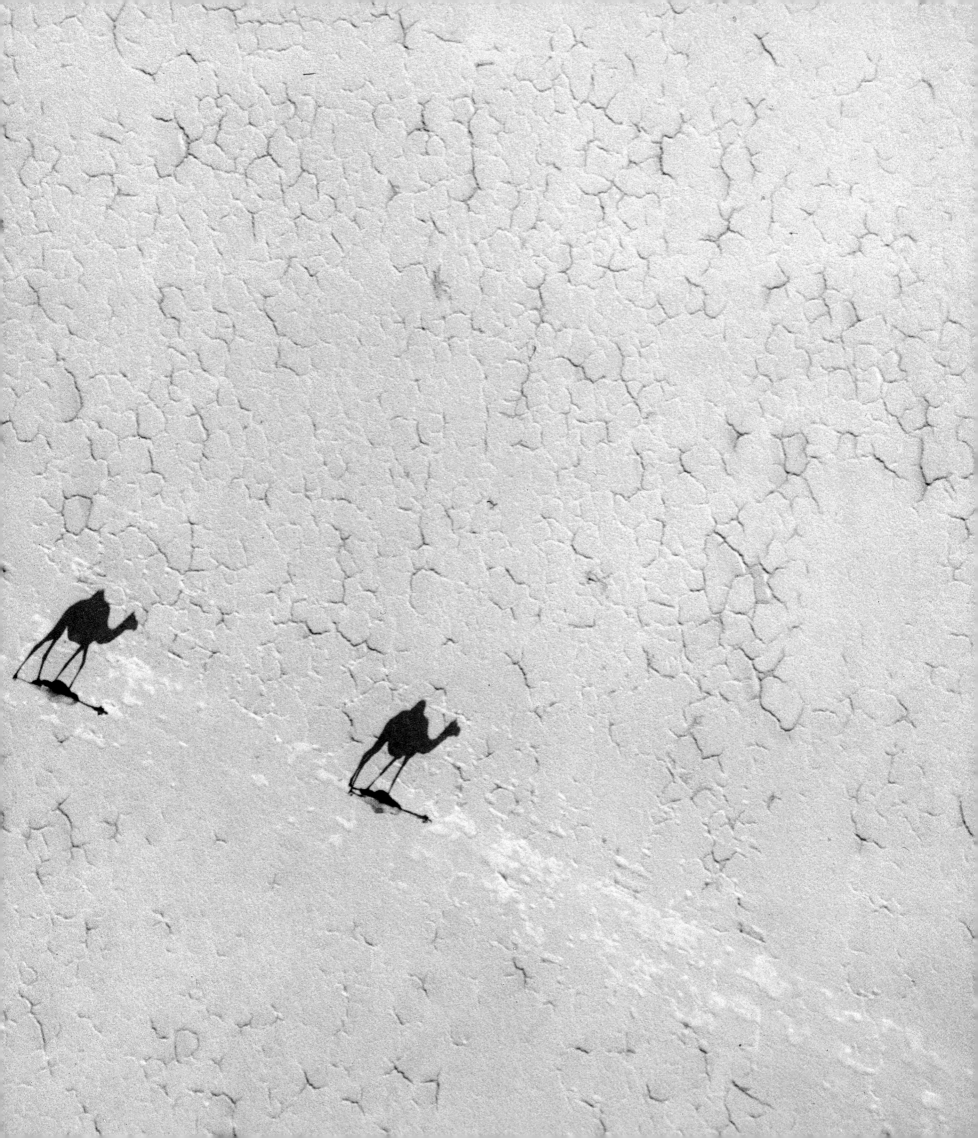

Burundi 1989
MICHAEL NICHOLS

Grown too strong to manage, Whiskey—a pet chimpanzee—was banished to solitary confinement in the back of a garage, a cruel fate for a naturally gregarious animal. He was taken by Jane Goodall to a sanctuary, where he died of tuberculosis in 1991. "The lighting and the bizarre style of the photograph are important," says Nichols. *"I wanted it to be disturbing."*

preceding pages:

Djibouti 1989
CHRIS JOHNS

Camels and their shadows cross the salt flats of Lake Assal. "This is one of the hottest, most barren places on earth," says Johns.

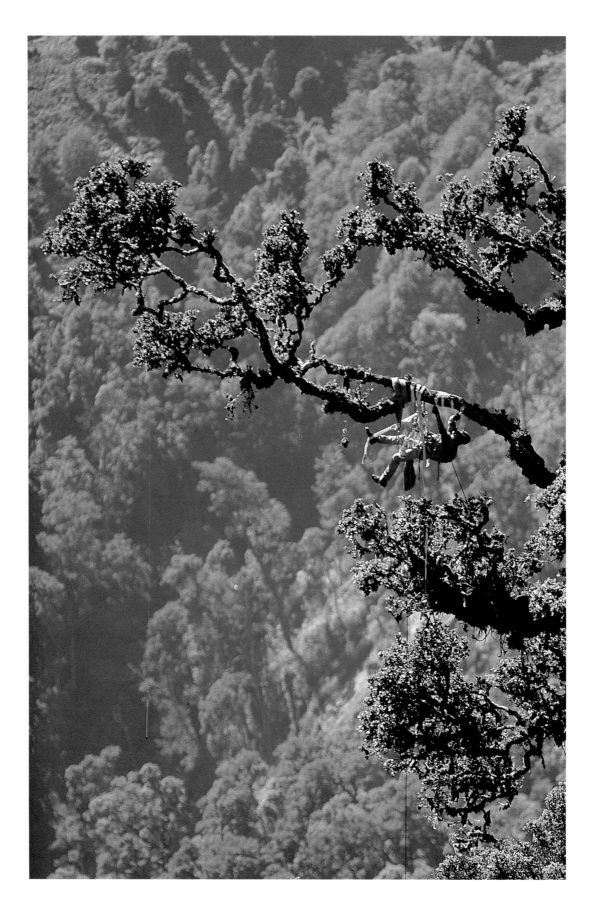

Costa Rica 1991

MARK W. MOFFETT

An ecologist near the top of a hundred-foot-tall tree—which is growing nearly perpendicular from a dangerously steep slope—paints rings on branches to measure growth in the oak-bamboo forest.

Sumatra 1991

MICHAEL NICHOLS

Fleeing from an angry dominant male, a subadult male orangutan swings into camera range. Nichols rope-climbed 150 feet to photograph the arboreal apes.

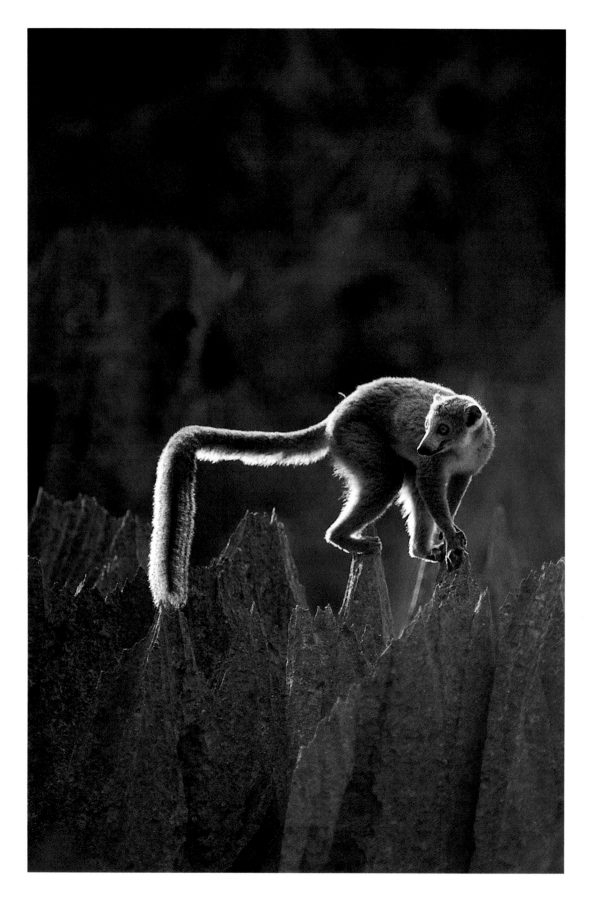

Madagascar 1987

FRANS LANTING

A crowned lemur teeters on pinnacles of eroded limestone. Lemurs are native to the island.
Lanting's photos turned these "wild creatures into ambassadors for an ecosystem."

Okavango, Botswana 1988

FRANS LANTING

As dusk settles, "things begin to happen" beyond Lanting's fire. "A flock of ibis wing back to their colony like ghosts at nightfall, their eyes for an instant reflecting my strobe lights."

following pages: Chobe National Park, Botswana 1992

BEVERLY JOUBERT

Elephants, doves, and hungry lions maintain an uneasy truce at a small water hole. Photographs of the nocturnal activities of lions required weeks of gradually introducing them to artificial light.

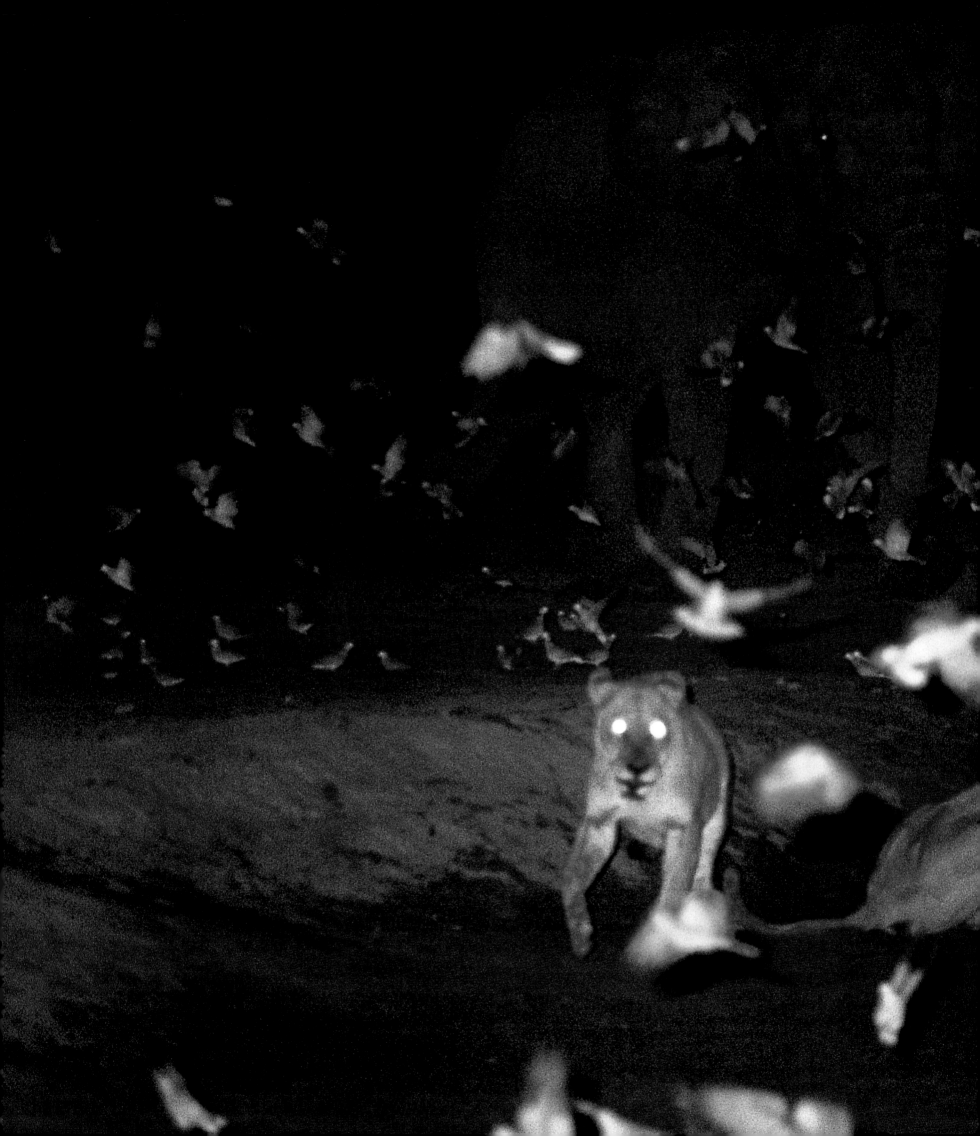

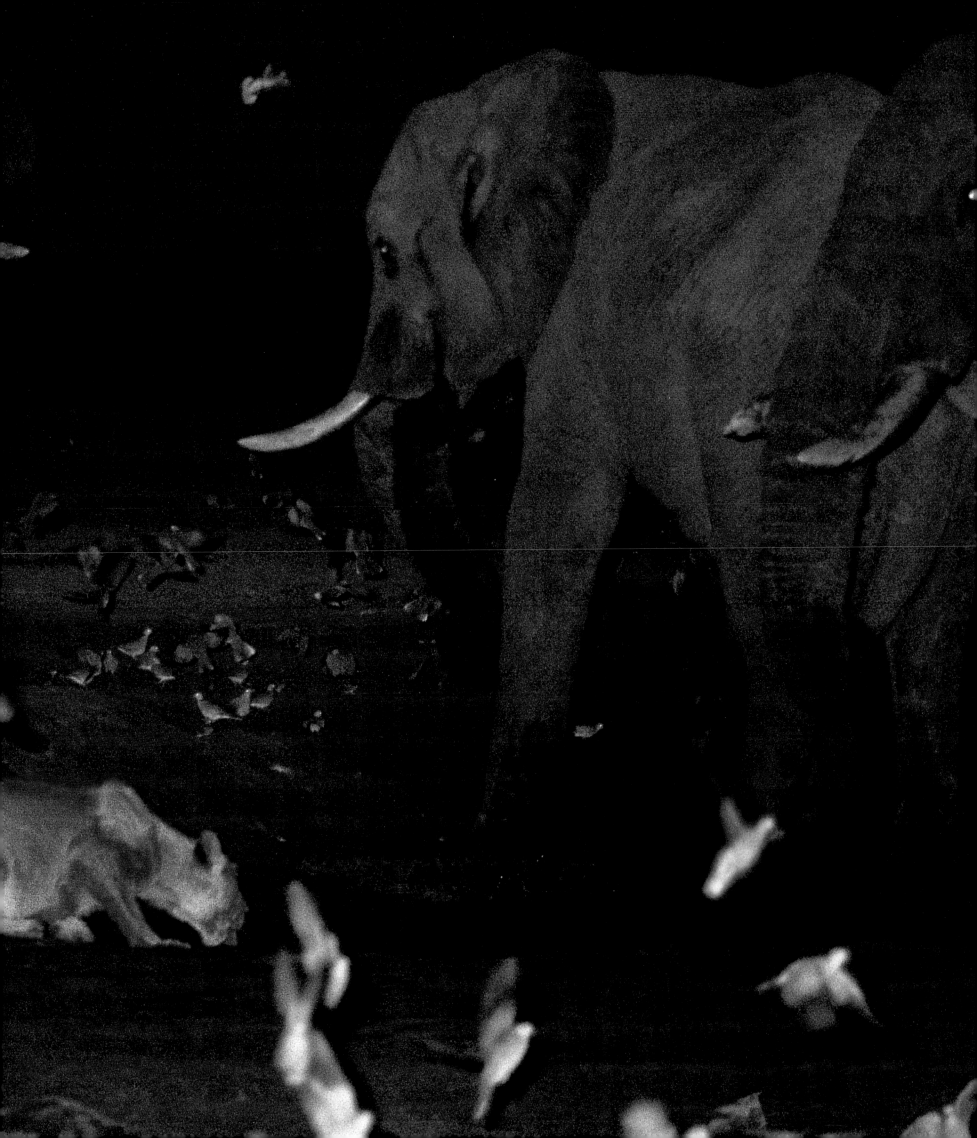

Kimberley Coast, Western Australia 1990
SAM ABELL

To photograph a "temporary note in an otherwise eternal setting is an ambition of mine," says Abell.
Here fleeting tire tracks, soon to be obliterated by tides, mark the retreat of Geographic *vehicles.*

Western Australia 1989

SAM ABELL

"It has the power of contrast," says Abell, of this photograph of gauzy mosquito netting draped from a boab limb. "I looked at thousands of boab trees until I found one that had the character I wanted."

China 1987

GEORG GERSTER

Spindly saplings attempt to hold the line against creeping desert sands of the Gobi. So pleased were Chinese authorities with Gerster's early aerials from a balloon that they approved an ambitious plan to photograph the entire country from the air— then an unheard-of liberty for a foreigner.

Minnesota 1992

JIM BRANDENBURG

The prairie smoke, or torch flower, graces a remnant of the American prairie, a subject Brandenburg has long pursued. "I'll never be finished with that story," says the Minnesota native.

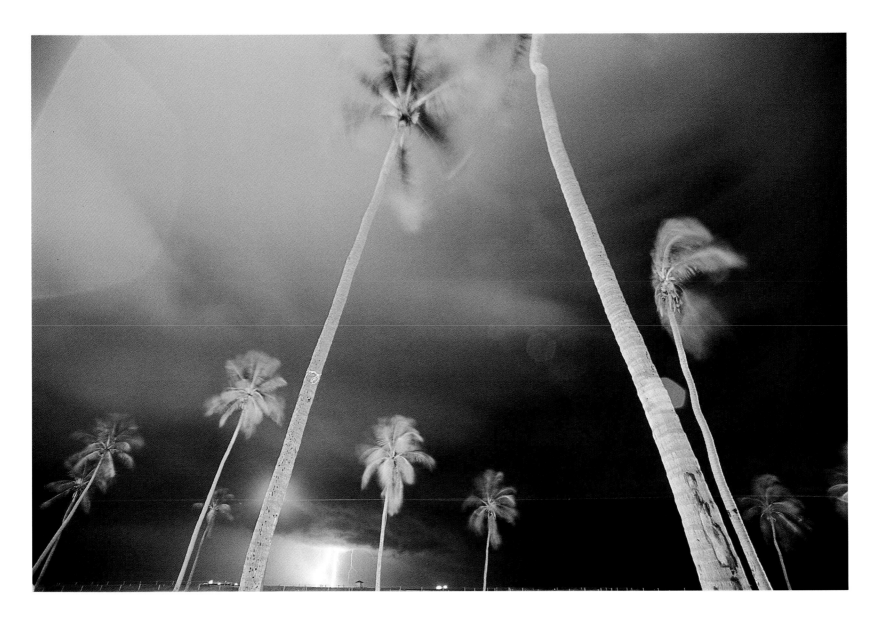

Miami, Florida 1991
MAGGIE STEBER

Palm trees shiver at an approaching storm. Steber sees this photo as a metaphor for the Miami she
covered: a beautiful city of palm trees and blue skies threatened by racial tensions.

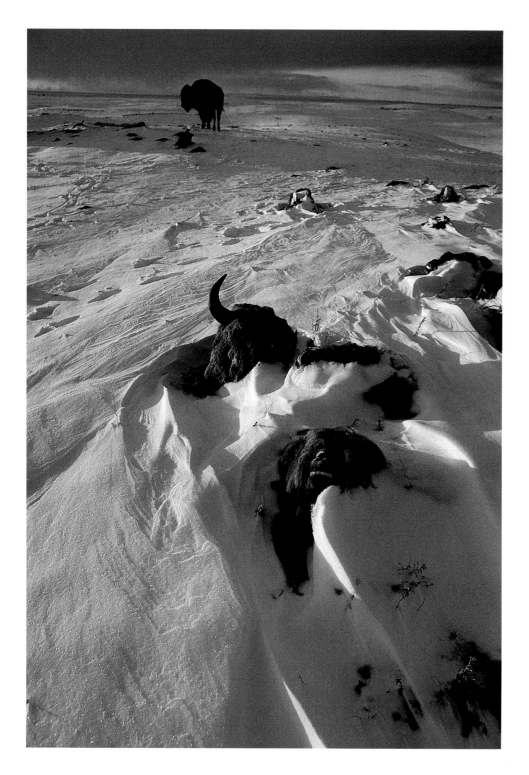

Canada 1985

SAM ABELL

Bison heads emerge from the snow at an Alberta ranch. Such skulls were symbols of the West to artist Charles M. Russell, subject of Abell's biographical story.

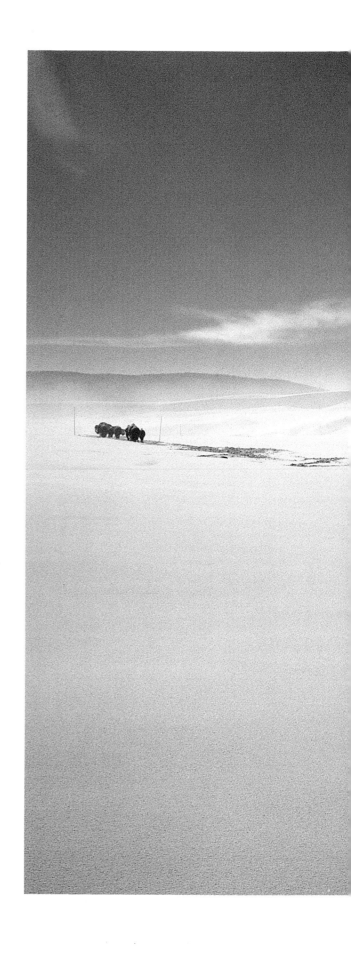

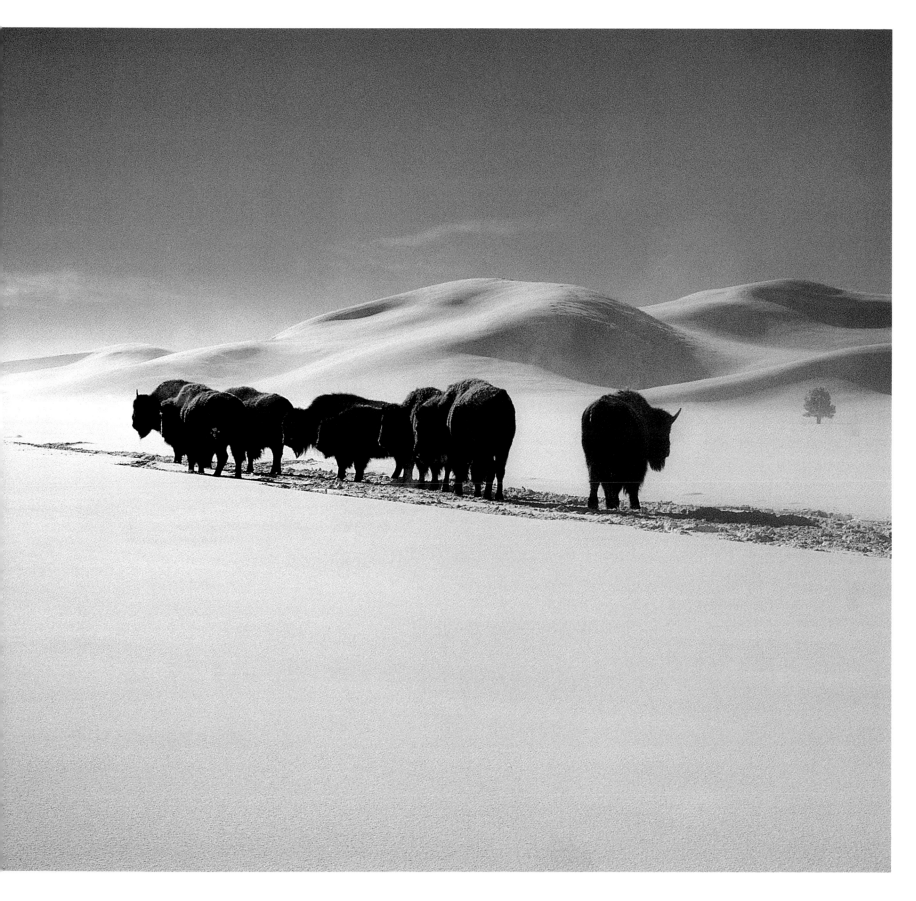

Wyoming 1978

R. STEVEN FULLER

*"Photography gives me an excuse to be out among animals," Fuller wrote of serving as a winterkeeper
in Yellowstone National Park. In a valley, a herd of buffalo stand in the cold of a February morning.*

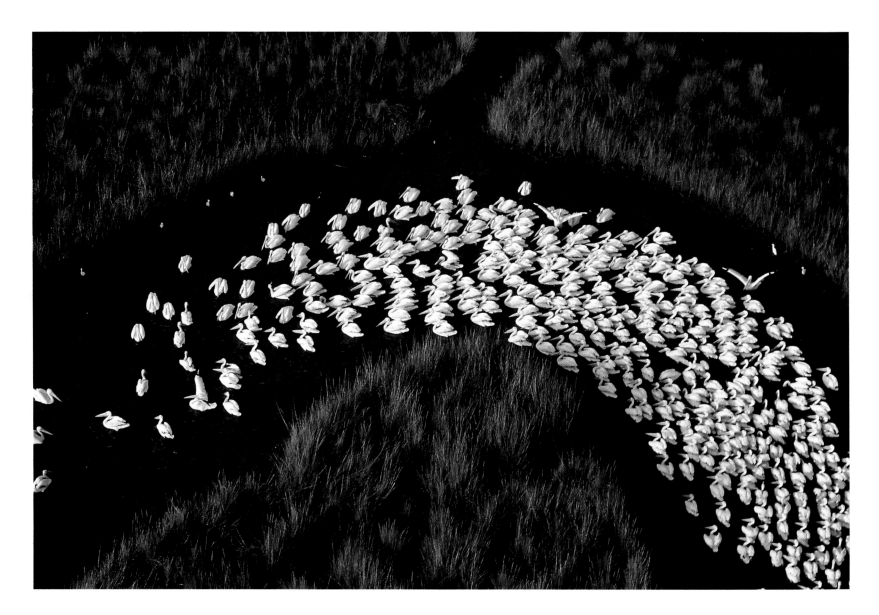

Mississippi Delta 1987

ANNIE GRIFFITHS BELT

*White pelicans rest in a delta channel. Taken for a book but not published, this photograph
languished for a few years—and won some awards—before being used in a 1992* Geographic *story.*

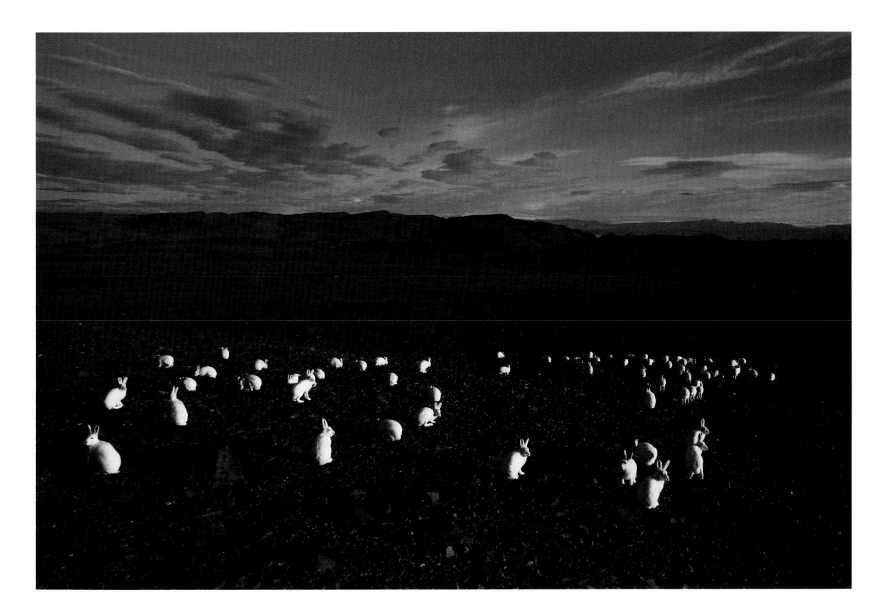

Canada 1986

JIM BRANDENBURG

Arctic hares spread out over a gravelly plain. "The Arctic tundra is one of the great untouched ecosystems left on earth," says Brandenburg. "The animals on Ellesmere Island have no fear of man."

ON ASSIGNMENT

JIM BRANDENBURG

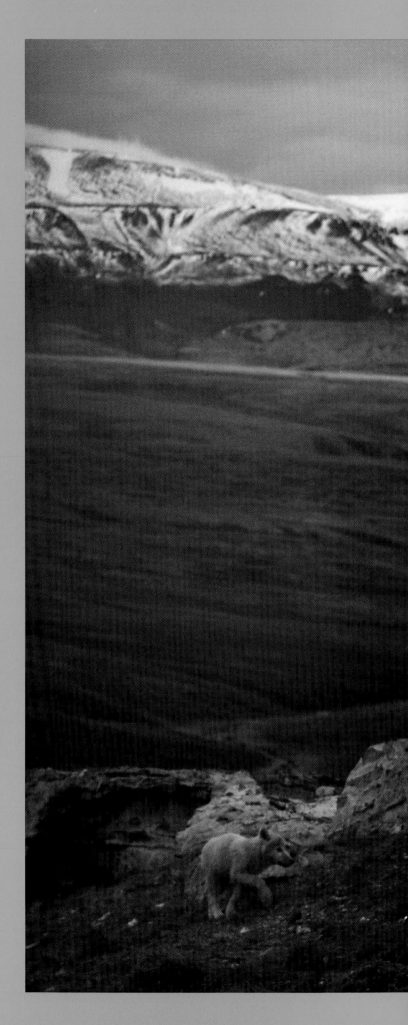

White Wolf

Jim Brandenburg had a little time to kill in March 1986, while on Canada's Ellesmere Island photographing an expedition to the North Pole. He and a companion decided to approach a distant herd of musk oxen. Four miles of walking brought them near the long-haired, ancient-looking creatures. Thrilled by the experience, they watched and photographed for several hours, then turned back toward their base.

They had separated briefly when six arctic wolves, emerging like ghosts from the dusk, startled Brandenburg. Three climbed a nearby embankment, sat, and eyed him inquiringly. His excitement made him breathe on the viewfinder, coating it with ice. He had to take off two sets of gloves in the minus 40°F temperature and scrape off the ice with his fingernail.

A few weeks later, joined by a field biologist, Brandenburg was at work on a story about all the white animals of Ellesmere (page 179). He had not been able to get the wolves out of his mind. The men set up camp near the wolf pack's den. It was high on a hillside, with rugged east and northeast views—breathtaking landscapes with sedges and poppies, streams, and snowcapped mountains. Men and wolves could watch a herd of musk oxen feeding in the distance.

The wolves were inquisitive, but wary. Brandenburg sat low and quiet. He used long telephoto

At home on Nebraska-size Ellesmere Island, members of a white wolf pack approach their den. Brandenburg and his field biologist companion became well enough acquainted with individuals in the pack to name them. This yearling male named Scruffy sometimes acted as baby-sitter while adults of the pack hunted.

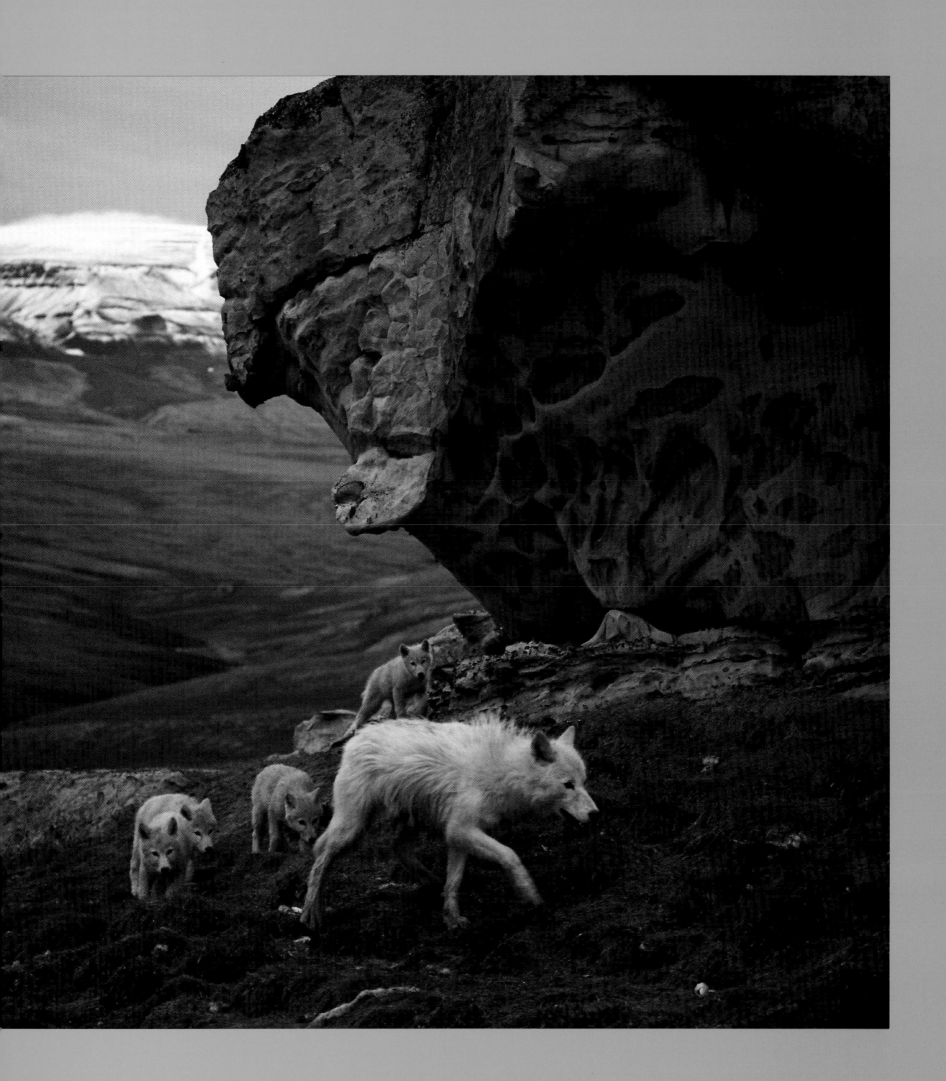

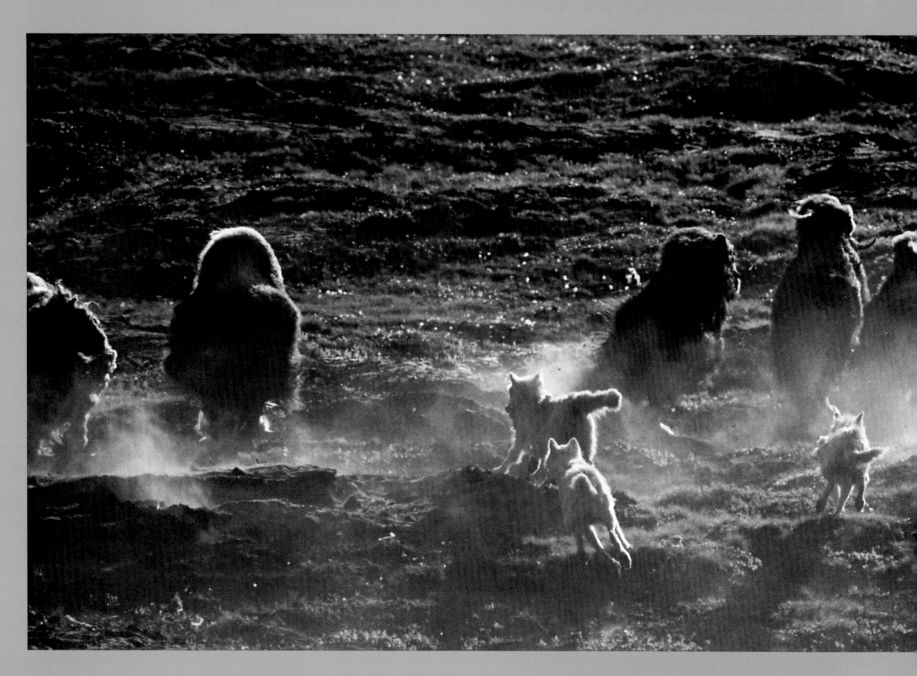

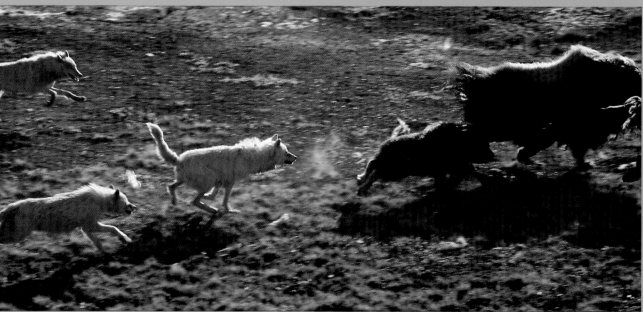

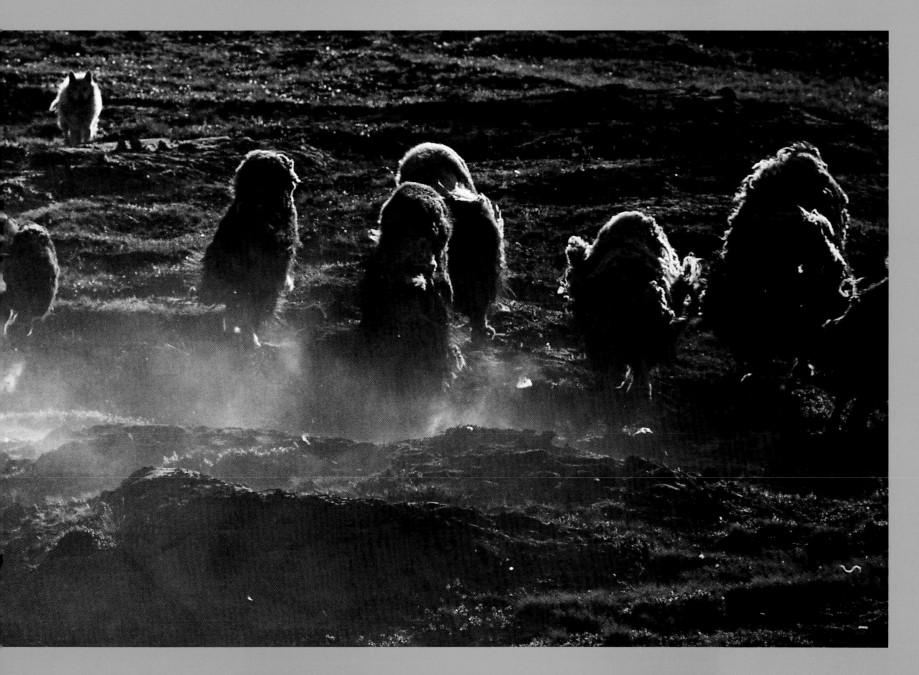

In the search for food, the wolves pursue a panicked herd of musk oxen (above). Seven wolves target three musk oxen calves, guarded by eleven adults. The musk oxen bunched in a semicircle to protect the calves. But soon the dominant wolf—Buster—closed in (left); the pack caught all three calves. One (right) makes a meal for the ravenous animals.

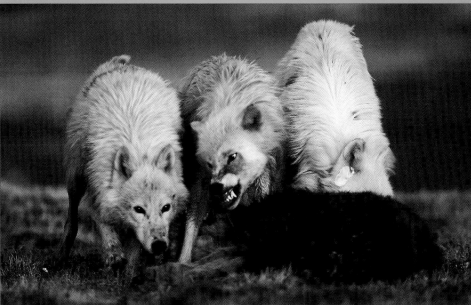

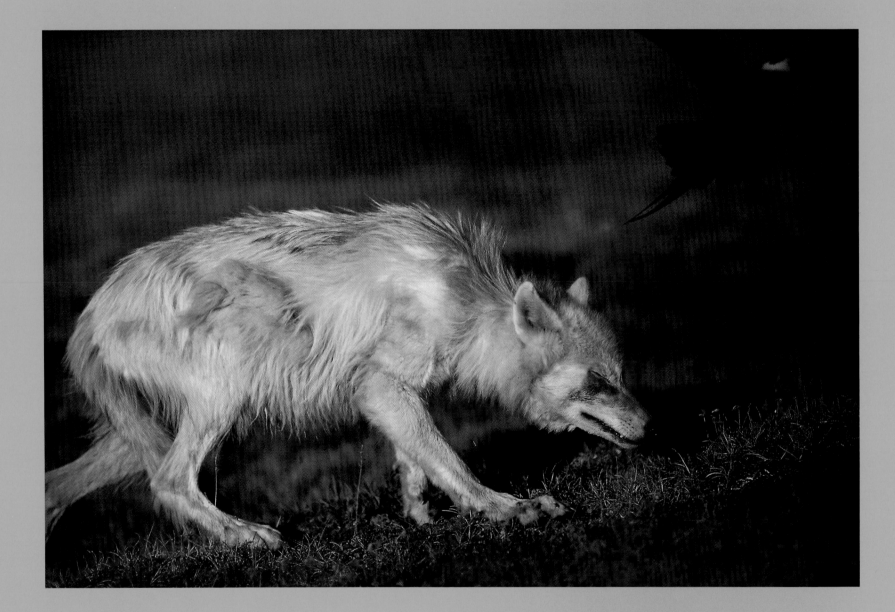

lenses—a 600-mm lens with a telextender that effectively doubled the focal length to 1200 millimeters, and an 80-to-200-mm zoom. But he wanted to take more intimate photographs of the wolves, and as he gradually worked his way closer he was able to use a 20-mm wide-angle lens.

Becoming acquainted with his subjects, he discovered a variety of distinct personalities. The pack stayed close to the den in spring, when the pups were small. Otherwise, the wolves roamed their huge territory, searching for food—musk oxen, Peary caribou, or arctic hares. Along the beach, they scavenged for char and other fish. Away from the den, Brandenburg carried his gear and followed the pack on an all-terrain vehicle.

After three seasons, the wolves became so comfortable around Brandenburg that Mom let him stick his head in the den and photograph her puppies.

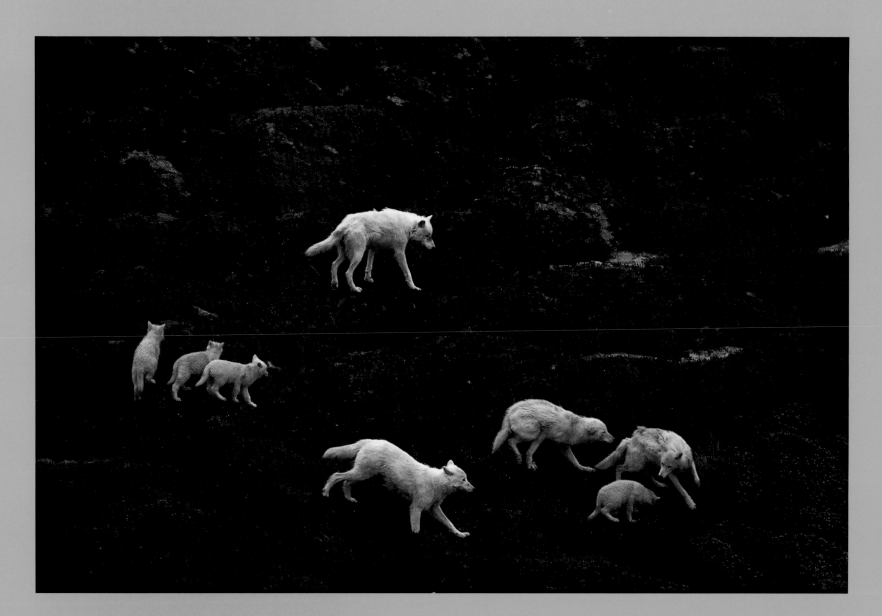

After a long sleep, the wolves would howl, possibly signaling their readiness to hunt. Each member of the pack had a distinctive voice and struck different notes. The resulting chorus, loud and discordant, could fool other wolves into thinking the pack was larger than it was. The urge to howl with the wolves tempted Brandenburg frequently while on Ellesmere, but he indulged only once. The wolves stayed agitated for a week afterward.

Predator becomes victim as a cringing Scruffy suffers an aerial attack from a long-tailed jaeger whose nest he threatened. Scruffy did not always hunt with the pack, but sought food near the den, often without success.

Learning their place in the pack's hierarchy, the pups engage adults in play that sometimes looks serious. A rigid hierarchy is crucial to wolf pack cohesion and survival in this harsh Arctic environment.

The midnight sun of a March night highlights a lone sentinel—Buster. Following the wolves, who enjoyed romping on the slopes of icebergs, Brandenburg set up two cameras—with 600- and 300-mm lenses—150 yards from this one. The windchill was about minus 70°F. To reload a camera, he had to take off his gloves; the speed of the motor drive snapped the cold film. He grabbed another roll. Meanwhile, Buster had found a shaft of light and sat for about 30 seconds. Brandenburg clicked madly. Did the wolf blink? Did the camera shake in the wind? Weeks passed before Brandenburg found he had six photographs of the lone wolf. One was just right.

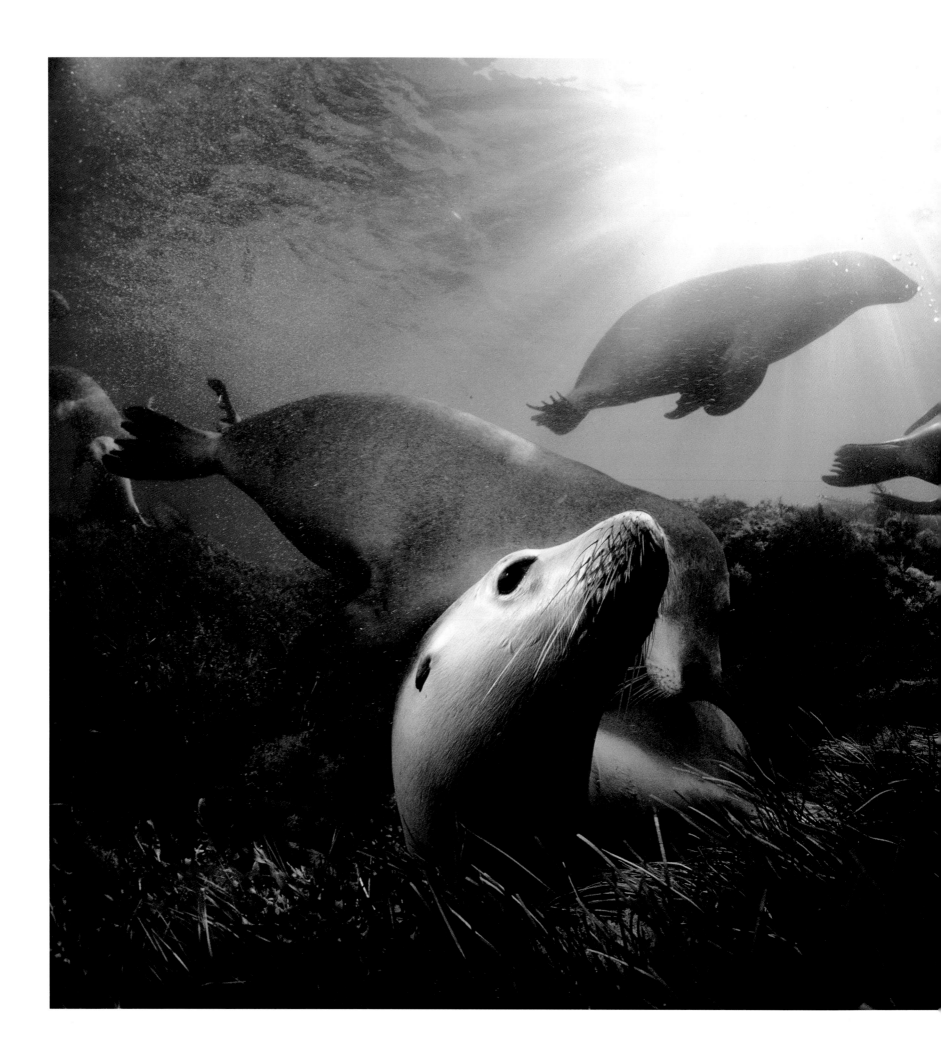

THE GREAT OCEAN OF DISCOVERY

Spencer Gulf, South Australia 1984

DAVID DOUBILET

Shafts of sunlight bathe sea lions "playing in a soft bed of sea grass, like children on a big feather bed." Doubilet knew this photograph was a success the moment he shot it.

In 1955, when Luis Marden sailed to the Indian Ocean via the Mediterranean and Red Seas in Capt. Jacques-Yves Cousteau's *Calypso,* he took one camera—he had another one shipped to him en route—and about 600 flashbulbs. He traveled relatively light, except for the flashbulbs, because the ship already carried photographic gear. There was another reason as well: Not much underwater equipment had yet been invented.

That voyage of *Calypso* marked the true beginning of color photography underwater. Though earlier successes had been recorded—the first black-and-white pictures in 1893, the first color published by the *Geographic* in 1927—this was the first time a photographer had been sent to do an entire, large-scale story underwater.

Underwater photography would prove to be the perfect enterprise for the National Geographic Society. It satisfied its goals of advancing science, exploring the planet, increasing and diffusing geographic knowledge, and putting adventure into the *Geographic.* The Society had money to invest in underwater photography—enough money to provide grants for underwater projects as well as enough money to support staff photographers and an equipment workshop and its technicians.

Beginning in 1953, the Society supported Cousteau's tropical-water research and proposed Marden's participation. By the time he went to the Indian Ocean with Cousteau in the summer of 1955, small cameras had replaced clumsy ones, but good underwater pictures had not yet resulted. Most of the camera users in those days were divers, not photographers, and, in Marden's opinion, "It was much easier to take a professional photographer and teach him to dive than it was to take a diver and teach him how to take professional pictures."

Marden took full advantage of *Calypso*'s machine shop and the ability of its engineers and mechanics to fashion gadgets at sea. Indeed, for the first extensive color series of underwater life in its natural habitat (right), Marden's equipment consisted of an "incredible rig of (literally) plastic and Scotch tape."

In the nearly transparent water off Assumption Island, about 240 miles northwest of Madagascar's tip, multitudes of brightly colored fish swam in schools and looked out from every crevice of the vast coral formations. When conditions were right, Marden, camera in hand and flashbulbs in a bag tethered to his shoulder, went down three, four, sometimes five times a day, a regimen that burned up energy. An assistant sometimes descended with him, carrying his second camera and extra bulbs.

Small flashbulbs were not yet on the market. Marden's were about the size of 60-watt bulbs, and, like all lightbulbs, they enclosed a partial vacuum, making them

Red Sea 1955
LUIS MARDEN

Sea whips, like curved white walking sticks, reach upward through a school of surgeonfish some 200 feet down a reef. Marden was a pioneer in the field of underwater photography.

sensitive to pressure. On an early dive in the Red Sea, water seeped into the bulbs' metal bases and short-circuited the lead-in wires. Cousteau came up with an ingenious solution. His crew, forming an assembly line, drilled two tiny holes in the base of each bulb. Then, with a syringe, the ship's doctor injected hot wax into the holes to insulate the wires. The team thus waterproofed about 2,500 bulbs.

At Assumption reef, Marden dived deeper. At 144 feet, 20 flashbulbs in a net bag imploded. The impact knocked him on his back. Another time, at about a hundred feet, a bulb imploded when he tried to unscrew it, shooting glass fragments straight through a heavy leather glove into his hand, severing a nerve and causing partial loss of feeling in a thumb. A Society employee found a company that manufactured women's mesh evening bags and chain-mail gloves for butchers. Marden had a glove made and stopped worrying about shattered bulbs. This was the first use of chain mail for diver protection.

COLOR PHOTOGRAPHY AT GREAT DEPTHS requires auxiliary lighting because the blue-green water progressively filters out the red, orange, and yellow colors as the diver descends. At a depth of 30 feet, red and orange become brown. "At a hundred feet," Marden remembered, "when I cut my hand on a flashbulb, the blood came out like green smoke."

Artificial light can restore the entire spectrum. But Marden wanted to do more than light up and record what was in front of him. He wanted to capture the look of daylight penetrating from the surface, to convey the sense of underwater life bathed in soft natural light. He wanted his subjects to look wet. This meant the flash must not be so strong that it overrode the ambient light, or the background would appear black, and no hint of water would come through. Artificial light, combined with blue water, looked like daylight only when Marden was at the right distance from the subject. Closer, the reddish artificial light dominated; farther away, the blue took over. For mounting his lights, Cousteau's engineers fashioned two long arms out of plastic tubing and Scotch tape. Amazingly, 85 to 95 percent of his exposures worked.

He dived with two cameras. For close-ups he had the Rolleimarin, a standard Rolleiflex in a watertight housing. It used daylight Ektachrome film and a single flash to make fish portraits. It did not have an exposure meter, but he could focus and control shutter speed. The other camera, a Leica for the broad view, used two flashes and daylight Kodachrome film. Its special wide-angle lens corrected the magnifying effect of underwater objects seen through a face mask. "My 35-mm Leica had no underwater controls for shutter speed, aperture, or focus. I could only wind and shoot. On deck I had to guess at the exposure a hundred feet down and preset everything before diving."

Nature designed the human eye—and humans, in turn, designed the camera—to function in air, not water. Water, denser than air, bends the light rays passing through it. It makes things look closer and typically, to a diver, about a third bigger. If Marden wanted to get more in the frame, he could move back. But he

Puget Sound, Washington 1970

BATES LITTLEHALES

A marine biologist wrestles a shy octopus from its lair. "The octopus decided it would rather wrestle me," Littlehales recalls. "It placed two tentacles right on the dome of the camera housing."

Mzima Springs, Kenya 1971
ALAN ROOT

As if in a dream, a 3,000-pound hippopotamus glides toward Root. Photographers Joan and Alan Root braved crocodiles to dive for the story, "Mzima, Kenya's Spring of Life."

would then have more water, more blue-green, between his camera and his subject. "You get the filtering effect," says Marden, "and, more important, all the little suspended matter." Even under optimal conditions, the water is not absolutely clear. To minimize the amount of water between camera and subject, the photographer must get close. To maximize the field of view, the photographer must move back.

Although a wide-angle lens makes it possible to move in while preserving the field of view, the lens also introduces distortion. Light rays that enter the lens at its center—the axial rays—register an accurate image while those entering at the edges show increasing distortion. "One solution," says Marden, "was to curve the glass of the underwater housing's viewing port into a hemisphere so that all rays struck the glass at right angles. Another was to use a housing lens of two elements, giving the same correction as the hemisphere. Both restored the angle of view and the sharpness of a photograph taken in air."

Since he could not develop Kodachrome at sea, Marden was working blind. Months passed before he saw his photographs. When *Calypso* docked in Marseille, he took a train to Paris. From there he sent his film to the *Geographic*. Fearing loss of everything if something happened to one package, he made three separate shipments.

He cabled the office: FIRST SUBMARINE SHIPMENT SENT PANAM NICE NEW YORK FLIGHT ONE FIVE FIVE PLEASE CONTACT AVOID HEAT TRANSSHIPMENT SAVE FILM BOXES THIS MY IMPORTANTEST SHIPMENT TWENTY YEARS REGARDS MARDEN.

The first shipment arrived at Washington National Airport on the Fourth of July weekend in hot summer weather. Lab chief Edwin L. (Bud) Wisherd rushed to the airport to pick it up, but everything was closed for the holiday. Days passed before he was able to confirm that all the film had survived the ordeal.

TO DOCUMENT COUSTEAU'S CONTINUING WORK, the *Geographic* assigned Bates Littlehales to *Calypso*. But when Littlehales first sailed with Cousteau, it was to photograph on deck only. He had to fight long and hard for the right to photograph underwater. Already an enthusiastic diver, Littlehales was impressed with the accomplishments of Marden, a good friend. "Luis had not been photographing underwater very long," he remembers. "But he was very free and generous with his information. He sort of set the stage for me to be as generous as I could."

On subsequent assignments, whenever Littlehales tried to work underwater, he was discouraged. The editors felt that one underwater photographer was enough. "I was told by Toppy Edwards, the illustrations editor, that I was not to do underwater photography. I couldn't even sign out equipment," Littlehales remembers. When he was assigned a story on the Channel Islands off Santa Barbara, California, he spent some time underwater but, lacking equipment, he could not photograph. "After that," he says, "I outfitted myself from top to bottom, including underwater camera housing, regulator, tank, flippers, mask, everything, all with my own money."

Littlehales and Marden did get an opportunity to dive and photograph together in 1958. Their assignment took them to the cenote of Dzibilchaltun, one of the

Suruga Bay, Japan 1989

DAVID DOUBILET WITH KENJI YAMAGUCHI

A bifocal view beneath snowcapped Mount Fuji captures the robot SeaROVER as it begins a dive into Japan's deepest bay. The over/under image is one of Doubilet's trademarks.

hundreds of natural wells that pock the northern Yucatan Peninsula. They raised some 6,000 artifacts and bones that gave scientists new insights into the Maya city.

"Bates and I decided one day to see how far we could penetrate into the cavern at the bottom of the cenote," Marden remembers. They found the floor of the cavern at 144 feet, spent 15 minutes there, and started up, rising in stages at the then-prescribed rate of 25 feet per minute, which, it turned out, did not take into account the cumulative effect of that day's consecutive dives.

"Within five minutes of emerging," Marden continues, "I felt a slight pain in my upper right arm." He put on a fresh tank of air and began trying to recompress, diving to 60 and then to 80 feet, and ascending by careful decompression stages each time. The pain returned. "There was no doubt now. For the first time in 17 years of diving, I had the bends."

The night before, Marden and Littlehales happened to have talked about the bends with an American engineer who was building a power plant nearby. "Just out of the blue," Marden remembers, "he said, 'If you guys ever get in trouble and need a tank for recompression, I can rig you one.'" They raced to his construction site, 30 minutes away. He made a recompression chamber from a square-sided oil storage tank. Marden climbed in, and Littlehales got in with him, though as yet he felt no symptoms.

Suruga Bay, Japan 1989

**EMORY KRISTOF,
MICHAEL COLE, AND
KEITH A. MOOREHEAD**

At 450 feet, a giant spider crab scuttles beneath the lights of MiniROVER, a remotely operated, camera-laden vehicle used for exploring depths down to 800 feet.

Tables called first for a pressure of three atmospheres, equivalent to a hundred feet of water. But before the tank reached even two, its sides began to bulge. The men climbed out and Marden entered a cylindrical tank big enough for only one. "I spent six hours and twelve minutes in that steel coffin," Marden recalls. "It was one of the least pleasant experiences of my life."

In the night, Littlehales's pains began. "They hit in the small of my back. The pain was like a dentist drilling a tooth, and I couldn't sit up," he recalled. "Now I was truly alarmed," Marden says. "If this was also the bends, Littlehales was in danger of complete paralysis." An emergency call brought a four-engined U. S. Navy plane with a fully pressurized cabin. At a Navy laboratory in Panama City, Florida, they recovered in a recompression chamber, where they spent 44 hours and 26 minutes— "figures I will never forget," says Littlehales.

Nor is he likely to forget his days in Tektite, an experimental underwater habitat named for the meteoritic nodules scattered on the ocean floor. Fifty feet under the surface of a bay in the U.S. Virgin Islands, Tektite II operated for seven months. Most of the five-person scientific research teams lived in the habitat on twenty-day shifts.

To work better underwater, Littlehales developed an improved camera housing he called OceanEye.

Inspiration for OceanEye came from Walter A. Starck II, a marine biologist. Starck had waterproofed a fish-eye lens on a Nikonos camera by covering it with a Plexiglas dome from a nautical compass. The optics improved dramatically over the flat port used up until then. Littlehales wondered if he could make a larger dome work with a variety of lenses. He convinced a friend who was connected to a Navy lab to have a prototype built of Plexiglas. It worked. Another friend, an optical geometrist, agreed to manufacture an aluminum housing.

OceanEye was the first housing that allowed photographers to use the whole Nikon system underwater. For Tektite, Littlehales even put a snout on the housing and attached a 500-mm mirror lens to his camera. "We used it as a telescope for observing fish behavior, just as birders use a spotting scope," he says. To document the habitat, he used a wide-angle 20-mm lens.

Bud Wisherd began encouraging Littlehales. The photo equipment shop refitted non-Nikon wide-angle lenses for Littlehales to use underwater and later bought OceanEyes, which remained standard equipment until the early 1980s.

UNDERWATER PHOTOGRAPHY EVOLVES from generation to generation, from photographer to photographer. Rarely can these passages be seen in a well-defined moment. But there were such moments in the careers of Littlehales and David Doubilet. They met for the first time at a convention of divers in Boston. Doubilet, who was then in his early 20s, was no novice. He began shooting underwater at the age of 12, using a Kodak Brownie Hawkeye in a rubber bag. Since college he had been selling his underwater photos to magazines. Littlehales, impressed by Doubilet's exuberance and his graphic black-and-white prints, encouraged him to work more in color and to show his pictures to Bob Gilka, the Society's director of photography. Gilka was unimpressed, and Doubilet was devastated.

Sometime later, while talking to Doubilet, Littlehales casually gave him a tip. "Bates told me that pictures have to be intimate," Doubilet remembers. "You have to shoot fish just the way you shoot children, on their level. It was as if a great bolt of lightning came out of the sky and struck me. And that was the beginning."

Another moment came at another convention, this one in San Francisco in the early 1970s. Standing in a hotel lobby, Littlehales reached into his coat pocket and pulled out a slide to show Doubilet. In green water a diver, one eye lit, is tangled up with a giant octopus. At the top of the frame, two tentacles reached forward to touch the camera, while between them a third tentacle arched back in an exquisite curl, giving the image extreme dimension (page 193). The lighting for the scene came from the upper left. It was the underwater picture Doubilet had dreamed of making.

"And it all happened in a split second," Littlehales remembers. "There is only one frame. It was over just like that."

Perfect preparation had combined with chance to create the best underwater photograph Doubilet had ever seen. "We grew up with visions of the underwater world going back to 19th-century illustrations that included sunken ships, giant

Simpson Harbor, Papua New Guinea 1986
DAVID DOUBILET

Downed Japanese Zero sprouts coralline algae. "Perfect," Doubilet calls the wreck. Most World War II
planes here either crashed into turbid water, broke up on impact, or fell upside down, he says.

sharks, octopuses," says Doubilet. "In 25 years, there hasn't been an octopus picture as dramatic or as exciting as this one."

Gilka revised his first assessment of Doubilet. "Most of the photographers who bombarded us with underwater stuff didn't know what they had photographed," Gilka recalls. "They were pretty fishes and pretty corals, pretty this, pretty that. David became one of the few to realize it was important to know what these things were, and he made it his business to find out."

Chukchi Sea 1977
BILL CURTSINGER

Streaked by Arctic sunlight, Pacific walrus swim beneath pack ice off the northwest coast of Alaska. "I specialize in elusive subjects," says Curtsinger, "that inhabit a netherworld of ice, darkness, and cold."

Not everyone whose underwater photography appeared in the magazine was an employee. Some helped out on occasional stories. Others were given research grants by the Society. One recipient, Harold E. Edgerton, MIT inventor of the high-speed stroboscopic flash, got a grant to build his first remote-control undersea camera.

Edgerton, who became interested in underwater photography around 1948, eventually concentrated on unmanned cameras that could be used in the cold, dark water below the 200-foot depth considered safe for divers. Littlehales and Edgerton, who was refining his deep-water strobes, met on *Calypso* in 1956. "We would hang out together," says Littlehales, "mostly because we were the two Americans on board. He was a clear person, simple in the best sense of simplicity. He just went right to the heart of every problem. I loved to watch him tinker."

Geographic photographer Emory Kristof, who worked with an Edgerton disciple in the mid-1970s, knew Littlehales and Marden well but had not worked with them. "I had the utmost respect for both of them," he says. "I looked at what they did in the water and thought, 'I can do that,' and copied it. That was my learning process." His first published underwater picture was made in Lake Champlain. The photo showed two heavily lit divers handling an unexploded 18th-century shell. "The water was polluted," he recalls, "and I got sick and nearly died."

In 1974 he was assigned to Project FAMOUS—French-American Mid-Ocean Undersea Study—to cover the first manned probe of the Mid-Atlantic Ridge. He was appalled at the low quality of existing deep-sea photography. "If we could just apply what we knew about shallow-water photography to deep water," he thought, "we would make a really major contribution to the quality of science being done—and get a whole new set of images."

Kristof worked frequently around shipwrecks but yearned to record more deep-water biology. He got a chance in the mid-seventies when he was assigned to work with scientist Robert D. Ballard on a story about a recently discovered phenomenon a mile and a half below the surface of the Pacific: Strange vents on the ocean floor, in the Galapagos Rift west of Ecuador, were spewing plumes of hot water. Scientists on

the surface, using towed instruments, had detected the vents. Ballard and Kristof wanted to go down and see them close-up.

The Society provided a research grant, as well as cameras, color film, shipboard processing, and a projector for on-the-spot viewing and evaluation. To prepare for the project, Kristof began a collaboration with Alvin M. Chandler, a World War II submariner who had become a photo engineer in the Society's equipment shop.

Kristof wanted to attach bait to his camera to attract the animal life he was sure would cluster around the vents. When the idea was transformed into a camera package, he and Chandler decided to test it during a search for the Loch Ness monster in 1976, an event sponsored by the Academy of Applied Science and the *New York Times.* The *Geographic* also assigned Doubilet to the project.

Kristof dropped his camera rig, studded with floodlights and strobe lights, 30 feet down, anchored it, and held it upright with buoys. He attached dead fish to the rig for bait and trailed containers of blood and fish scent at various depths. Low-frequency sound simulations of distressed fish were broadcast.

Key among the devices Kristof wanted to test was a sonar trigger sensitive enough to snap a picture after detecting a slight nearby movement. But the trigger was too sensitive. The shutter opened when nothing was there, and Kristof repeatedly found that his film was blank. "My whole project was built upon this camera working with this sonar trigger," he says. "I was panicked and depressed."

One midnight, he wandered into the former horse stable that housed the equipment. There were Chandler and a stranger huddled over a table, the parts of the sonar trigger spread before them. Chandler had met the man, a Scottish engineer, at a pub and had told him about the trigger problem. About 3 a.m. they found a design flaw and began solving the problem. "Even though we didn't find the Loch Ness monster," Kristof says, "we showed that the camera system worked." An eel triggered the shutter, "and we published the most expensive picture of an eel ever made."

For the descents to the Pacific vents in 1977 and 1979, Kristof used his baited camera to attract fish. He also was among the first people ever to see the expedition's greatest discovery: Around the vents were clumps of giant clams and thick clusters of tube worms several feet long, both new to science.

ASK BILL CURTSINGER why he often works in icy waters and he replies: "I specialize in elusive subjects that inhabit a netherworld of ice, darkness, and cold." He learned his craft in a Navy diving photographic unit in the mid-1960s and was ordered to Antarctica to photograph the scientific work being done there. In December 1970 his

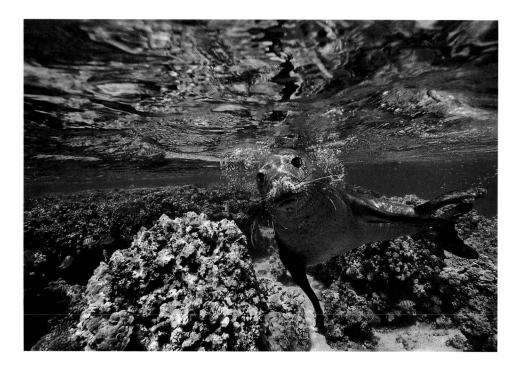

French Frigate Shoals, Hawaii 1991
BILL CURTSINGER

A Hawaiian monk seal, one of only some 1,500 surviving, swims among corals in the Northwestern Hawaiian Islands, its only sanctuary.

portfolio won him an assignment from the *Geographic* to shoot a story he had proposed on Antarctica.

Since then he has been photographing animals of the sea—walrus swimming under pack ice (page 200), Hawaiian monk seals (page 201), harp seals in ice-filled 28.5°F seas off Canada's Magdalen Islands (page 212-13). And, on assignment in the Caroline Islands, he met a gray reef shark.

"I was snorkeling in a lagoon and I looked up and saw a shark coming at me," he remembers. "I tried to fend it off with my hand, and it bit me." He reached the surface, yelled for the dive boat, and was swimming frantically toward it, each stroke leaving a cloud of blood in the water, when the shark hit him again, raking his shoulder with its teeth. He scrambled aboard a dinghy. It took him a summer to recover. "As a result, I probably look around more than most people," he says.

Curtsinger is quiet and is "a lot like the sea," says Joe Stancampiano, a Society equipment specialist. "You look at him on the top and he's very calm, like pretty waves, but underneath, he's going all the time. He's an excellent diver, tough as nails."

Stancampiano started out as a kid building bicycles out of parts. When he could not find a needed piece, his father, a mechanical engineer, would not give him the money to buy it. "He would say, 'Here's a piece of metal. Here's a drill. Here's a file. Make it,'" Stancampiano recalls. "He would make me sit there for half an afternoon making some silly bracket or something that I could have just walked off and bought. But because of that I can make anything out of anything." He has stripped parts out of cars for emergency use in cameras. He has made two broken cameras into one. He is a miracle man in the field.

Stancampiano's job usually begins when an underwater photographer explains what kind of picture he needs. Stancampiano builds the equipment in the Society shop and then goes to sea with it and the photographer. At Curtsinger's request, for example, he designed a camera rig to photograph the sharks of Bikini Lagoon.

The rig looked something like a torpedo, with fins on the back and a dome housing a video camera, which was plugged into the rear of a still camera and served as a viewfinder. A fishing line was strung through a tube beneath the device. When a fish bit, a crew member drew up the line to within about a foot of the camera. Curtsinger, safely out of the water, watched on the video camera's color monitor, ready to release a shutter toggle when he saw what he wanted.

"We watched," says Stancampiano, "and saw one gray shape. Two, five, seven, twenty. All of us were yelling, 'Let the fish out a little more, pull the fish in, pull the fish in, the sharks are coming!' It was total bedlam in the water. It worked beautifully" (pages 218-19).

Stancampiano does not usually go out with Flip Nicklin. Stancampiano hates the cold, and Nicklin likes to work in the polar regions. And luckily Nicklin has the mechanical skills to keep equipment functioning on his own. Nicklin's father, Chuck, had been Bates Littlehales's diving partner, and, as a teenager, Nicklin learned from a master. Later, he worked as Doubilet's assistant. "He's the only guy I know who can

Red Sea 1991
DAVID DOUBILET

A school of glassy sweepers turns at once, "making the sound of a bed sheet flapping," recalls Doubilet.
After years of diving in the northern Red Sea, he found "new wonders in its southern depths."

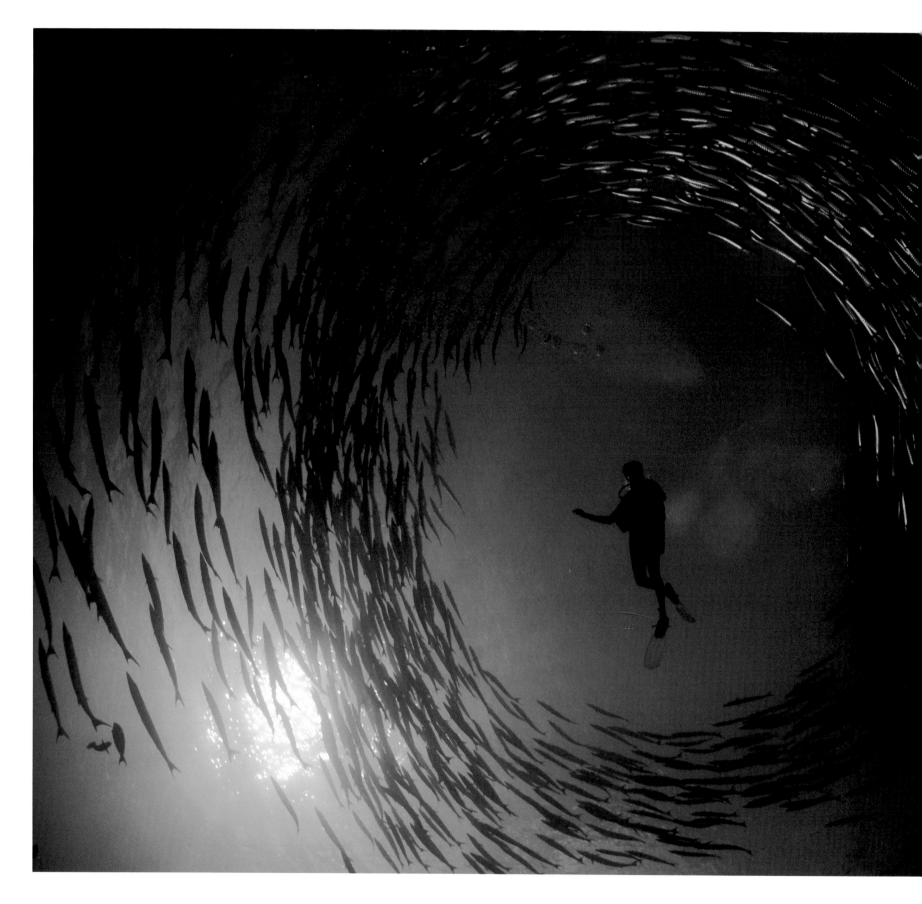

New Hanover Island, Papua New Guinea 1987
DAVID DOUBILET

*Silvery-skinned barracudas form a perfect circle around naturalist Dinah Halstead. "She was in the
middle of a magical dance," says Doubilet. "It was one of my most wonderful moments in the ocean."*

go out and sit on an ice floe for four months and come back with twenty rolls and know he's got a story," Doubilet says.

Nicklin will use any technology that does the job, as long as it works in freezing temperatures. He can only stay underwater 30 minutes before his hands get too cold to work. He spent five seasons at the edge of the Arctic ice, photographing animals ranging from tiny krill to whales, his favorite subject. They starred in what he calls his dream assignment: "It's like the old days when the *Geographic* said, 'Take two years and do India.' They told me, 'Take 18 months and do whales.'"

David Doubilet needed the equipment shop and the help of Littlehales to develop one of his trademarks, the over/under photograph that shows half a scene above water and half below. It cannot be made simply by partially submerging an ordinary camera. A lens half in water and half in air makes one section of the picture blurry, the other sharp.

The split-field 85-mm and 20-mm wide-angle lenses devised by Doubilet and his colleagues have two parts: diopters that adjust for the different refractive qualities of air and water, and graded neutral density filters—darker on top and lighter on the bottom to compensate for the variation in light above and below the surface.

Doubilet's most sophisticated over/under photograph—made with the help of Stancampiano and Kenji Yamaguchi of the equipment shop—was taken in Japan's Suruga Bay (page 196). "I wanted to photograph Emory's remotely operated vehicle going underwater with Mount Fuji in the distant background," says Doubilet. "We had to develop a technique for splitting the field in the lens." They masked the film, cutting a matte and placing it across the film plane, then covered the top half of the frame, photographed a series of halves, wound the film back, moved the matte down, and shot the other half.

"The sea is visually the most complex, confusing place on earth," Doubilet says. "A coral reef has more color, especially when you light it, than any other place. It is a Jackson Pollock painting come to life." He learned to simplify the visual chaos. "I wanted to make pictures of the ocean, the creatures, the environment, the color, and the light. And I also wanted to photograph gesture. Gesture is behavior, fish actively living their lives," he says. "It's the hardest thing to photograph."

On assignment in South Australia, he waited out two weeks of bad weather. Finally, on an afternoon when the sea turned flat and calm, he and his companions made a dash to the sea lion colony in Spencer Gulf. When he slipped into the water, unusually clear that day, he saw shafts of light. The light showed sea lions "playing in a soft bed of sea grass, like children on a big feather bed. They were in constant motion," he remembers. "All of a sudden, they made a terrific, ballet-like movement, and I shot the picture. And I knew I had it" (pages 188-89).

Like his colleague Nicklin, Doubilet was a diver first and then he was a photographer. "We all have that one thing in common for a very simple reason," he says. "The sea demands too much knowledge and too much skill for a photographer to just plunge in."

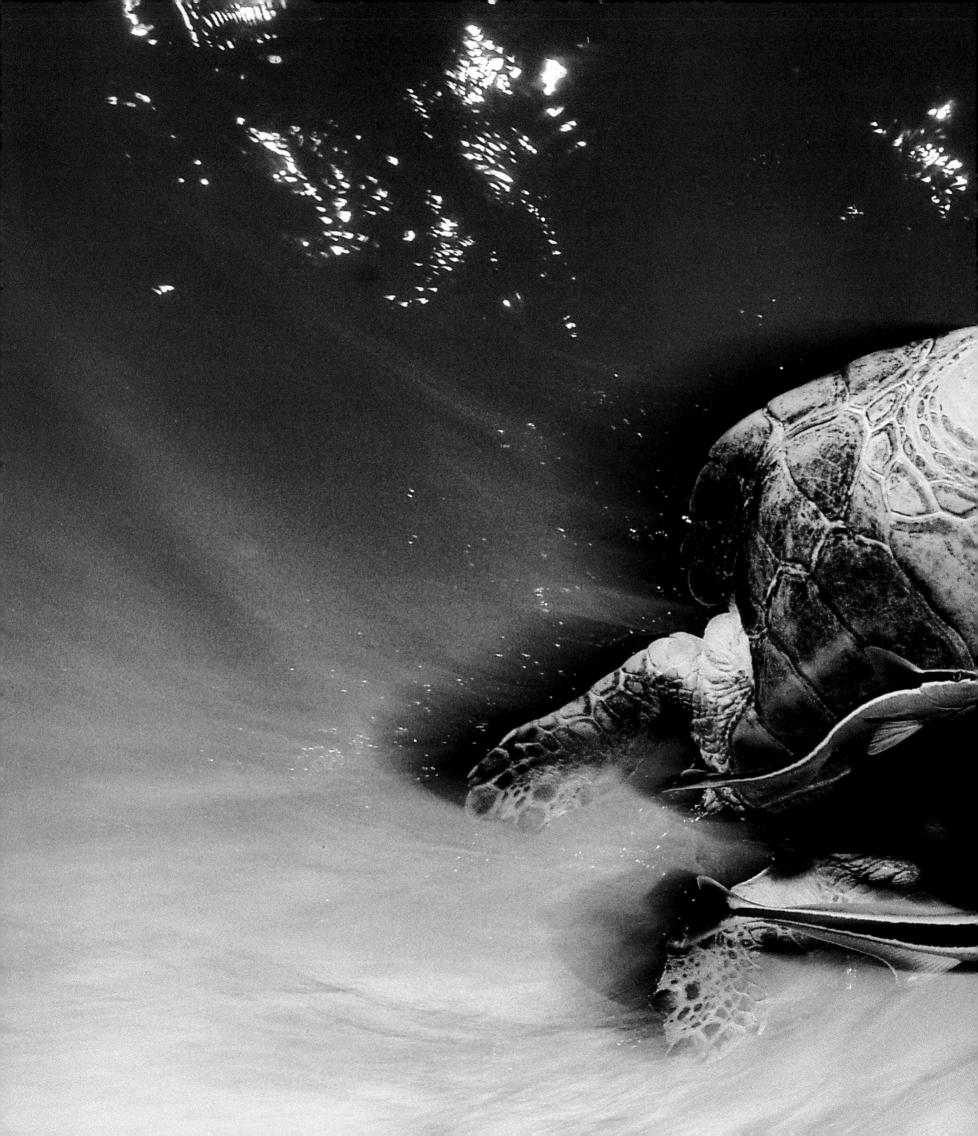

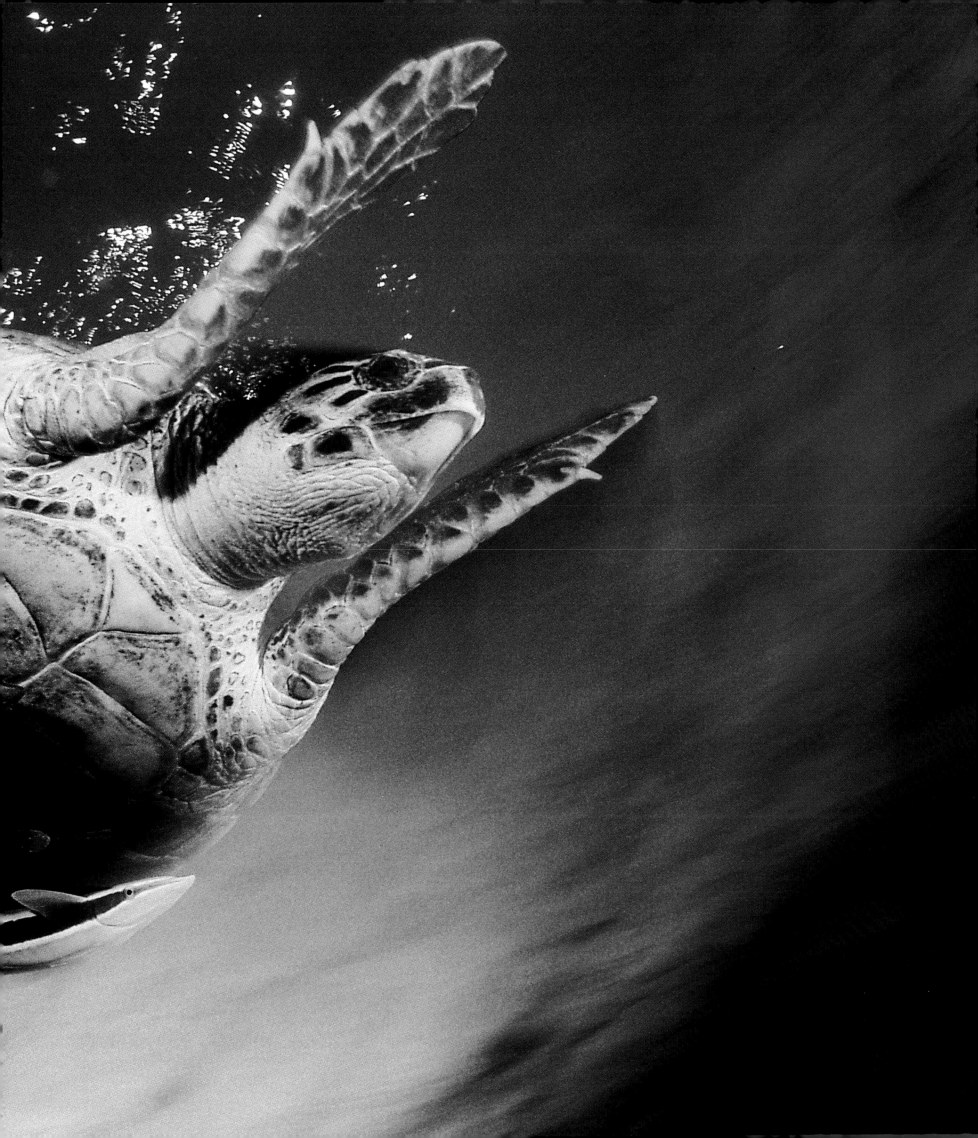

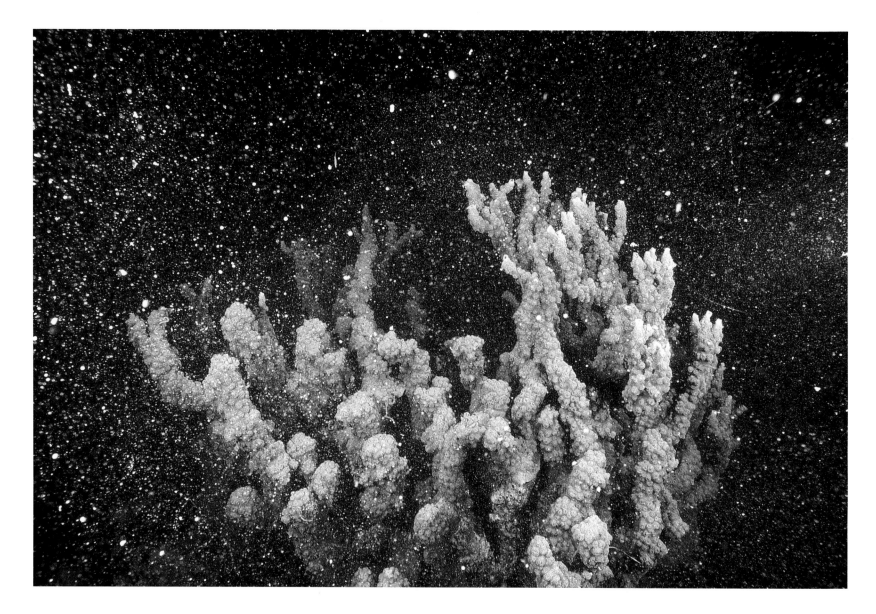

Ningaloo Reef, Western Australia 1990
DAVID DOUBILET

Like confetti, spawn swirls from the branches of a hermaphroditic coral. The spawning occurs in an explosion each March. "One of the most astonishing shows in nature," a scientist told Doubilet.

preceding pages: Gulf of Aqaba, Red Sea 1991
DAVID DOUBILET

A strobe and slow shutter at twilight made this hawksbill turtle "appear to fly through the darkening water," Doubilet says. He compared the turtle's swimming to a human doing the breaststroke.

Milne Bay, Papua New Guinea 1987

DAVID DOUBILET

A school of purple anthias glides past a yellow damselfish and the sculptural form of chalice coral.
Waters here teem with perhaps a thousand species of corals and some two thousand species of reef fish.

North Sound, Grand Cayman 1988

DAVID DOUBILET

"Gentle, wondrous birds of the sea," Doubilet calls these graceful stingrays flying through crystalline waters. "When I raised my camera half out of the water, I had a vision of stingrays and clouds."

Eil Malk, Palau Islands 1980

DAVID DOUBILET

Stingless jellyfish envelop biologist William M. Hamner in a seawater lake. "I glanced at Bill, who was reaching out toward a tiny jellyfish. He was joyously engulfed in a living cloud," says Doubilet.

Magdalen Islands,
Canada 1975

BILL CURTSINGER

*A harp seal's body language
—head up, flippers extended
—warns Curtsinger off.
He photographed the
animals by helicoptering day
after day far out onto the ice,
donning a dry suit, and
plunging into the frigid
waters. Visual observations
of harp seals in their natural
environment are rare.
Curtsinger's photos were
"a notable contribution to
our knowledge," said
the scientist who wrote "Life
or Death for the Harp Seal"
for the magazine.*

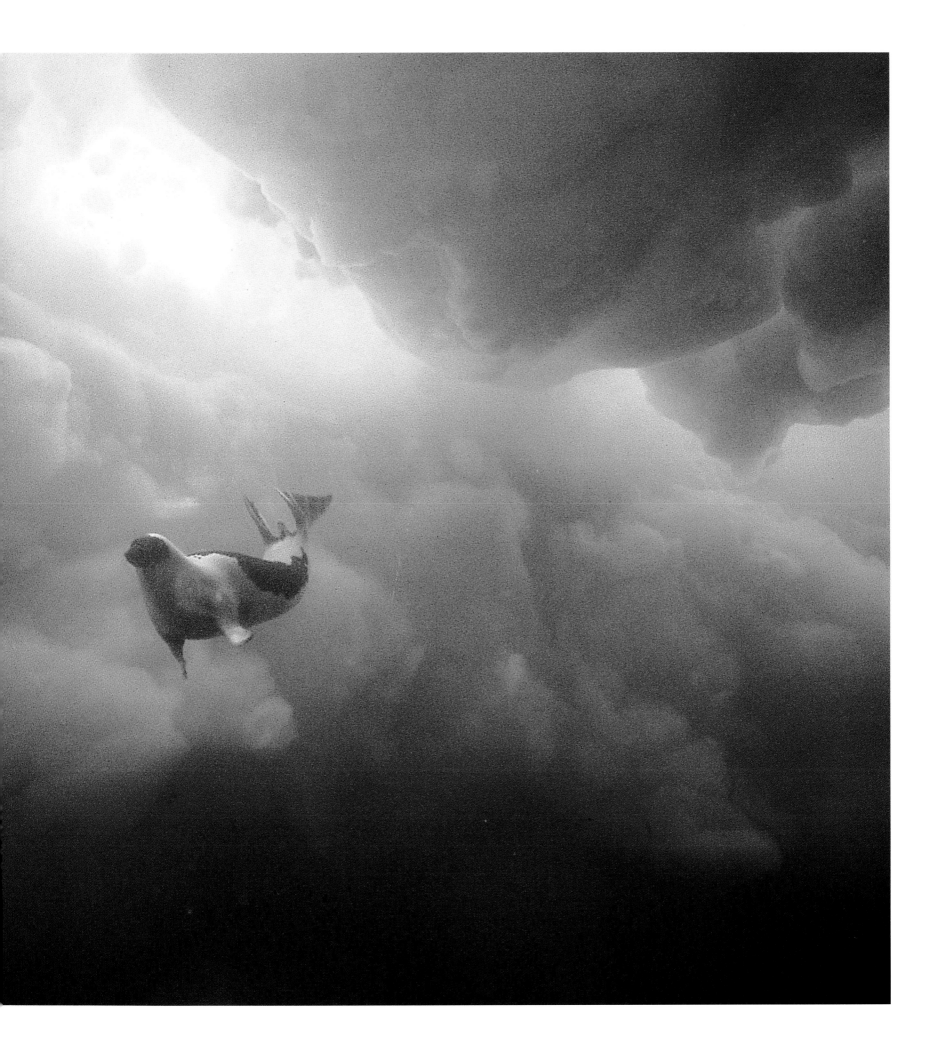

McMurdo Sound, Antarctica 1984

BILL CURTSINGER

Starfish feed near Turtle Rock. Curtsinger calls McMurdo "among the last of the divers' underwater
frontiers. There seems no end to the interesting and beautiful forms of marine life here."

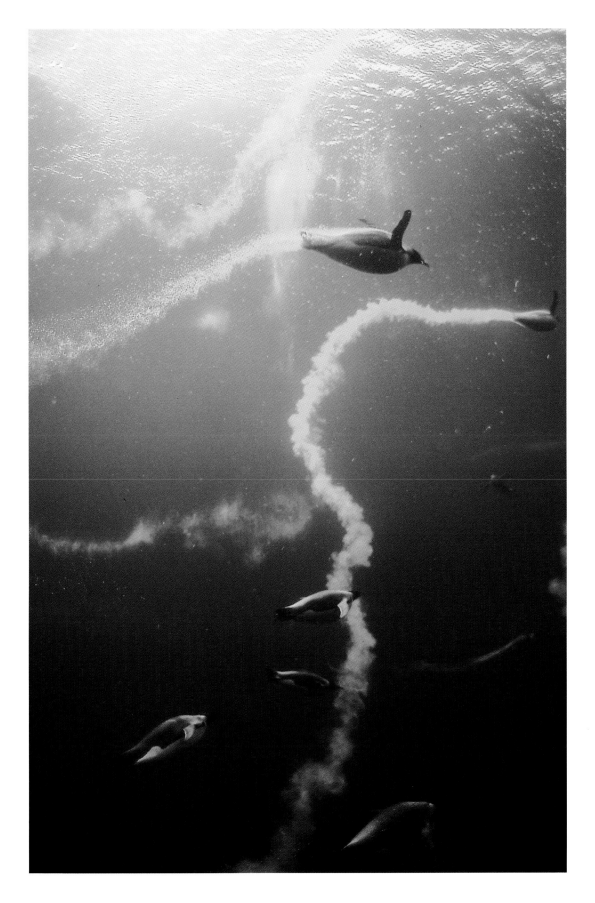

McMurdo Sound, Antarctica 1984

BILL CURTSINGER

Contrails of air bubbles escaping from their feathers make penguins look jet-propelled. "In spite of the cold," Curtsinger notes, "these were some of the most fascinating dives I have ever made."

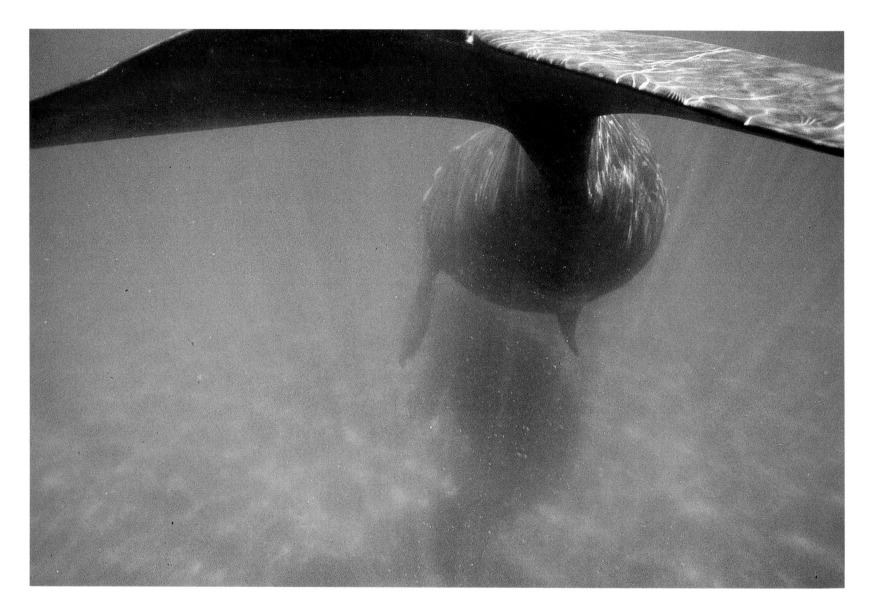

Patagonia 1971
BILL CURTSINGER

A southern right whale leaves Curtsinger in its wake. His photographs were the first published of a large whale underwater. "I wanted to capture the graceful majesty of so huge a beast," he says.

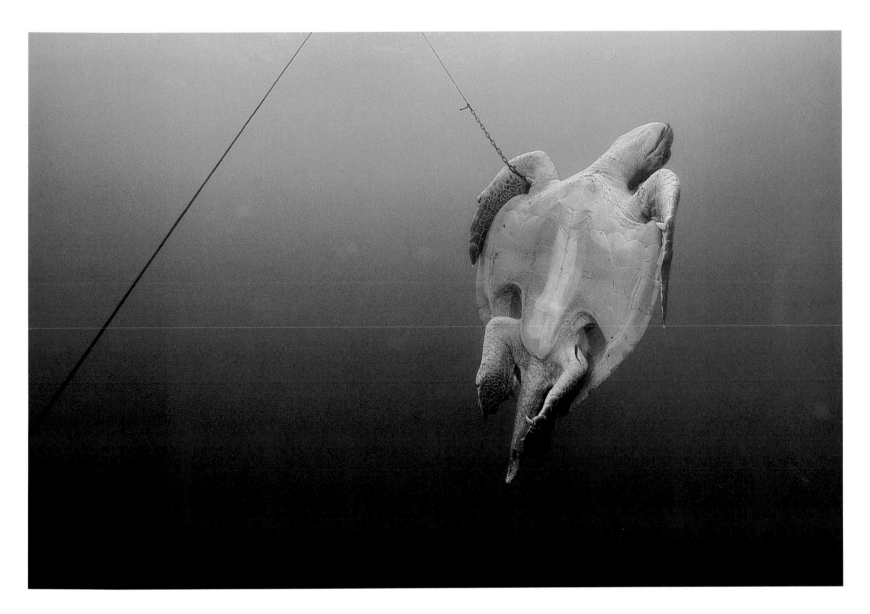

Costa Rica 1991

BILL CURTSINGER

"Losing an adult sea turtle is like breaking thousands of eggs on the beach," a marine biologist once said. This male olive ridley succumbed senselessly—and poignantly—to a longline set for sharks.

Bikini Lagoon,
Marshall Islands 1990
BILL CURTSINGER

*A frenzy of gray reef sharks
feed near Curtsinger's boat,
evidence of the return of
marine life to the once
radioactive Pacific lagoon,
site of 23 nuclear blasts
between 1946 and 1958.*

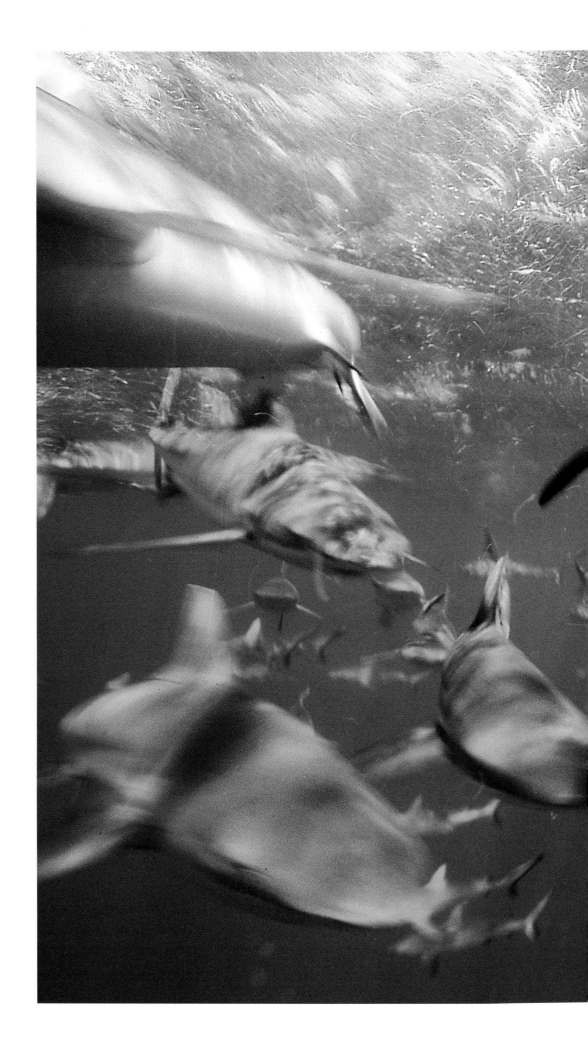

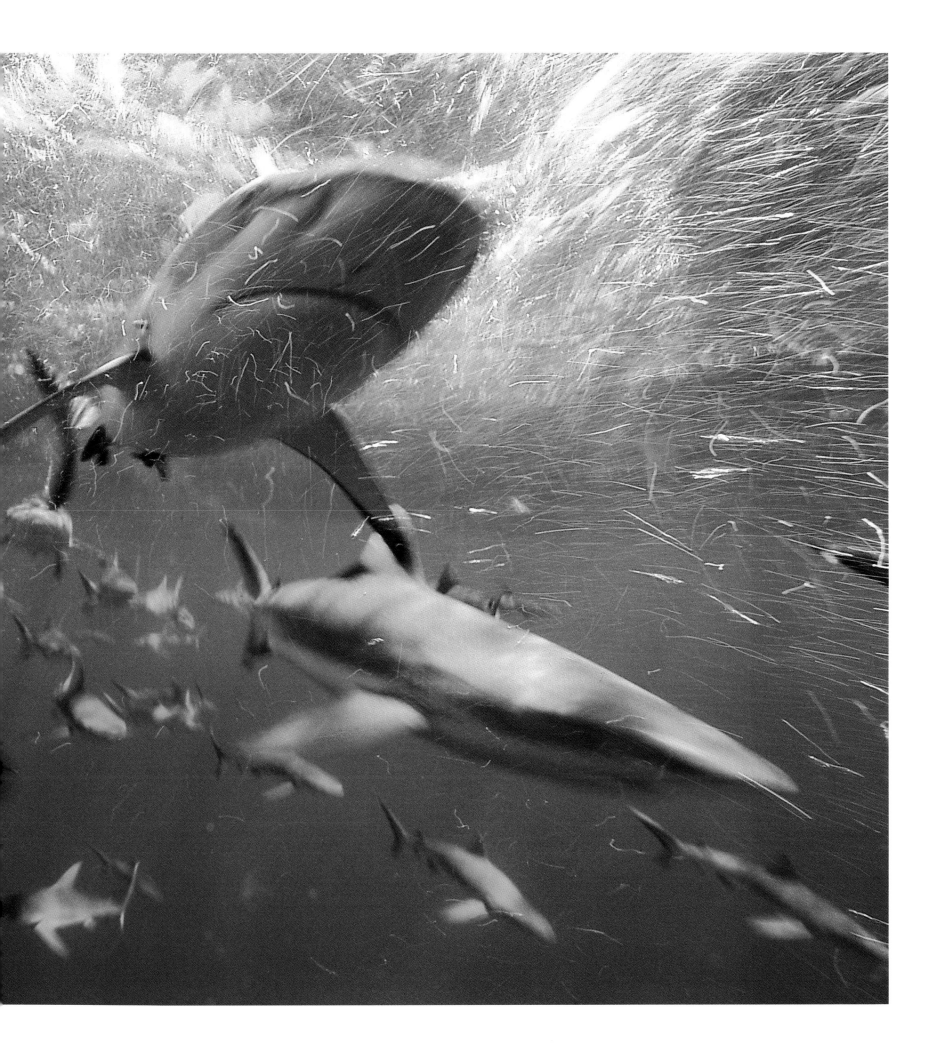

Antarctic Peninsula 1971

BILL CURTSINGER

Eyes of a leopard seal glare through a veil of plankton 120 feet beneath the surface.
Curtsinger made this arresting portrait while the seal was repeatedly striking at his strobe.

McMurdo Sound, Antarctica 1984

BILL CURTSINGER

Otherworldly in her solitude, a diver drifts beneath sea ice. "She is in a dark, cold, forbidding, and unforgiving world," says Curtsinger, "as far from human help as one can get on this planet."

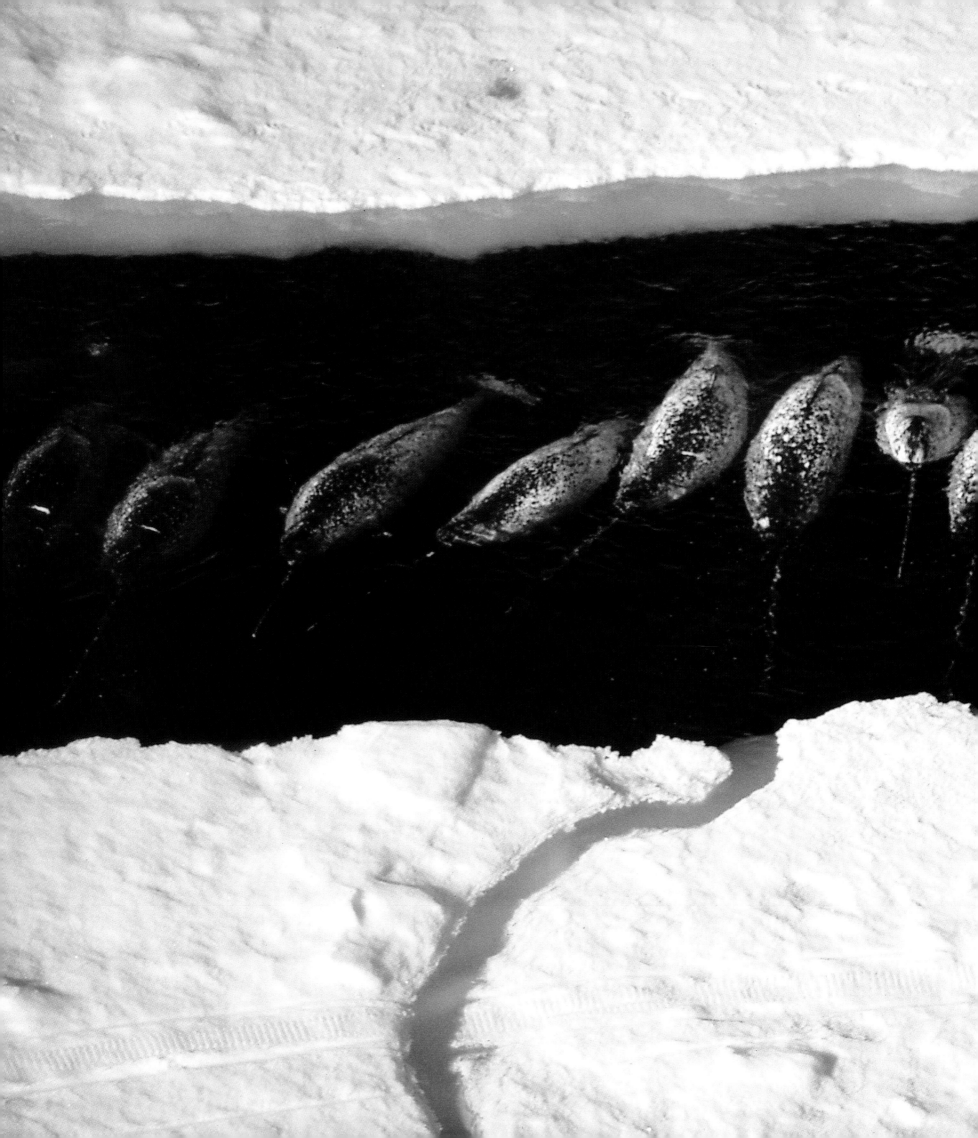

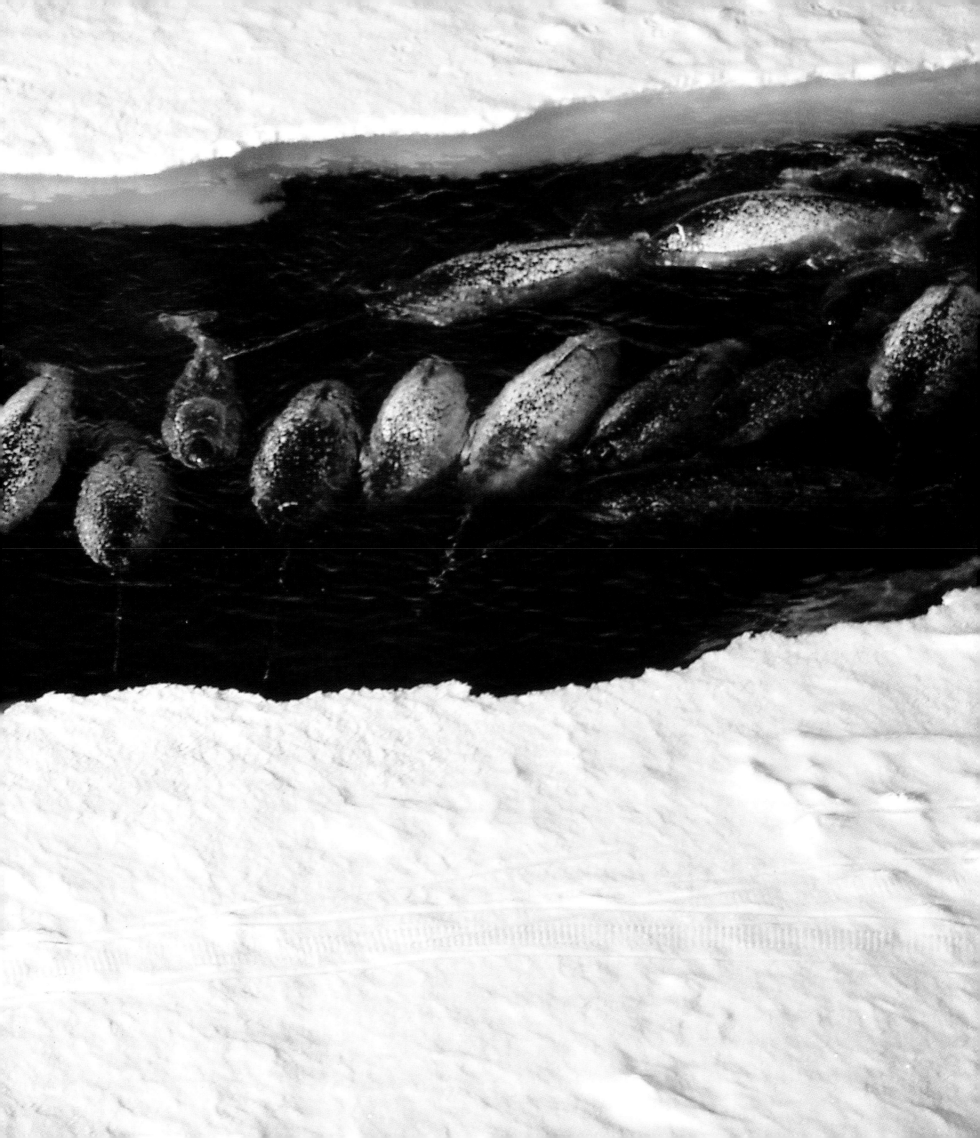

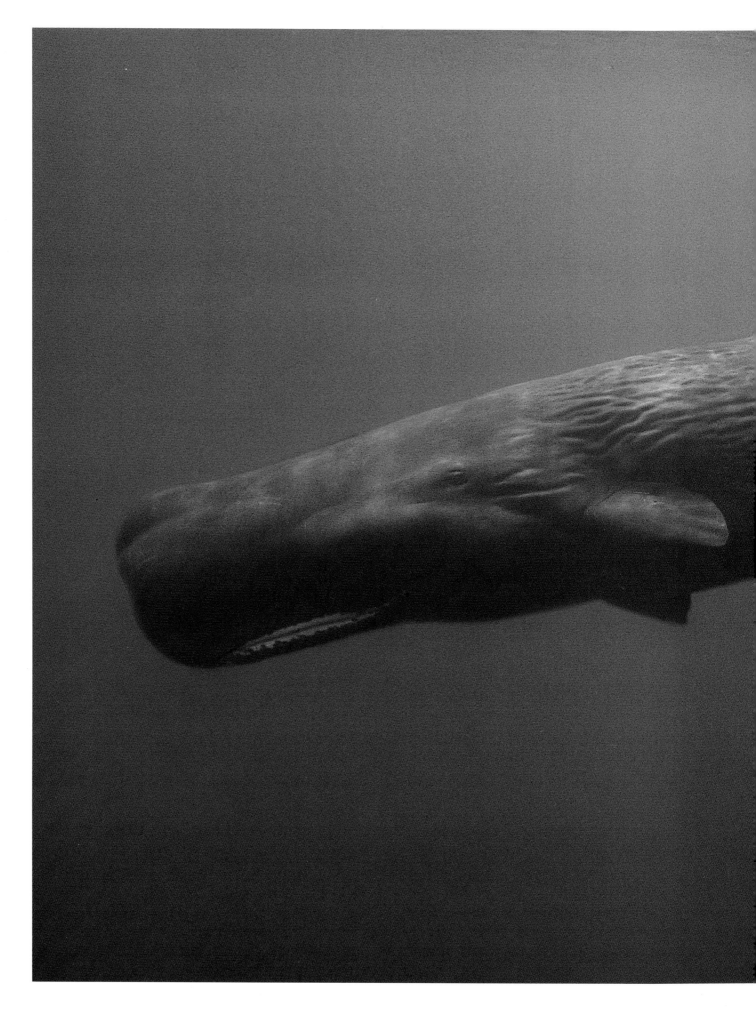

Indian Ocean 1984
FLIP NICKLIN

A sperm whale, long the target of whalers, swims gracefully by. As relentless as Ahab, Nicklin specializes in photographing whales. Because the animals dislike bubbles from air tanks, Nicklin sometimes free dives to photograph them as deep as 70 feet.

preceding pages:

Lancaster Sound, Canada 1987
FLIP NICKLIN

Nicklin's patience in polar regions is legendary among his colleagues. It pays off with such rare photographs as this aerial view of male narwhals lined up in a narrow lead—perhaps driven there by killer whales or Inuit hunters.

EMORY KRISTOF

The Titanic

Dribbling icicles of rust, the still graceful Titanic *prow rests two and a half miles down on the floor of the North Atlantic, where it settled after striking an iceberg on April 14, 1912. Emory Kristof succeeded in photographing the wreck's long-lost remains.*

Encased snugly in a blimp-shaped steel submersible, Emory Kristof sank two and a half miles down to one of the deepest graves on earth. It was the summer of 1991, his third trip to the vicinity of R.M.S. *Titanic*, and he had worked for this trip, yearned for it, for 17 years.

Just to keep human beings alive in the *Titanic*'s abyssal resting place required complicated, expensive technology. And to create conditions suitable for photography meant facing nearly insurmountable problems.

But obstacles never stood in the way of Kristof for long, so when he sensed the time was right, he schemed and lobbied to get the support and technology to photograph the wreck.

Kristof had taken the first step in 1978. Near the wreck, 350 miles off Newfoundland, Kristof and photo engineer Al Chandler dropped a camera to the seafloor to check the water's turbidity. Theoretically, constantly churning currents would make it impossible to see anything, but Kristof's experiment showed a hundred feet of visibility.

At the time, the wreckage of the *Titanic* had not yet been found. With Society support, Robert D. Ballard of the Woods Hole Oceanographic Institution, working with French scientist Jean-Louis Michel,

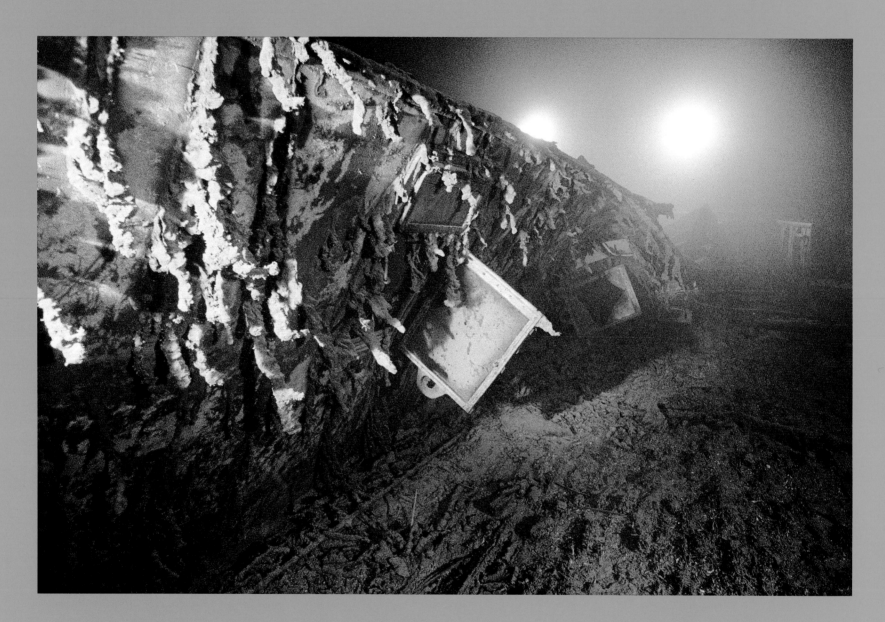

Its glass pane still intact, a window of Capt. Edward J. Smith's cabin hangs open. The lights of the Russian research submersible Mir 2 glow beyond. Now lacking the wooden ship's wheel, the bronze telemotor on the bridge (right, upper) once operated the steering gear. First class cabins (right, lower) appear undamaged even after eight decades underwater.

began searching for it. They made headlines around the world. On September 1, 1985, with Kristof aboard, they found the *Titanic.*

Using a maneuverable camera sled that was based on a conception of Kristof's, they made photographs of the ship with lights that bounced off the millions of particles in the water. Because of this "backscatter," visibility and contrast were low, but nonetheless the pictures were a remarkable achievement.

But reaching and documenting the all but inaccessible *Titanic* did not satisfy Kristof. The haunting feeling of being in the presence of the wreck was absent from the pictures, he thought. To capture it, he would have to increase the lighting intensity many times over, and that required more research, innovation, and money.

Kristof and Anatoly Sagalevitch, a Soviet scientist and longtime friend, put their heads together. The expedition that was finally assembled included scientists and filmmakers, large 70-mm IMAX movie cameras, video equipment, and still cameras. The Soviets contributed *Akademik Mstislav Keldysh,* a research vessel outfitted with two of the deepest diving manned submersibles in the world.

The twin subs, *Mir 1* and *Mir 2,* with their high-capacity battery systems, could stay below 15 to 20 hours at a stretch. With two subs, Kristof could light the wreck from the top, back, or side.

The lights themselves, developed in Germany, were used underwater for the film *The Abyss.* Technicians adapted them to withstand ocean pressures and to work with the Soviet subs. Compact and efficient, they were key to the expedition's success. They could penetrate seawater to an extent impossible with conventional underwater lights.

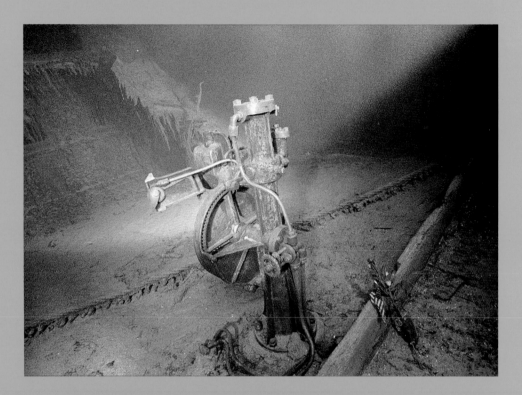

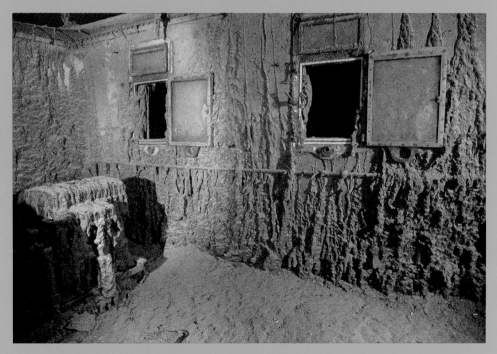

Kristof controlled the lighting and the camera shutter through a video monitor mounted next to him when he went down in *Mir 1*. "The screen gives a very good simulation of what the picture will be like," says Kristof. "It is better than looking out the porthole." The new pictures were an eerie, dreamy memorial to the wreck, and to the forces of nature and history that brought it about.

When the *Titanic* struck the iceberg, Capt. Edward J. Smith was in his quarters (page 228) on the starboard boat deck near the bridge. The outer wall of the cabin has collapsed. Experts have identified the open window in the foreground as his bedroom and the windows beyond it as his sitting room.

Over the course of the three-week expedition, Kristof descended four times. "But what it all comes down to is f/4 at 1/100 of a second," he says. "And you have to figure out quickly where to put your 1/100 of a second because time is very expensive.

"I was allotted 50 hours of dive time. Most of that time was spent looking at video monitors and shooting video. I looked out the porthole only 15 minutes, just to say I actually saw the *Titanic.*"

The divers faced danger as well as expense. Maneuvering through the wreckage was tricky even for experienced submersible pilots. On one occasion *Mir 1*, with Kristof inside, touched down on an upper deck, a good vantage point for photographing first class windows. The submersible caught a skid beneath a railing, and it took 20 minutes to free it.

But to Kristof, the *Titanic* was well worth the hazards. "I think of this as my signature piece," he says. "The *Titanic* is everything a legendary sunken ship could be. I can't think of any other wreck in the ocean that would be worth doing more than this."

When the Titanic's *stern hit bottom the starboard propeller broke off. Here Kristof in the darkened* Mir 1 *photographs the prop in the spooky lights of* Mir 2.

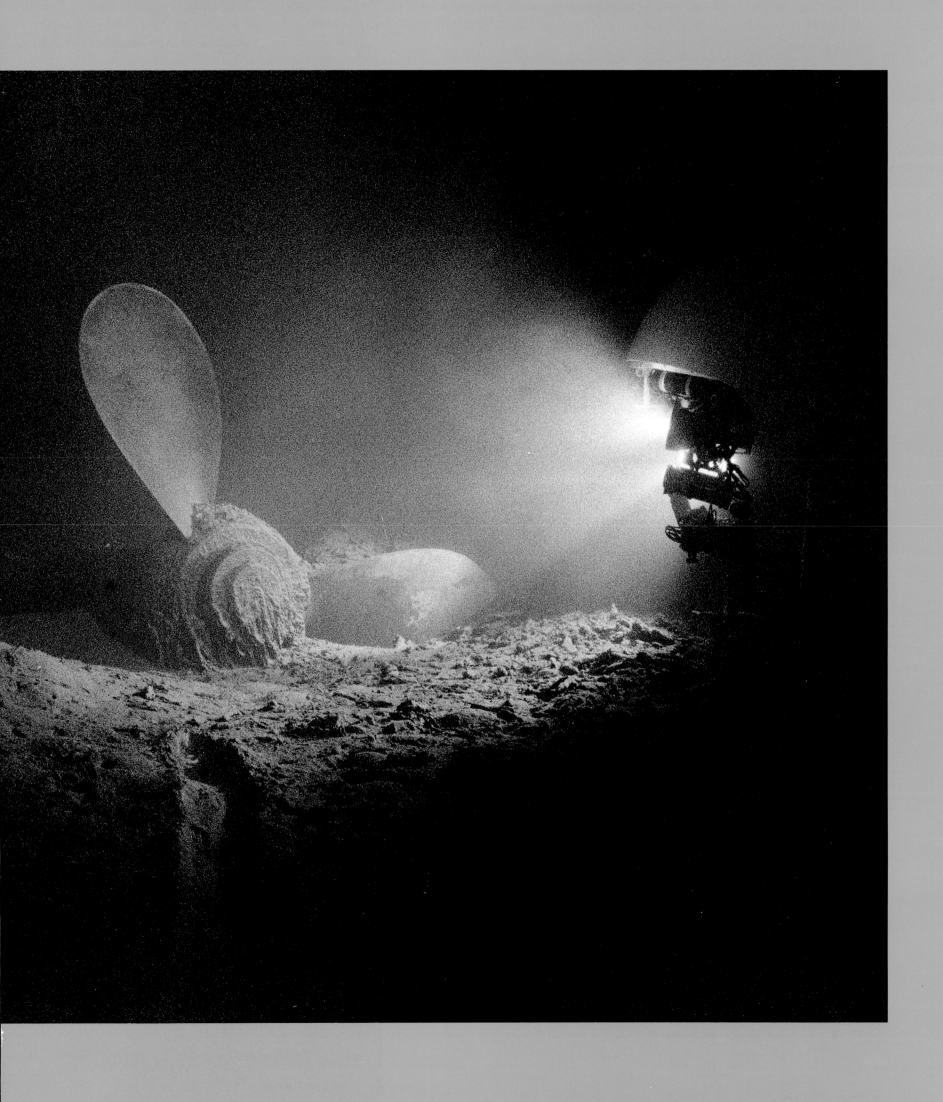

ON THE BRINK OF TOMORROW

Okeechobee, Florida 1991

FRED K. SMITH

Waiting for lightning to serve as his flash, Smith captured this monster waterspout—
a tornado over water. He kept the shutter of his camera open for three or four seconds.

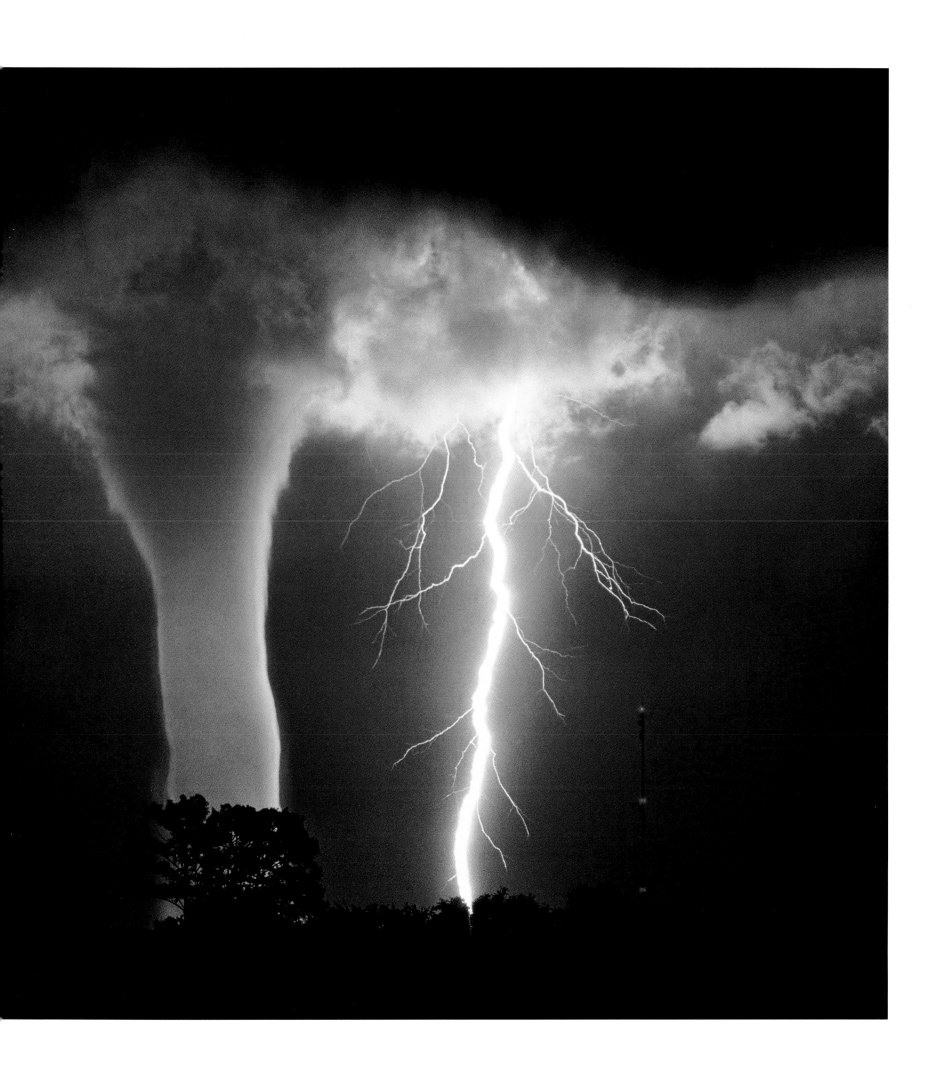

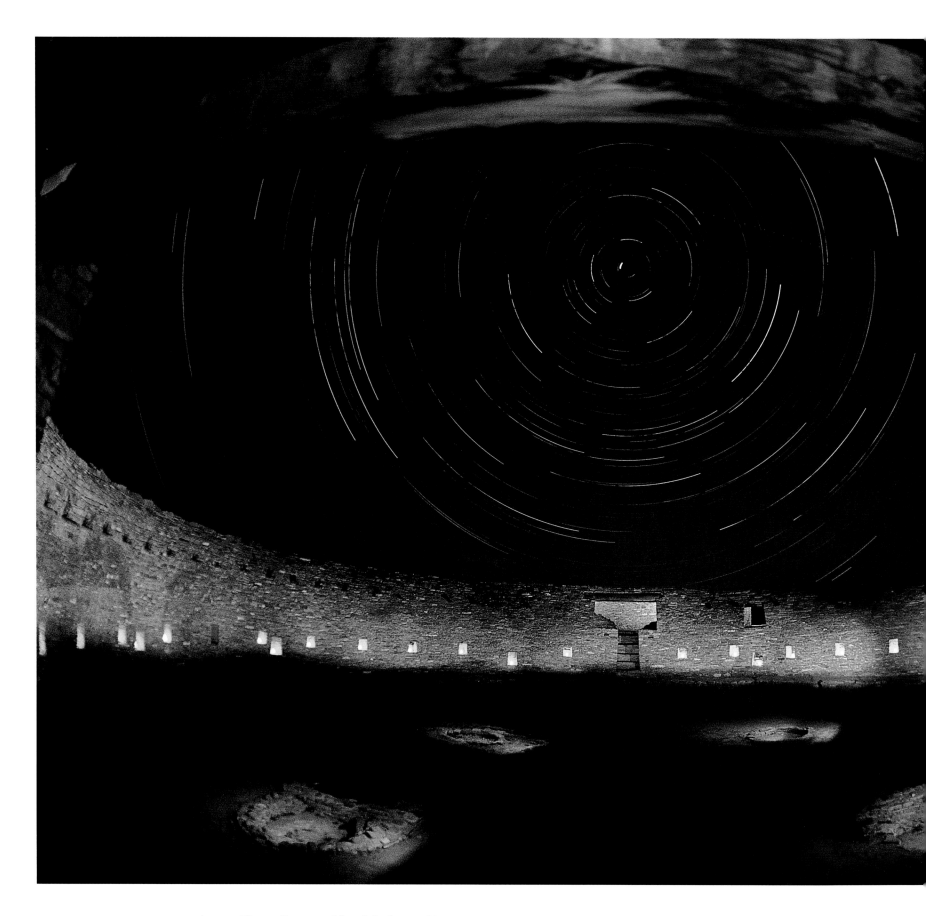

Chaco Canyon, New Mexico 1988

BOB SACHA

"One feels an immense power here," observed Sacha of the great kiva Casa Rinconada, built by the
Anasazi. His camera, aimed north, captures star trails as the earth rotates beneath the polestar.

Picture editor Bill Douthitt needed to figure a way to illustrate a story on dinosaurs. He began by staying home for a few days, reading. "The only way I know to attack this process," says Douthitt, "is to gather a tremendous amount of information, digest it, and then I'm in a position to scratch my head and come up with ideas."

The photographer would be Louie Psihoyos, who had a reputation for bringing wit to a story. He already had shown his skill in covering other abstract subjects for the *Geographic,* including "What Is This Thing Called Sleep?" (pages 268-73), "The Intimate Sense of Smell" (page 248), and "The Fascinating World of Trash."

"I sort of stayed away from more traditional stories," Psihoyos says. "When you do a science story, nobody knows what you're going to come up with. I like the freedom. And I like to push what the magazine does toward the next level, if I can."

During the planning stage for a story, Douthitt meets with anyone who can be helpful—the writer, experts in the field, the photographer, the director of photography, the head of the art department. With them, he works to find an approach, a theme, or a thread to hold the story together. Next, he and the photographer put together a list of situations that might make strong pictures.

For one story his initial notes consisted of 70 pages of ideas and a 40-page contact list. "On all these mega-science stories," he says, "the problem is figuring out when to stop. The most fragile thing in the equation is the serendipity, the thing that occurs on that extra day you stayed." He usually has eight to ten projects in some stage of development. "So you're constantly running from pot to pot on your stove, stirring things and hoping you don't burn something."

In a magazine, Douthitt and Psihoyos saw a picture of a *Tyrannosaurus rex* hot-air balloon on display at the Albuquerque International Balloon Fiesta. They decided it would help show that dinosaurs are part of pop culture. Psihoyos located the balloon, had it floated over Dinosaur Provincial Park in Alberta, one of the richest dinosaur boneyards in the world, and photographed it from a helicopter.

Coverage would not and could not be all pop. Psihoyos also had to do the fundamentals. To photograph dinosaur bones in various museums, he carried about 5,000 feet of black velvet and 42 cases of equipment (pages 256-57). "We wanted the velvet so we could have a 150-foot wall of it, 30 feet high," Psihoyos says. When he was on the back roads of China, the car carried a 50-gallon gasoline tank that leaked. "The velvet was basically one big damp gasoline rag for most of our trip. We were always worried that it would erupt into flames."

The dinosaur pictures, says Douthitt, "could have been just a pile of bones and fossilized things, all with meaning, to be sure, but not pictures people would look at very long. With a hundred TV channels and a million magazines, we are competing for people's attention. Humor helps get past their defenses."

The idea of attracting readers with entertaining photographs fits the Society's program established nearly a century earlier. Only styles have changed. The educated gentlemen who founded the Society believed there was no higher calling than assuring the furtherance of science. To them, geography encompassed many things—the description of land, sea, and universe; the interrelationship of man with the flora and fauna of earth; and the historical, cultural, scientific, and social background of people.

The photographing of science has evolved with photography itself. As the camera and film improved, new worlds opened to view. The camera became a tool for showing what the eye could not see: crabs on the ocean floor, close-ups of planets, pictures of living cells. A scientist or photographer could produce images that instantly conveyed useful information in almost any scientific field: a centipede crushed by a marauder ant, the partial jaw of an apelike creature that lived 13 million years ago. Computer-generated images carry on the mission of knowing through seeing: three-dimensional looks through the human skull; the region where Voyager 2 would pass between Uranus and its moon Miranda; bands of color representing varying temperatures on the skin of the space shuttle *Columbia* as it landed.

From early days, the Society has used the camera—in the hands of scientists, along with professional (and amateur) photographers—to record images of science. Occasionally, a scientist who got a research grant from the Society also got a camera, film, and tutoring.

Only rarely do chance images find their way into the magazine. Florida amateur Fred K. Smith submitted a remarkable photograph. He had walked out of his Okeechobee home on June 15, 1991, with his camera and tripod to photograph lightning. Turning to the southeast, he saw a powerful waterspout. He waited for lightning to illuminate it. When a bolt lit up the sky, he held his camera shutter open for three or four seconds, until the lightning disappeared and he thought his film had recorded it (pages 232-33).

When Mount St. Helens erupted in 1980 (pages 250-51) the magazine assigned ten photographers to cover it, but photos by 21 different photographers appeared in the January 1981 issue. And—a rare occurrence—the cover photo was taken by

Virginia 1981
BRUCE AND GREG DALE

Dale and his son set up camera, infrared triggering beam, and flash sequencer in their kitchen to illustrate how popcorn pops.

Douglas L. Miller, who was not one of the photographers assigned to the story.

Surveys show that *Geographic* readers consistently enjoy archaeology stories. They also express steady interest in geology and astronomy. Curiosity about other fields fluctuates, but there has been a continuing interest in anthropology.

Mary Smith began working as the picture editor on stories about early humans when Melville Grosvenor introduced her to anthropologist Louis Leakey in 1961. Much of her job involved filtering and balancing the coverage. "I take a good look at the developing story to make sure it's proportionally proper for our kind of magazine," she says. Talking about a story on alcohol, published in February 1992, she explains, "The photographs shouldn't all be horror pictures, nor should they be all sunshine and light and grapes growing on the vine."

Accompanying the story was a four-page report on children tragically damaged by fetal alcohol syndrome. When photographer George Steinmetz suggested covering them, Smith admits she was dubious. "I said something picture editors say, something like, 'OK. Go ahead, but don't spend a lot of money. Go ahead and try a few things.'" After initial hesitation she became an advocate of the photos and brought others around. "I think it was one of the most powerful things we've published in the magazine," she says.

Over the decades, Smith closely watched photographers change their ways of visualizing anthropology. She describes the photography of her first ten or twelve years at the *Geographic* as "straightforward." There were pictures of the Leakeys at work, with their finds; pictures of Olduvai Gorge; pictures of the Masai herders with their cattle.

Then photographer David L. Brill went to cover anthropologist Donald C. Johanson's early man work in Ethiopia. "He began to make pictures with shadows and fossil elephant tusks sticking out of hillsides. Oddball things," says Smith. "It was a whole new way of looking at early man photography—the same kinds of artifacts, but done very differently."

Nine years later, for another story on early man, Brill needed to come up with a lead picture that would symbolize bipedalism in the evolution of early hominids. He contacted Owen Lovejoy, a locomotion specialist at Kent State University, who suggested reconstructing the three-million-year-old skeleton dubbed Lucy, even though just 40 percent of the skeleton existed. Lovejoy and his students cast, sculpted, mirror-imaged, and articulated a model that included hands and feet from other individuals of Lucy's species—*Australopithecus afarensis*.

California 1988
JAMES A. SUGAR

In a vacuum, a feather falls as fast as an apple. Sugar had three cameras set up for this "most difficult picture."

Different colors indicated which bones represented originals from Lucy and which were reconstructed additions. Brill said, "After the scientific research had been done to reconstruct Lucy on paper, we took the next step and made a one-to-one model that brings her alive; in photographs, she can run, jump, and walk. It took about 2,620 man-hours to photograph the many poses."

The Society has supported archaeology since 1912, cosponsoring—with Yale University—Hiram Bingham's second expedition to Machu Picchu. The entire April 1913 issue was devoted to his article, "In the Wonderland of Peru." Since then, archaeologists on Society grants have dug all over the world. Photographers, or sometimes scientists with cameras, documented their work.

Nowadays, after hundreds of archaeology and anthropology stories, editors and photographers must struggle to keep the subjects looking fresh. New information is not enough to sustain a *Geographic* story.

As an experienced photographer of archaeology, Ira Block knows the problems of working in cramped, ill-lit spaces in museums. He has had to convince reluctant curators to remove fragile objects from glass cases. And he often has to urge disgruntled technicians to persist when rusty screws will not budge on a case that has been sealed for decades.

For a Society book, *The Adventure of Archaeology*, Block went to the Moesgård Prehistoric Museum in Denmark to photograph the remains of Grauballe man, a villager whose body had been preserved in a peat bog since about 100 B.C. (page 262). Block was surprised to see not bones but "a real body, a real dead person," he remembers. "It had a face and hair, and the rippled body was a deep, dark color, almost like leather." Block, disconcerted because he had never photographed a corpse, needed a moment to pull himself together.

When the museum closed, the body had to be moved to an open area on the floor. Block realized that the peat bog man was more than a museum artifact; he was a good candidate for portrait photography. So Block aimed a large light toward the face, then taped a paper tube to another, smaller light and positioned it off to one side, to highlight the hair. He used crosslighting on the ripples, the way he would for an athlete or bodybuilder with well-defined muscles. The picture was so successful that the magazine published the portrait two years after it had appeared in the book.

BOB SACHA LIKES TO WORK AT NIGHT, when he wants to see things differently. On assignment in New Mexico for the article "America's Ancient Skywatchers," he needed to photograph the Anasazi great kiva Casa Rinconada in Chaco Canyon at night. He believed that the best way to illustrate the circular structure—which was built precisely on the compass—was with a photograph showing circular star trails overhead (pages 234-35). He would need an hours-long exposure to record them.

He put his camera squarely in the south doorway and pointed the fish-eye lens northward, toward the doorway opposite. He lit the walls a section at a time, working on moonless nights, walking around triggering a flash many times, painting with

England 1991

JOE McNALLY

Blind since birth, 11-year-old Anna Cannings gathers raspberries. "You feel for them in the middle of the bush," she told McNally, who photographed her extensively for an article on the sense of sight.

The Moon 1971

ALAN B. SHEPARD, JR.

A chest-mounted camera operated by commander Shepard of Apollo 14 sweeps 300 degrees of lunar landscape near Fra Mauro Crater. Shepard's shadow appears in the center; lunar module pilot Edgar D. Mitchell aims a television camera at right.

light. To illuminate the niches, he lit a candle in one of them, counted to three, blew it out, moved on to the next and did the same, with the shutter open all the while.

"In doing long exposures like this, you have no idea what's really going on," says Sacha. "You can't watch through the lens." He went through the process on several nights, "because the sky gives you a different expression each night." Soon he became adept enough at lighting the walls to take hour-long naps in his car while his film stayed exposed to the stars.

Moonlight is a favorite source of illumination for space photographer Roger H. Ressmeyer, who also works with long exposures at night. "I feel I'm returning to photography's roots," he says. "Back in the early 1800s it could take minutes or even hours to take a picture by sunlight."

Ressmeyer's photographs of science and technology are often grand productions. When possible, he plans everything precisely. He pays attention not only to the timing of an eclipse, for instance, but to the sky positions of galaxies and individual stars. "To cover my bases, I may set up ten or twelve cameras to take a picture simultaneously with different exposures," he says. "If I'm doing a two-hour shoot that ends with the moonrise, I can't do it twice."

In situations where he feels fairly confident about the exposure, he sets all the cameras the same, makes his pictures, takes the film from one camera, processes it first, and adjusts the processing of the remaining rolls accordingly. Photographing an observatory in Chile, he spent hours perched precariously on top of a shaky 70-foot antenna tower. In the image, moonlight illuminates the observatory, which is laced with tracks created by red flashlights carried by astronomers.

Even though Ressmeyer specializes in space photography, he still refers to his pictures as photojournalism. "When the shutter opens, the camera is pointed in one direction," he says. "When it closes, after a thousandth of a second or after ten thousand seconds, the picture is done. There's no manipulation after the fact." By exposing the picture for a few hours, the photographer can create visions that explain natural forces in a way not otherwise possible, he says.

Ressmeyer spent 15 months on one of his favorite assignments—a global look at volcanoes. To get his fiery imagery, he hovered over pools of lava, walked on smoking, inches-thick crusts that had just hardened, and learned all the ways volcanoes can kill. "It's like being one with the universe when you see a volcano erupt," he says.

WHEN THE SOCIETY WAS FOUNDED, and for more than three-quarters of a century afterward, science was considered the key to economic, social, and intellectual progress. Scientific research led to longer life, increased economic production, and prosperity. The culmination came in the 1960s, when the United States was going to the moon. The public was awestruck by the adventure and the science and technology that surrounded the adventure. Then came defeat in Vietnam, Three Mile Island, Chernobyl, and, with them, skepticism about our institutions and the power of science. The approach of *Geographic* writers, photographers, and editors reflected the change. The *Geographic* still celebrates the accomplishments of technology, but now it also looks at the consequences.

Society-funded natural history research over the generations illustrates the shift most strikingly. The drive to understand nature led to the urge to preserve it. Real

commitment to conservation came when Gilbert H. Grosvenor camped in California under a giant sequoia in 1915 and was spiritually moved by the experience. But Grosvenor, firmly believing science and politics did not mix, promoted conservation in the magazine only in an upbeat, noncontroversial way. When people see how beautiful the world is, the philosophy went, they will want to preserve it.

Fifty-five years after that camping trip, staff photographer James P. Blair was assigned a story on the world's environmental crisis—especially in the United States. Times had changed, and Blair suggested photographing the negative effects of industry for the first time—the Cuyahoga River thick with oil and debris, air pollution in Los Angeles. Blair's photographs illustrated "Pollution, Threat to Man's Only Home," the first *Geographic* story to show grim images of pollution.

The 1970 article marked a major turning point. Steadily increasing in the years since were images reflecting concern about environmental threats: dead brook trout in an Adirondack stream, victims of acid precipitation (page 254)…the dark legacy of industrialization in Eastern Europe (page 127)…the blackened sand and sky that came in the wake of the Gulf War (pages 4-5; 252)…oil spills throughout the world.

The *Geographic* also linked concern for the environment with the technology of remote sensing. The Society collaborated with NASA and the Seaver Institute to monitor the tropical rain forest in Belize. In 1993, for its special edition on North America's freshwater, the *Geographic* published far more photographs of drought, waste, and pollution than of water's beauty.

Photographers documented wildlife research and management in the field, in laboratories, and in zoos. They used sophisticated lighting, remote control devices, and any other equipment they believed would dramatize their subjects—and portray the victims of civilization's folly.

INTEREST SHIFTED from emphasizing technological accomplishments to describing the impact of technology on ordinary people. A photo in an article on medical donors shows the grieving family of an eight-year-old boy who is dying after an automobile accident. His parents are signing a document to donate his tissues and organs (page 310). In earlier days, the *Geographic* would have emphasized the technological accomplishments. But in 1991 the magazine thoroughly covered both the science and the emotional complexity behind transplants. Photographer Bill Luster knew from the story's conception that portraying a donor's family would be essential.

A single *Geographic* story may simultaneously be about medical technology and the human condition.

The desire to humanize stories requires photographers to be versatile. To photograph the story on sight (page 15), Joe McNally combined technical expertise with intellectual curiosity and a deep interest in people. He spent days with a blind 11-year-old English girl during the school year, then returned in summer to photograph her in a raspberry patch (pages 238-39). He wanted to show what it was like to grow up blind. A photograph of a Chinese child very early in the morning, following her

Mexico 1990
MERLIN D. TUTTLE

Eating in flight, a lesser long-nosed bat bites into the fruit of a cactus. Using night-vision scopes to aid observation, Tuttle studied cactus-pollinating bats in the Sonoran Desert.

Washington, D.C. 1990
MARK W. MOFFETT

Trailing a silk safety line, a tiny jumping spider vaults the inch-wide gap between two twigs.

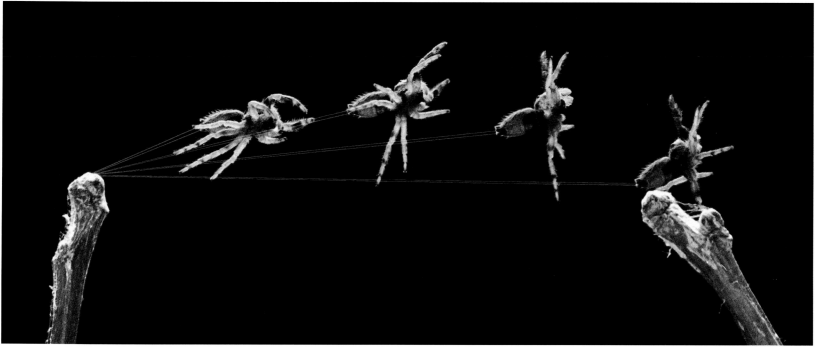

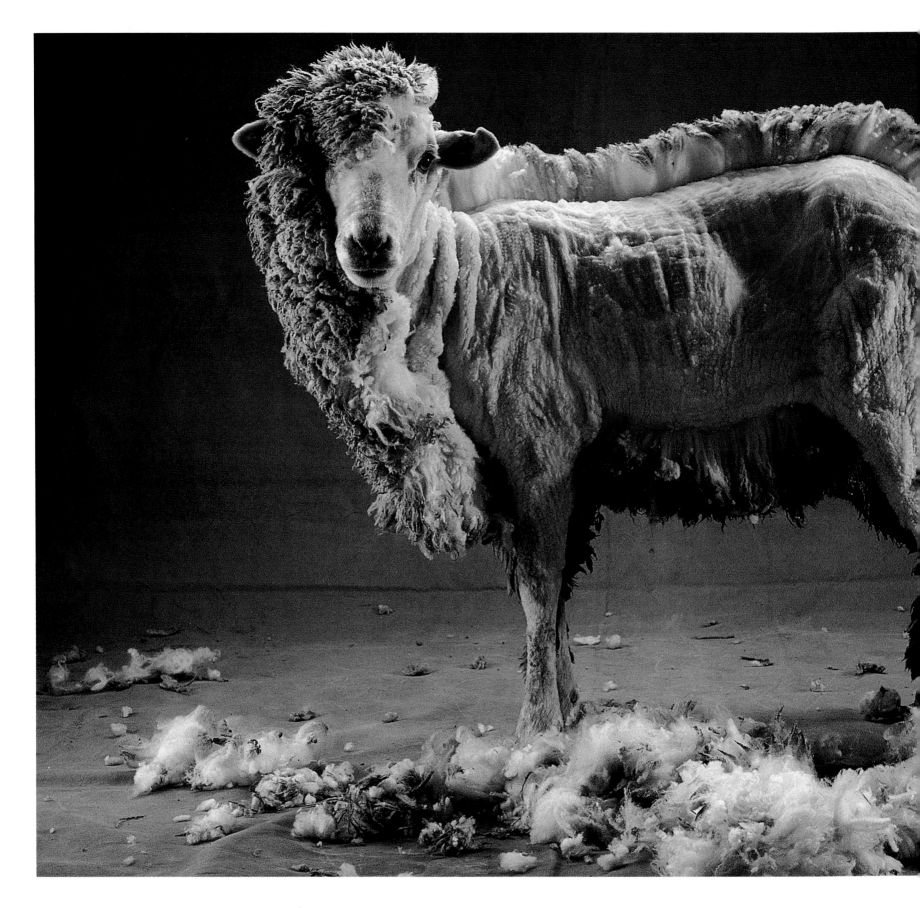

Victoria, Australia 1986

CARY WOLINSKY

A merino half-shorn shows a season's lush growth of wool. Setting up his photograph, Wolinsky
found that some sheep so shorn tended to capsize to wool-ward.

eye surgery for strabismus, summed up the story for McNally, "because there was a certain element of hope. She had awakened, and I was drifting around the hallway," he remembers. "I quietly slipped into her room as she was looking out the window with her newly repaired eyes, and I managed to photograph her in a very quiet way that didn't disturb her."

SOME STORY IDEAS BEGIN with a single word. Coal. Gold. Salt. Oil. Water. Bamboo. For want of a label, the editors began calling these one-word ideas "commodity stories." For a story on the potato, the author, anthropologist Robert E. Rhoades, and photographer Martin Rogers traveled 145,000 miles. Coffee, photographed by Sam Abell, took 30 months of work, from the time the magazine's planning council approved the subject until the *Geographic* published the story in March 1981.

Commodity stories are part science, part social commentary, and part travel literature. "A commodity story is like a river story," says Cary Wolinsky, who has photographed three of them. "The commodity, like the river, is a thread to give the writer, the photographer, and eventually the reader an opportunity to see people and places and to understand cultures."

Bamboo, a versatile commodity, took Jim Brandenburg abroad for the first time. He intended to photograph examples of the uses of bamboo but also wanted to convey the commodity's exotic quality. He found a pair of Japanese kendo fencers working out in their practice hall. Their slatted bamboo swords made loud clapping noises but were not dangerous like the steel swords used by samurai. Brandenburg's photograph, made in a bamboo grove near the practice hall, became the cover of the October 1980 issue.

Cary Wolinsky conceived the notion of photographing a half-sheared sheep for his wool story. He wanted to describe how, through breeding, people have turned sheep into walking wool factories. His picture would show how much wool grows on a sheep in one season. An intensive search for suitable sheep took him through Australia and New Zealand. An important requirement was a good shearing job, one that would not leave bloody, unsightly nicks. The sheep had to stand still in front of a background; Wolinsky created one by painting and hanging a large piece of canvas. With everything set, the shearer took the wool off half the sheep and let go. The fleece remaining on the other side of the sheep was so heavy that the sheep fell over and could not get up.

Many sheep later, in Australia, the team finally had a specimen without nicks, that looked good for the camera, and was able to stand up. Surrounded by strobes and people, it posed for a portrait (left).

"One of the things you have to decide as the photographer of a commodity story is whether you want an elaborate setup shot or something real that tells the story," says Wolinsky. "Real is livelier but even more time-consuming and costly than a staged situation." Then he added what a *Geographic* photographer says about any subject: "You have to keep looking until you find it."

following pages:

Cape Canaveral, Florida 1982
JON SCHNEEBERGER

Triggered by the rockets' thunderous roar, a remote camera one and a half miles away captures the space shuttle Columbia's *spectacular liftoff.*

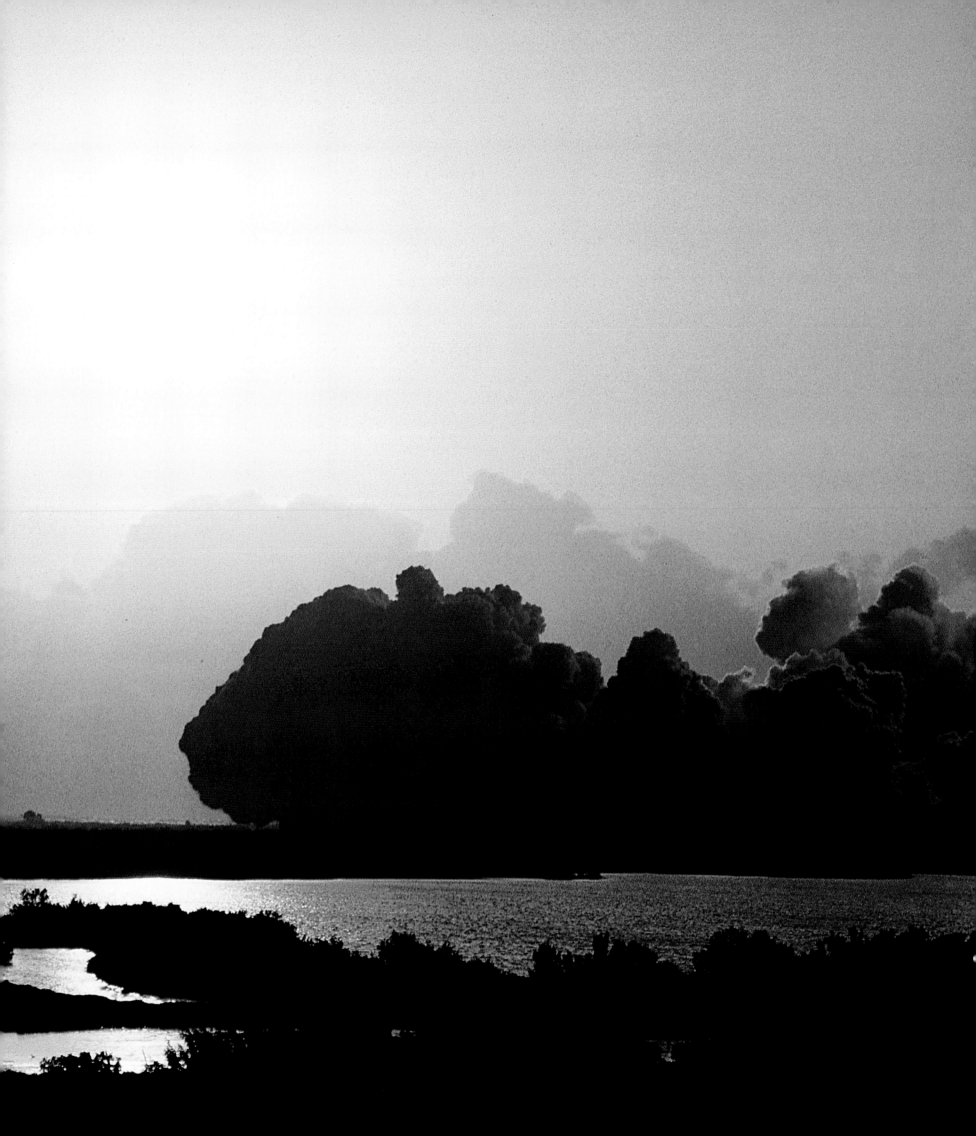

Maryland 1985

LOUIE PSIHOYOS

His subject the sense of smell, Psihoyos equipped a colleague's dog with a red-lighted collar,
then recorded its zigzag path along a trail of pheasant scent leading to a stuffed bird.

European Southern Observatory, Chile 1987

ROGER H. RESSMEYER

When an exploding star was discovered in 1987, this radio telescope helped observe its emissions.
The supernova was the first since 1604 that could be seen with the naked eye.

Ephrata, Washington 1980

DOUGLAS L. MILLER

Clouds of ash roil over a hawthorn tree three hours after Mount St. Helens erupted 145 miles away.
"I thought at first it was a beautiful thundercloud," says Miller, "not history in the making."

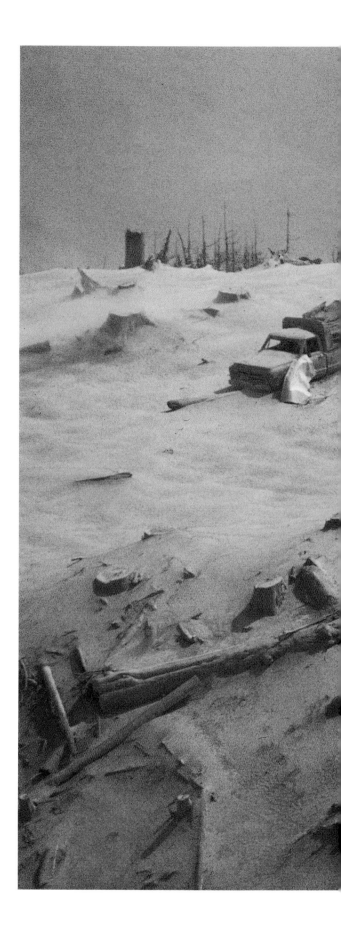

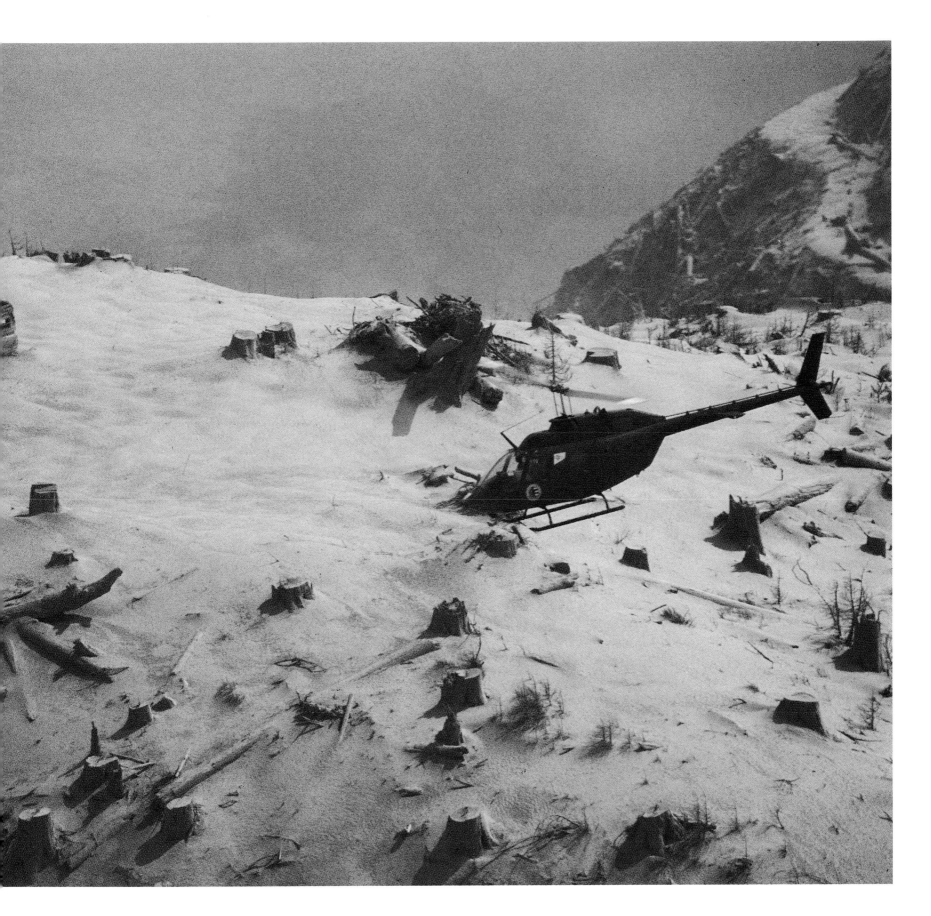

Washington 1980

RALPH PERRY

In the eruption's wasteland, this truck yielded two victims to searchers ten miles from Mount St. Helens. Photos of the destruction by 21 photographers appeared in the January 1981 magazine.

Kuwait 1991

STEVE McCURRY

Fountains of fire leap from oil wells dynamited by Iraqis during the Gulf War. Oily, soot-covered sand stuck to McCurry's tires, uncovering white desert. A canopy of smoke turns day to night.

Altamont Pass, California 1988

JAMES A. SUGAR

*"Logistically it was a nightmare to pull off," says Sugar of this photo of wind turbines backlit
by the rising sun. He took the picture from a low-flying helicopter in buffeting 60-mph winds.*

Adirondack Mountains, New York 1980

TED SPIEGEL

Brook trout succumb to gill damage in a stream polluted by acid rain and snow during a spring melt that brought a lethal "acid flush." Spiegel took the photograph while kneeling in ice-cold water.

Sutton Avian Research Center, Oklahoma 1991

JOEL SARTORE

In camouflage to minimize eaglets' contact with humans, biologists move the birds to a barn. Sartore was not allowed to speak in the eaglets' presence; he used a telephoto lens to get this picture.

Senckenberg Nature Museum, Germany 1991
LOUIE PSIHOYOS

Sixty-five feet from head to tail tip, this Diplodocus *thrived millions of years before* Homo
sapiens *evolved. Once thought to be aquatic, it now is believed to have foraged on land.*

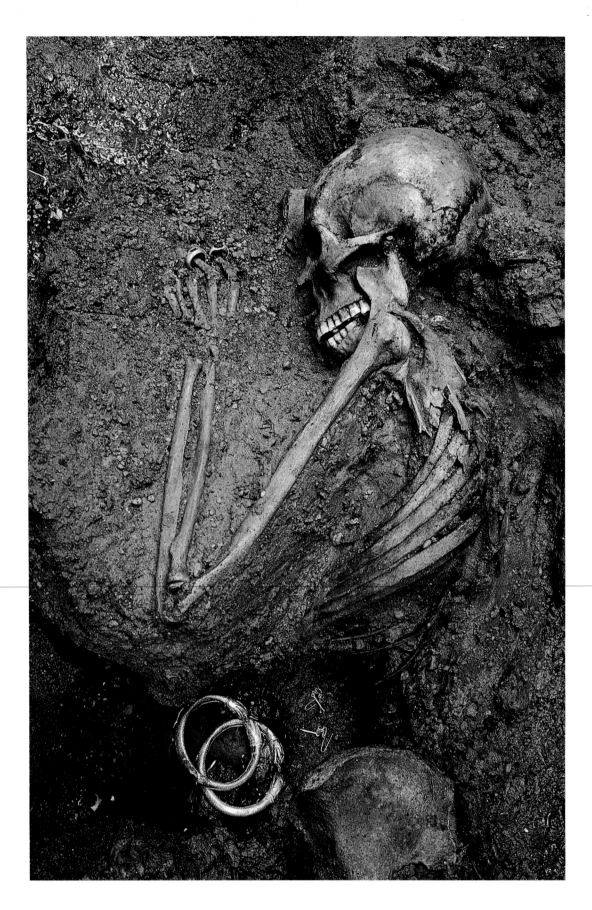

Herculaneum, Italy 1983

O. LOUIS MAZZATENTA

With rings on her fingers and gold bracelets at her side, a woman lies as she fell in A.D. 79 when erupting Mount Vesuvius buried the seaside town. The same cataclysm destroyed Pompeii.

Aphrodisias, Turkey 1975

DAVID L. BRILL

Soaking in water to leach out nearly two millennia of impurities, the marble face of Aphrodite
is swathed in cloth to hold moisture on features above the waterline.

Milan, Italy 1983
VIC BOSWELL, JR.

Returning to life after five centuries of abuse, Leonardo da Vinci's celebrated "Last Supper" undergoes a major restoration in a monastery's former refectory. The luminous section at right has already been restored. The device at left monitors the room's humidity.

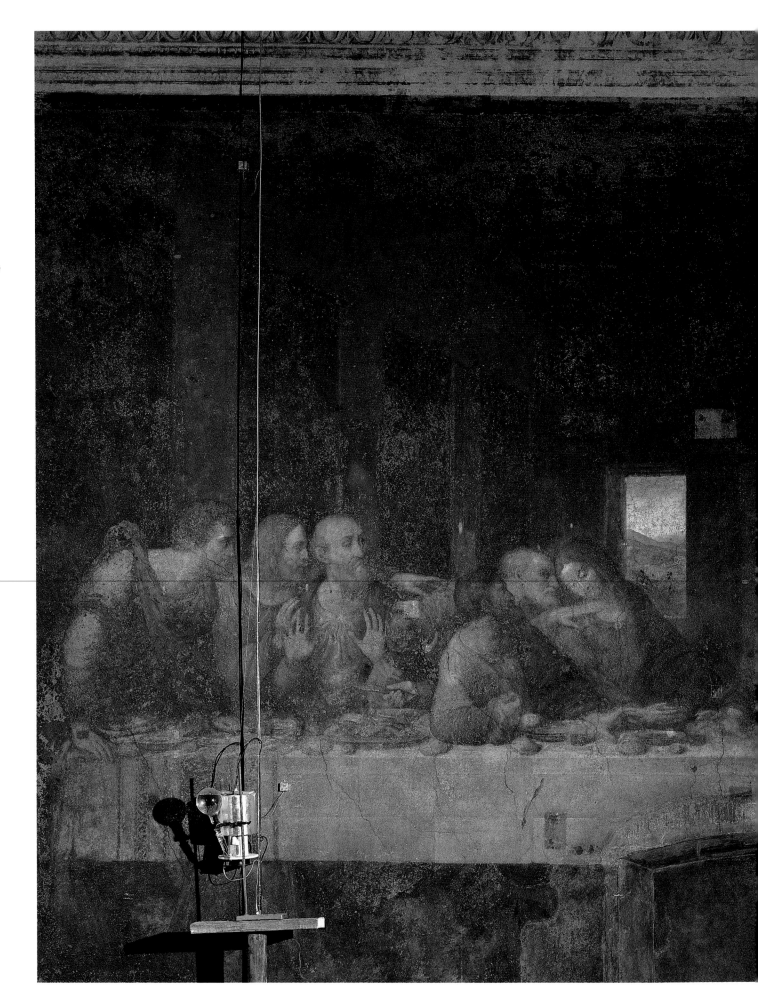

Moesgård Prehistoric Museum, Denmark 1984

IRA BLOCK

A Danish bog preserved this sacrificial victim—its throat deeply slit—for 2,000 years before its discovery in 1952. Peat acids reddened the hair and tanned the skin to a leathery texture.

Lake Ontario, Canada 1982

EMORY KRISTOF

The figurehead of the American warship Hamilton *greets discoverers 290 feet down. A storm sank
the schooner during the War of 1812. A remotely piloted vehicle carried Kristof's camera.*

Virginia 1988
BRUCE DALE

A fragile planet under stress: A crystal globe is shattered by a projectile. Dale destroyed several globes
making a hologram for the cover of a centennial issue that featured environmental articles.

Corning Museum of Glass, New York 1993

JAMES L. AMOS

A rhapsody of rosy hues glows from a sculpture of glass tinted by minute amounts of gold. This nine-inch-high masterwork provided a cover photo for Amos's article on the versatile commodity.

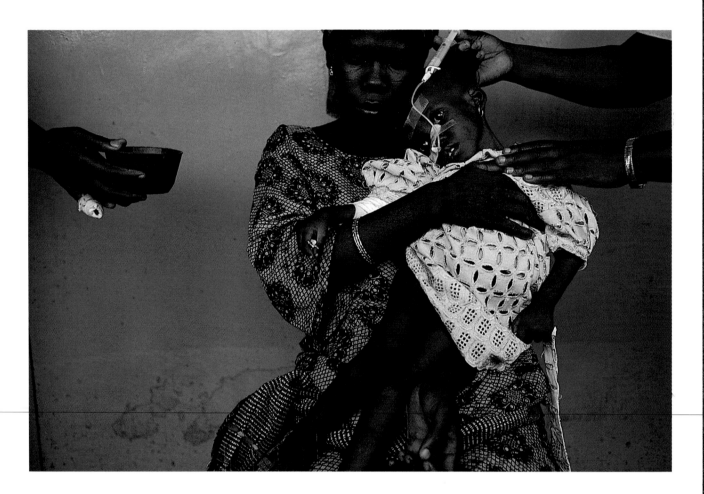

Ogbomosho, Nigeria 1990
LYNN JOHNSON

Near death from malnutrition, a girl receives soy milk from a syringe. Johnson photographed a troubling article: "The World's Food Supply at Risk." A few days later the child died.

Kazakhstan 1992
GERD LUDWIG

Victim of fallout? A homey decor lessens patients' fear of tests for radiation damage in a region where the former Soviet Union conducted nuclear tests, and which now has a high frequency of cancers.

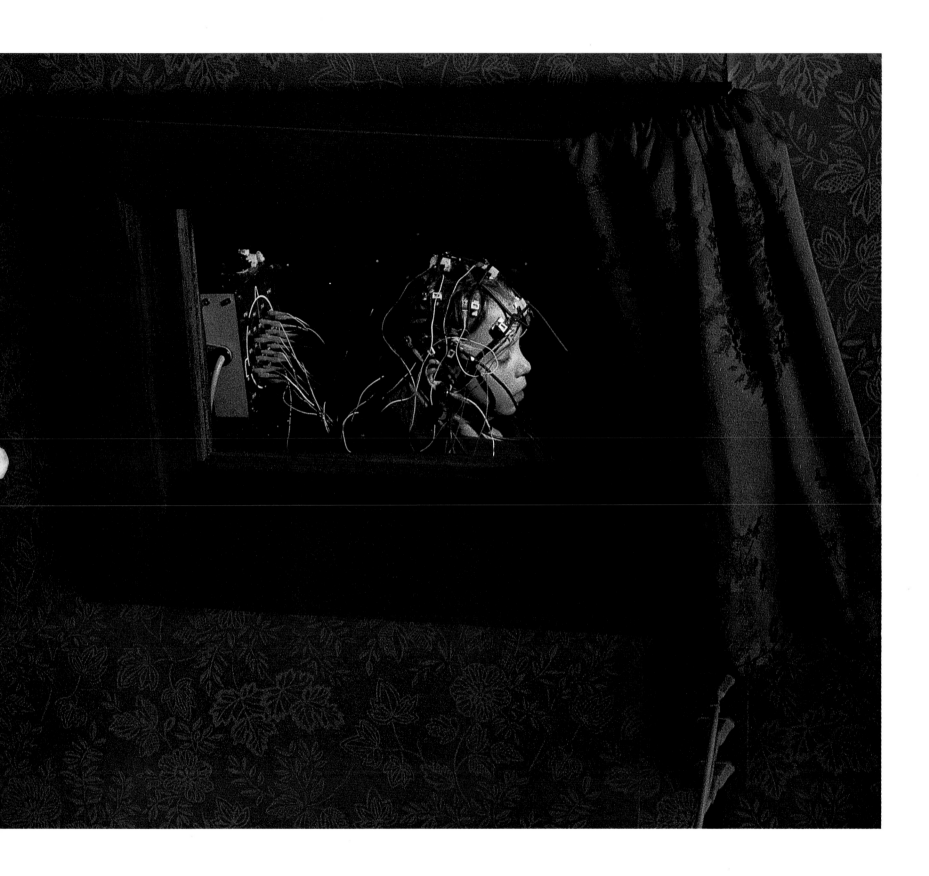

ON ASSIGNMENT
LOUIE PSIHOYOS

Sleep

When Louie Psihoyos was assigned a story on sleep, he decided to discuss the project with Salvador Dalí. He hoped the artist, who claimed his inspiration came from dreams, would have some ideas for surreal pictures and would perhaps even pose as a dreamer. "We wanted something very dreamlike for this story," says Psihoyos.

He went to Spain to try to meet with Dalí. "I spent about a month going back and forth through his manager with my ideas," Psihoyos says. "Every idea I had he considered too crazy—which I took as a compliment." Psihoyos was never able to meet Dalí so gave up on him and, instead, proceeded with a plan originally hatched with the artist in mind. He would find someone to feign sleep and stage an old cliché: counting sheep.

In search of the perfect sheep, Psihoyos discovered that there's more to a sheep than a pretty fleece. "People say, 'A sheep's a sheep,' but there are dozens of species," he says. "And if they're just sheared, they don't look like sheep. They look atrociously skinny, like they're malnourished." It took him a month to finally find sheep that satisfied all his requirements at the Cornell University sheep barn in Hartford, New York.

When his sheep were in full splendor, Psihoyos

An old cliché, counting sheep, was photographed to illustrate "What Is This Thing Called Sleep?" Psihoyos tackled the amorphous subject in the December 1987 issue. Readers found it of interest, for millions suffer from the more than 50 distinct disorders that result in sleepless nights.

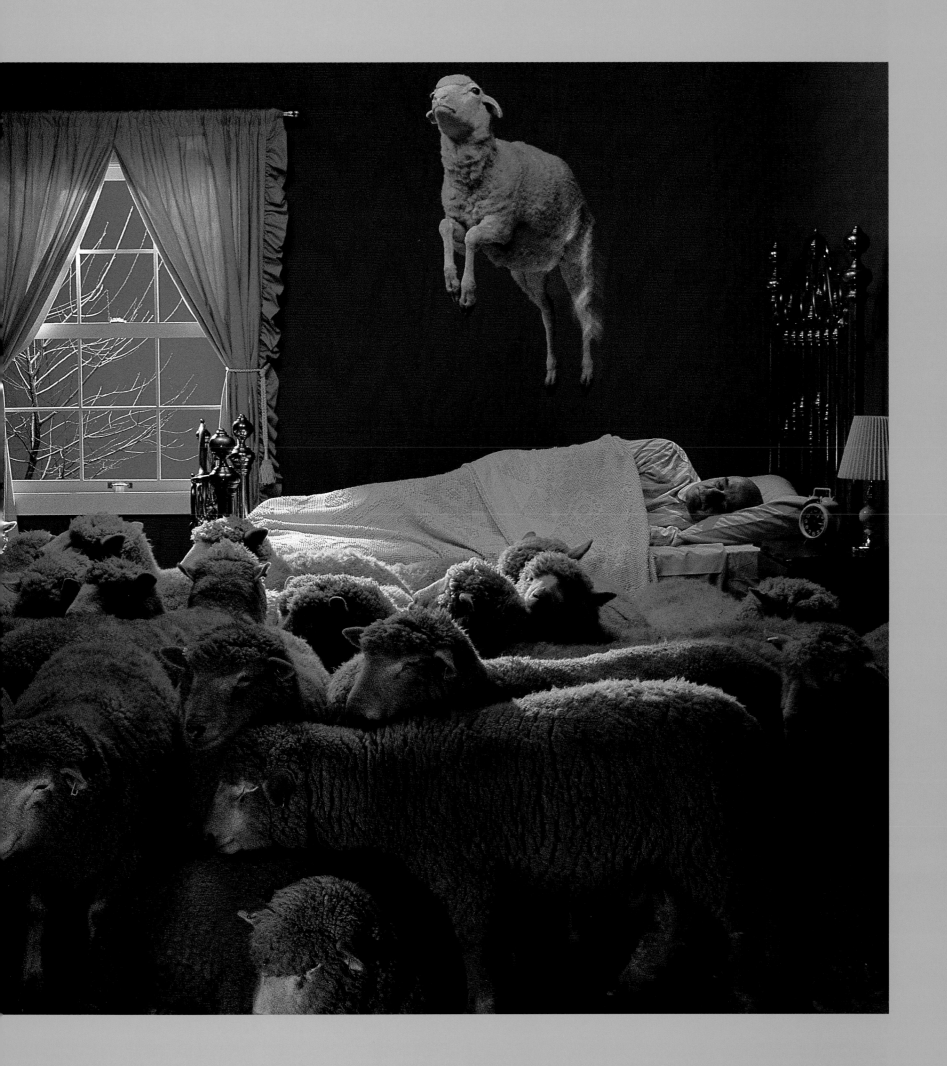

Psihoyos uses strobe flashes to make multiple images of himself in the ancient theater at Epidaurus in Greece. The city held a shrine to Asclepius, god of medicine, who was thought to work his cures during sleep. At MIT, a bed rotates with the head at the pivot point, simulating gravity. It could help astronauts combat weightlessness in space as they sleep.

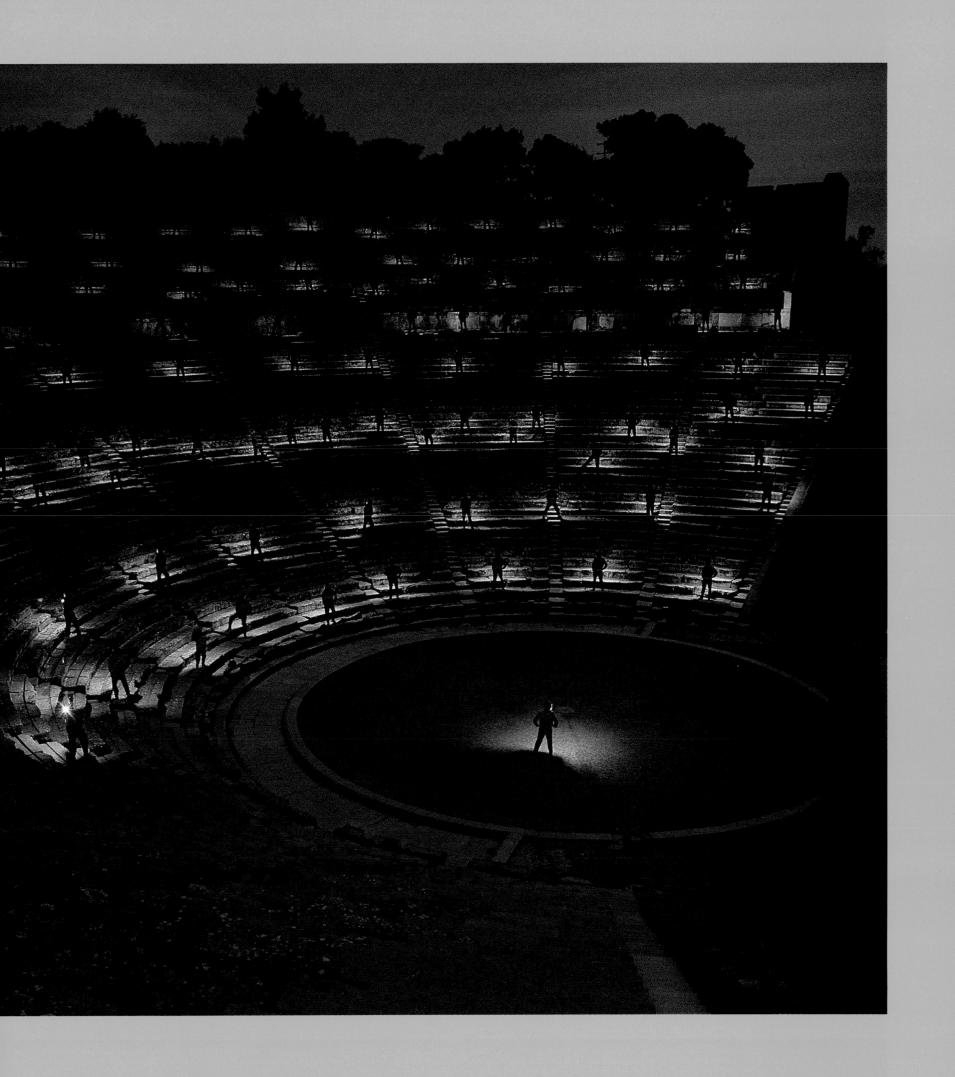

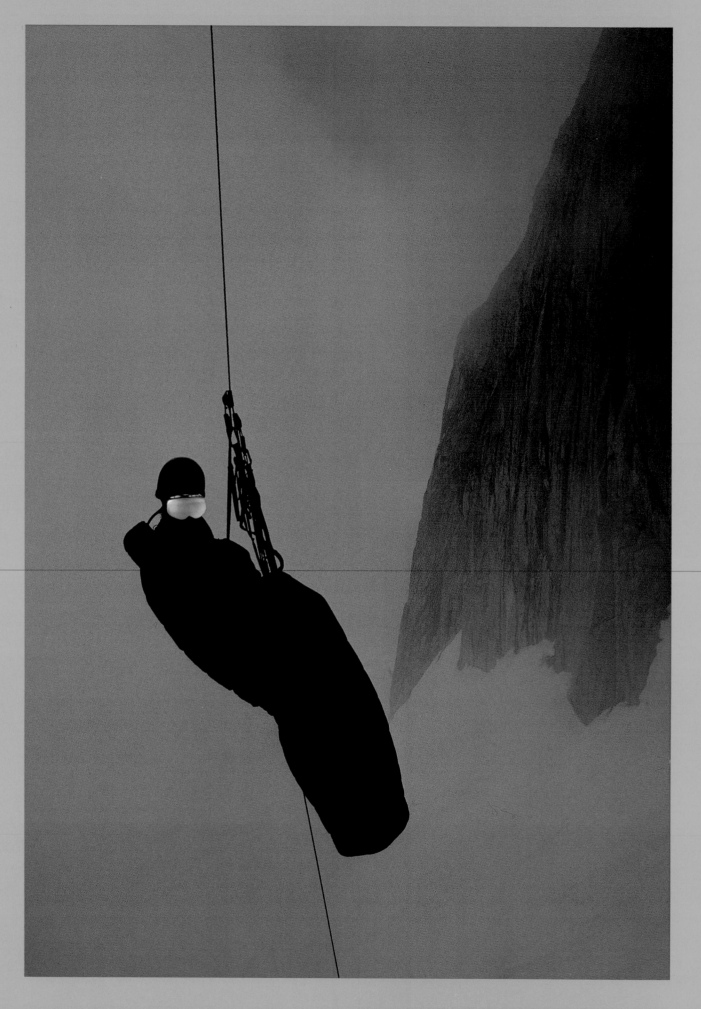

Frontiers of sleep: Wrapped in a hammock, a climber dangles from Alaska's Mount Barrille to show a potential use of Tranquilites—goggles designed to induce relaxation with blue light and soothing sound. Goggles with a pulsing red light (opposite) purportedly enable dreamers to be aware that they are dreaming. Sensors detect eye movements that accompany dreams and trigger the light in this experimental work at Stanford University.

designed and built his set—a peaceful bedroom. In the bed he placed a New York neighbor. Psihoyos filled the room with sheep—a lamb even peers from a bureau drawer—and, though he had hoped to photograph a live sheep jumping over the bed, he had to settle for hanging a stuffed one overhead (pages 268-69).

Psihoyos' photograph succeeded in entertaining the readership and provoking thought about the process of falling asleep. But he also needed to show science. To get ideas, he and picture editor Bill Douthitt went to a sleep disorders conference. Sitting in a motel room, they puzzled over press handouts, wondering how to illustrate the research being done into sleep disorders and dreaming.

They decided to photograph an attempt to induce "lucid dreaming." A subject donned goggles with sensors that detected eye movements during vivid dreams; the eye movements triggered a pulsing red light (right). The light purportedly suffused the subject's dreams and stimulated his brain to make him aware of his dreaming.

Other intriguing photographs made for the sleep story showed a dangling climber wearing goggles that generate soothing light and sound to bring on sleep in adverse conditions (left), and a rotating bed devised to counteract weightlessness, thereby helping astronauts minimize the effects of weightlessness as they sleep in space (page 270).

Psihoyos, who specializes in science, has never worked on a traditional, location-based geography story, and he likes it that way. "When you do a science story, nobody knows what you're going to come up with," he says. "You make your own path rather than putting a new spin on expected pictures.

"I like the freedom."

PORTRAIT OF A PEOPLE

El Paso, Texas 1990
WILLIAM ALBERT ALLARD

A minor league ballplayer pauses for the anthem. "I find the United States just as visually inspiring as the rest of the world," says Allard.

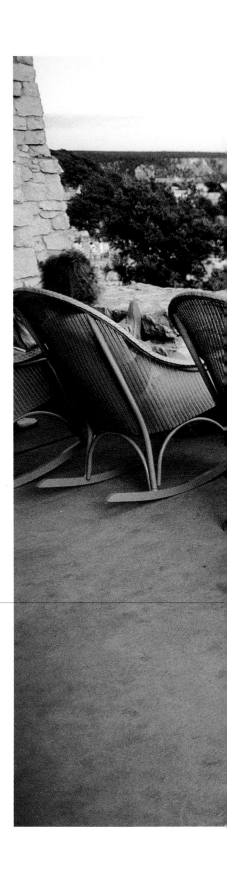

P olish photographer Tomasz Tomaszewski walked into Editor Bill Garrett's office one May day in 1987 and was handed a dream assignment: drive across the United States and photograph whatever caught his fancy. The results would be published in the *Geographic*'s January 1988 centennial issue.

"I took a car and drove between New York and Los Angeles three times," says Tomaszewski. "I followed the American slogan, 'Go West, young man,' and since I wasn't limited by a story line, I only stopped when I saw something interesting." American movies, books, and music had filled Tomaszewski's imagination before he saw the United States. But nothing in his imagination had prepared him for the diversity of the real thing.

He intended to visit the Grand Canyon without photographing it. "I assumed the *Geographic* had already published hundreds of Grand Canyon pictures," he says, "but I wanted to see this famous place anyway." On the balcony of a hotel facing the canyon he found men playing chess. "I was astonished that people drove hundreds of miles just to sit. I expected to see them with tired faces, hiking or riding horses into the Canyon." His picture of the balcony filled two pages of his 36-page story (right).

Tomaszewski says he does a better job of reporting when he is away from Poland. "I know so much about my own place, I simply go and shoot what I know." Far from home, on the other hand, he relies more on instinct than intellect. "I am less afraid to look for strong images, more anxious to ask questions because I am hungry for knowledge," he says.

There is an obvious difference between covering the exotic and the familiar. Generally, though, the *Geographic* has covered the United States the way it has covered other places. Stories had to be told within a geographical framework. They had to be interesting to the typical *Geographic* reader, and they had to be thorough. Theoretically, editors also followed the principles set by Gilbert H. Grosvenor, the first editor, and approved by the Board of Trustees of the National Geographic Society in 1915: Stories could contain little controversy. And, as Grosvenor put it, "Only what is of a kindly nature is printed about any country or people, everything unpleasant or unduly critical being avoided." Editors have tended to use their discretion in applying these standards.

Editors carved the United States into story types. There are "state stories" and "city stories," with regional variations, such as a "river story." The stories presented facts and reinforced popular perceptions about the places. Thematic stories, often touching the heart of American mythology, concentrated on topics that were colorful, inspiring, or unusual. The *Geographic* covered aspects of U.S. history, conservation of

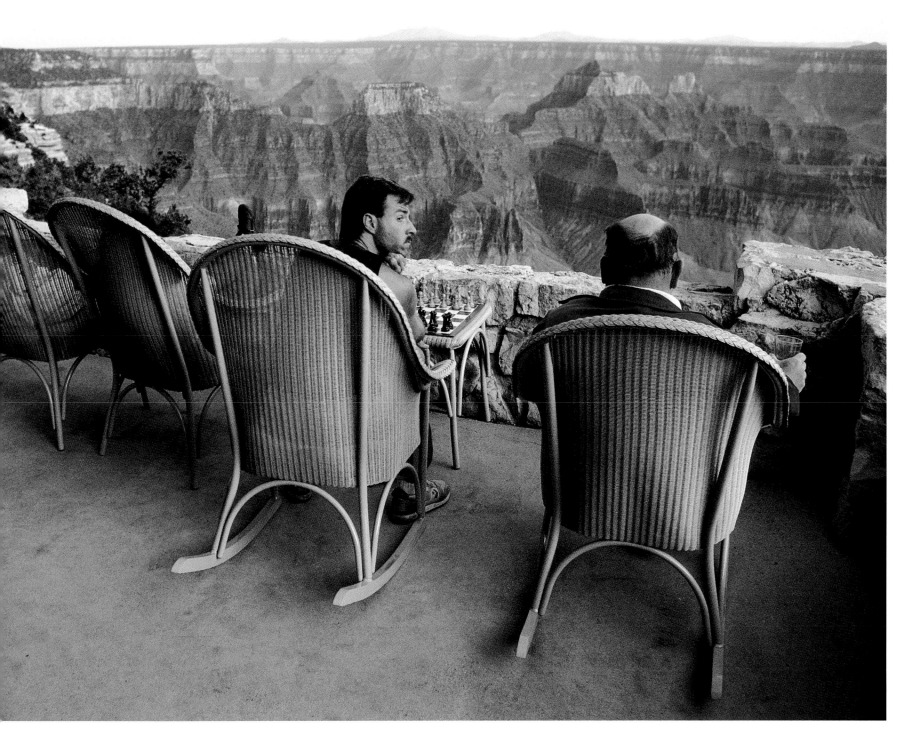

Arizona 1987

TOMASZ TOMASZEWSKI

Blasé tourists rock on the balcony of a lodge overlooking the Grand Canyon. Polish photographer
Tomaszewski was deliberately chosen by editors to provide a "foreigner's" look at the U.S.

U.S. parklands, and wildlife. Distinctive communities, such as those of the Shakers and the Hutterites, were featured, as were cowboys and baseball players.

Marching along from the 1930s to the 1970s, story titles show how the *Geographic* presented the U.S.A.: "Connecticut, Prodigy of Ingenuity" (September 1938), "Nevada, Desert Treasure House" (January 1946), "Work-hard, Play-hard Michigan" (March 1952), "Today on the Delaware, Penn's Glorious River" (July 1952), "St. Louis: New Spirit Soars in Mid-America's Proud Old City" (November 1965), "Minnesota, Where Water Is the Magic Word" (February 1976).

Geographic stories published since the 1980s bear little resemblance in style or viewpoint to those of the 1930s, 1950s, or any other period. Today the magazine examines issues that would not have been seen earlier—the poaching of wildlife on federal lands, for example. For photographers, the change has had a profound effect. The diversity of picture styles, unknown in earlier days, makes it possible for photographers to portray American scenes as they see them.

Tomaszewski, a stranger to American culture, was unlike typical American photographers, for he says he started out with few preconceptions and no personal agenda. But when he talks about his published story, he says it pleased him because, "I think there's a balance between my private way of seeing and pictures that represent a *Geographic* point of view."

Photographer Chris Johns received a history lesson on the policy of positive coverage shortly after he arrived at the *Geographic* in 1983. His first full-length magazine assignment was on the Okies, fifty years after they headed west from the Dust Bowl. The *Geographic* had a long history of reporting on the American West. But Johns, going through copies of the *Geographic* in the 1930s, discovered that the magazine did not show the plight of the Okies during the Great Depression.

Instead, "How Warwick Was Photographed In Color," a story in the July 1936 issue by photographer Maynard Owen Williams, typified *Geographic* coverage during the depths of the Depression. Williams laid out in personal and technical detail how he had photographed the castle using the Finlay color process, a grainy but relatively fast system, developed in 1930. The editors gave prominent display to 13 images. The *Geographic's* photographic mission in the 1930s, as it had been for some years, was to break new ground in color technology, and articles were shaped to support the goal. State stories like "Southern California At Work" (November 1934) and "Indiana Journey" (September 1936) showed color and abundance.

Adventure and natural history stories also filled *Geographic* pages during the Depression. The July 1933 issue began with a story of a couple who canoed up the dangerous Inside Passage of Alaska "just for the fun of it." A month later, "California Trapdoor Spider Performs Engineering Miracles" offered remarkable behavioral photos illuminated by flash. Editors believed that showing the Depression was not part of the National Geographic Society's mission.

Photographers like Dorothea Lange and Russell Lee, working for the Historical Section of the Farm Security Administration, documented Okies on the road,

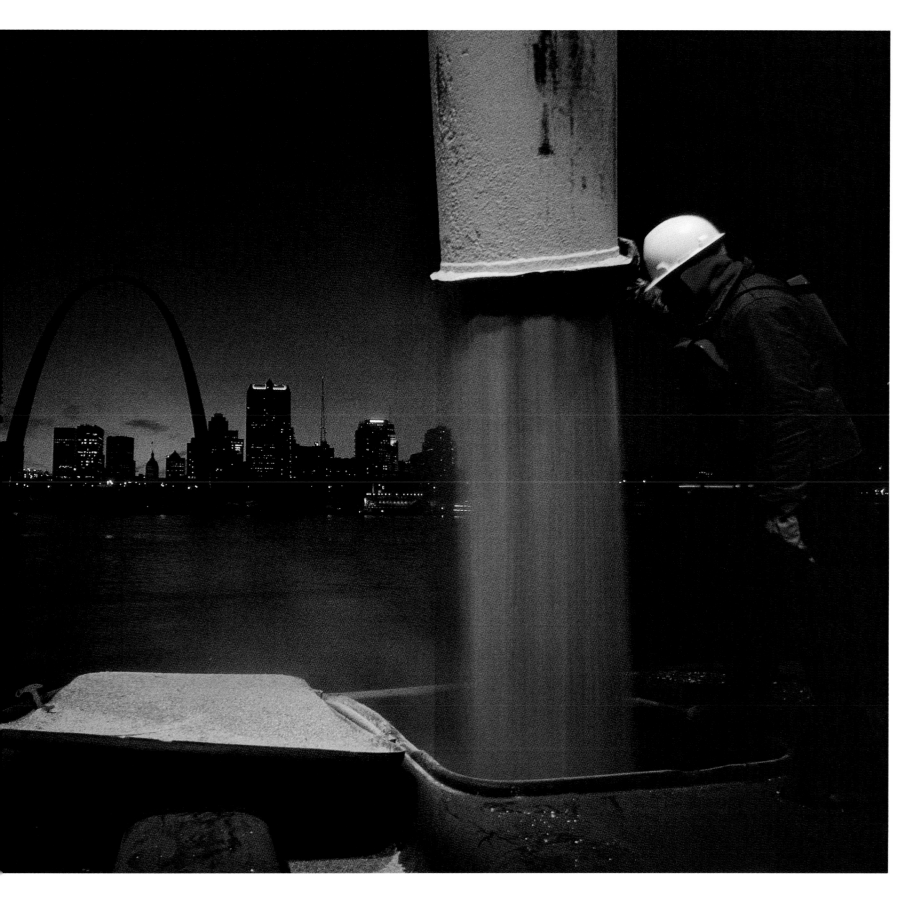

St. Louis, Missouri 1991

PETER ESSICK

*Golden corn flows into a barge tied up across the river from Gateway Arch. The photo appeared in
one of the* Geographic's *commodity stories—those with a one-word subject, like corn.*

heading west from Texas, Oklahoma, Kansas, and Arkansas in search of work and new lives. Johns knew these now classic black-and-white photographs, but as he went in search of the Okies and their descendants in 1983, he was less concerned with history than with proving he could fulfill his assignment.

He did fulfill the assignment. And he went on to cover other American subjects —Hawaii, the Everglades, Highway 93 from Arizona to Alberta (page 317). But, a decade after his first assignment, he wishes he could redo it. Rather than trying to cover every point, he would find a uniquely photographic thread that would carry from picture to picture. "Instead of a scattergun approach," says Johns, "I would try to take a more thoughtful approach about what we are trying to say about Okies and how we could visually tie those things together. It might be a sense of light, it might be a sense of composition, it might be a sense of moment. Just something, an additional layer, so when you look through that story all those pictures add up to just a little bit more than they do on a single basis."

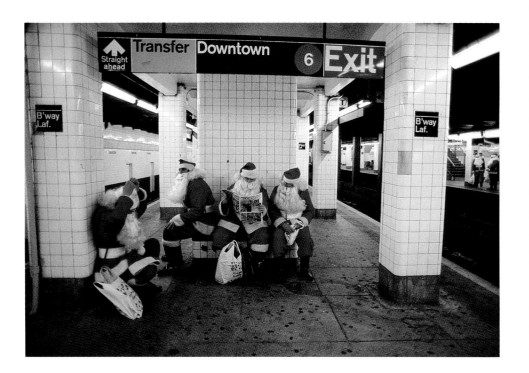

New York City 1987
JODI COBB

Big Apple Santas commute by subway. Cobb's assignment—Broadway— took her the length of the Great White Way, from the southern tip of Manhattan to well into suburban Westchester County.

FOR SIX YEARS Annie Griffiths Belt campaigned to do a story on North Dakota. She grew up in Minneapolis, then worked for the *Worthington Daily Globe* in southern Minnesota, the same one Jim Brandenburg had worked for. She brought her affection for the Midwestern prairies with her when she began photographing for the *Geographic*. "My goal in North Dakota was to peel back the layers of something I know, to find the heart of it," she says. "You can't see this place from an interstate highway. You've got to meet the people, walk on the land, and feel the light."

She also felt wind chills of minus 80°F and blizzards that whipped up whiteouts. One day she was sitting in a farmhouse kitchen, chatting over cookies and hot chocolate, when the farmer rose, put on his boots, and left the house. "He went to make sure his cows were all right in the brutal weather," she remembers. She jumped up from the table, followed him out, and photographed him fighting the wind to open the barn door. It was the best picture in her story.

William Albert Allard, also raised in Minneapolis, went to Montana for the first time in 1969, at age 31, to photograph a German-speaking Hutterite colony. The western landscapes elated him. A year later he was riding a motorcycle along the Mexican border, stopping often to photograph cowboys. He so identified with cowboys that he spent the next decade making photographs portraying their character and ways. ("Allard got to be a cowboy," says Bob Gilka, former director of photography, "and that was all he wanted to do. Every goddamn story…I strained to get it out of him.")

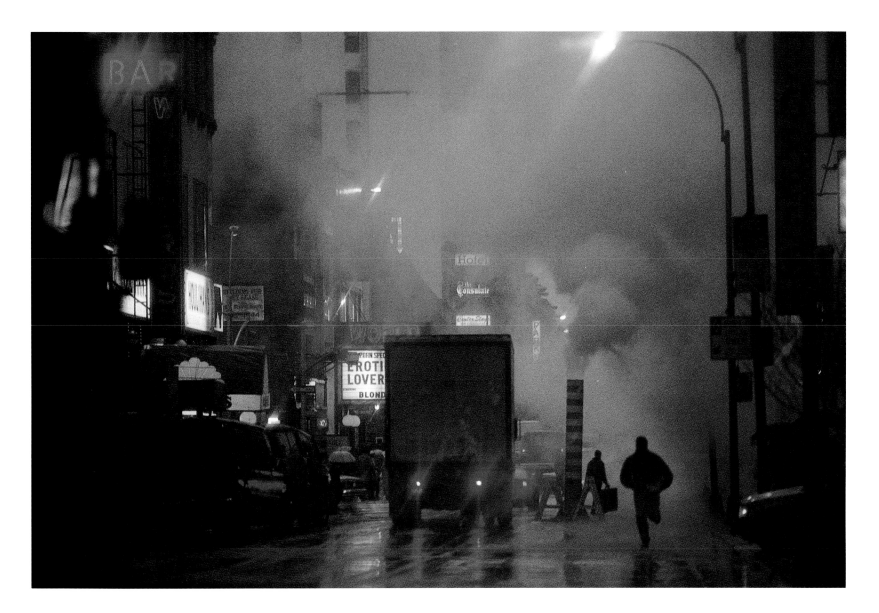

New York City 1988

JODI COBB

*Steamy, paradoxical, and a victim of its own icons, Broadway typified the best and worst of the U.S.
to Cobb. This dark scene offered her "that ominous, out-of-control" feeling many have for the city.*

Vermont 1973
NATHAN BENN

Citizens of Burke Hollow begin a town meeting with the pledge of allegiance. Long a favored method of covering the U.S., "state stories" take in-depth looks at individual—and manageably sized—chunks of the country.

Assigned in 1987 to do a story he had proposed on William Faulkner, Allard went to the writer's home in Mississippi. He had been in the state only once before, some 20 years earlier, when he covered a civil rights protest, the Poor People's March, for *Life*. "So I was carrying around some apprehensions about Mississippi," he says. "Just the fact that I'm an American doesn't make me familiar or comfortable with every part of the country."

Reading Faulkner's works, Allard noted phrases for visual inspiration but he carefully selected images that would keep his own artistry fresh. "I was working in the spirit and shadow of this man," Allard says.

Late on an Easter afternoon, he made his way to a rural house where blues musicians had gathered. Allard drifted around the house. A sultry 15-year-old named Paula insisted that she change out of her shorts so he could photograph her in her Easter suit. Dressed in shiny white, she drew him into a back room, where, on one bed, a youth sprawled unconscious, and, on another, a couple sat kissing. Soft light streamed through a window, touching an elbow here, a bedpost there, illuminating Paula's suit and the mini-dramas on the beds. It looked like a stage set, with characters out of a Faulkner novel. "I thought, 'Paula, don't pose,'" says Allard, "but in this case her posing really completed the image" (page 300).

Allard's photographic strategy linked Faulkner's life with his characters, combining journalism with fantasy. Other *Geographic* photographers and editors have used similar techniques for stories on artists' lives. David Alan Harvey's assignment was Andrew Wyeth. Harvey had to capture the artist's personality and work style while also photographing other members of the Wyeth family. Three generations— N. C. Wyeth, four of his five children, and twelve of his thirteen surviving grandchildren—worked in the arts.

Before setting off, Harvey planned strategy with picture editor Susan Welchman. "We thought about doing what Andrew Wyeth did," he says, "going to Chadds Ford, Pennsylvania, and making a reasonable facsimile in still photographs of what Wyeth had done in his art." But they realized that color photography would look jarring alongside Wyeth's monochromatic paintings. So they came up with the idea of photographing the family in black-and-white while the paintings would stand alone in color. "I had a breakfast meeting with the editor to propose this, thinking it wouldn't fly," recalls Harvey. "But he bought it immediately."

Harvey, who had been photographing in color for 20 years, had no trouble switching to black-and-white. "I think most color photographers are closet black-and-white photographers. That's how most people began." he says. "There is something so clean and pure about black-and-white" (pages 290-91).

When Harvey heard that President Bush would present a Congressional Gold Medal to Andrew Wyeth at the White House, he got permission to cover the event as a member of the press corps. At the end of the ceremony, Harvey approached Wyeth. "He was in a good mood and the next thing I know, I'm walking along with Andrew, Barbara Bush, and the Bush dog Millie," Harvey recalls. "I was on my way to the

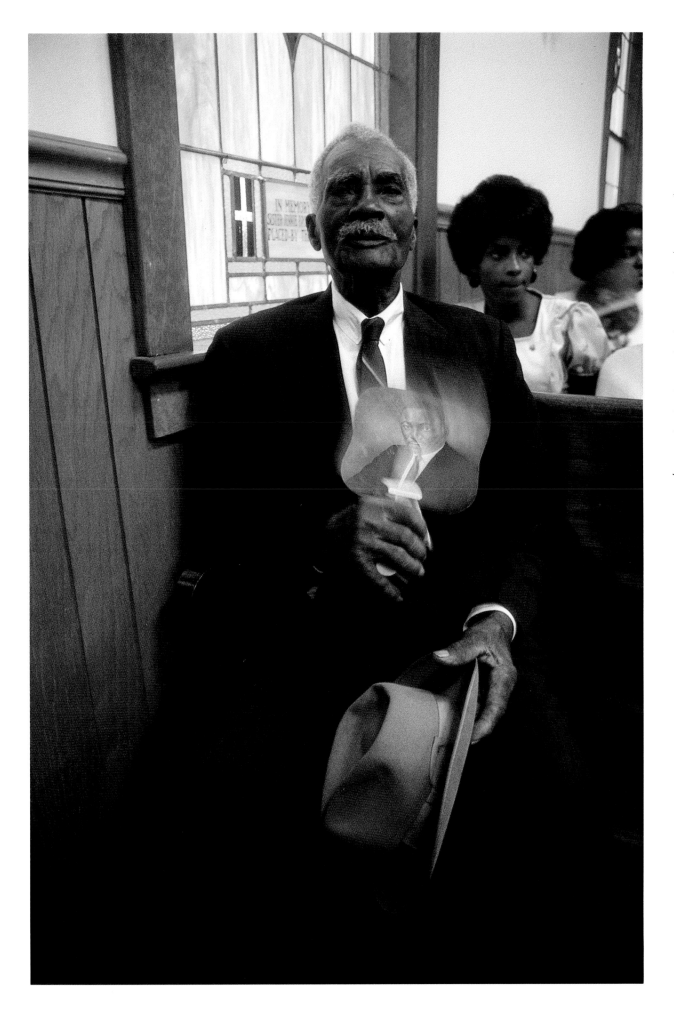

Virginia 1975

JAMES L. STANFIELD

At his Baptist church in Rosier Creek, deacon Carolinas Peyton keeps cool with an image of Martin Luther King, Jr. Stanfield had spent three months trying to capture the character of life along the Potomac River before he met Peyton—a character in his own right. They remained friends for years.

family quarters and nobody threw me out." Wyeth, basking in Presidential glory, gave Harvey permission to visit his family.

But maintaining solid, workable access became a constant struggle. Harvey pursued Andrew's son Jamie. "He used to hang out with Andy Warhol," Harvey says, "and since he was in my generation, I figured I could probably communicate with him." Andrew, who had been photographed by Henri Cartier Bresson and had appeared in *Life*, grudgingly cooperated, mostly to get recognition for his father.

"I pushed hard to get N. C.'s painting of Treasure Island on the cover of the Wyeth issue," Harvey says, "and I let Andy know that even though I was a mere photographer, I had some say as to how this story would come down." To demonstrate his respect for Andrew's concerns, Harvey broke tradition and showed Andrew the layout of the story, even though there was the risk that he would hate it. But Wyeth approved. By then, Harvey had been a guest for Thanksgiving and was a friend of the family. The Wyeths still invite him for Christmas.

Harvey considers the ability to photograph in the U.S. a prerequisite for photographing abroad. Americans look at the world from a distinct perspective, he believes. It is important to be aware of it before working in another culture. Doing otherwise can result in pictures that look exotic but are devoid of significant content. "I blend with different cultures by being a middle-class product of sixties and seventies America," he says. "I don't try to be one of the people I photograph. I blend with them while still being me."

New York 1991
MARIA STENZEL

Bathers in the Catskill Mountains savor the cold, refreshing water of the Neversink River.

THE ART OF ARCHITECTURE met the art of photography when Sam Abell documented the vanishing Shaker culture in Maine, New Hampshire, and Kentucky. Abell decided to convey Shaker values—permanence, simplicity, spirituality—by presenting Shaker construction. His symmetrical compositions linked structural simplicity with spirituality. Like the Shaker architects themselves, he infused his creations with light to heighten their spiritual feeling. Shaker architecture is outlasting the Shaker community. To portray this paradox, Abell photographed solid buildings surrounded with fleeting foliage, snow, and mist (pages 296-97).

The story could not be devoted entirely to buildings. There were also photos of a few Shakers, most of them elderly. *Geographic*'s U.S. assignments invariably feature people. Photographers must be able to establish rapport with men, women, and children, and portray them intimately. Sometimes, though, photographers have trouble figuring out an angle.

Jim Stanfield, assigned to photograph the Potomac River, did what he says he

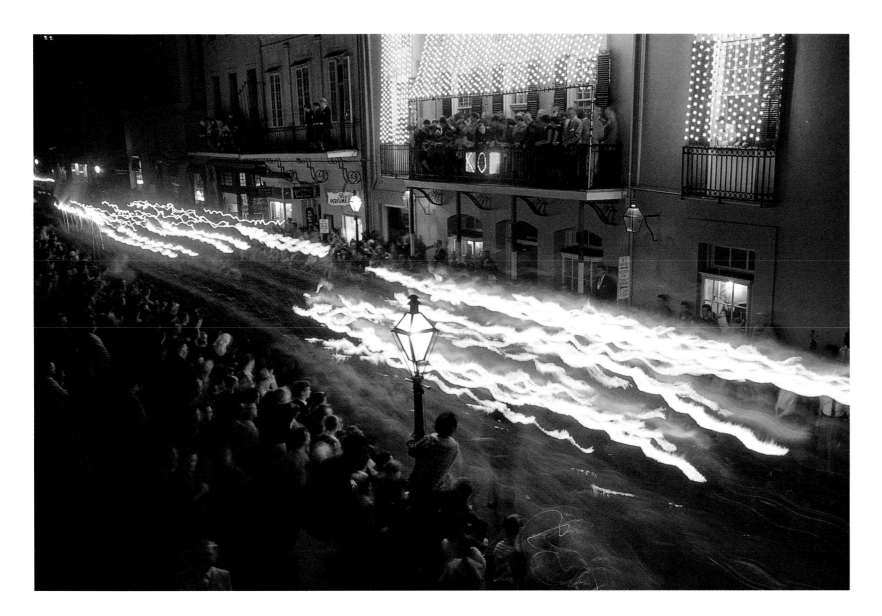

New Orleans, Louisiana 1960
ROBERT F. SISSON AND JOHN E. FLETCHER

*In a several-second time exposure, a Mardi Gras parade down Royal Street becomes a ribbon of
torches. Sisson—the photographer—and lighting expert Fletcher shared the story's byline.*

always does: "On assignment, I try to photograph every blade of grass, and then I'm satisfied." He labored this way along the Potomac for three months, even managing to photograph a howitzer shell spiraling from a gun barrel at a weapons' proving ground. But, hard as he tried, he did not feel he was capturing the river's personality.

Then he heard about a 88-year-old farmer named Carolinas Peyton who lived on a 50-acre farm with his daughter, two mules, and a great-grandson. Stanfield hit it off with the family, moved in for three days, and photographed them doing chores, singing in church, socializing (page 285). "The story started to change," says Stanfield. "I started to live with the people who needed the river—miners, hermits, farmers." From then on, the only problem he had was chiggers.

DURING A THREE-WEEK PERIOD when Jodi Cobb started photographing Broadway, first her watch and jewelry were stolen, then her wallet, then her coat. "I got a bodyguard, a big guy to walk around with me and watch my back," she recalls. "But he was always getting lost, wandering off." In Times Square, two men tried to steal her cameras. "They used a well-known trick. One sprays your back with catsup that looks like blood, and yells, 'Lady, what happened to you?' The other walks up on the other side and snatches your camera bag." He tried to get it, but he couldn't break Cobb's tight grip. She was not about to be robbed again.

Her experiences on the mean streets seem to be reflected in at least one of her pictures. "I wanted to get that ominous, out-of-control feeling a lot of people have about New York," she says. One evening, when wet snow glistened on the streets, she got a taxi and drove around. Near Times Square, steam was rising from street grates, and she shot a picture—a shadowy scene of billowing mist, fragments of neon, and tense, silhouetted figures—that projects the mysterious foreboding she felt (page 281).

Cobb has delivered her share of memorable cityscapes and landscapes to *Geographic* editors, but, she says, "I am more interested in people." One of her earliest assignments took her to the Suwannee River. She found a family of ten living in a three-room shack at the water's edge. To her, they typified the river people. She spent a week gaining their acceptance. "I ate rattlesnake and turtle, proved myself a good sport, and they couldn't shake me," she says. In one image, five separate, personal moments unfold in a crowded two-room space. "To me this picture is about how ten people can live in one house and find privacy," says Cobb. "Just as they were able to find privacy among each other, they were able to find it from me" (pages 308-09).

Cobb likes humor in some of her photographs. "Some people say, 'Hmmm, not art,'" she says. "But to me, a lack of predictability, a certain whimsy, is a worthy goal in photography." Her Broadway assignment put her to work in the United States for the first time in eight years. She felt liberated. "On Broadway, our cultural icons and cultural jokes, the best and the worst, marched up and down the street," she says. "It was a roller coaster of American life." She photographed Santa Clauses whenever she met them. "I ended up with a photograph of Santas in the subway [page 280]. It's often easier to photograph in your own culture, where people recognize the cultural

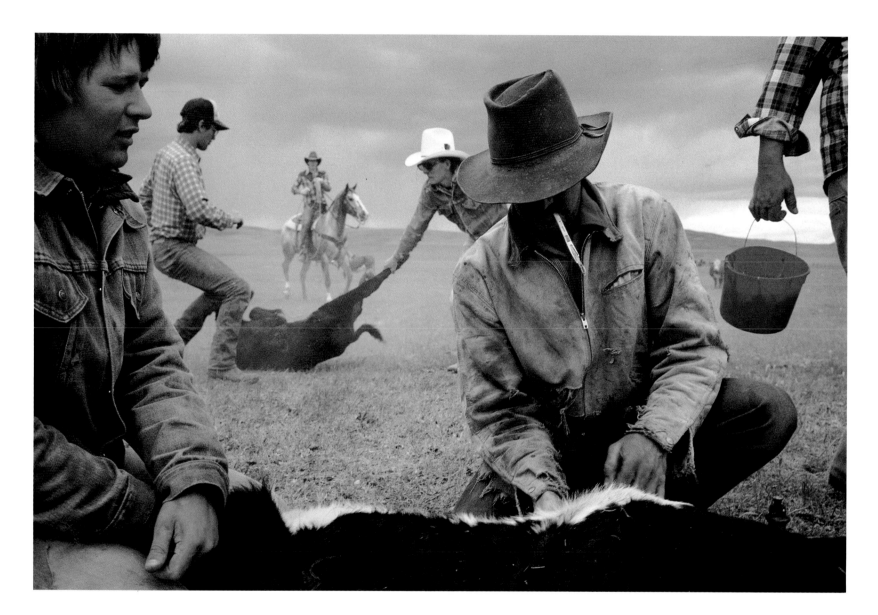

Utica, Montana 1984

SAM ABELL

*Waiting for an image that would express both the expanse of the open range and the action of
branding time, Abell focused his attention on one cowboy—John Flanagan—for an entire afternoon.*

references. If Santa Claus had been an equivalent Chinese character, Americans would not understand the humor of that photograph."

Cobb notes the interplay between photographer, subject, and reader. Working in unfamiliar cultures outside the U.S., she begins by photographing things that look interesting because they are strange. As her understanding of a culture deepens, she may discount her first pictures as shallow or superficial. But, paradoxically, the sophisticated pictures earned by learning about a foreign culture may not get published because they are not understood back home.

Karen Kasmauski, who is part Japanese and an anthropologist by training, has strong opinions on cultural matters. "Because of my appearance and my profession, I don't have the option of blending in," she says. "In the U.S. I am viewed as different when I walk in the door. Ironically, in many other parts of the world I am mistaken for a local. I can't tell someone's nationality by looking at their pictures. But I can tell a lot about how they view people. That's more significant than where they're from."

She describes herself as a "story-line person." Her images, "though very, very important to me, are not as important as my story," she says. She wants the people in her photographs to be more than subjects. She wants them to be friends. Casual street shooting, she believes, can produce pictures in which people function merely as design elements. "To me, a success is when I walk away from a story and feel sad because I'm leaving someone I've gotten close to," she says.

She had to work hard to gain access to the Gullah people of South Carolina's Sea Islands, descendants of West Africans who came as slaves as early as the 16th century. The community was hostile and in turmoil. Land developers, hoping to cash in on the islands' beauty, had purchased tracts, developed resorts, and forced up land values. Black owners, suddenly unable to afford the taxes on their own land, lost it and had to move off the islands. They did not like what they called the "white press," and that included the National Geographic Society.

"My impression is that the *Geographic* often is not accepted outside mainstream white society," Kasmauski says. "I had to convince the Sea Islanders that we do try to portray people honestly and fairly." She came back with straightforward, close-up pictures of the Gullah people in real situations as they carried on with their lives.

"I used to be a good fisherman when I was younger," Kasmauski says. "I sat for long periods of time and just waited for the fish to bite." Now, as a photographer she does the same, planting herself in a choice location and waiting for a picture. "If you stay long enough, life passes by," she says.

In a small West Virginia town there came a moment when she used this technique. "When I arrived, there wasn't a soul on the street," she remembers. "Suddenly, there was a group of people wondering what in the world I was doing in the middle of the street, with my cameras, waiting for someone to show up." A man approached curiously, then walked away. His dog followed, jumping. Kasmauski got a picture of a small-town street and a man and his dog. Her secret of good photography is simple: "Interesting things happen in front of you."

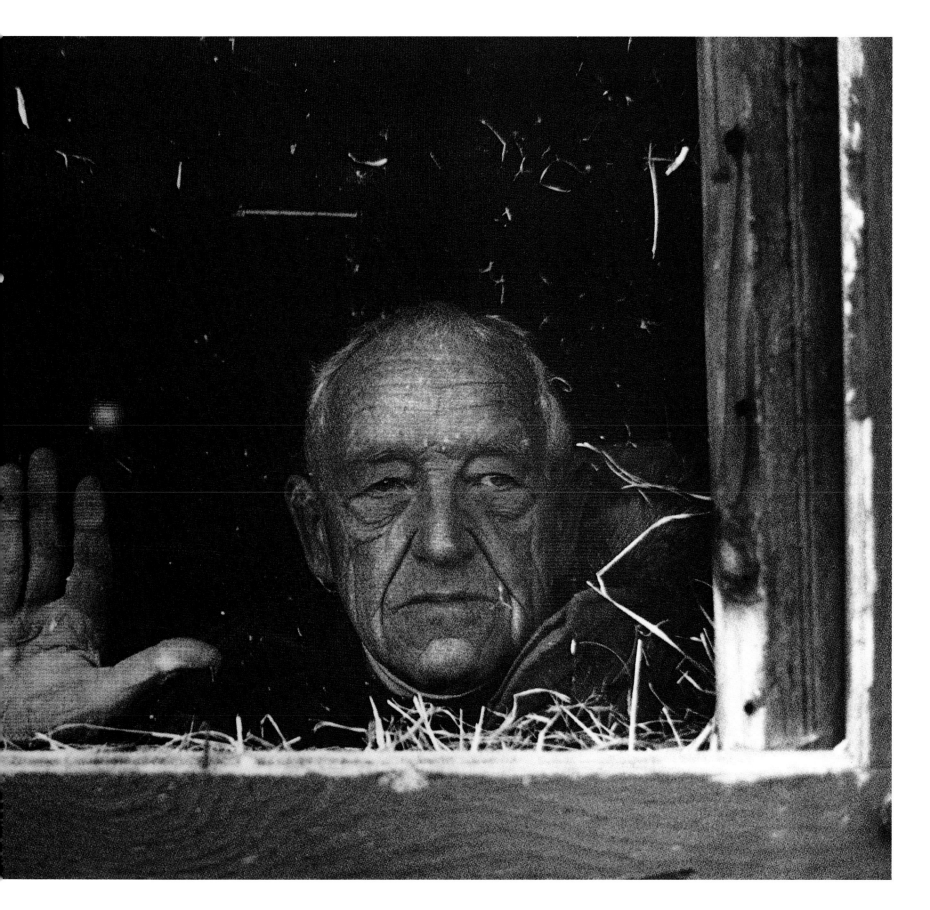

Chadds Ford, Pennsylvania 1991
DAVID ALAN HARVEY

Painter Andrew Wyeth—here the subject instead of the artist—peers from the window of a barn.
When asked if he posed this picture of the theatrical Wyeth, Harvey said, "No, but maybe Andy did."

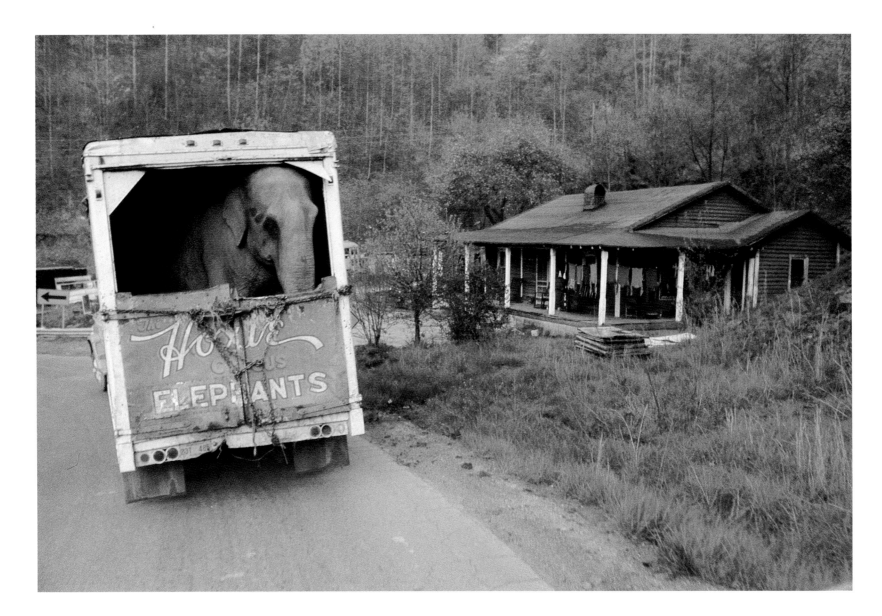

Kentucky 1971

JONATHAN BLAIR

*On a 7-month tour through 13 states, this veteran of the Hoxie Bros. Gigantic 3-Ring Circus
appeared in nearly 200 towns. Now called the Great American Circus, the show is still on the road.*

preceding pages: Imperial Sand Dunes, California 1985

CRAIG AURNESS

*On a holiday weekend, dunes near the town of Glamis blaze with the glow of off-road vehicles; lights
of the vehicles, caught in a time exposure, paint a surreal picture of an activity now widely criticized.*

Gortner, Maryland 1973

ROBERT W. MADDEN

Amish farmer Simon Swartzentruber, 81, trudges to church. Madden carried a small camera in a pocket and only used it—unobtrusively—when the notoriously shy Amish didn't object.

Pleasant Hill, Kentucky 1988

SAM ABELL

"I have seen many rooms made lovely by light," Abell says, "but none more so than those built by Shakers." Here he opened two doors to let natural light pour through the large arched doorways.

Pleasant Hill, Kentucky 1989

SAM ABELL

Mist engulfs the Kentucky village of Pleasant Hill, founded by members of the Shaker sect in 1806. Though the Shakers have nearly disappeared, the perfect lines of their architecture endure.

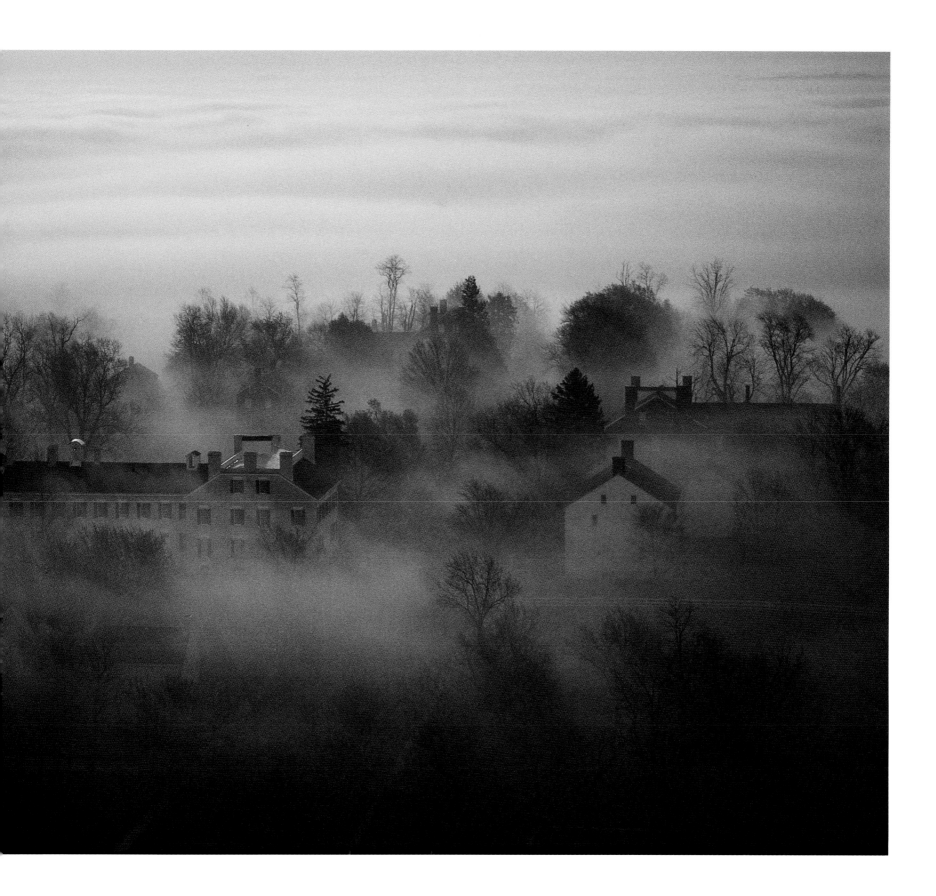

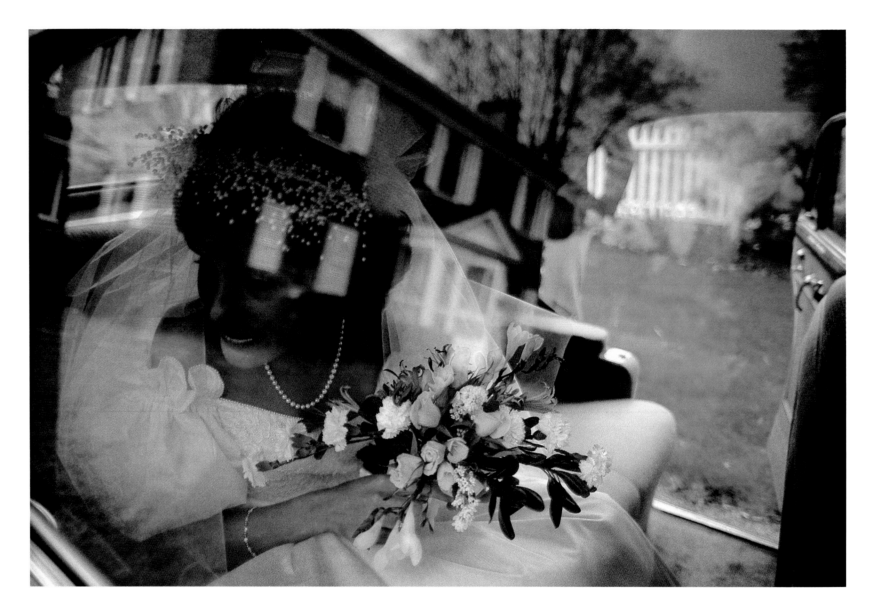

North Tarrytown, New York 1988

JODI COBB

Following Broadway out of the bustling city and into the pastoral countryside, Cobb photographed this bride in front of her childhood home, here reflected in the car window.

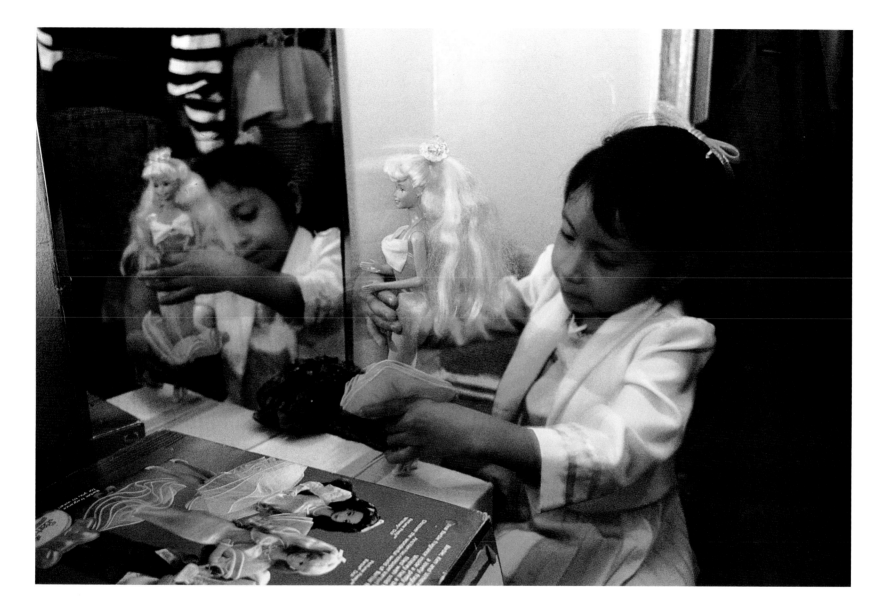

New York City 1989

PAM SPAULDING

*Even newcomers to the U.S. quickly adopt the icons of the pop culture. Spaulding, photographing
a story on Ellis Island, found this young Mexican immigrant engrossed in her Barbie doll.*

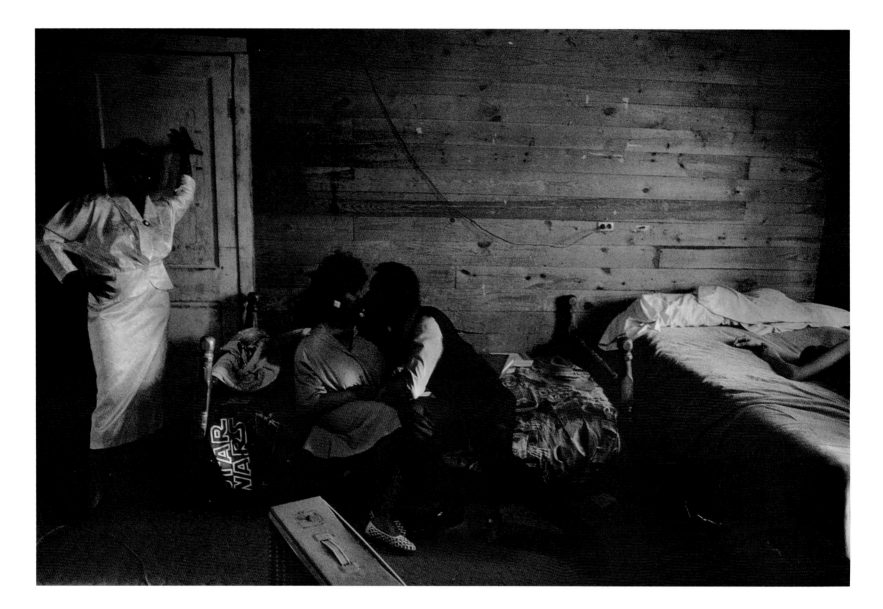

Holly Springs, Mississippi 1987
WILLIAM ALBERT ALLARD

*While exploring Faulkner's Mississippi, Allard photographed this Easter afternoon scene in the home
of bluesman "Junior" Kimbrough. Such biographical stories offer yet another way of covering an area.*

Sand Hills, Nebraska 1991

JIM RICHARDSON

*Lightning filigrees the sky, promising much-needed rain for the Ogallala Aquifer, subject of a March
1993 magazine story. Unexpected colors heighten the drama of this unusual photograph.*

Nags Head,
North Carolina 1985

DAVID ALAN HARVEY

*An angler casts from a
pier on the Outer Banks.
"A picture in passing,"
Harvey calls this photo. He
wandered onto the pier and
found two couples—
members of a religious sect—
fishing. Hesitant about
disturbing the shy people,
he nonetheless began
photographing. Three of the
people moved out of the
picture, but "this woman
either didn't notice or
didn't care or was more
interested in the fishing.
She didn't seem to mind,"
so Harvey photographed—
"just three or four frames."*

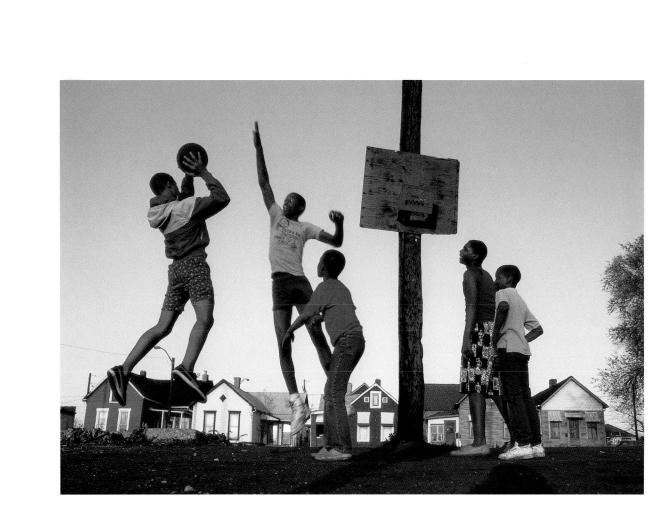

Indianapolis, Indiana 1987

SANDY FELSENTHAL

Hoosier hopefuls see basketball as a way out of the inner city. City stories give photographers a tightly focused subject, the freedom to explore all its facets, and the challenge of accurately representing it.

New York City 1988

NATHAN BENN

Twin towers of the World Trade Center cast long shadows across Manhattan. Benn shot the scene for "Skyscrapers," a story that featured several artfully posed architects with their buildings.

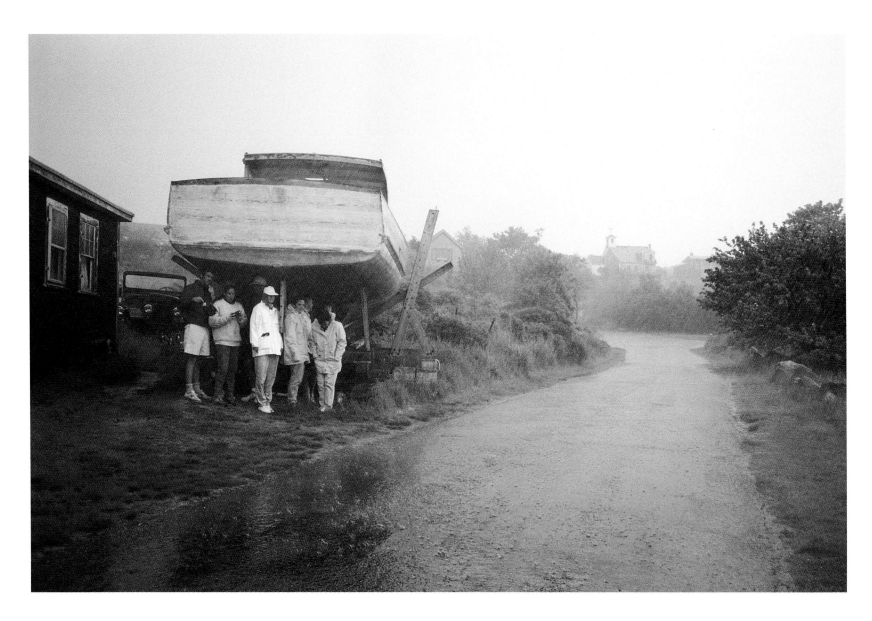

Cuttyhunk Island, Massachusetts 1991

DICK SWANSON

Rain dampens the plans of day-trippers who have come to enjoy Cuttyhunk, a quaint
New England island some ten miles off the coast of Massachusetts' southern heel.

Northfield, Massachusetts 1971

DAVID L. ARNOLD

Bearing a remarkable likeness to her grandmother's portrait, this woman lived among the
Brotherhood of the Spirit, a religious group committed to a pure and simple life in New England.

Suwannee River,
Florida 1976
JODI COBB

*Ten people, members of an
extended family, lived in the
small home of riverman Jake
Colson (at lower right), but
Cobb was made welcome,
too. While covering the river,
she spent a week with the
Colsons, sharing their
rattlesnake and turtle meals
and getting a close look at
their lives.*

Merrillville, Indiana 1990
BILL LUSTER

Family members console one another as they donate the organs and tissues of a dying eight-year-old boy. A photographer shooting such a scene requires fierce determination, compassion—and tact.

Macon, Georgia 1993

KAREN KASMAUSKI

A very private situation: Struggling with a cocaine addiction and an HIV-positive status, "Scott" sits head-in-hands, surrounded by his children and former wife, who is also HIV positive.

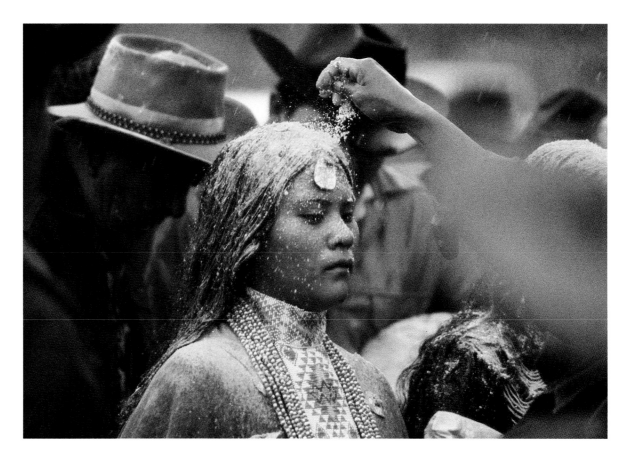

Fort Apache Indian Reservation, Arizona 1976

BILL HESS

Paying homage to ageless tradition, an Apache girl marks her coming of age with a four-day
Sunrise Dance. Well-wishers sprinkle her with cattail pollen, a sacred substance.

California 1986

CRAIG AURNESS

Centuries-old intaglios, marred now by the swirling track of off-road vehicles, pattern the desert floor
near Blythe. Photos like this one can help save such threatened sites by raising public awareness.

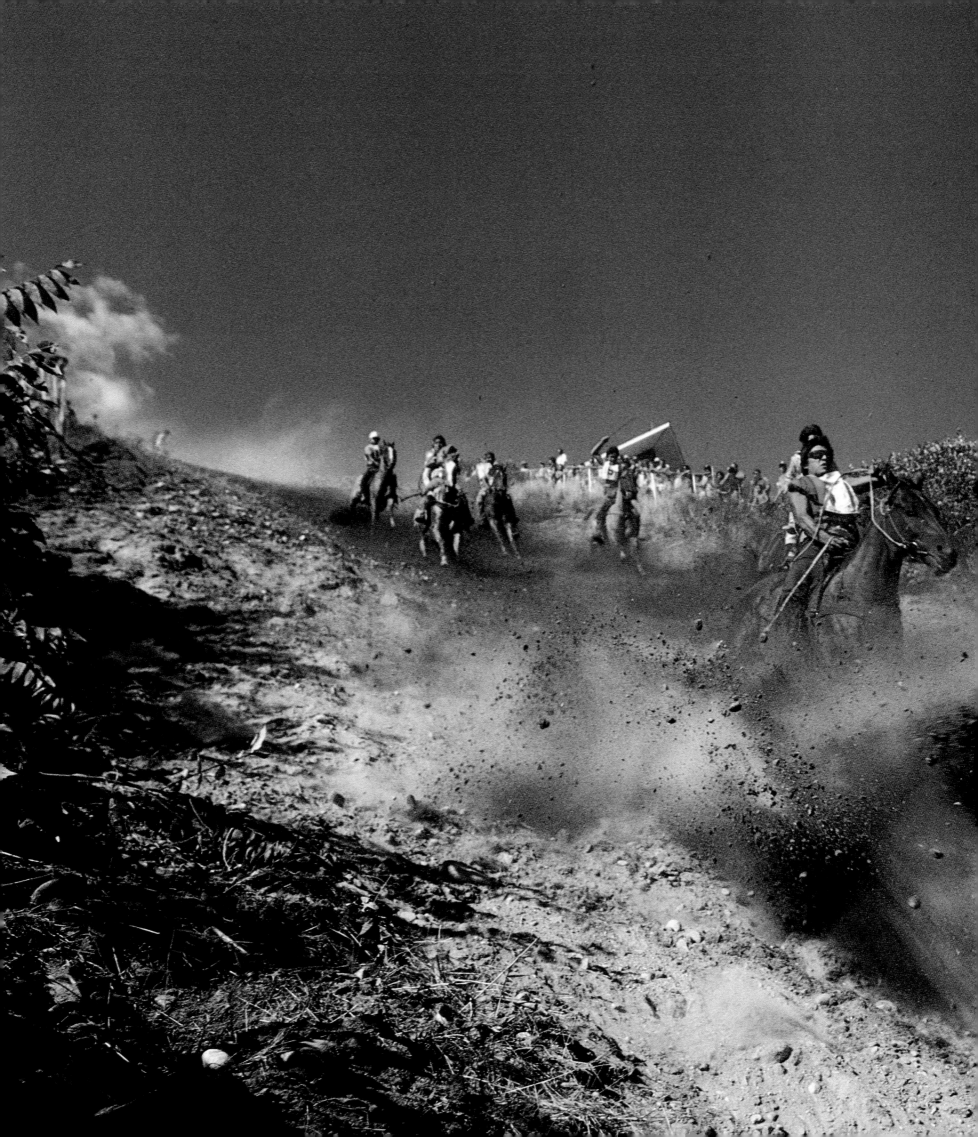

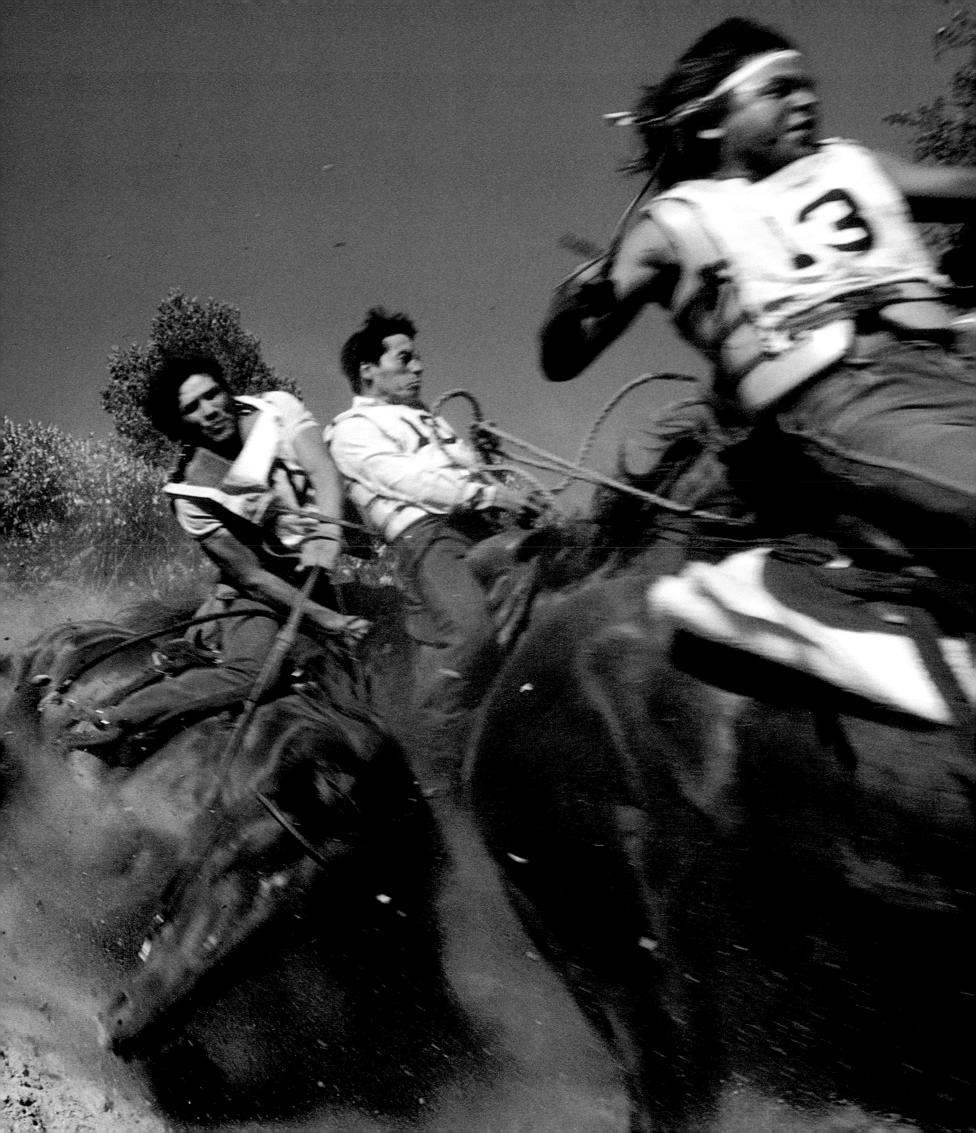

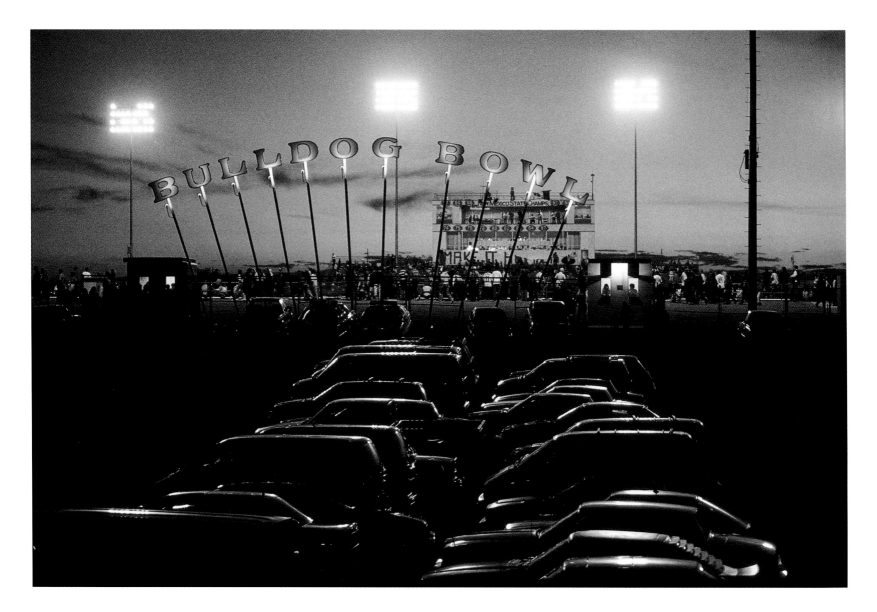

Artesia, New Mexico 1992

BRUCE DALE

A small town's passion for its championship team shows up in bright lights above the local high school football stadium. Though Dale often relies on serendipity, this photo was carefully planned.

preceding pages: Okanogan River, Washington 1987

SANDY FELSENTHAL

Barely out of harm's way, Felsenthal captures the plunging downhill momentum of riders in the infamous Omak Suicide Race, a 50-year-old tradition among Indians of the Colville Reservation.

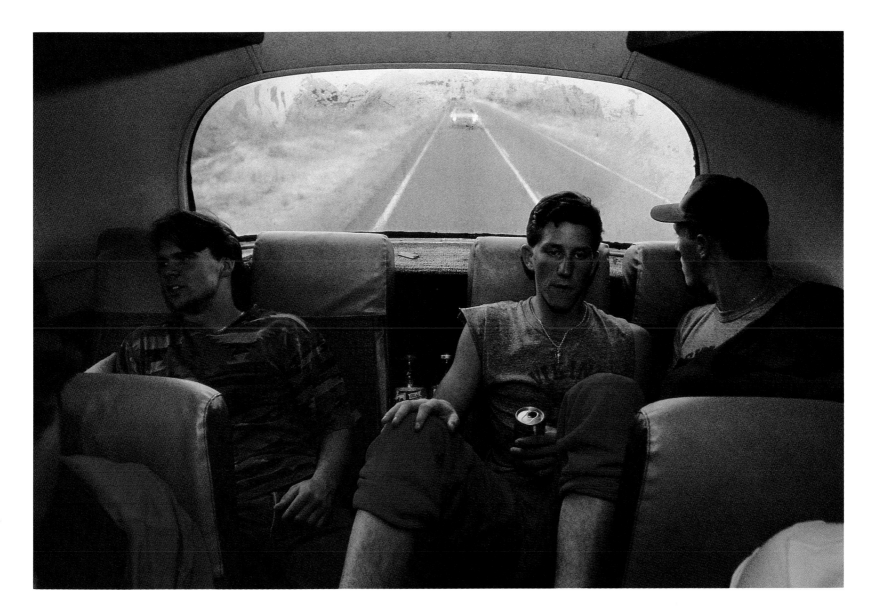

Idaho 1991

CHRIS JOHNS

*Tense high school football players head down Route 93 toward a game. Highway stories represent
another way to approach a region geographically; the magazine published its first in 1959.*

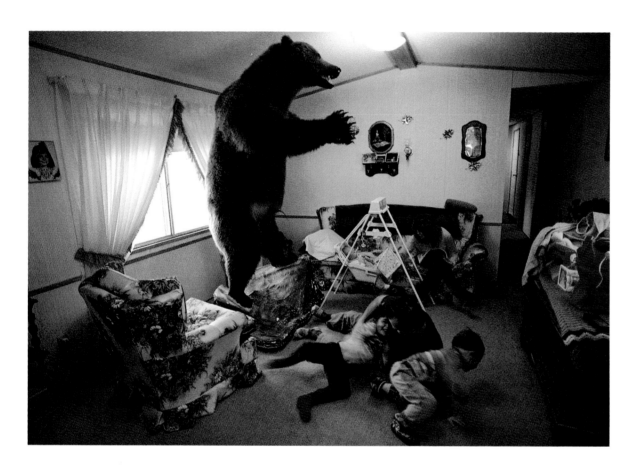

Alaska Highway, Alaska 1991
RICHARD OLSENIUS

An eleven-hundred-pound mounted grizzly makes an unexpected living room centerpiece.
The bear came into the room through a doorway, but upside down and sideways.

Salmon, Idaho 1992
JOEL SARTORE

While photographing a story on the ever controversial use of federal lands, Sartore found
that tempers—of both man and beast—can run high on the subject.

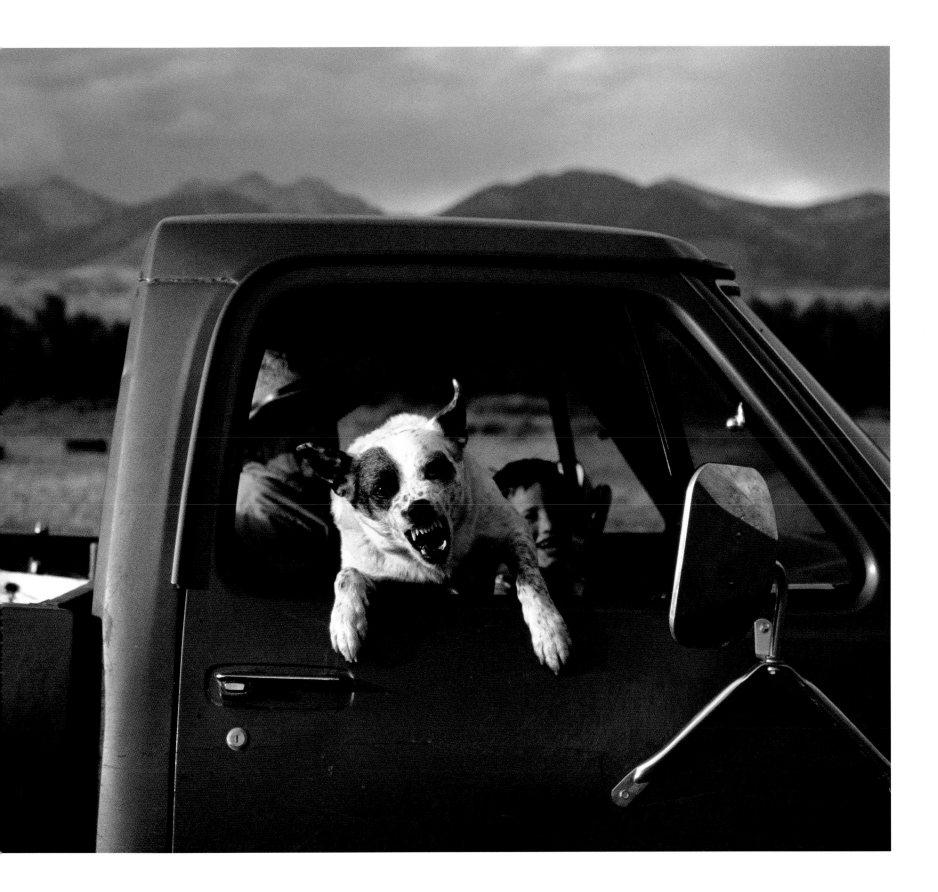

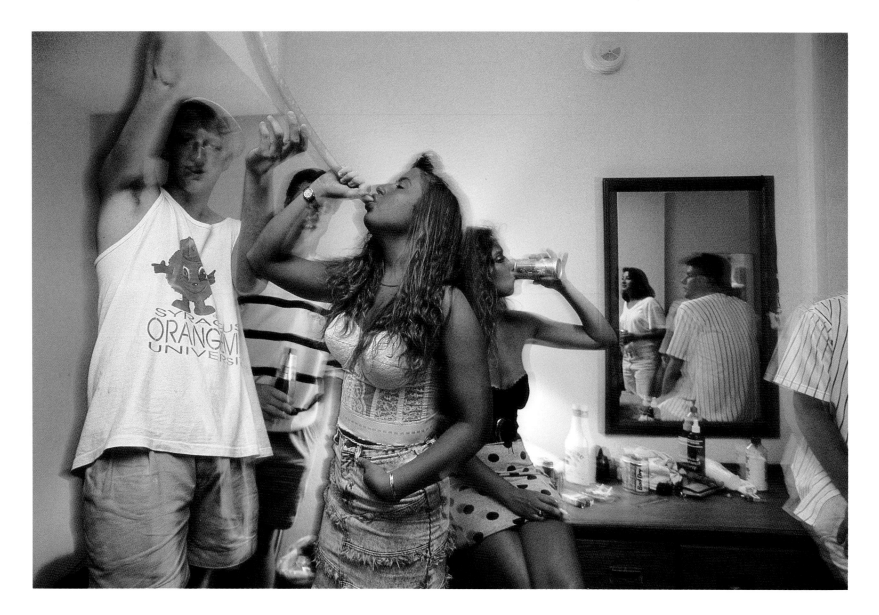

Daytona Beach, Florida 1991
GEORGE STEINMETZ

College students on spring break guzzle from a "beer bong." A story on alcohol and its abuse would not have been attempted by the magazine in its early days.

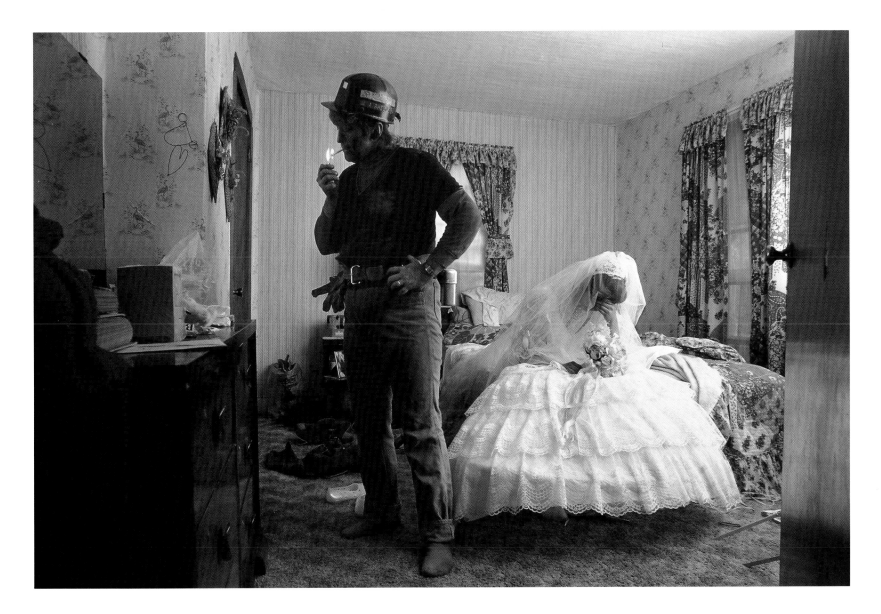

Pineville, West Virginia 1986

JAMES L. STANFIELD

A work-hardened, coal-mining mother lights up during a talk with her 15-year-old bride-to-be daughter. In his 30 years at the magazine, Stanfield has photographed virtually every type of story.

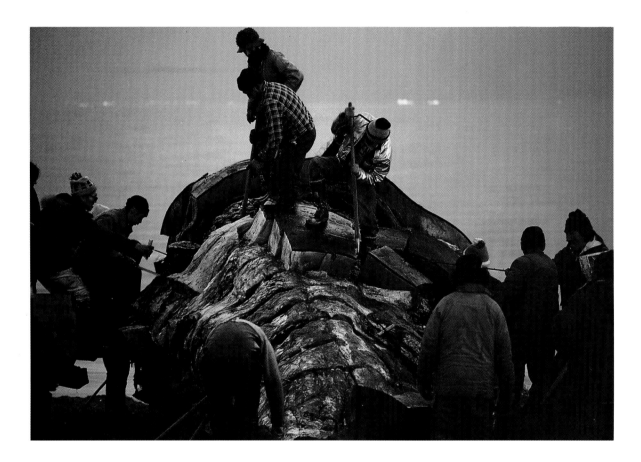

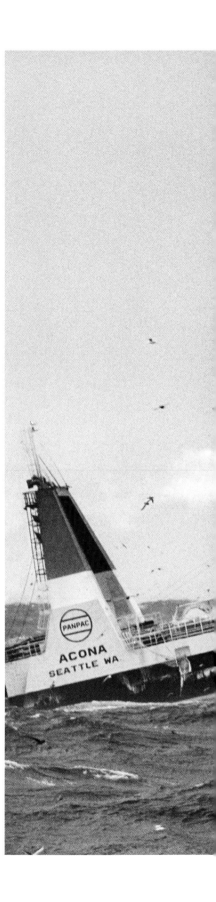

Beaufort Sea 1981
LOWELL GEORGIA

Harvesting a living from the sea, Inupiat whalers butcher the carcass of a bowhead whale, carefully removing the skin and top layer of fat to make into a delicacy called muktuk.

Bering Sea 1991
NATALIE FOBES

A factory trawler heaves with the swells on rough seas. Of the area's brutal weather, Fobes said, it was minus 35°F "on bad days, with a 70-knot wind." She kept extra film warm in her mittens.

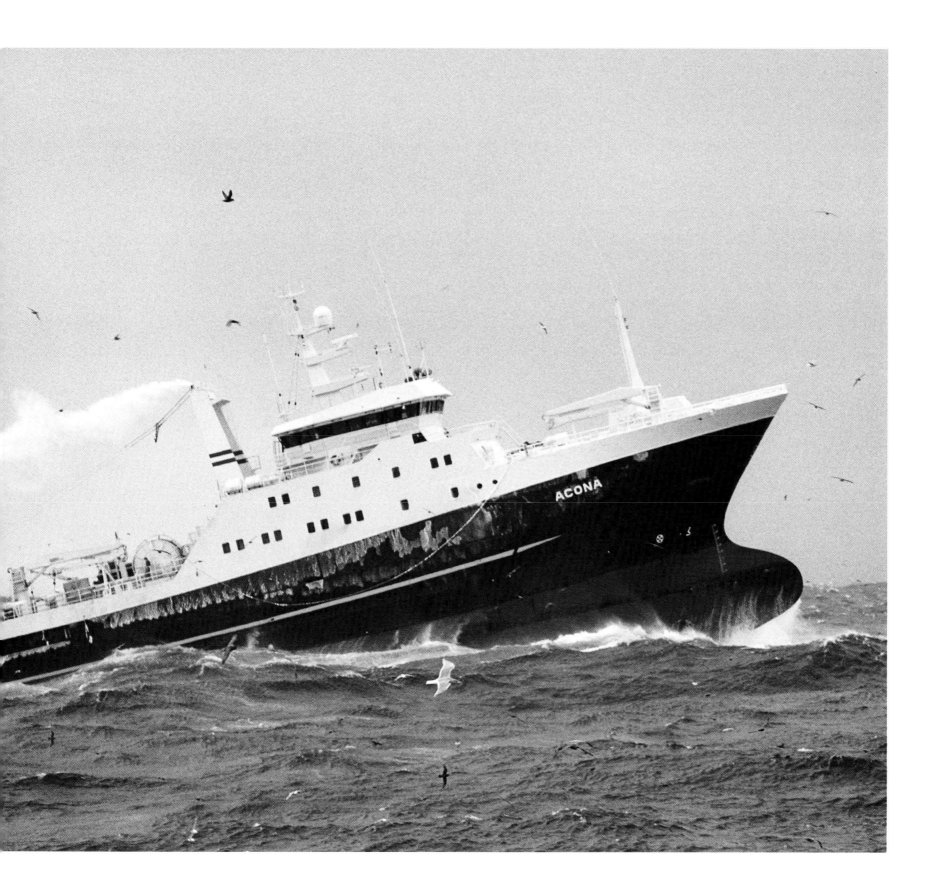

New York City 1992
JOSÉ AZEL

A dusting of snow adds to the nostalgia of a nighttime carriage ride through Central Park. Azel experimented here, getting this photo even when his meter said there was insufficient light.

New Mexico 1980

GEORGE F. MOBLEY

Georgia O'Keefe sits with her painting "Black Place III" at her home, Ghost Ranch. Despite a reputation for being difficult, she proved "cooperative and eager to talk about her life" with Mobley.

Cowboys

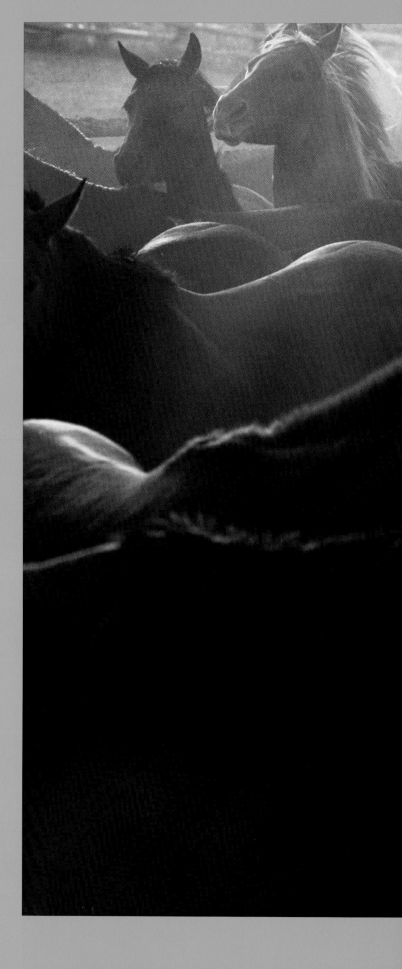

Bill Allard could have used a four-wheel drive when he photographed cowboys, but usually he rode a horse that satisfied his professional requirements. "You can't have a horse that stuttersteps all over the place," he says. "Ideally you use an old roping horse, the kind you can ground-tie, which means you can get off and drop the reins and the horse stays there."

To carry his photographic gear, he tried various backpacks and saddlebags. To keep his camera steady, he tied elastic around his midsection. Nothing worked perfectly, but all the trouble was worth it, for on horseback he kept close to his subjects.

Allard became obsessed with the West on a 1969 magazine assignment. The *Geographic* wanted him to photograph the Hutterites in Montana because of his success with the Pennsylvania Amish five years before. Both sects were extremely publicity shy, and Allard had a knack for inspiring the kind of confidence that allowed him to get close.

The raw simplicity of the Hutterites' lives touched him. "Some of the boys were young cowboys," says Allard. "They just happened to be Hutterites also." He spent evenings drinking beer and singing with them, and he made tender pictures of their children praying and tending livestock on communal ranches.

At day's end, a buckaroo in a Nevada cow camp works a corral. A longtime interest in American cowboys led Allard to photograph them for more than a decade. He says that good ranch hands love their way of life "and what comes with it: the freedom of space in country bigger than one's problems."

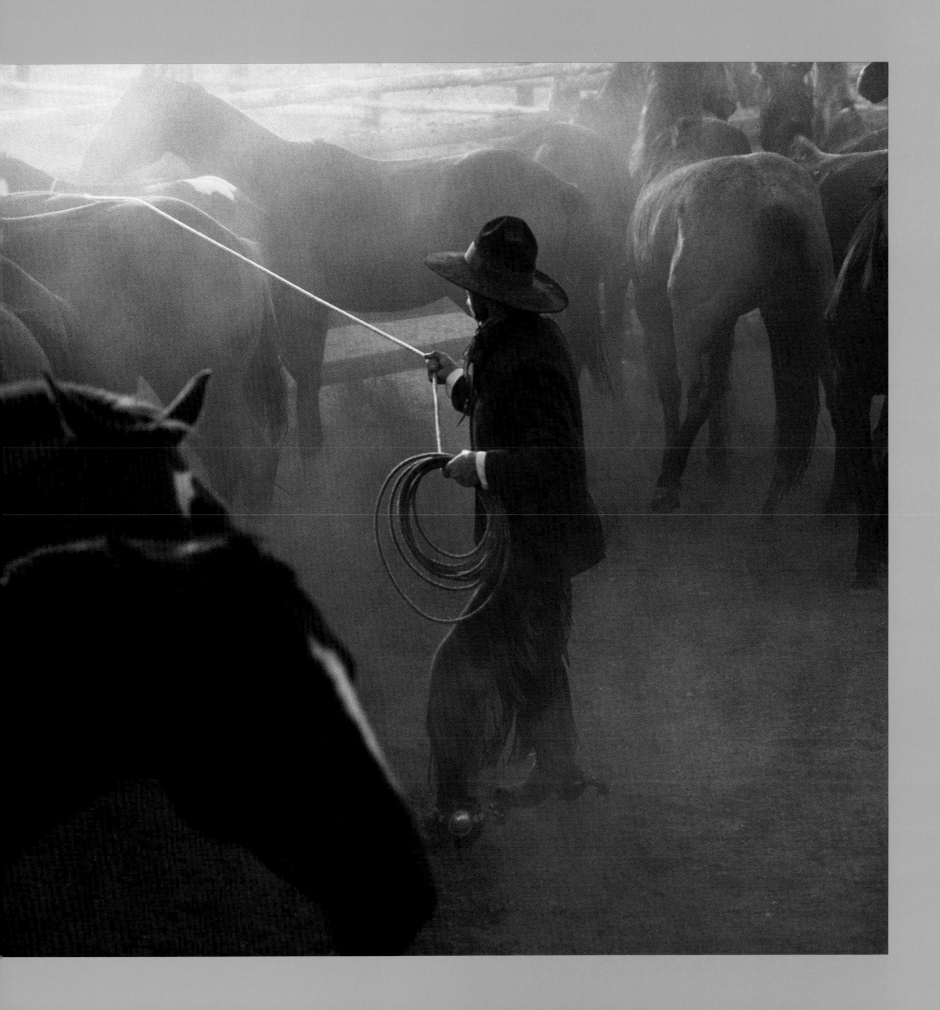

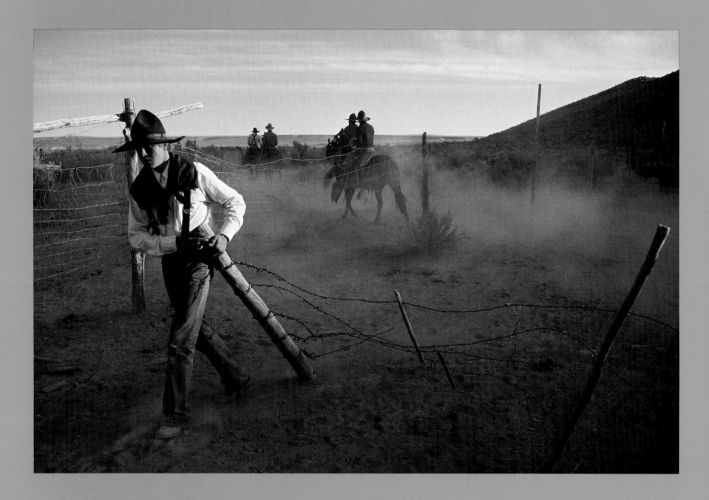

Young hand T. J. Symonds shuts a corral behind his departing partners. T. J.'s father sent him from South Dakota to work for a while on this Nevada ranch, where he quickly picked up on buckaroo dress and habits— including slathering camp bread with peanut butter and syrup. His new shirt was bought just the night before during a trip to town.

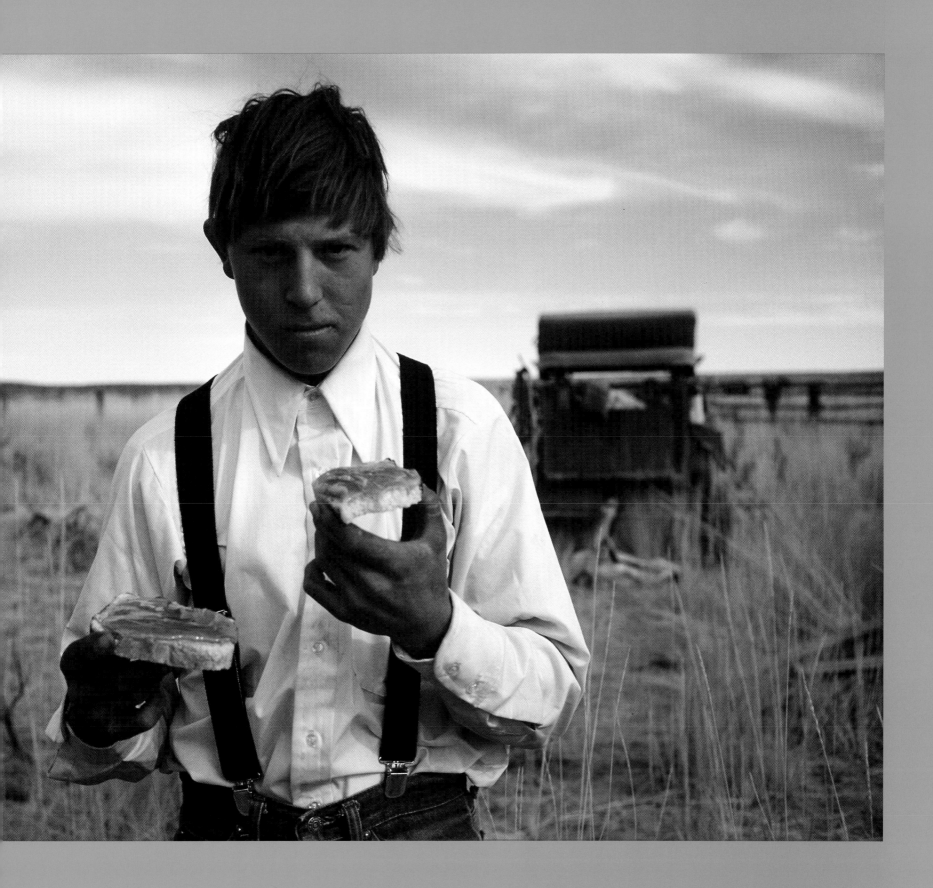

Autumn snow turns a photograph of a Montana cattle drive into a frigid dreamscape. "There's nothing," Allard contends, "that would take as much abuse as a cowboy." And a cowboy's horse shares his hard life.

He looked for a chance to return to the West, and got it a year later when the *Geographic* assigned him to a story on the 1,948-mile border between the United States and Mexico. Allard persuaded the editors to buy him a motorcycle—a Triumph 650. He attached his camera equipment and duffel bag to the sides and back and tied a sleeping bag to the handle bars. Colleagues feared for his safety, but he had only two mishaps. Once he skidded and fell on a sandy road; another time he crashed into a low-flying nighthawk.

He meandered nearly 8,000 miles from the Pacific Ocean to the Gulf Coast, talking to merchants, matadors, U.S. customs agents, illegal immigrants, farmers—and cowboys. He found rancher Henry Gray at his home near Ajo in the Sonoran Desert of Arizona (pages 10-11). The elderly cowboy stood with his hands on his hips, a 48-star flag above him and the head of a steer mounted on the wall behind him. The picture became the lead for Allard's May 1971 border story and,

later, an icon for Allard's work among cowboys.

Allard went to Wyoming and Montana one June to photograph cattle roundups, calf branding, and cowboy life on a big ranch. He returned in October for a fall cattle drive and photographed two riders in a heavy snowfall (pages 330-31). "I kept going back West because I kept feeling I could do better," he says. His 1973 magazine story, "Cowpunching on the Padlock Ranch," focused on individual cowboys and their brutal chores—as well as the beautiful landscapes.

Six years later, Allard arrived one night at a cow camp in the high desert country of northeastern Nevada. Here ride cowboys who call themselves buckaroos, from the Spanish word *vaquero*. When the buckaroos returned to camp, Allard introduced himself and opened a bottle of George Dickel whiskey. He stayed a couple of weeks, sleeping in his van.

Early one morning he photographed T. J. Symonds closing the gate as a day's work started (page 328). "The picture pretty much depicts the traditional buckaroo of the region," says Allard.

Sitting on a corral rail, he photographed a cowboy separating his horses from the herd for the night (pages 326-27). They were his working horses, the five or six that were his to use during the roundup. "Sometimes the buckaroo drives a circle of picket stakes into the ground and strings a single strand of rope between them as a corral," says Allard. "The horses will stay inside the rope."

Cowboys, Allard says, "could just draw their pay and leave. It's a tradition to do that." At a bar he photographed a cowboy who was clutching a beer, deep in thought (right). The day after Allard took the photograph, the cowboy picked up his pay and moved on.

"It's lonely as hell if you don't like being alone," Allard says of the cowboy life. This buckaroo, drinking in a remote Nevada bar, left the ranch on the day after the picture was taken. "I get asked if I used a filter for the picture, because there is so much red in it," Allard says. "I didn't. I almost never use filters."

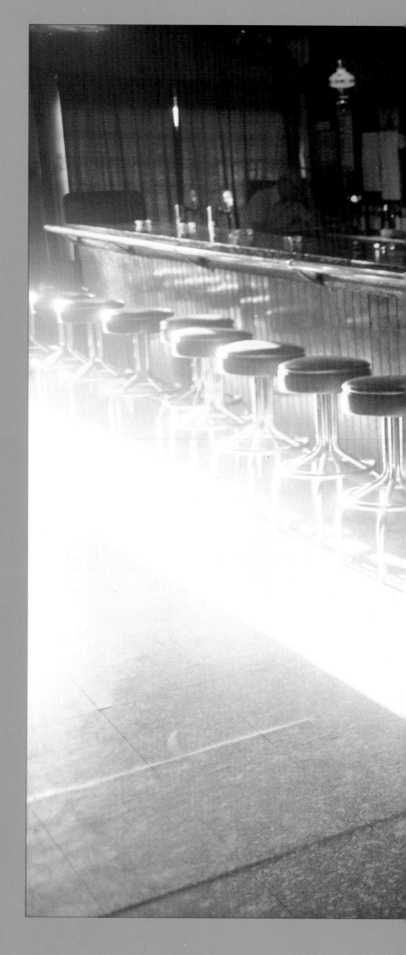

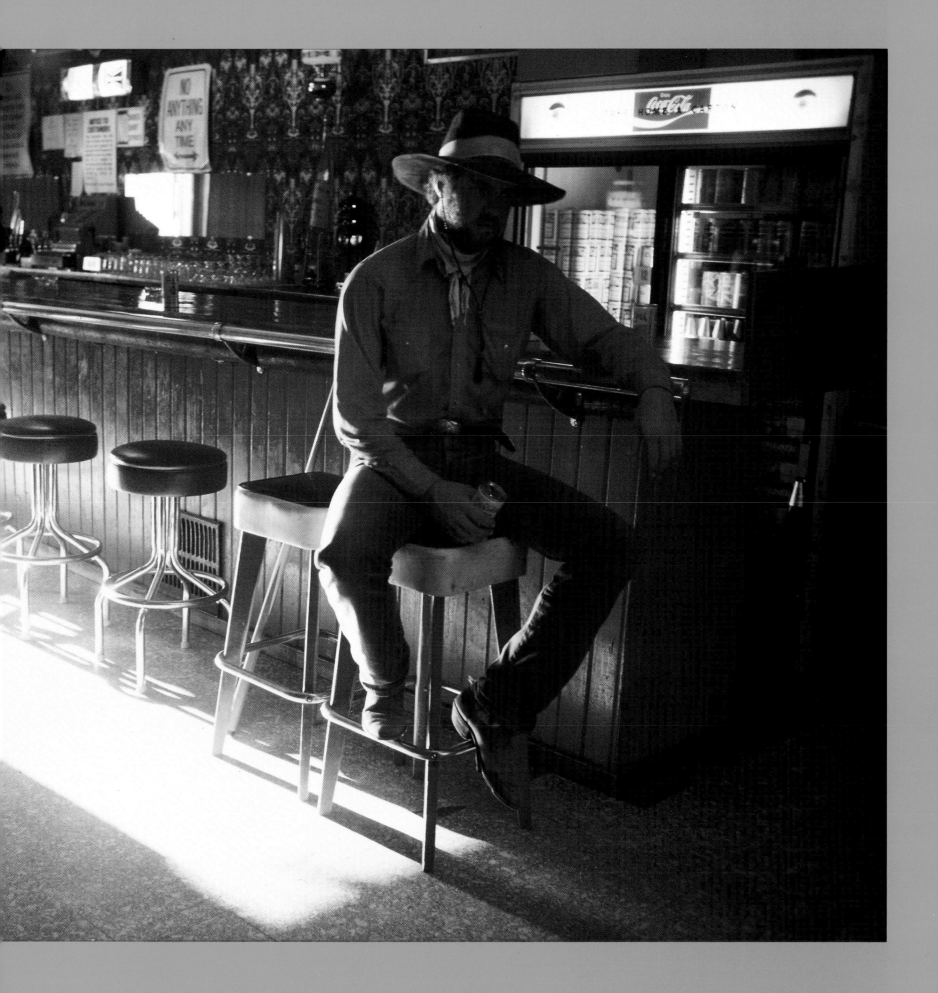

INDEX

THE AUTHOR

Leah Bendavid-Val is a senior editor for National Geographic books. She has worked as project director and picture editor for seven Society books, edited photography for *U.S. News & World Report, Science, National Wildlife,* and other publications, and has written about photography for several popular publications, including an article on Swedish photographer Lennart Nilsson for *In Health* magazine. Bendavid-Val is the author of *Changing Reality: Recent Soviet Photography,* published in 1991.

ACKNOWLEDGMENTS

The Book Division gratefully acknowledges the assistance of all who have helped make possible the publication of this volume, in particular, the individuals and organizations named, portrayed, or quoted in its pages. Also, National Geographic photographers, past and present, who shared with us their time and experiences. The Division extends special thanks to the people cited here: Marietta Nelson, Kenneth Pratt, and Kenneth F. Weaver; at the National Geographic Society: Todd A. Gipstein, Elizabeth Hillman, Kathleen M. Jennings, Bethany T. Judt, and Valerie F. Mattingley; the Custom Photographic Laboratory; with the Image Collection—Maura A. Mulvihill, Flora D. Davis, Vickie M. Donovan, and Robert A. Henry; and, with Records Library—Kathrine A. Fague, Cathy S. Hunter, Michael D. Murphy, Eric J. Rasmussen, and Samuel E. Rocha. Leah Bendavid-Val is especially grateful to Bob Gilka, Thomas R. Kennedy, Kent J. Kobersteen, Susan A. Smith, and the late Declan Haun for their guidance and inspiration.

ILLUSTRATIONS CREDITS

OPENING PORTFOLIO: pages 4-5 Steve McCurry/Magnum; 8 Michael Nichols/Magnum; 8-9 Michael Nichols/Magnum; 15 Joe McNally with Dennis Thayer, Jules Stein Institute; 29 Grosvenor Collection, Library of Congress

THEN AND NOW: page 32 Robert E. Peary Collection; 42 George Rodger/Magnum; 56-57 Michael Nichols/Magnum; 60-61 Frans Lanting/Minden Pictures

FARAWAY PLACES: page 127 James Nachtwey/Magnum

IN THE WILD: page 149 James Balog/Black Star; 162-63 Michael Nichols/Magnum; 165 Michael Nichols/Magnum; 175 Maggie Steber/JB Pictures

THE SCIENCES: page 237 James A. Sugar with Kevin Schumacher and Larry D. Kinney; 238-39 Joe McNally/Sygma; 249 Roger H. Ressmeyer/Starlight; 250-51 Ralph Perry/Black Star; 252 Steve McCurry/Magnum; 240-41 Alan B. Shepard, Jr./NASA; 253 James A. Sugar/Black Star; 254 Ted Spiegel/Black Star; 262 Ira Block, courtesy Moesgård Prehistoric Museum, Århus, Denmark

Composition for this book by the National Geographic Society Book Division, with the assistance of the Typographic Section of National Geographic Production Services, Pre-Press Division. Printed and bound by R. R. Donnelley & Sons, Willard, Ohio. Color separations by Digital Color Image, Cherry Hill, N.J.; Graphic Art Services, Inc., Nashville, Tenn.; Lanman Progressive Co., Washington, D.C.; North American Color, Inc., Portage, Mich.; Penn Colour Graphics, Inc., Huntingdon Valley, Penn. Paper by Consolidated/Alling & Cory, Willow Grove, Penn. Dust Jacket printed by Inland Press, Menomonee Falls, Wisc.